Picturing Tropical Nature

Picturing Tropical Nature

Nancy Leys Stepan

CORNELL UNIVERSITY PRESS
ITHACA, NEW YORK

First published in the United States of America
in 2001 by Cornell University Press
512 East State Street, Ithaca, NY 14850

Originally published in Great Britain in 2001 by
Reaktion Books, London
in the Picturing History series,
edited by Peter Burke, Sander L. Gilman,
Ludmilla Jordanova and Roy Porter

Series design by Humphrey Stone
Printed and bound in Great Britain by
Biddles Limited, Guildford and King's Lynn

Library of Congress Cataloging-in-Publication Data

Stepan, Nancy,
 Picturing tropical nature / Nancy Leys Stepan
 p. cm.
 Includes bibliographical references.
 ISBN 0-8014-3881-0 (cloth)
 1. Philosophy of nature. 2. Human ecology–Philosophy. 3. Tropics
 4. Tropics–In art 5. Tropics–In literature. I. Title.

BD581 S719 2001
909´.093–dc21
 00-060393

Contents

Acknowledgements

This book took shape in my mind in 1993, which turned out to be right before I left the United States for a five-year stay in Europe – two years in Hungary, at the newly founded Central European University, and then three years in Britain, as Senior Research Fellow at the Wellcome Unit for the History of Medicine at the University of Oxford. These moves, and my new job responsibilities, caused a certain delay in writing the book, but on reflection, I think being based in Europe while writing it was good for me. It made me to think about 'the tropics' not as a matter of places and people I visited often but at a certain remove, from a geographical distance. As a result, tropical places began to acquire for me some of the fantastic, or even the phantasmatic, character of the images of the tropics I was examining for the book; I visited tropical nature not in reality but in my imagination. From the perspective of colder places, I found that I sometimes could not help but share in the very perceptions of tropical nature that I was simultaneously trying to take apart, or study as cultural inventions. I have tried to keep this sense of sharing, and not sharing, the pictures of the tropics I discuss in this book; to evoke the power of images to affect us but to show that they are only images, not the world itself.

Writing this book took me in new directions, first because it is about images, at which I had to learn to look hard, and second because I had to become acquainted with some of the approaches used in art criticism, visual anthropology and the history of photography. I also found that the subject of tropical nature, as I had defined it, cut across many academic disciplines, such as environmental history, the history of art and photography, and landscape design, as well as the history of natural history and medical history.

Writing this book was filled with adventures which turned challenges and obstacles into fun. For instance, Paulo Sergio Pinheiro introduced me in Rio de Janeiro to Dr Jorge de Souza Hue, who in turn showed me a number of Burle Marx's paintings in his possession and helped arrange visits to a number of Burle Marx's private gardens. My

son, Adam Stepan, a documentary filmmaker, drove me out to Petrópolis, where in the past the Emperor of Brazil had kept his summer palace, to see the gardens. He also bicycled with me through the huge public park of Flamengo in Rio, to see the repair work belatedly being carried out to Burle Marx's designs, and took me hiking in the hills of Tijuca. I want to thank him and my daughter-in-law, Mónica, for giving me a home base in Rio, and Mónica especially for helping me see Rio through the playful and at times critical eyes of a native *carioca*.

In Amazônia, in Manaus, a passing stranger, a photographer, helped me by taking pictures of some rare images held in the municipal library. Four hours away from Manaus, some local residents in one of the last remaining remnants of primary forest in the area showed me what visiting naturalists have always known, that nearly all the plants in the forests have names and value to those who live with them on a daily basis.

In Rio de Janeiro, again, a young curator at the National Museum of Fine Arts managed to get into the basement to take a photograph of a particular painting for me when it was in storage. Bluma Gamerman and Andréa Moreira, in Rio, did valiant work tracking down images for me. In the magnificent New York Public Library, a librarian in charge of permissions personally delivered a letter in a rendezvous by the lifts. In Boston, the great expert on Martin Heade's paintings, Theodore E. Stebbins Jr, gave me a personal tour through the Heade collection in the Museum of Fine Arts. In England, Colin Leys and Judith Kazantzis listened to my ideas about the book, and with interest. Darrell Posey supported me in Oxford at a crucial moment, both through his deep knowledge of Amazônia and through his enthusiasm for the kind of interpretations I was making. Tanya and Robert Murray brought Isabel, joy, great fun and animated discussions during the writing of the book. I could go on; without these efforts by others, and by the many kindnesses that add up, it would not have been done.

Librarians always figure greatly in my life; I especially want to thank those at the Rare Book and Manuscript Library at Columbia University, New York; colleagues and experts at the Oswaldo Cruz Archive, Fiocruz, Brazil, one of the great collections of visual materials in medicine in the tropics; and the librarians at the splendid Wellcome Library, London. My special thanks go to Carole Satyamurti and Alfred Stepan for their close reading of the book in manuscript, and for the great tact with which they suggested that certain alterations would make it much better.

Parts of this book have appeared in previous publications or in public lectures which should be acknowledged. Part of Chapter 2

appeared as 'Tropical Nature as a Way of Writing', in A. Lafuente *et al.*, eds, *Mundalización de la ciencia y cultura nacional* (Madrid, 1993), pp. 495–504. The argument of Chapter 3, on Agassiz, was first presented when I was scholar in residence at the University of Sussex, in the *Stories/Narratives/Discipline* programme in February 1997. A portion of Chapter 4 was published as 'Portraits of a Possible Nation: Photographing Medicine in Brazil', in *Bulletin of the History of Medicine* 68 (1994), pp. 136–49. A short section in Chapter 5 is taken from 'Tropical Medicine and Public Health in Latin America', in *Medical History* 42 (1998), pp. 104–12. The main argument of Chapter 6 was presented at the Wellcome Institute, London, at the 'Art, Ethnicity and Illness Symposium' on 5 December 1997. Finally, a shorter version of Chapter 7 was published as 'Tropical Modernism: Designing the Tropical Landscape', in a special issue of *The Singapore Journal of Tropical Geography* edited by Brenda Yeoh and Felix Driver (21/1 [2000], pp. 76–91). I thank these journals for permission to reproduce materials, the universities mentioned, and the many other institutions to which I have been invited to speak and at which I have had the chance to try out my ideas in public.

Last but not least, I want to thank the Wellcome Trust for its generous support of my work on tropical medicine during my three years in Britain, some of the results of which are reflected in this book.

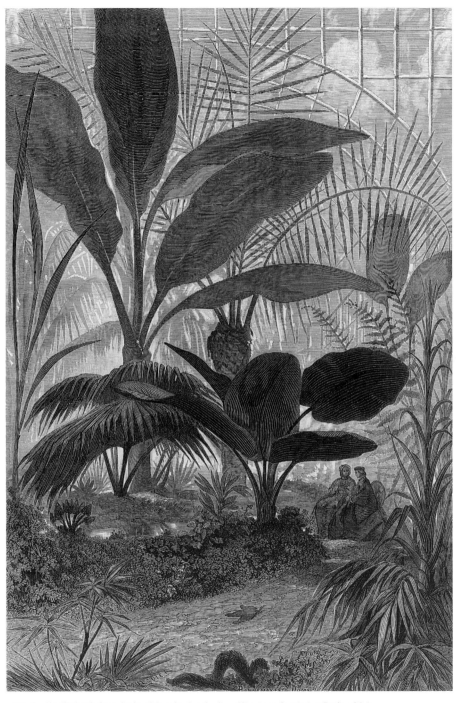

1 'Un Jardin d'Hiver', from Arthur Mangin, *Les Jardins: Histoire et description* (Paris, 1867).

Introduction

I open this book with a print taken from a French book of 1867 on garden history, showing two women enjoying a hothouse in midwinter (illus. 1). This picture suggests the great interest the tropics had for Europeans in the nineteenth century. But it also indicates that tropical nature was an imaginative construct as much as it was an empirical description of the natural world.[1] The plants depicted in the print, for instance, have a certain botanical plausibility but are also subtly exaggerated in scale and shape, thereby creating an impression of a world of nature that is different from, or alien to, nature in the temperate world. Tropical nature in the hothouse also seems strangely melancholy, even somewhat sinister; the huge, dark palms and tree-ferns contrast almost comically with the tiny figures of the women visitors enjoying the balmy air. The image suggests a vegetative existence belonging to an older, more primitive world than the temperate world of the present – plant analogues, perhaps, of the gigantic dinosaurs that were being reconstructed by palaeontologists at the time.

The visual grammar of this tropical picture has been, I believe, remarkably persistent in Western representations; so familiar is it, perhaps, that we often forget what a selective (and in several respects misleading) picture it is. To this day, it frames our expectations. When we go to the tropics, perhaps as eco-tourists to see the jungle (or, as we call it today, the rain-forest), we imagine ourselves stepping back in time, into a purer or less spoilt place than our own; we hope to see plants and animals quite unlike, and more exotic than, those familiar to us; we expect somehow to come closer *to* nature in the tropics or to find that objects, or ourselves, achieve there a kind of transcendence.

Even the most sophisticated of observers is not immune to such expectations. The French anthropologist Claude Lévi-Strauss, whose famous book *Tristes tropiques* (first published in 1955) was written in ironic commentary on the entire genre of travel writing (a genre from whose conventions he nonetheless could not entirely cut himself loose), confessed that an unanticipated invitation to go to the tropics in

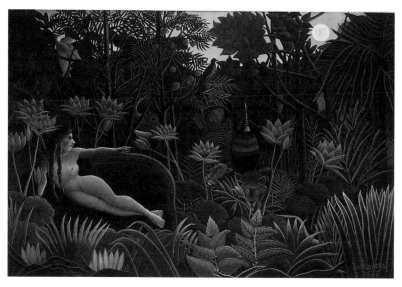

2 Henri Rousseau, *The Dream*, 1910, oil on canvas. Museum of Modern Art, New York (gift of Nelson A. Rockefeller).

the 1930s had immediately conjured up a mental picture of utter difference. 'I imagined exotic countries to be the exact opposite of ours,' he wrote,

and the term 'antipodes' had a richer and more naive significance for me than merely its literal meaning. I would have been most surprised if anyone could have told me that an animal or a vegetable species could have the same appearance on both sides of the globe. I expected each animal, tree or blade of grass to be radically different, and its tropical nature to be glaringly obvious at a glance.

'Looked at from the outside,' he added,

tropical nature seemed to be of quite a different order from the kind of nature we are familiar with; it displayed a higher degree of presence and permanence. As in the Douanier Rousseau's paintings of exotic landscapes, living entities attained the dignity of objects

(Rousseau's evocation of the tropics through the image of a naked female body in the jungle being another familiar representation of the tropics in the Western imagination [illus. 2]).[2]

Such views of the tropics as places primarily of untamed nature, a nature pregnant with meaning, awaiting discovery, interpretation or exploitation, bring in the nature tourists (and pharmaceutical companies) today, but it can also cause irritation among the inhabitants of tropical countries, even those who place a high value on their unspoilt

3 Railway lines cutting through jungle in Brazil, early 20th century. Casa de Oswaldo Cruz.

nature and are most concerned with defending it against environmental spoliation. They feel, quite rightly, that there is more to their countries than jungle. The landscape designer and environmentalist Roberto Burle Marx, for example, whose tropical gardens I examine in this book, commented that when he was a boy growing up in the tropics, the most common sight where he lived was not the jungle of the European imagination but a scarred and charred landscape cleared for urban development (illus. 3).[3] Lévi-Strauss himself concluded, after a few months of living in the tropics, that they were less exotic than out-of-date.[4]

These remarks serve to introduce the subject of this book: representations of tropical nature. Nature, of course, has never been so popular a subject as it is today, tropical nature never so much in the news. But this book is neither one more account of the crisis of the tropical rainforests, nor of their disappearing biota, nor of their disappearing indigenous populations (though it touches on all of these subjects in some fashion, at some point). Its focus is, rather, genealogical, in that it aims to trace, through selected moments, episodes and, above all, visual images, some of the ways in which tropical nature has been imagined, produced and interpreted in modern history. The historian David Arnold uses the term *tropicality* to indicate the constructed or discursive representation of the tropics in modern geography.[5] My own purpose is to situate a diverse set of images of tropicality in historical context, and to examine the role tropical nature plays in the

Western imagination as a foil to other kinds of nature. How did some of its most enduring representations emerge, what assumptions framed them, and how and when did they alter over time? My point is that our representations, and therefore our understanding, of tropical nature reflect political, aesthetic and other projects that have the capacity to expand, or limit, our imaginative engagement with the natural world.

This book, then, is framed by the following question: How did nature, people and diseases come to be seen and represented *as* tropical, and with what consequences? To many people, of course, descriptions and illustrations of tropical nature are not matters of representation but of straightforward fact. They are realistic referents to an empirically established, discrete geographical region of the world (i.e. the area between the Tropic of Cancer and the Tropic of Capricorn, or 12 degrees latitude north and 12 degrees latitude south of the equator). Or they refer to the animals, plants and diseases commonly found there – the hummingbirds, snakes and monkeys, the bromeliads, orchids and giant water-lilies, the Ebola virus or malarial fevers named and described in books of natural history and medicine. There is of course some truth in this view. I am not one of those who think that the natural world does not exist, or that there is nothing 'outside the text'. On the contrary, I think that the real world of nature is physically very present to most of us and speaks to some of our deepest symbolic and emotional needs; and that some representations we make of nature are better – more accurate, more subtle, more expressive – than others.

I would argue, however, that history shows us that there is no single map or picture of the natural world that increasing knowledge progressively fills in, but rather many different maps and representations, articulated and shaped by numerous factors of politics, culture and aesthetics, by beliefs about reality, codes of seeing and representational conventions. Even the most scientific of our pictures of natural objects are not a matter of a simple transfer of perceptions into representations, but rely on a repertoire of what Martin Kemp calls 'graphic tricks' (that is, visual conventions) to create their empirical or 'truth effects'.[6] The illustration exists, therefore, within a system of scientific communication whose code we need to understand if the picture is to work as one of empirical referentiality. Of course, we are so accustomed to scientific illustrations nowadays that we easily forget that they are just representations and take them for literal transcriptions of reality.

My point is the now familiar one that all representations and pictures of the world, even the most technical and scientific ones, are

partial and selective. We see the world by means of and through such representations and systems of communication, which allow us to make sense of landscapes and objects. Charles Darwin, the founder of the theory of evolution by natural selection who spent five years as a naturalist going round the world on HMS *Beagle*, commented that on first entering a tropical forest he saw tropical nature through eyes prepared by the German naturalist and traveller Alexender von Humboldt, whose account of his own journey through the tropics Darwin had read before starting out. 'As the force of impressions generally depends on preconceived ideas,' Darwin wrote, 'I may add, that all mine were taken from the vivid descriptions in the *Personal Narrative* of Humboldt.'[7] Without these descriptions, Darwin was often at a loss to make sense of what he saw before him. Of course, his own direct experience entered into the picture he made in his mind; his later evolutionary perspective, for instance, could not have been further from Humboldt's world-view. Today, similarly, our perceptions of the natural world are equally shaped by visual representations, such as the images we see in books, videos or films, and by the frames provided by viewing nature through the windows of a car, and by the packaging of nature by the tourist industry.

This is just to say that nature is always culture before it is nature. Or, as Simon Schama says in *Landscape and Memory*, his long reflection on the way we invest natural landscapes with memory, longing, nostalgia and history, 'Even landscapes that we suppose to be most free of our culture may turn out, on closer inspection, to be its product.'[8] This idea that our view of the natural world is always historically constituted by human material and perceptual interactions, so that our understanding of it is always a form of social knowledge, has become almost a cliché of contemporary historical studies. It is useful, nonetheless, in making clear that nature is not just 'natural' but is created *as* natural by human desires and intentions.

In this regard, it is my argument in this book that our idea of tropical nature as a particular kind of place or space, with its own characteristic ensembles of plants and animals (as well as peoples and diseases), represented via a repertoire of images that we can immediately identify as 'tropical', is fundamentally a modern one, belonging, that is, to our post-Enlightenment era. It came to the fore especially in the nineteenth century. This book is therefore bounded at one end by Humboldt, the great pre-Darwinian naturalist and scientific traveller whose long account of the sublime tropics did so much to inspire later artists and naturalists, and at the other end by late twentieth-century images of tropical destruction and disease.

Of course, the idea of the tropics predates Humboldt. The notion that there is something distinctive about hot places is a very old one, going back to Classical Antiquity. In the Age of Discovery, the conquistadors, missionaries and naturalists who went to the New World marvelled at the sight of tropical wonders; written accounts of the landscape expressed delight in the perpetual green of the vegetation at the equator and the strange character of the animals there. In the New World tropics, nature indeed seemed new, a potential paradise, perhaps the actual location of Eden (an idea that did not long survive the realities of loneliness, disease and disaster).[9]

But depictions of tropical nature were unsystematic; words often seemed inadequate to the task of conveying to readers the unusual features of species seen for the first time and their difference from species at home.[10] The imprecise language of 'wonders' and 'marvels' was often all the writer could muster; even in the 1860s, the philosopher William James, describing Rio de Janeiro, wrote that 'No words, but only savage inarticulate cries can express the gorgeous loveliness of the walk I have been taking. Houp la la!'[11]

To grasp 'tropical nature' – to see it as a distinctive ensemble of natural history and geography, a specifically tropical site and sight – requires intellectual and perceptual frames which help the viewer sort out what is salient, striking, useful or scientifically novel. Such frames began to appear in the eighteenth century, in the era of European colonial expansion and scientific circumnavigation of the globe.

Three areas of knowledge were especially important to the emerging definition of tropical nature in European thought. None were completely new, but each became more systematic in the eighteenth century. The first was natural history, with its emphasis on collecting and classifying species from across the globe, in order to make an encyclopaedic catalogue of living things. Natural history placed species in geographical relation to each other and thereby helped clarify the distinguishing features of tropical species. The process was greatly aided when Linnaeus's standardized nomenclature (his well-known binomial system in which every species received a generic and a specific name in Latin) was widely taken up by naturalists; his sexual system of plant classification placed botanical species in a universal schema of scientific communication (while admittedly hastening the disappearance of local names and vernacular knowledge). A similar impulse to collect and classify underlay the second field of inquiry, the new human sciences, which aimed at ordering all of the varieties of humankind into a single natural hierarchy of difference and similarity. It was in the new anthropology that racial differences between human

groups became a chief means by which the human world was mapped. The third field, medicine, saw a revival of a classic geographical approach to disease, which explained illness in terms of variables of place and milieu; as a result, a new awareness of the special features of disease in tropical environments emerged, and the new speciality of tropical medicine was eventually defined. All three fields of inquiry greatly extended the study of tropical regions; in turn, tropical descriptions and depictions contributed fundamentally to their contents.

As Janet Browne remarks in her study of biogeography (the science of the distribution of species across space and time), the transfer to natural history, geography and anthropology of the political terminology of the eighteenth century – 'kingdom', 'nation', 'province' and 'colonist' – indicates just how closely the notion of a distinctive tropical nature was tied to political empire and the geopolitical concerns of the day.[12] In the context of a profoundly utilitarian approach to the natural world, in which nature was to be systematically described, measured, classified and turned where possible into a commodity, the distinction between what was tropical and what was not took on new material, representational and symbolic meanings. Old terms for the equatorial regions, such as the 'equinoctial' or the 'torrid' zones, began to be replaced by a new terminology of 'the tropics', designating a worldwide space of a particular type of nature. A similar shift in perception and interpretation occurred in medicine; in 1787, for instance, the phrase 'tropical disease' was introduced for the first time in an English medical work, to indicate the special illnesses associated with hot climates.[13]

Over time, the geography of this tropical world expanded as new places and countries were folded into its conceptual category. In medicine, for example, the West Indies had come to be considered tropical by the middle of the eighteenth century, when European physicians first began to articulate their ideas about the novel character and special dangers of the diseases they encountered there. By the 1830s, India and Africa had come to be considered tropical in their disease characteristics as well. Eventually, many places came to be seen as tropical that in a literal (geographical) sense were not (e.g. Algeria was considered medically tropical by the late nineteenth century).[14] In this way, the 'tropical' came to constitute more than a geographical concept; it signified a place of radical otherness to the temperate world, with which it contrasted and which it helped constitute. Descriptions and pictures of the tropics in this way contributed to the formation of European identity, as distinct from that of the tropical

zone, where the superabundance of nature was believed to overwhelm human endeavour and reduce the place to nature itself.

Picturing tropical nature

Most Europeans and North Americans, even in this day of mass tourism, do not see the tropics at first hand but at second hand, in the form of spectacles of species and objects assembled in greenhouses, botanical gardens, zoos and exhibitions (the antecedents of which were the nineteenth-century World Exhibitions to which were sent all sorts of natural and cultural exotica, including human tribes, for display and entertainment).[15] Above all, Europeans get to know about the tropics through pictures – copper engravings, woodcuts, drawings, lithographs, photographs and, today, films and videos. Indeed, to a larger extent than is usually acknowledged, the identity of 'tropical nature' in the European mind depends upon its visual representations. For this reason, the pictures in this book are not just *illustrations* of tropical nature but its *argument*.

This reliance on the visual image has long been recognized as a characteristic feature of the modern world. Yet for all our acknowledgement of the immediacy and power of images, and for all our talk *about* the visual, somehow images, as the critic W. J.T. Mitchell says in his seminal book *Picture Theory*, seem to escape our intellectual control.[16] Even the commonly drawn distinction between word and image is open to question. How visual images function in particular domains of culture often remains quite opaque. Science, for example, is particularly image-driven, yet its images and diagrams have only very recently begun to receive critical attention from historians.[17]

Mitchell, in addressing several of these crucial issues (though not in relation to images of the natural world), argues that words and images, while different from each other, at the same time cannot easily be separated from one another. 'All media are mixed media,' he argues.[18] The visual exists in complex tension with the verbal, and vice versa; so books often incorporate pictures, and pictures often either incorporate words (e.g. captions) or implicitly connect to them. At times, of course, pictures lose their historical or contingent links to texts or implied verbal representations, and somehow 'speak' to profound human emotions across time and space (but note how the word *speak* once again suggests a verbal dimension to visual experience).

As its title indicates, my book is concerned with the way tropical nature, broadly defined, has been pictured. My aim in writing it is to approach images of tropical nature as much as possible *qua* images –

that is, as cultural artefacts that require analysis in their own right, while bearing in mind how they might be seen to interact with other kinds of representations. As a historian, the contexts in which images are produced and consumed are of course essential to my interpretations; yet I acknowledge that images cannot simply be reduced to those contexts. My purpose is to examine how images work as such, how they differ from words, or work *with* words and other images, to structure our perceptions and give meaning to the natural world.

Like the verbal descriptions of the tropics, pictures and illustrations of the tropical world would seem to have a history that is essentially modern. Of course, a European iconography of the Torrid Zone predates the nineteenth century (in 1502, only two years after Cabral discovered Brazil, a Portuguese map maker drew blue and red macaws on his map to indicate the exotic character of the country).[19] By the seventeenth century, a taste for the tropical was already shaping the art market. If one looks, for example, at the small number of tropical landscapes painted by the Dutch artist Franz Post in the New World Dutch colony in Brazil in the 1660s, one sees delicate pictures that follow European landscape conventions, with little of the exotic in them; in comparison to these, the many pictures which Post produced for the European art market once he had returned to Holland give far greater emphasis to the primitive and the exotic, such as huge, fantastic serpents glimpsed in the forest, and native peoples.[20] The demand for tropical pictures was further stimulated, as Bernard Smith has shown, by the eighteenth-century ocean voyages, especially Captain Cook's to the South Pacific in the 1770s and '80s, which opened up new landscapes, as well as natural-history and ethnographic subjects, to artistic and scientific scrutiny.[21] The New World political independence movements in the early nineteenth century had a similar effect in opening up the South American tropical regions to an intellectual and visual rediscovery in the early nineteenth century.

As a result of these developments, we could say that the tropics became visually 'tropicalized'. Take palm-trees, for instance. These tall and graceful plants, which had long symbolized the origins of civilization in Asia or the biblical desert lands of the Middle East, were claimed by Humboldt to be the most noble of tropical plants, whose mere presence was responsible for much of the aesthetic impact that tropical landscapes had on the human imagination. Palm-trees thus came to be valued in themselves, primarily as objects of nature. Over time, the palm-tree became the ubiquitous sign of the tropics, images of it instantly signalling less a botanical species than an imaginative submersion in hot places (illus. 4, 5).

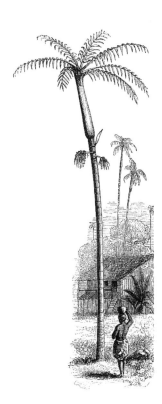
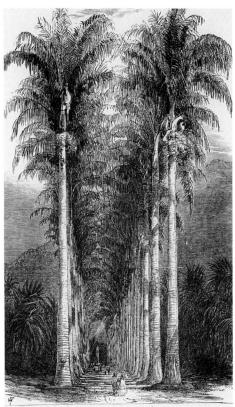

4 'Assai Palm (*Euterpe oleracea*)', from Henry Walter Bates, *The Naturalist on the River Amazons* (London, 1863).

5 'Vista down the Alley of Palms', from Professor and Mrs Louis Agassiz, *A Journey in Brazil* (Boston, 1868).

Images like these circulated widely in the nineteenth century, as the number of illustrated books of travel and natural history grew by leaps and bounds, stimulated by the demands of a self-improving, literate public interested in imperial adventures and faraway places, as well as by innovations in the technology of reproducing images. For instance, lithography, which had made its first appearance in the 1790s, took off in the 1820s as a means of illustrating books; lithography made fine detail possible at far less cost than copper engraving. Wood engravings were even cheaper, and also finer than woodcuts; both kinds of images could be printed in texts. Illustrations gave vivacity and the appearance of verisimilitude to verbal accounts. For example, we could turn to *The Naturalist on the River Amazons* (1863) by Henry Walter Bates, who collected species in the Amazon between 1848 and 1859. The pictures

in this classic book of travel and popular science do much to add visual excitement to the narrative: 'Bird-Killing Spider Attacking Finches', 'Ant-Eater Grappling with Dog' and the marvellous frontispiece 'Adventure with Curl-Crested Toucans', which depicts a bespectacled Bates, dressed in rough checked shirt and floppy hat, defending himself against an onslaught of toucans coming to the rescue of one of their own that he had wounded (illus. 6). Photography was another new technology of visual representation introduced in the nineteenth century; first used in the form of daguerreotypes in 1839, it came into its own in the 1860s, when faster lenses and the wet collodion process of reproduction made photographs easier to make and cheaper to use.

Though naturalists and travellers tried to anchor the meanings of their images by tying them to texts, captions or diagrams, images often escaped from these contexts, to be viewed and interpreted in unexpected ways. Since representations are not stable and often require periodic reinvestment in times of change and challenge, moments of representational instability, when an accepted mode of seeing the tropics is contested and the representation revealed for what it is (namely a representation that is by definition only partial), can be especially valuable to historians. Focusing on such moments allows us to uncover some of the cultural, intellectual and scientific work that goes into the making of images.

A view from the tropics

Nature, by which I mean landscapes, empirical descriptions of flora and fauna, parks and gardens, as well as aesthetic and emotional responses to the natural world, has no trans-historical meaning, but rather many different meanings corresponding to specific material, social and intellectual conditions.[22] Thus tropical nature could be viewed very differently by a European naturalist spending a few months or years collecting exotica in the tropical forest, with an eye to a career or an audience back home; by an immigrant hoping to make a living from farming, for whom tropical nature was viewed as either a natural resource or a physical barrier; or by a long-time resident in a modern city in the tropics, for whom tropical nature was so familiar as to have perhaps little aesthetic or novelty interest. Even within European representations, tropical nature stood for many different values – for heat and warmth but also for a dangerous and diseased environment; for superabundant fertility but also for fatal excess; for species novelty but also for the bizarre and deadly; for lazy sensuality and sexuality but also for impermissible racial mixings and degeneration.

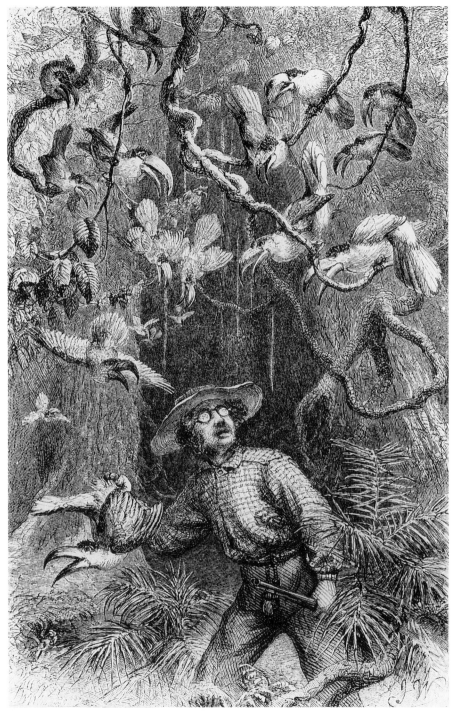

6 'Adventure with Curl-Crested Toucans', from Bates, *The Naturalist on the River Amazons*.

But however inconsistent or even contradictory such views of the tropics were, European representations had weight. They mattered. To politicians, intellectuals, scientists and artists born in tropical countries, the picture presented of the tropics as a space of 'pure' nature, different in content and kind from other natures, was often discomfiting. They often drew responses in the form of corrections, new representations and new images. People described by others are not always passive objects of scrutiny but active subjects, capable of assessing the world about them in their own words and images. The terms of self-representation are often not completely *sui generis*, but involve the selective appropriation and re-elaboration of elements in a repertoire of established pictorial and verbal conventions.[23]

It is in order to understand this element of self-representation and interrogation of images that I turn in this book to several instances of representations of tropical nature made *in* and *from* the tropics. The New World is especially (though not exclusively) emphasized for a number of reasons. First, the scientists and painters who depicted New World tropical and neo-tropical regions have profoundly influenced our perceptions of the natural world; among the scientists who travelled there, for example, were Humboldt, Darwin, Bates, Alfred Russel Wallace, Louis Agassiz, Thomas Belt, Richard Spruce, Fritz Müller and William Beebe, to mention only a few. Among painters who made the New World tropics their subject were Johann Rugendas, Titian Peale, Frederick Edwin Church, Martin Heade, Marianne North and Margaret Mee. The books, illustrations and paintings by these naturalists and artists shaped tropical perceptions, but these representations in turn often sparked contrary reactions in the newly independent American republics, where politicians and intellectuals were struggling to create their own mythologies of national identity.

A second reason for emphasizing the New World is that, though imperial history has enjoyed a renewal in our supposedly post-imperial age, the general focus has been on India, Africa and those areas that were formally part of European colonial possessions overseas. Yet Latin America was part of a system of informal European empire; the British, for example, were the major bankers and lenders of credit to many countries there throughout the nineteenth century. The ships of Her Majesty's Navy, like HMS *Beagle*, were sent to map the South American coastline, while agents from Kew Gardens and the Royal Geographical Society were dispatched to collect botanical 'intelligence'. In fact, more naturalists, painters and commercial travellers probably went from Europe to the New World tropics in the nineteenth century than to any other tropical region.

Finally, by focusing on the New World, we are brought thoroughly up-to-date in tropical controversies. The area contains the largest tract of rain-forest still in existence (57 per cent of the world's total), and one of the most famous (or infamous, because of its rapid destruction). The rain-forests are home to a huge number of the known living species of plants and animals (Brazil alone has 55,000 plant species or 22 per cent of the planet's total), as well as to thousands more that await scientific discovery and description.[24] They are also places where 'unknown' indigenous tribes can still – just – be discovered.

The threats that contemporary development present to the survival of the New World rain-forests place tropical nature at the heart of contemporary ecological debates. At the same time, the American tropics are so large, encompassing regions so humanly diverse, where there are found together appalling poverty and extreme wealth, backwardness and modernity, sprawling cities and vast uninhabited rural areas, scrubby, desertified terrain and lush forests, that they create a bewildering mix of impressions and images. This very heterogeneity challenges the reduction of the tropical world to a simple, or single, notion of 'the tropical'.

Tropical places, tropical people, tropical diseases

Given the huge array of visual images and verbal descriptions of tropical nature available from the nineteenth and twentieth centuries, there is no way to tell 'the' story of tropical representations, and this is certainly not my intention here. Indeed, I have been as selective in my choice of representations of tropical nature as any nineteenth-century tropicalist. The result is a series of connected essays on tropical themes. My aim is to focus on key or representative figures whose images I think capture important moments in the history of representations of tropical nature or raise interesting questions about the subject of representation itself.

The book is organized around the themes of tropical places, peoples and diseases. In the past, these were the most powerful conceptual frameworks employed for understanding the tropics (and they still largely are, in my view). I have tried, however, to avoid too neat a division between these frameworks, since they continually overlap and intertwine. The images examined include drawings, paintings, engravings, diagrams, photographs and built landscapes such as gardens. I have selected many images from books of popular science. As David Knight remarks, science is a particularly public kind of knowledge, and its printed images are therefore of special interest; nonetheless, they

tend to receive less attention from cultural historians than other kinds of representations, especially in the 'tropical field', which has been largely the preserve of literary critics and art historians interested in the romance and green hell of Gauguin and Conrad.[25]

In Chapters 1 and 2, I am concerned with tropical nature understood as a special kind of landscape or place. The word *landscape* refers to a manner of perceiving space in terms of a scene situated at a distance from the observer, as though it were a painted picture; it is rooted, then, in a Western way of organizing the visual field. But we also project onto different landscapes or natural objects all sorts of social and symbolic meanings concerning home, nation, human identity and transcendence. Particular places or natural sights are often singled out as special locations of commemoration and tourism. The designation of a site as one of 'nature' often results in our ignoring the social matrices that frame or produce it (e.g. the development of Niagara Falls as a fundamental symbol of the grandeur of American nature in the nineteenth century), or the realities and textures of human activities necessary to make it work as a site of nature. Postmodern geographers have drawn our attention to the way in which certain places or landscapes are structured socially or politically so as to exclude or include certain groups of people (e.g. in the distinction drawn between private and public spaces, and who can enter them). The word *landscape*, in short, has many meanings.

In Chapter 1, then, I explore some of the social factors and visual means by which tropical places and nature came increasingly into sight in the arts and sciences in the nineteenth century. Why did so many naturalists and artists have such a passion to go to the tropics? Which tropics? How did empire, the cult of natural history and the demand for exotic travel books affect how tropical nature was viewed?

The key figure here is, inevitably, the German scientific traveller Alexander von Humboldt. One of the great nineteenth-century polymaths, whose major work of synthesis was simply titled *Cosmos*, Humboldt was both traditionalist and innovator, perpetuating many stereotypes about humanity and nature in hot places while introducing new symbolic meanings, scientific data and visual representations. His *Personal Narrative*, describing his five years of travels through the American tropics in what are now Venezuela, Peru, Colombia and Ecuador (1799–1804), provided a model for writing about and viewing the tropics that influenced naturalists and artists for decades. We might say that he put the tropics on the world map in new ways; they became, in his works, a grand theatre of life where a particular kind of drama of living nature was enacted. In particular, Humboldt made the tropical

jungle an important interpretive framework, from Mowgli to Tarzan.

The influence of Humboldt is examined in a number of mid-nineteenth-century representational genres, from fine art to popular nature writing. I also trace the darkening of the sublime tropics, when Humboldt's pre-evolutionary optimism was replaced by a more pessimistic view, as Europeans extended their dominion over tropical nature in their overseas colonies and came to terms with its unfamiliar environments, diseases and peoples.

In Chapter 2, my subject is Alfred Russel Wallace, co-founder with Darwin of the theory of evolution by natural selection. The chapter's title refers to the impact of the evolutionary outlook on tropical representations, but also to the shifting representations Wallace himself employed. Wallace has, I believe, as good a claim as any naturalist to have inherited from Humboldt the title of chief tropicalist of his times. Spending a total of twelve years as a frequently lonely commercial traveller of nature in the tropical Americas and Malay Archipelago, Wallace was, like Humboldt, a prolific writer; his most famous book, *The Malay Archipelago* (1869), went through many editions and was supposedly Joseph Conrad's favourite read.[26] Another of his books, *Tropical Nature* (1878), gave me, incidentally, the title for this book.

Wallace was also an intellectual and social maverick, given to both realistic perceptions and quirky enthusiasms. His radical social philosophy placed him at an interesting and critical tangent to many of the pieties of Victorian science. An unusually empathetic traveller through tropical nature, he brought an eye and a mind to it that were largely free of the unreflecting colonial prejudices that jar today's reader of so many nineteenth-century books of travel and natural history. In many respects, then, he serves as an ideal voyager through the tropics, elucidating the changing possibilities in tropical representations and suggesting some of the sources of 'anti-tropical', 'tropicalist' and 'environmentalist' positions that an evolutionary perspective opened up.

In Chapters 3 and 4, I turn to my second framework, tropical peoples. In Chapter 3, my main concern is with the interpretation of a collection of racial photographs made in the tropics in the mid-1860s for Louis Agassiz, who was arguably the leading naturalist in America at that time. Agassiz was to anti-Darwinism what Wallace was to Darwinism, and in this sense makes a useful foil to Wallace. He shared with Wallace a great interest in ethnography, turning it, however, in severely racialist directions. As with Wallace's first efforts to represent the tropics, Agassiz's pictures of tropical races might be said to be 'anti-tropical' in that they are deliberately non-aesthetic depictions of the tropical body which contrast with the romantic images of semi-

naked beauties familiar to us from Gauguin's paintings (or *National Geographic* magazine).

The stated purpose of Agassiz's pictures, and what perhaps makes them unique for their times, was to provide accurate visual evidence of the character of racial *hybrids*, or mixed race types, especially evidence of the supposed degenerations caused by the mixtures which seemed so pervasive in the sensual climate of the tropics. The photographs he produced in the Amazon, with the aid of one of his students, raise a series of interpretative issues surrounding the compulsion to make the hybrid racial body transparent to the naturalist via a new visual technology, and the difficulties of doing so. In this regard, his photographs embody an entire problematic about tropical bodies and their representations. For a verbal and visual commentary on Agassiz's representations, I turn to the young William James (brother of the future novelist Henry James, and himself the future founder of American pragmatism and psychology), who, somewhat incongruously one might think, was to be found in the tropics as a student member of Agassiz's expedition. James's letters from the Amazon, his diary and especially his drawings provide a witty counter-view of tropical places.

In Chapter 4, a first view of the tropics *from* the tropics, I consider how Agassiz's ideas were both taken up, and turned upside-down, in the tropical country that had served as his laboratory. Starting in the nineteenth century, writers, painters and scientists from Brazil began to construct their own mythology of tropical civilization, based on the very fusion of races so despised by European theorists. This narrative of racial and political transformation, which by the 1930s would become elevated to a national myth of Brazil's unique tropical identity (and which to a large extent remains intact to this day), can be understood as one response to the long and dismal history of Western denigration of tropical places and peoples. Here, I examine the theme of tropical/racial regeneration as expressed in a number of photographic portraits taken in the interior of the country in the early twentieth century, portraits which might be said to both partake of the racial inventory and to disrupt its conventions, and, in so doing, to represent the country as a 'possible' civilization in the tropics.

Chapters 5 and 6 look at how place and race converged historically and visually in the concept of tropical disease. The belief that hot climates are harmful to human health is a very old one, but the simultaneous expansion of Europe overseas into tropical colonies and the discoveries of microbiology at the end of the nineteenth century transformed the older climatic and geographical theory of disease into a new discipline or medical speciality of tropical medicine focused on

diseases believed to be specific to the tropics. The visual iconography of the diseased tropics shifted from climatic maps to pathogens, insect vectors and clinical portraits of the tropically ill.

Almost by definition, tropical medicine was a colonial medicine, and tropical diseases were diseases of colonial people; the pictures of the sores and other horrible signs of tropical illness shown in medical textbooks were those of Africans, Samoans and Indians. Many of these pictures circulated beyond professional medical circles to the newspapers and popular publications feeding public interest in colonial empires overseas. Such medical portraits are among the darkest images we have of the tropics – polar opposites of the images of the sublime tropics with which this book opens, and perhaps the ultimate vision of the green hell that is always part of European tropical imaginings.

In Chapter 5, I select for special examination the clinical portraits used to illustrate the disease called elephantiasis in Sir Patrick Manson's *Tropical Diseases: A Manual of Diseases in Hot Climates* (1898). Manson is considered the British founder of tropical medicine (Britain of course having the most extensive colonial possessions of all the European countries), and his book is a classic source of the basic ideas of the new medical speciality. Elephantiasis (also called filariasis) was one of the speciality's paradigmatic diseases, since it was one of the first to be shown through experimental techniques to be caused by parasitic infection and transmitted to humans by the bite of an insect. I argue that Manson's clinical pictures of elephantiasis are important because they exemplify the processes by which disease was projected onto tropical people. They also show the complicated interactions of place, race and gender in the making of disease representations. Scrutiny of these images can therefore tell us a great deal about how Europeans constructed the 'tropical' visually in tropical diseases.

In Chapter 6 my subject is a strange story of the appearance and disappearance of a tropical pathology discovered in Brazil, a story closely connected to how the disease *looked*. This is a second 'view from the tropics'. I examine the conflict that arose between the potential of the new tropical medicine to sanitize the tropics and the danger that it would reveal the tropics to be, once again, a place of peculiarity, a vast scene of horrific pathologies and diseases. My story revolves around a disease discovered in 1909 and called Chagas's disease after the Brazilian who identified it, Carlos Chagas. I trace the connections that existed between the many disputes that arose over Chagas's disease (which today infects millions of people) and its manner of visualization – its strange and often disturbing photographic portraits, which worked to reinforce doubts about both the disease's reality and

the validity of the new medical speciality of tropical medicine itself. I am interested here in the underlying ideological, symbolic and representational meanings of disease, and treat the images as condensed sites (and sights) in which were deposited all the contradictions and tensions surrounding tropical medicine in relation to a country's tropical identity – its racial make-up, natural environment and potentiality for modern civilization.

Finally, in my last chapter, I return to the broad theme of tropical nature with which I started, in order to frame the book chronologically and conceptually, and link it to some twentieth-century concerns. This chapter is once again a view produced *in* and *from* the tropics. Its theme is the artistic transformation of tropical nature into a form adequate to a modern Brazilian sense of appropriateness, given the history of tropicality as a European concept and given contemporary concerns about tropical environmentalism. My subject here is the deliberately designed or constructed landscape as exemplified by the innovative modernist gardens of the Brazilian landscape designer Roberto Burle Marx. I have always loved his gardens, so characteristic of Rio de Janeiro and impossible to miss, but I had never scrutinized them closely, in an historically informed fashion. It was only in researching and writing this book that I began to see that Burle Marx's tropical landscapes, which he began designing and building in the 1930s, at the height of the international modernist movement in art and architecture, and which he continued to design until his death in 1994, were highly relevant to my themes. Burle Marx's gardens were among the first public spaces built in his country to deliberately incorporate tropical plants as fundamental design elements instead of the European plants historically preferred by the social élites. At the same time, the radical uses which Burle Marx made of tropical plants, and the overall abstraction of his designs, could not have departed further from the expected associations of tropical nature as generally understood in Europe.

In Chapter 7, then, I examine Burle Marx's gardens not in the purely formal design terms usually employed in art and landscape commentaries on his work, but in historical and contextual fashion, considering them as metaphorical, visual and material means of recasting the symbolic possibilities of tropical nature – as interesting comments on, or solutions to, the problems of nature and culture in a country burdened by the designation 'tropical'. Though Burle Marx's gardens have been hugely influential in the world of professional landscape design, they are almost completely neglected by cultural historians; they have provided me with unexpected and deeply pleasurable

images of tropical nature, whose contemplation has given me the chance to weave together many of the themes of this book. Burle Marx was also a pioneer of tropical conservation in his country, and the discussion of his gardens brings the book up the present, to some of our contemporary debates about tropical ecology and the tropical imagination.

In a brief epilogue, I reflect on some of the continuities and discontinuities in the perceptual frameworks with which we view the tropical world, especially the impact of the new ecology. As all of nature is turned into commodities, as nature as we know it disappears, as we become even more image-obsessed in this digital age, shall we find, as Lévi-Strauss did, that as an idea, the tropics are out-of-date? In partial reply to ecological despair, or to fashionable post-modern hyper-irony, when nothing is allowed to be 'real' or 'natural' any more (quotation marks of course indicating a writer's thorough scepticism), I return to Burle Marx's tropical gardens, to consider them, both as real places of visual delight and as metaphorical spaces that might serve to help us rethink our relationship to the tropical world, and to nature more generally.

1 Going to the Tropics

'Sleeping or waking, my thoughts were constantly bent on how I could get abroad, and revel in the zoology of the tropics,' exclaimed the naturalist William Swainson.[1] What explains this passion for the tropics? What factors made the nineteenth century the tropical century *par excellence*?

First was political opportunity. The European imperial powers confidently extended their dominion over places and people in their colonies, sending out ships to map coastlines and harbours. They set up botanical gardens in tropical places to acclimatize exotic plants and commissioned naturalists to bring back medicinal plants, such as cinchona for the treatment of malaria. In the case of the American tropics, the independence movements opened up the once-closed colonies of Spain to new imperial interests (especially Britain's), to travel, commerce and scientific exploration. The transfer of the Portuguese Crown from Portugal to its New World colony in 1808, followed by Brazil's independence in 1822, did the same for that country's vast territory. Among those going to the Americas were European naturalists, whose complex agendas of resource assessment and imperial trade were often disguised by their stated scientific, ostensibly universalistic and neutral aims.[2] The period between the 1840s and the 1860s was particularly important to the representation of the Amazonian tropics: Prince Adalbert, Henry Walter Bates, Alfred Russel Wallace, Richard Spruce, W. H. Edwards, William Herndon and Louis Agassiz were all in the Amazon valley in this period, exploring, collecting and mapping the region for science and commerce. Many British naturalists were there for years – Wallace for four, Bates for eleven, Spruce for fourteen.

A second factor was cultural. The activities of naturalists and travellers had as one of their social bases the emergence of natural history as a popular cultural activity in Europe.[3] The vogue for natural history was especially strong in Britain and takes us some way to explaining the large presence of British naturalists in the tropics.

The interest in nature in Britain was related to such factors as the cultural authority of natural theology, which allowed people to see God's work in nature; the development of a leisured middle class, with time and money to spend on gardens and the cultivation of novel plants; and the idealization of the unknown and wild in nature among people for whom an urban cnvironment increasingly defined their daily habitat. The first industrial nation had the greatest of reasons to invest, psychologically and practically, in wildernesses in faraway places.

Roderick Nash's idea of the import and export of nature – of nature as an actively traded commodity in European markets – is extremely useful for clarifying, as he says, the cultural and political meanings of nature appreciation in the modern period.[4] Whether as luxury items for aesthetic-scientific consumption by rich, private collectors, or as public displays of imperial novelty in parks and gardens, or as part of the pursuit of new species for commercial development at home or in overseas tropical colonies (e.g. rubber and cinchona, both obtained from the Americas for commercial planting in Eastern plantations), tropical nature had scarcity and exotic value in the nineteenth century. Many naturalists – commercial travellers of nature, not gentleman travellers like Humboldt or Darwin – depended on this form of commercial tropicality for their living. In the case of Alfred Russel Wallace, for instance, low social status, little formal education, uncertain economic prospects and a great interest in nature made earning a living trading in tropical specimens a reasonable option, as well as a chance at an active, outdoor kind of life. The deciding factor that sent Wallace and his travelling companion, Henry Walter Bates, off to the Amazon in 1848, rather than to some other part of the world, was the assurance they received from an expert at the British Museum that they would find buyers for sets of Amazonian fauna and flora. In the almost twelve years Wallace spent out of England (four in the Amazon and eight collecting on the islands of the Malay Archipelago), a key figure in his life was his commercial agent, Samuel Stevens, who sold his specimens for him, remitted him sums of money and insured his collections against loss, as any good Victorian businessman would.[5]

As collectors, Wallace and Bates received on average only 3 pence per specimen less postal costs; Bates reckoned that in eleven years' work collecting in the Amazon he made just over £800, giving him a very small average annual income. On these kinds of sums, Wallace and Bates could hardly travel in the style of Joseph Hooker (the botanist son of William Hooker, Director of Kew Gardens), who at

one point on a collecting expedition to India in 1849 travelled with 110 coolies, several elephants and at least six assistants.[6] Nor could Wallace vandalize nature to the extent that collectors supported by large commercial firms could; in the 1860s, for example, there were at least a thousand European agents searching for exotic plants in the mid-Atlantic *planalto* (high plateau) of Brazil alone; a single British firm was importing between 100,000 and 200,000 orchid plants per year from the highlands.[7] So determined were the collectors that they often simply cut down entire trees to get at the epiphytes growing in them. If Wallace and Bates did far less harm to tropical habitats, they nevertheless relied, like their more wealthy counterparts, on British bankers, consuls and government patronage to get there (for example, in obtaining free steamship passage, as Wallace did to the East in 1854), and in so doing benefited from the reach of Europe's imperial and commercial power. They also, given collecting practices at the time, took up guns to shoot animals; thus were the links between hunting, empire and nature established.[8]

The exploration of the tropics was facilitated by a number of technical developments in the period, such as steamboats (which, for example, began operating along the Amazon in 1853), railways and reliable postal networks, but also by the introduction of Wardian cases (botanical boxes which came into circulation in the 1830s and which allowed plants to be kept alive on long sea journeys) and heated greenhouses, which provided the opportunity for 'escapist dreams of the Empire's tropical forests'.[9] One of the most important material and symbolic expressions of tropical nature in the nineteenth century was the great Palm House at Kew, which was opened to the public in 1849. The excitement generated by the blooming of the great Amazonian water-lily that year, after the Royal Geographical Society had instructed one of its agents to bring back seeds from the Amazon, was another such expression, encapsulating many symbols of the Victorian era, from the naming of the species by a European scientist (after Queen Victoria, and in Latin), to the great size of tropical plants (the leaf of the *Victoria regia* could bear the weight of a child), to the role of scientific institutions in co-ordinating the work of surveying and collecting natural products overseas (as Lucille Brockway has shown, behind Kew stood the Colonial Office).[10] The ribs of the leaf of the Amazonian lily provided the basis for the design for the supports of the Crystal Palace, built for that great symbol of Britain's political and commercial power, the Great Exhibition of 1851, to which flowed manufactured and natural objects from countries around the world.

Another feature of natural history that relates to the way in which

the tropics were viewed concerns collecting itself, as an implicit philosophy of natural knowledge. When he went to the tropics in the mid-1860s, Louis Agassiz claimed that collecting species had become 'almost the lowest kind of scientific work', far removed from the study of the fundamental laws regulating animate nature, which he believed was the scientist's proper goal.[11] Yet in reality, collecting dominated Agassiz's own journey in the tropics. Boasting about the numbers of specimens bagged and named is a theme in most natural-history writing. It was as though collecting itself, the sheer enumeration of nature's products, would result in the understanding of, and therefore the possession of, nature. As a dream, however, collecting as complete knowledge proved illusory. Most of the thousands of specimens Agassiz sent back from the Amazon to his Museum of Comparative Zoology at Harvard University were found, years later, still unpacked, mouldering in their barrels of pickling alcohol.[12] (William James made a humorous sketch of Agassiz chortling over '4,000,000,0000 new species of fish' which efficiently expresses the impossible goal of a perfect representation of nature.)[13]

Finally, we need to take books and printing into account. For though the general public could see tropical nature at home, in the greenhouses of Chatsworth and Kew or in 'acclimatization' houses in Paris, perhaps the most usual way people learned about the tropics was from books. As Wallace wrote in his first published travel book, *A Narrative of Travels on the Amazon and Rio Negro* (1853), '… it was the impression on the reader' that counted.[14]

The discursive production of tropical nature is significant not only to the history of the cultural consumption of nature but to its history as a social form as well. Lower middle-class naturalists like Wallace and Bates found it difficult to get paid work in scientific establishments once they returned home from their tropical journeys. Paid positions were few in number in the museums, universities and scientific societies of Europe, especially in Britain, where the cult of the gentlemanly amateur remained an ideal until the late nineteenth century. Bates, for example, worked for more than three years in his family's small hosiery business following his return to Britain from the Amazon in 1859. Only the financial success of his book of travels, *The Naturalist on the River Amazons* (1863), which earned him £250, equivalent to two years' income, allowed him to leave the world of manufacturing for that of science. Even after he obtained the paid position of Assistant Secretary to the Royal Geographical Society in 1864, his salary was so low that he had to supplement it by ghost-writing and editing.[15] Wallace meanwhile failed in all his efforts to find a

paid position; he therefore depended on the income from the sale of his collections, supplemented by money from lecturing and writing.

And how the Victorians wrote! And how long their books often were! There was a growing market for cheap illustrated books that could satisfy the curiosity of a self-improving public hungry for information and novelty. Expensive multivolume works depicting classified natural-history specimens in the form of beautiful copper engravings or lithographs – for example, Bateman's *Orchidaceae of Mexico and Guatemala* (1837–40) or John Gould's *Humming-Birds* (1849–61), which were produced in limited-subscription editions for well-off and discriminating buyers – were beyond the reach of the general public. Situated between the profusely illustrated natural-history book and the scientific text of the future, with its more technical and diagrammatic illustrations, were popular works of natural history, geography and ethnography that fed the public's appetite for the exotic and the foreign. Such works sustained cultural claims to the tropics by evoking the sensual experience of tropical nature, the shapes and colours of distinctive fauna and flora, the utility of tropical products, the adventure of stalking and capturing wild animals or hunting rare orchids, and the scientific principles surrounding their production.

There was a skill in writing that mixture of adventure and scientific fact that would satisfy both the general public and an increasingly professional and scientific audience; this skill was exploited by publishers like John Murray, who in 1845 bought the reprint rights to Darwin's *Journal of Researches* (later known as *The Voyage of the Beagle*) for his 'Home and Colonial Library' series, whose books he advertised as 'entertaining as romances, yet not frivolous, but absolutely abounding in sound information'.[16]

The Humboldtian tropics

The representation of tropical nature was not a straightforward result of exploration, but rather the product of complicated Western European cultural conventions. By the middle of the nineteenth century, an author could draw upon a number of themes, metaphors, analogies and figures to convey the uniqueness of tropical nature, its otherness, its discursive differentiation from home and the familiar. Tropical nature, that is, like tropical medicine later, had characteristic tropes or modes of representation which were developed in the process of colonial expansion. They were products of active construction that often told readers at home as much about themselves as about abroad. By

contrasting the scenery, animals, plants and people at hand with those far away, naturalists instructed and confirmed their readers' sense of European superiority even as they appeared to extol the merits of the foreign. Tropical nature was, in this sense, part of the formation of Europe's identity as a place of temperateness, control, hard work and thriftiness as opposed to the humidity, heat, extravagance and super-fluity of the Torrid Zone.

The chief tropes of tropical nature were in fact its fertility and superabundance. This language and vision of the tropics derived fundamentally from the work of Alexander von Humboldt, who rediscovered the American tropics as a special place of scientific and imaginative interest in the early nineteenth century. In recent years, Humboldt himself has been variously rediscovered, or re-invented, by scholars; revered by historians of science as the founder of modern physical geography, he has recently been attacked by post-modernist literary critics as *the* imperialist of knowledge, whose very gaze – the knowing eye/I – appropriated tropical nature wholesale for European consumption and exploitation.[17]

Humboldt is significant not only because he described tropical nature in detail, but because he measured it precisely, using more than 70 of the finest scientific instruments his private wealth could buy. To his empirical descriptions of the physical environment he married an intensely aesthetic approach to nature, creating a view of the tropics as a sublime place, a *topos* that lasted long after his pre-evolutionary and Enlightenment political optimism had been replaced by an evolu-tionary, and more pessimistic, interpretation of the natural and social world.[18]

Humboldt's reputation as the great encyclopaedist of tropical knowledge who had something to say about every topic under the sun – plants, animals, mining, the origins of languages, built monuments, colonial culture and the aesthetic impact of nature on the human mind – was based on his historic five-year journey (1799–1804) with the botanist Aimé Bonpland through the tropics of the Spanish American colonies (present-day Venezuela, Colombia, Peru and Ecuador) – nearly two thousand miles by canoe, donkey and horse-back, on foot and on the backs of peons. But it also owed a great deal to his extraordinary production of books – 30 folio and quarto volumes between 1805 and 1834 even before his most famous work, the multivolume summary of the world's physical geography, *Cosmos*, began to appear. His *Personal Narrative of Travels to the Equinoctial Regions of the New Continent during the Years 1799–1804* was praised by nearly every traveller and naturalist who followed him to the trop-

ics.[19] Humboldt's scientific-literary-aesthetic production represents one of the most astonishing publishing efforts of the nineteenth century (a veritable 'intellectual conquest' of the Americas, as one historian has called it), putting forth a view of tropical nature that was influential for decades.[20]

So what was that view? First, it was global in scope; it embraced the *cosmos*. Second, it suggested that the natural world should be understood as a set of 'aspects' or 'views' (I refer here to two of Humboldt's other titles, *Aspects of Nature* [1807] and *Views of the Cordilleras* [1810]). This was a way of seeing and representing the natural world that related to the taste for organizing a landscape for a spectator, from a distance or from a height, as though it were a fine painting. For Humboldt, nature in the American tropics was sublime because it could evoke in the alert viewer a sense of awe in the presence of the vast and mysterious. Its apparent monotony – the dark forests that formed an undifferentiated mass of vegetation, the slow, broad rivers, the endless *llanos* (interior grasslands) – all had to be *given* interest by the human mind. Without this mental and aesthetic involvement, Humboldt believed, much of nature was not of interest and could not compensate for the hardships involved in travelling through it.[21]

A third feature of the Humboldtian view of the tropics was that tropical nature was essentially vegetative. 'It is the vegetation,' he remarked, 'that determines the character of a landscape and acts on our imagination by its mass, the contour of its forms, and the glow of its colours.'[22] Humboldt's seemingly arbitrary selection of plants over animals to represent the special character of tropical nature was connected to his concern with infusing the empirical study of nature with human emotions, thereby preventing the rupture between the objective and subjective appreciation of the natural world that modern science threatened.[23] In his opinion, the greatest emotional impression nature could make on the human senses was communicated by the mass of vegetation rather than by fleeting animals. This mass was greater in the tropics than in temperate regions because of the superfecundity of plants that grow beneath the tropical sky.

The fourth significant feature of Humboldt's view of tropical nature was his belief in the special intensity of life in tropical regions when compared to the temperate world. 'Nature in these climates,' he wrote, 'appears more active, more fruitful, we might say, more prodigal of life.' Altogether, South America was a 'vast continent where everything was gigantic, the mountains, the rivers, the mass of vegetation'.[24] The tropics were a place of eternal creativity; Humboldt

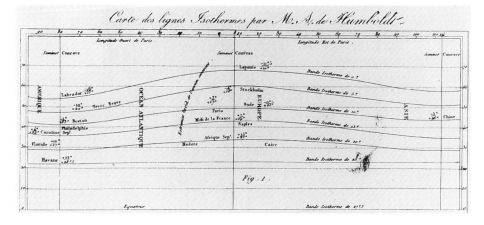

7 Alexander von Humboldt, 'Chart of Isothermal Lines', from *Mémoires de physique et de chimie de la Société d'Arcueil*, vol. 3 (Paris, 1967; facsimile of 1807–17 Paris edn).

delighted in the climate, the variety of life forms, the miraculous vistas.

These views were conveyed in Humboldt's published works by means of innovative pictures and diagrams. His special interest in visual images derived from the doubt he had about the power of words alone to do justice to tropical nature's distinctive physiognomy. Of course, visual images, perhaps more than verbal descriptions, involve schematizations and selections which carry conceptual frameworks along with them. This is especially true of the diagrams that characterize modern science.

Among Humboldt's well-known visual innovations was his use of isothermal lines, a graphic device used to join together all the points on the globe sharing the same average temperature (a technique he introduced in 1817, and which, he commented, had been made possible as accurate knowledge had expanded from the world's temperate areas to the tropical areas of the vast Spanish Americas).[25] Isothermal lines presented the world encircled by climatic bands of 'regular sinuosity' (to use Michael Dettelbach's deft phrase) (illus. 7).[26] Within these bands, different places were connected in a common tropicality that set limits on the kinds of plants and animals (and people) that could exist within it. Though global maps were certainly not new, Humboldt's isothermal maps reconfigured the world by drawing attention *away* from the distinction between the Old World and the New that had preoccupied geographers for much of the eighteenth century, and that had in effect cut the globe in two. Instead, Humboldt imagined a globe of encircling climatic zones; in doing

8 Cross-sectional diagram of the Andes, after a drawing by Alexander von Humboldt, from Humboldt and Aimé Bonpland, *Essai sur la géographie des plantes: Accompagné d'un tableau des régions équinoxiales* (Nanterre, 1990; reprint of 1805 Paris edn).

this, he separated visually and conceptually the northern climatic bands in the Americas from the tropical southern ones. The United States was thus redefined as a fundamentally temperate region, capable by reason of climate and geography of producing a civilization resembling that of Europe; in the southern tropics, on the other hand, it would be suggested, the heat and humidity so favourable to the production of nature posed a permanent challenge to the emergence of high civilization.

Humboldt's most famous representation of the Americas, his cross-section of the huge volcanic mountains of Chimborazo and Cotopaxi in the Andes, drew attention in a different way to the distinctiveness of tropical places.[27] First published in the 1807 volume he co-authored with Aimé Bonpland, *Essay on the Geography of Plants; Accompanied by a Physical Atlas of the Equinoctial Regions* (the first volume of his great oeuvre on his South American travels), Humboldt's coloured print – half-picture, half-diagram – shows, in an almost impossibly steep profile, the distribution of vegetation as the eye moves up from tropical lowlands through an intermediate, temperate region to the arctic highlands at the top (illus. 8).[28] On the right side of the cross-section, the names of the plant species are marked in their proper locations. This picture states the relations between geographical place and plant type in diagrammatic form, an effort that made Humboldt a pioneer in plant geography and earned him the title of 'proto-ecologist'.[29]

This diagram, along with Humboldt's essays on physical geography and plant distribution, suggested a diversity of climatic zones and plant types within each geographical area, thereby hinting at the complexity of the laws determining the distribution of life forms.

These points were often lost sight of in later representations of the tropics, where hot, humid lowland forests were taken to represent all of tropical nature, ignoring the fact that large areas of South America are not low-lying, or forested, or especially hot and humid. Humboldt was unable to conclude from his studies of plants and his physical measurements what the actual laws were that governed plant distribution. Later in the century, naturalists like Wallace would explain plant and animal geography in terms of biological evolution, a theoretical framework foreign to Humboldt's way of thinking. What did emerge as a lasting impression from Humboldt's writings and diagrams, however, was that climate and physical geography set limits on the species found in different areas of the world; that there were 'nations' of living things, just as there were political nations of peoples.

There was little of the 'tristes tropiques' in Humboldt's view of tropical nature thus far. But Humboldtian geography was also very much a political geography and was closely connected with the outlook of his times. Without being too deconstructive about it, we can say that every representation tends to contain, or conceal, within itself the opposite representation. If tropical nature was, to Humboldt, a sublime paradise, the tropics as a site for human habitation were not. Thus it was in regard to human civilization in the tropics that Humboldt's climatic and geographic determinism was most strongly expressed.

Humboldt had gone to the Americas when Latin America was little known to European scientists. And despite the fact that he travelled through Spanish America in the formative period leading up to the movements for independence from Europe, that he relied on Spanish colonial officials and met many of the leading Creole scientists, that he wrote treatises on the region's political economy (e.g. *Political Essay on the Kingdom of New Spain*) and was responsible for stimulating European, especially British, investments in Latin American mining and commerce, his primary interest in the New World was as a scene of nature.

Drawing on the taste for wild, untouched nature then fashionable in Europe, Humboldt identified the region's major natural wonders for his readers. In *Views of the Cordilleras and the Monuments of the Indigenous People of America*, which appeared as two folio volumes in 1810, the bulk of his descriptions were given over to stupendous waterfalls and cataracts or strange geological formations, suggesting the great power of natural forces to shape the earth (illus. 9).[30] The huge forest trees seemed to Humboldt to be the tropics' most impres-

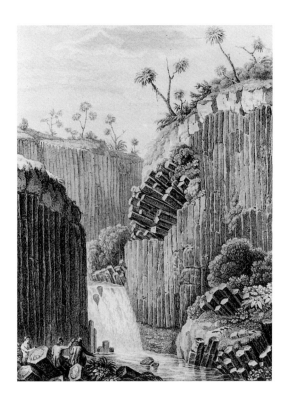

9 Alexander von Humboldt, 'Basalt Rock Formations', from Humboldt, *Vue des Cordillères et monuments des peuples indigènes de l'Amérique* (Nanterre, 1989; facsimile of 1810 Paris edn).

sive monuments, equivalent to the solemn cathedrals of Europe in their capacity to inspire the soul and reflect their majestic solitude back onto the viewer.[31]

In comparison, the role of human beings seemed insignificant. Humboldt was unusual in taking an interest in the ancient ruins of Peru and Mexico (for instance, depicting an Aztec codex and discussing the Aztec calendar), but he remarked that when he referred to these ancient monuments, he did not mean to indicate what was usually meant by 'civilization'.[32] The best such ancient remains could suggest to the human mind was a sense of the slow but steady progress civilization had made from such simple beginnings to the achievements of the Old World.

In this respect, as Brading shows so well, Humboldt was very much of his time and place. The notion that hot locales were unfit for human habitation and that only colder regions stimulated the human mind to the inventions necessary for civilization was already well established in the Western tradition. It had been articulated by any number of social theorists in the eighteenth century, most famously, of course, Montesquieu in *The Spirit of the Laws* (1748). Northern latitudes and climes, Montesquieu affirmed, stimulated human

reason and industry and produced a well-regulated society, while hot places caused relaxation, sloth and precocious sexuality, and produced despotic forms of government.[33] We see here the persistent belief that the tropics were an inferior place for culture. The temperate areas of the world were positioned as places of culture and reason; tropical areas as places of nature and passion.

The colonial culture Humboldt encountered in South America he found on the whole monotonous; the Spanish colonists he believed were without deep attachments to the soil. As for the indigenous populations, it was only in the cold regions at high altitudes, in the Andean mountains and on the high plateau of Mexico City, Humboldt thought, that they had established the rudiments of culture. In the tropical lowlands, Humboldt found only isolated tribes living in a state of barbarism. The very fertility of the soil, he believed, 'retards the progress of nations towards civilization'.[34] In the midst of abundant vegetation, 'intellectual faculties unfold less rapidly than under a rigorous sky.'[35]

Humboldt realized that a purely climatic explanation of cultural differences was insufficient in itself, since different countries in analogous climates showed great variations in their cultural achievements. Various other factors, then, had to be considered in order to explain why civilization in the tropical Americas had advanced so little. One factor about which Humboldt speculated was the barrier that dense forestation posed to human communication and settlement. In a kind of vegetable sociology, he linked the extremely varied and fertile but 'unproductive' tropical lowland landscape, composed of many different plant species with few exemplars of each species, to the many small and isolated tribes who lived there. This he contrasted with temperate lands where he saw productive landscapes, made up of social plants (large tracts of single species) such as woodlands of oak trees, which he thought of as corresponding to the social life of the human inhabitants.

Yet the fact that large areas of the southern Americas seemed destined to be places of nature, not culture, did not cause Humboldt disappointment. Human beings in the tropics, he remarked, get used to the idea of a world 'that supports only plants and animals; where the savage has never uttered either a shout of joy or the plaintive accents of sorrow'. The force of nature in the tropics, so attractive to the visiting naturalist, 'perpetuated', said Humboldt, 'the misery and barbarism of solitary hordes'.[36]

Humboldt's approach to tropical places implied that their vistas counted largely with reference to European visitors. This was, he

believed, their great advantage over temperate ones, namely their influence on the human imagination. The European visitor, unlike the native inhabitant who simply happened to live in the tropics, possessed, said Humboldt, the language, arts and sciences needed to appropriate tropical nature, to transform it into a higher aesthetic and, through imagination and painting, 'create within himself a world as free and imperishable as the world in which it emanates'.[37] Humboldt therefore urged European and North American artists and scientists to follow him to the tropics, to see tropical nature for themselves and to communicate its physiognomy in pictures and words.

Popularizing tropical nature

And follow Humboldt they did. The North American artist Frederic Edwin Church, for instance, made his way to South America in 1853 and again in 1857. He retraced parts of Humboldt's original routes through Ecuador and Colombia (in Quito even staying in the very house that Humboldt had lived in 60 years earlier), visited the natural sights established by Humboldt as emblematic of Latin America's powerful vistas (such as the Magdalena River and the lagoons of Guayaquil) and ended with an ascent of Chimborazo, the volcano believed to be the highest mountain in the world at the time and which Humboldt had climbed in 1802 to within a thousand feet of its snow-capped summit (also, at the time, a record). With Humboldtian eyes, Church observed the harmony and unity of nature in the tropics; the freshness, variety and exuberance of the vegetation; and the powerful forces that had given rise to the towering Cordilleras. Church's vast landscapes, such as the famous *Heart of the Andes* and others like *Cotopaxi* and *Rainy Season in the Tropics*, were Humboldtian in their mix of scientific detail and romantic idealism; they recreated, in painterly terms, Humboldt's vision of the tropics as a scene of sublime nature, exemplifying the dynamic and creative forces responsible for producing the natural world (illus. 10).[38]

In addition to the market for fine paintings of tropical nature, there was a growing demand for cheap illustrated publications. Books on natural history, travel, popular geography and ethnography were in fact second only to novels in popularity in the nineteenth century, and the division between the two genres was not as wide as one might think. In the case of Latin America, so great was the demand for information about the newly independent republics that it was difficult, say McNeill and Dean in their catalogue of relevant nineteenth-century travel books, for travellers *not* to put pen to paper: 'All sold, whether good or bad.'[39]

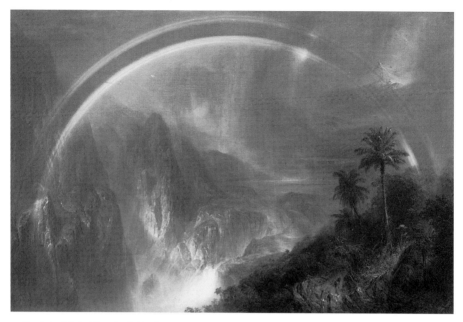

10 Frederic Edwin Church, *Rainy Season in the Tropics*, 1866, oil on canvas. M. H. de Young Memorial Museum, San Francisco (Mildred Anna Williams Collection).

The demand was sufficient to support a number of skilled nature artists and engravers who transformed travellers' specimens, sketches and photographs into illustrations suitable for popular books. Such illustrations were often far removed from the technical pictures of zoological and plant specimens used by professional naturalists and serious collectors. In the latter, classificatory frameworks shaped the mode of illustration, usually with a single species being represented against a white background; landscape details, if employed at all, were introduced in a perfunctory fashion. The point of such pictures was detail and accuracy. Of course, they presented 'ideal types' of nature (individual oddities in any particular specimen being eliminated for illustrative purposes, for example); nonetheless, they offered a standard of objectivity for scientists.

But as Ann Blum points out in her history of zoological illustration, natural history was integrated into many other genres, such as popular geography, where interest was less in accurate detail than in visual dramas that could convey the overall impression, or 'personality', of places.[40] Since many of the travellers and naturalists who went to the tropics lacked training in draughtsmanship (Wallace, for one, had little talent for drawing), they had to rely on trained natural-history artists to create images of the tropical world. This involved

complex processes of transposition from specimen to printed image, processes we often take for granted but which depend for their success on the acceptability of a series of visual conventions regarding how the natural world should look.

Many naturalists were aware that the pictures in their books were not always accurate; in default of a sketch made in situ, engravers would draw on a stock repertoire of images, sometimes transposing a scene from one country to another. Wallace, for example, commented that in his short book on palm-trees published in 1853, following his return from the Amazon, his illustrator, the well-known botanical artist from Kew W. H. Fitch, added a few artistic touches to give the images life and variety, in one case producing a picture of natives that was quite unlike the real thing.[41] Other instances involved not so much stereotyping as the compression of information, which could cause erroneous impressions. One picture would frequently place in one frame plants and animals from a tropical zone that could not possibly be seen together at the same time and place in reality. Blum points out that while this could be a useful way of conveying a lot of information, it could also be misleading to an unsophisticated viewer, disappointment at not finding what one had been led to expect from such pictures being a common experience, as we shall see.

Since different kinds of representations carried different kinds of authority, combinations of images were often used to establish both narrative interest and the truth or empirical veracity of the account. An adventurous, often exaggerated picture of a landscape would be brought down to earth, or to reality as it were, by the positioning nearby in the text of a classificatory type of zoological or botanical illustration, which worked visually to secure the scientific nature and empirical authenticity of the overall account. The growing authority of science as the objective medium for depicting empirical reality increased the possibility that such representations would be taken to be true – that the objects and landscapes were equivalent to the natural world itself.

Finally, I want to mention photographs in relation to tropical scenery. Although the daguerreotype was introduced in 1839, for a long time difficulties in printing photographs in books meant that photographic illustrations were rare. Sometimes, original (unique) daguerreotype images were tipped into books; later, photogravure and photolithography allowed the multiple printing of photographic images in books. Even so, conveying the image of the tropics photographically was a challenge, given pre-existing visual conventions. The flatness and darkness of jungle scenery explain why the camera

was rarely used to depict jungle scenes *per se* (apart from the problems associated with the weight of early cameras and developing equipment, and the damage heat and humidity could cause to photographic plates). For example, the British photographer Samuel Bourne, who photographed India in the 1860s, remarked that the country seemed 'altogether too gigantic and stupendous to be brought within the limits imposed on photography'. In fact, he had great success with his pictures, but many of his landscapes were of the mountainous and stony Western Himalayas, landscapes, that is, that provided him with sharply delineated outlines around which to organize images that satisfied European criteria of a 'landscape' (while also hinting at heroic and arduous exploration and adventure in the outer reaches of the British Empire).[42] Photographs, then, were especially useful in documenting military campaigns, buildings and monuments, and in making portraits; they were best suited for use in topography, archaeology and, especially, ethnography.

On the other hand, lithographs and wood engravings, many of them based on original artists' drawings, in addition to being cheaper than photographs, were better suited to making the jungle light, because the engraver could deliberately introduce an opening into the image through which light could be made to shine (light carrying connotations of enlightened knowledge which would render obscurity clear). This device allowed pictures to highlight details of vegetation, such as sinuousness and entanglement. A particularly fine example is found in the album of watercolours painted by the German painter Johann Moritz Rugendas, prints of which were used to illustrate his *Picturesque Journey Through Brazil* (published in French and German in 1835).[43] In this view of the virgin forest, light is let through the dense forest canopy to illuminate a scene of huge tree trunks intertwined with lianas, and a natural bridge made by a fallen log. The eye is drawn to two flamingos in the centre, thus creating an image of almost idyllic beauty, elegance and vegetative luxuriance (illus. 11). Charles Darwin recommended that his sister, Caroline, get hold of this picture, so that she could have an accurate idea of the tropical forest and be reassured as to his safety as he wandered in it.[44]

Philip Henry Gosse, an enormously prolific writer of popular books of natural history and a famous anti-evolutionist (and protagonist of the Victorian classic *Father and Son*), used this artistic convention in books directed towards the more popular end of the market. Neither a Humboldt nor a Church, he nonetheless made his way to the tropics, travelling to Jamaica. And in many respects, having a more ordinary imagination, he represents better than either of them

11 Johann Moritz Rugendas, *Floresta Virgem* (Virgin Forest), 1835, lithograph copy by G. Engelmann, from a 1930s São Paulo reprint of Rugendas, *Voyage pittoresque au Brésil* (Paris, 1835).

what had by mid-century become the clichés of tropical romanticism. Its themes were expressed well in Gosse's *The Romance of Natural History* (1860), whose chapters, as its title indicates, were organized around the contrasting categories of Romanticism: the harmonies and discrepancies in nature, the vast and the minute, the sublime and the beautiful. The tropics served to exemplify the memorable in nature – exotic butterflies, the amazing bird of paradise, the first sighting of the Royal water-lily. In Humboldtian fashion, Gosse emphasized the dynamic, active and palpitating aspects of nature in the tropics. In his book, plants creep, entangle, overwhelm, spring, embrace, choke, strive and glow; animals hang, burrow, rush, cry, flit and crawl, piercing the night with their hoots, shrieks, wails, cackles, squeaks, snores and hoots.[45] The number of everything is prodigious, the variety bewildering, the size huge. Gosse's tropical nature is also dark and overbearing – a 'gorgeous gloom', he calls it.

All of this dynamic 'otherness' was crammed into Gosse's illustration, which was designed to evoke a very general sense of the jungle

rather than function as an accurate natural-history scene in the classi-ficatory, botanical style (illus. 12). The spectacle of a tangled bank of twisted vegetation, so dense as to dwarf animal life and create an almost insuperable barrier to human activities, was a standard trope of tropical illustrations, found in the work of painters and illustrators of very different abilities and styles, as can be seen in an example from Bates (illus. 13), whose work in other regards was very different from Gosse's.

The darkening tropics

By mid-century, the general delight in tropical abundance was giving way to dismay at tropical excess. To the average British reader, schooled in the dismal metaphors of Malthusian political and natural economy, fertility also carried negative connotations of superfluous-ness, disease and death. Thus the heat and humidity of tropical places stimulated growth that was luxurious but also rank and wanton; trop-ical plants were wonderfully novel but at times bizarre; the animals were unusual but often deadly.

Many factors contributed to the darkening of the tropics at this time. Disease was one and racial preoccupations another, both of which I discuss in some detail later. Disease was especially critical to negative perceptions of the African tropics. Africa had, in fact, never really offered Europeans the lyrical image of tropical nature that the Americas had done; the tropical environment there was viewed as a daunting space of unfamiliarity. In the 1840s, disease took such a toll on European expeditions into the African interior that it became a major factor in what Patrick Brantlinger has called the 'genealogy of the myth of the "Dark Continent"'.[46]

Even in pictures of the American tropics, a gloomier view of nature was emerging as Europeans competed to exploit nature in unfamiliar climates and environments. The green tropics were increasingly represented as distasteful scenes of waste or lacking in proper vegetable order and responsibility. Henry Walter Bates quoted a German traveller who said that the contemplation of the jungle

produced in him a painful impression on account of the vegetation display-ing a spirit of restless selfishness, eager emulation, and craftiness. He thought the softness, and repose of European woodland scenes was far more pleasing, and that these formed one of the causes of the superior moral char-acter of European nations.[47]

12 'Brazilian Forest Scene', from Philip Henry Gosse, *The Romance of Natural History* (New York, 1861).

13 'Interior of the Primaeval Forest', from Bates, *The Naturalist on the River Amazons.*

Climbing plants were seen as ambitious, insectivorous ones as immoral killers. The language of thrift, efficiency and merit was applied to nature, and tropical nature was found wanting.

Visually, the excesses and overbearing presence of nature in the tropics were often conveyed by close focus on the bizarre. Very often, a single large plant or animal would be pictured in conjunction with a much smaller object, so as to suggest the immense scale of nature in

14 'Lizard and Serpent', from Philip Henry Gosse, *A Naturalist's Sojourn in Jamaica* (London, 1851).

the tropics and its apparent indifference to human concerns and activities. Alternatively, the same effect was achieved by the opposite means, namely the removal from the picture of points of comparison that would put the sizes of objects into accurate relationships. In this fashion, or by means of other techniques such as the foregrounding of an object to make it fill the entire visual plane, pictures created a sense that even small objects in tropical nature were really large, or at least had a large 'object-hood' or presence.

Sometimes, the objects represented would be chosen for their fantastic or eccentric quality – a strange toad, an alarming insect, a huge snake. Of course, to most of us, this is not just something made up; dangerous snakes and biting or stinging insects *are* among the most salient features of a tropical environment. Nonetheless, many of the representations involved subtle distortions of scale or actual errors and exaggerations that were somewhat surprising in the work of authors whose reputations supposedly depended on their scientific accuracy (illus. 14).[48] As I have said, the tropics were imaginative spaces as much as empirical ones, nowhere more so than in the realm of popular illustration.

This tradition of tropical representation may add an interpretive context to the unusual tropical pictures by the American painter, Martin Johnson Heade. Generally known as a New England landscape painter, Heade's hummingbird and tropical-flower pictures have puzzled critics, in the past and the present, because they seem to fit neither the traditional landscape-painting genre of his times nor

50

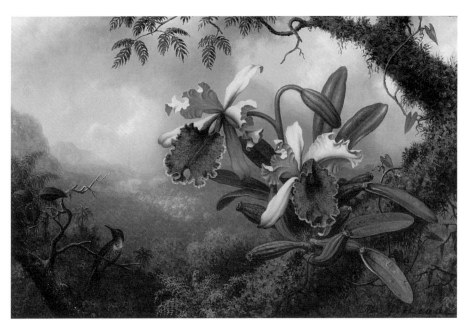

15 Martin Johnson Heade, *Orchids and Hummingbird*, *c*. 1875–85, oil on canvas. Museum of Fine Arts, Boston (gift of Maxim Karolik for the M. and M. Karolik Collection of American Paintings).

that of natural history (illus. 15).[49] It is not exactly clear what sent Heade off to tropical South and Central America in the 1860s, nor why he chose tropical plants and hummingbirds as themes (though his acquaintance with Church, America's foremost painter of tropical landscapes, may have had something to do with it).[50]

Hummingbirds, found only in the New World, fascinated people because of their tiny size (two and a half inches), their vivid colouration and their astonishing powers of flight. They had been illustrated by a number of artists, such as James Audubon and John Gould; they were counted as 'memorable' in Gosse's romance of nature, and were used by Wallace to exemplify the powers of natural selection in producing varieties of species.[51] The orchids that Heade depicted in many of his hummingbird pictures were of such great interest to Europeans that, as I have already noted, plant collectors denuded large areas of the tropics in the nineteenth century in pursuit of them. Darwin used the orchid's remarkable flowers to demonstrate the extraordinary adaptations of plants to insect pollination, trying in this way to determine the role of sexual reproduction in evolution.[52] In terms of aesthetics, gardening taste, commerce, evolution and sexual symbolism, then, orchids had enormous appeal.[53]

Whether Heade's use of landscape details in his hummingbird pictures reflects his absorption of Darwinian ideas about evolution and the interdependency of species (as several art historians now think) is, I believe, impossible to say without more direct non-visual evidence (see my comments in Chapter 2 on the pictures of Margaret Mee).[54] As a painter, of course, Heade was less tied to the pictorial criteria of natural history than were naturalists, yet it would be a mistake to draw too clear a distinction between the two genres of representation. We might perhaps think of his pictures as 'natural history-painterly hybrids' – images, that is, that are not so far removed from other narrative-natural history pictures of tropical nature of the period I have been discussing. Heade followed certain natural-history conventions (for example, striving for accuracy in specific bird markings) while at the same time filling in background landscapes in an unusual way. What impresses us now is the way his foregrounding of the orchid, his extreme attention to natural detail in the birds, the hint he conveys of something sexual in the flower parts, and the haziness of the distant background combine to create a dream-like image in which birds and flowers seem to exist outside normal nature.[55]

Another example would be the British flower painter Marianne North, whose strange paintings from around the world, many of them done in and of the tropics, make up the extraordinary collection of over eight hundred pictures in the Marianne North Gallery at Kew Gardens, which was designed in the 1880s specifically to house them. North had received some formal training in watercolours and oils, but the source of her highly unusual style is unclear. She began her paint- ing travels in 1871, when she made her first journey to the United States and Canada. In New York, she met several artists, including Church, whose tropical paintings she saw, but there is little in her pictures to connect them with his (Heade would seem a more likely influence, though we have no evidence that North met him).

Compared to Heade's delicate images, North's pictures seem almost crude and garish; there are nonetheless certain stylistic and thematic similarities that are intriguing (illus. 16). Like Heade's, North's pictures fit into neither the natural-history genre nor the fine-painting category, suggesting once again that tropical nature offered an imaginative space for the fusion of these forms. Like Heade's pictures, too, North's tropical plants were painted in such a way as to accentuate their exotic presence; many focus on the flower and its parts in close-up, indicating a plant heavy with meaning. Sometimes, her flowers are presented without points of comparison

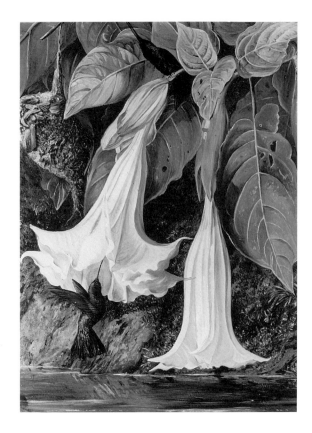

16 Marianne North, 'Flowers of Angel's Trumpet (*Brugmansia arborea*) and Hummingbirds (*Colubri* sp.), Brazil', 1872/3, oil on board. Royal Botanic Gardens, Kew.

with other objects, or without backgrounds that would give an accurate sense of their real size. Along with this vagueness as to real size goes a considerable attention to botanical detail, which nevertheless does not entirely satisfy the modern critic's notion of a scientific illustration.[56] North's pictures also share with Heade's an uncanny sexualization, hinting at the extreme fertility of the tropics but also at the superfluity that such fertility brings. Altogether, there is a morbid and melancholy quality to many of her tropical pictures which transports them out of the normal conventions of plant painting and of ordinary time and space.[57]

This melancholy was, as I have already noted, becoming a routine part of the representation of tropical nature by mid-century. 'What a rich and redundant vegetation,' remarked James Bateman, in his book on the orchids of Mexico and Guatemala.[58] The fertility of the tropics was considered especially inimical to human civilization. Henry Thomas Buckle, for instance, reiterated in his much read *History of Civilisation in England* (1857) Humboldt's view on the correlation between tropical nature and tropical backwardness. 'Amid the pomp

and splendour of Nature,' he wrote in his social-statistical version of climatic determinism,

no place is left for man. He is reduced to insignificance by the majesty with which he is surrounded. The forces that oppose him are so formidable, that he has never been able to make head against them, to rally against their accumulated pressure. The whole of Brazil, notwithstanding its immense apparent advantages, has always remained entirely uncivilised, its inhabitants wandering savages, incompetent to resist those obstacles which the very bounty of Nature has put in their way.[59]

The image of tropical degeneration, linking the super-fertility of organic nature and tropical heat to the supposed low capacities of tropical peoples, was expressed in most travel narratives in terms of the laziness of the natives and their inability to meet European standards of neatness, thrift and control. Natives were usually found to be remarkably uncurious (about Europeans), dirty and above all 'indolent'. Almost to a person, of course, naturalists failed to understand indigenous harvesting techniques and their suitability to the fragile ecological systems of the tropical forests.[60] They saw instead a lack, an absence of cultivation, due to the hot climate, the Amerindians' lassitude, laziness or refusal to do the Europeans' hard work. 'Where is the population to come from to develop the resources of this fine country?' inquired Bates.

They might plant orchards or the choicest fruit trees ... grow Indian corn, rear cattle and hogs, as intelligent settlers from Europe would certainly do, instead of relying on the produce of their small plantations, and living on a meagre diet of fish and farinha.[61]

(Given the devastating effect cattle raising has had on the vulnerable soils in the Amazon in the twentieth century, such comments by one of Britain's best students of nature in the tropics at the time make ironic, indeed painful, reading.)

To even the most enthusiastic tropicalist of the nineteenth century, it seems, tropical nature was too much – too disorderly, chaotic, large – and too different from the remembered landscapes of home. In particular, the productive farm of Europe, the outcome of centuries of human manipulation of the terrain, of the systematic enclosure of land, and of scientific agricultural management, remained the ideal of a natural landscape for most Europeans, providing a standard of utility and beauty against which the tropical forest or plantation seemed shoddy, backward in technology, wasteful and unproductive. 'What a scene for an enterprising agriculturalist!' exclaimed the British traveller John Mawe, as he contemplated the uncultivated, unkempt land-

scape of Brazil.[62] Such views revealed the limits of tropical romanticism and the underlying utilitarianism of natural history; the tropics were places awaiting rational exploitation by Europeans. Until that time arrived, their fate was to be dynamic but unproductive nature, not culture.

The end of tropical romanticism?

Mindful of their readers in cold and wet England, who wanted not to settle abroad but to read about adventures in exotic places, naturalists and travel writers often provided positive glimpses of alternative ways of organizing life in the tropics. Bates, especially, in his extremely successful narrative of travels, *The Naturalist on the River Amazons*, entered into the spirit of what he called the 'gypsy' life of the people he met in the small settlements along the various rivers of the Amazon where he collected. His descriptions of the cigar-smoking wife of the riverboat captain, serving him coffee in the early dawn, and of picnics near sparkling waterfalls are part of the great appeal of his narrative. The misery, hunger and poverty of his life (at one point, he was reduced to rags and bare feet) took a back seat to the fable of escape from the routines of British life that the reader of books of tropical travel wanted.

But even Bates concluded that the contemplation of tropical nature was not enough – not enough, that is, to fill a European's soul. As he looked back on the tropical landscape from the boat returning him to England in June 1859, he asked himself whether he could say good-bye to the glorious nature and climate of the tropics. Would the civilized interactions that Britain offered compensate for the 'gloomy winters, long grey twilights ... factory chimneys and crowds of grimy operatives ...' that awaited him back home? Three years after his return, completing his wonderful narrative of his adventures, he told his readers that they did; culture was more important than tropical nature. And in the penultimate paragraph of his book, he sketched a fantasy of the future in which the perfection of tropical nature would be matched by the perfection of its European human population: 'For I hold', he said, 'that although humanity can reach an advanced state of culture only by battling with the inclemencies of nature in high latitudes, it is under the equator alone that the perfect race of the future will attain to complete fruition of man's beautiful heritage, the earth.'[63]

Just two months before Bates said goodbye to the tropical Amazon, which had been his home for so many years, Frederic Church opened

a three-week blockbuster exhibition in New York City of his most famous picture, *Heart of the Andes*. Presented with consummate showmanship, as high art and popular entertainment, this huge canvas (ten by five feet in size), depicting tropical nature in the Americas sold almost immediately for the then astounding sum of $10,000; paid admissions brought in another $3,000, and a proposed engraving a further $6,000.[64] Church hoped to take the painting to Berlin, to show it to Humboldt, who had inspired it; but he was too late, for Humboldt died, at the great age of 92, within days of the opening of the exhibition in New York.

A few months later, in November 1859, Charles Darwin's *Origin of Species* appeared, a work that owed its genesis to Darwin's journey into nature inspired largely by reading Humboldt ('My whole course of life,' wrote Darwin, 'is due to having read and re-read as a youth his *Personal Narrative*').[65] But Darwin's book also signalled the birth of evolutionism, and the beginning of the end of the Humboldtian view of nature. Romantic views of the tropics would not disappear (Gauguin's South Seas paintings were yet to come, after all.) Nevertheless, a new era, intellectual and visual, was about to begin.

2 An Evolutionist's Tropics

The naturalist Alfred Russel Wallace, the subject of this chapter, was Britain's foremost tropical naturalist and co-founder with Darwin of the theory of evolution by natural selection. Yet Wallace is not as well known as Darwin; his name is not attached to the intellectual revolution he helped to produce, and to this day many people have little idea of his significance to the history of biology, zoological biogeography and, above all, tropical studies.

The reason for Wallace's comparative neglect in most cultural histories of the nineteenth century, and even to some extent in evolutionary studies, relates to what has been called 'the delicate arrangement' concerning priority.[1] A story familiar to professional historians of evolution, it is worth retelling here, because it has a bearing on Wallace's life, reputation, and intellectual originality and independence. Darwin, who had seized the opportunity of a journey of five years on board HMS *Beagle* to make himself into a first-rate naturalist, had converted to the theory of the evolution of species only after his return to England in 1836. Not only had he become convinced that species were not created and static, but by 1838 he had conceived of the mechanism of their evolutionary change. This was the theory of natural selection by which, under conditions of Malthusian overpopulation pressure and the constant variation of all living things, those variations giving organisms an advantage in the struggle for life survive, to be passed on to succeeding generations, slowly altering species over time.

Committing this theory to paper, in the form of a 'Sketch' in 1842 and then a longer 'Essay' in 1844, Darwin kept his heretical views to himself while gathering all the facts he could to provide the evidence he needed to write a big book on the subject. Only very cautiously did he confide his theory to a few of his most intimate scientific friends. Then, twenty years later, came the bombshell Darwin had feared. He was scooped. In 1858, he received a paper from a young naturalist who was collecting natural-history specimens in the Malay Archipelago, a

paper that in concise language spelled out Darwin's own theory. The young naturalist was Alfred Russel Wallace.

In a panic, Darwin, anxious to be fair to Wallace but also eager to establish his own priority, consulted his close friend the geologist Charles Lyell, who in turn consulted the botanist Joseph Hooker, son of the Director of Kew Gardens, on what to do. They quickly arranged for a joint communiqué of Darwin and Wallace's ideas, to be presented at the prestigious Linnean Society of London. Spurred on by this event, within less than a year, Darwin completed an abstract of his long-planned book. Appearing in November 1859, *On the Origin of Species by Means of Natural Selection, or the Preservation of Favoured Races in the Struggle for Life* sold out immediately. Adorned with only a single diagram and lacking footnotes, this long argument in favour of species transmutation launched a scientific revolution.[2]

Wallace was away in the tropics during all these events; in fact, he did not return to Britain until 1862. Darwin was nervous about what his reaction would be to a delicate arrangement which had in fact resulted in the lion's share of recognition going to Darwin. Darwin was, after all, well placed and present; Wallace was neither. Darwin was therefore immensely relieved to find that Wallace was self-effacing and generous to a fault, seemingly unconcerned about the priority issue and greatly admiring of the older scientist's depth of knowledge. There was also the question of class. Darwin was wealthy, university educated, a squire; Wallace was hard up, socially diffident and 'in trade', selling butterflies and beetles to collectors to make his life in nature pay. He was also iconoclastic, free thinking, a Utopian socialist (ideas he acquired as a young man, when he spent a short time attending discussions at an evening, working-class club in London), a feminist and, eventually, a spiritualist. In short, he was not Darwin.

What Wallace was, makes him all the more relevant to this book, however. He was a highly successful traveller through the tropics who published 22 books as well as hundreds of articles, many of them for a general audience. His *Contributions to the Theory of Natural Selection* (1870), *The Geographical Distribution of Animals* (1876), *Tropical Nature and Other Essays* (1878), *Island Life* (1880) and *Darwinism* (1889) are still read with interest by biologists. Most importantly, Wallace was also a faithful Darwinian on everything *but* the application of the theory to human society and progress; in fact, he combined a very materialist theory of animal and plant nature with a non-materialist, indeed spiritualist, theory of the evolution of humanity.[3]

It was precisely this latter characteristic, and the way in which Wallace's radical positions intertwined – his faith that some kind of willpower or spirit, lying outside or beyond natural selection, was responsible for moral evolution in the human species; his rejection of the more crude, social Darwinian deductions from biological theory; and his attack on the wastage of nature caused by rampant industrialism – that make him a valuable exponent of both the potentialities and the limitations of evolutionism as a philosophy. I am particularly interested here, of course, in Wallace as a tropicalist, especially the concern he articulated for the despoliation of tropical nature, a theme that emerged in his mature consideration of his tropical experiences and which, though connected to the new evolutionary outlook, was not a necessary outcome of it (Darwin, for example, did not share Wallace's concerns about the consequences of tropical destruction). This is perhaps the most overlooked aspect of Wallace's multifaceted contributions (most histories of environmentalism make no mention of him). In this chapter, then, I approach Wallace as arguably the most interesting student of tropical nature in the second half of the nineteenth century, a writer of popular natural-history books who was also a philosopher of nature, someone whose evolving representations of tropical nature take us into the post-Humboldtian, evolutionary era, and into the beginnings of the ecological era properly speaking (he died in 1913 at the great age of 90).[4] In following his personal and representational journeys through tropical places, science and politics in the late nineteenth century, I assess how Wallace can be seen to both engage and disengage with the representations of tropical places analyzed in the previous chapter.

Tropical anti-tropicalism

My point in this book is to draw attention to the verbal and visual selections that are made in representing the environments in which we live. And because representations are all we have – after all, a complete representation of the world could only be the world itself, as the great Argentinean writer Jorge Luis Borges points out in his pithy story, 'Of Exactitude in Science' – they are always partial and often disappoint.[5] By examining the phenomenon of disappointment in relation to perception, we gain some insight into how fragile, even deceptive, popular representations of the world often are, and how they take cultural work to maintain. Given the power of representations of the natural to shape our knowledge of the social, and vice versa (since the natural and the social are always in complicated

interaction), it seems especially important to examine points of rupture and change in representations of tropical nature.

Wallace's first account of tropical nature, his *Narrative of Travels on the Amazon and the Rio Negro*, is a case in point. Often described as a classic example of tropical-nature writing, we might in fact call it 'anti-tropical', in that it disrupts the conventions concerning the representation of tropical nature described in the previous chapter. The circumstances surrounding Wallace's first effort to describe tropical nature were unusual, in that he lost nearly all his specimens, drawings and notes in a fire on the boat that took him back to England in 1852, after nearly four years collecting in the Amazon valley. Only his notes on palm-trees and his journal covering one of his four years away were salvaged. But though these losses affected the scientific quality of his book (Darwin said it lacked sufficient 'facts'), they do not, I think, wholly explain its anti-romantic tone. More important than lost materials was Wallace's tropical realism and his laconic refusal to adopt, or perhaps his inability to write in, the romantic style of the popular natural-history genre. His passage from *A Narrative of Travels on the Amazon and Rio Negro* of 1853, to *The Malay Archipelago* of 1869, and then to *Tropical Nature* (1878) and the ironically titled *The Wonderful Century* (1898) was mental as well as geographical, literary as well as scientific, and tells us a great deal about the discursive project of the tropics in the nineteenth century and the processes involved in its contestation and construction. Many naturalists and visitors found it difficult at first to see the tropical nature they anticipated, to find in it the expected forms and colours or the appropriate associations and emotional response. Wallace reveals such experiences particularly clearly.

When Wallace left England for an adventure along the Amazon, he was 25 and untried in the worlds of travel and science. Having left school at fourteen, he had been apprenticed in building and surveying (the latter to his older brother, William, between 1837 and 1844). Surveying had given him a taste for the outdoor life and taught him to think spatially, an approach that was critical to his work on the geographical distribution of species. When the surveying business went through one of its periodic busts, Wallace took up teaching in Leicester. Meeting Henry Walter Bates, two years younger but already a knowledgeable insect collector, Wallace's interest turned to zoology. Based on his reading in a number of popular speculative books, he fairly quickly concluded that species were not fixed and began to ask how they changed over time. Going to the tropics was one way to find out.

Joining forces, Wallace and Bates sailed from Liverpool to Pará (Belém) in 1848. They spent two years collecting together, then went their separate ways (probably to increase their chances of financial success), Bates collecting along the Amazon's southern tributaries, Wallace going north along the Rio Negro. Two years later, in 1852, Wallace was ready to go home. Exhausted by repeated bouts of malaria, with no proper quinine to treat it, intensely lonely and missing intellectual companionship, he travelled back to Pará, packaged his specimens and set off for England. Surviving the fire at sea that caused him to lose most of his papers and specimens, he recouped something at least through insurance money and by turning his hand to writing. The result was the now well-known *Narrative of Travels*.

In the opening pages of the book, Wallace remarks that

> My previous wanderings had been confined to England and a short trip to the continent, so that everything here had the charm of perfect novelty. Nevertheless, on the whole I was disappointed. The weather was not so hot, the people were not so peculiar, the vegetation not so striking, as the glowing picture I had conjured up in my imagination, and had been brooding over during the tedium of a sea-voyage ... the travellers who crowd into one description all the wonders and novelties which it took them weeks and months to observe, must produce an erroneous impression on the reader, and cause him, when he visits the spot, to experience much disappointment.[6]

As Wallace would learn from experience, seeing and representing the tropics were culturally acquired skills. His expectations had been fed, like those of his companion, Bates, by reading Humboldt and Darwin, but most immediately, it had been stimulated by a book called *The Voyage up the River Amazon*, which had appeared in 1847. The author was the American traveller and self-styled naturalist W. H. Edwards, whom Wallace had met almost by chance in London on the eve of his departure for Brazil.[7] Edwards's book had the advantage, if not of accuracy, at least of immediacy; his first-person account of his three-month jaunt along the Amazon derived its authority from his being in, and seeing, the tropics directly, wandering and rambling about its forests and rivers. Edwards praised the Amazon in overblown and fervid prose as the future garden of the world, extolled its healthy climate and in general led Wallace to expect an environment pulsating with exotic life forms. Edwards's overblown literary style is captured in the following excerpt:

> ... vast numbers of trees add their tribute of beauty, and the flower-domed forest from its many coloured altars ever sends heavenward worshipful incense. Nor is this wild luxuriance unseen or unenlivened. Monkeys are frolicking through festooned bowers, or chasing in revelry over the wood

arches. Squirrels scamper in ecstasy from limb to limb, unable to contain themselves from joyousness. Coatis are gamboling among the fallen leaves, or vying with monkeys in nimble climbing, pacas and agoutis chase wildly about, ready to speed away at the least noise ...[8]

According to Edwards, even the sloth was enlivened by the general atmosphere to climb more rapidly than usual![9]

But Wallace found that the sights and sounds of the Amazon did not match these descriptions exactly, and his *Narrative of Travels on the Amazon and Rio Negro*, often characterized as fitting the mould of romantic natural history, did not disguise the anti-romantic, ironic aspects of his encounter with tropical nature. He blamed Edwards indirectly for his misconceptions, but his remarks applied to the genre of tropical-nature writing more generally. The problem lay, he said, in 'picture drawing travellers who, by only describing the beautiful, the picturesque, and the magnificent, would almost lead a person to believe that nothing of a different character could exist under the tropical sun'.[10] This theme of disappointment, when representations do not live up to reality, or better put, when reality does not live up to its representations, is common in many tropical journeys (suggesting that the tropics were indeed constructed through their representations).[11]

Thus the town of Pará, where Wallace and Bates first collected specimens and which Bates in fact found 'picturesque', to Wallace looked 'strange and unsightly to a European eye'. In the forest, there was 'something wanting that we expected to find'. Even the plants did not please him: '... the vegetation ... was by no means luxurious or beautiful.' The insects were not as numerous as he had hoped, of birds he saw only a few, 'and then not very remarkable', and when he did find them, they were not very rare or handsome. The engagingly named 'goat-sucker bird' made, to Wallace's ears, only a 'monotonous conversation'. Even the solemnity and grandeur of the virgin forest (the qualifying terms being by then standard clichés of tropical romanticism) were undermined in Wallace's work by unfavourable comparisons with the scenery in England: '... there is nothing in this country to surpass the beauty of our own rivers and woodland scenery.' Indeed, '... nothing could make up for the desolation and death which the incessant rain appeared to have produced in all animated nature.' In his first week in Pará, Wallace did not manage to spot a single hummingbird, parrot or monkey.[12]

Not only is Wallace's *Narrative of Travels* unromantic, it is unheroic. Of course, a naturalist was not expected to be heroic in the manner of an intrepid explorer like David Livingstone or Richard

Burton. Nonetheless, there was a place for the heroic in nature writing which Darwin, for instance, exploited very successfully in *The Voyage of the Beagle*.[13] Narratively, Wallace's book took the form of a first-person account, which, like Darwin's *Voyage*, opened the way for adventurous exploits. Naturalists used a variety of narrative devices to carry the readers into the supposedly empty spaces of nature, inviting them to participate in the excitement of shooting or capturing rare species, to thrill from the safety of home at the dangers of snakes, panthers and alligators in foreign lands, and to overcome the solitude and ennui that were regular aspects of any collecting expedition. The enumeration of specimens collected, especially species new to Europeans, was of course another important narrative device; Bates exulted in the fact that within three months of his arrival he had collected six hundred diurnal Lepidoptera.[14]

Wallace's book was given its narrative organization by his journeys along the waterways of the Amazon valley. But the forward impulse of the text is constantly checked by his inability to reach his immediate destination because of boats that fail to materialize or Indians who run away or refuse to work for money at all. Such movements forward and the checks to them are common in travel books, the overcoming of difficulties (and mastering of the natives) being one of the narrative points. But in Wallace's book, the resolution fails to occur; the author fails to present himself as the stoical but resourceful Englishman who solves all problems with European dispatch and in full command of his circumstances. A check in narrative momentum that reads rather comically is Wallace's failure to capture the desired specimens: 'The undulating *Morphos* frequently passed us, but their undulating flight baffled all our efforts at capturing them.' Though this failure could be a useful narrative device (eventually, the birds and beasts *are* captured, named, skinned, pickled and packed), Wallace's insistent recording of his misses was decidedly anti-climactic: 'The beautiful pavon (*Europygia helias*) which I most wanted, wisely kept out of the way'; 'The next day we left the land of the blue macaw without a single specimen.'

Indeed, Wallace appears to have been positively maladroit with his gun; there is an absurd episode concerning an alligator, in which not only does he fail to kill or secure the wounded animal but he also manages to drop his gun into the water and almost swamp his canoe. Later, he narrowly misses shooting himself and his Amerindian assistant. Wallace, in short, did not choose to present himself with the skill or pluck expected. Even with bees he was circumspect rather than brave: 'Many different kinds of wasps and bees nests are met with,' he

tells the reader, 'but we were rather shy of meddling with them.'[15] Perhaps Wallace was too revealing of his awkward, gangling, observant self, and too honest about his life in tropical nature, to fully engage the conventional reader's sympathy.

Another example of Wallace's anti-tropical view that disturbs the conventions of representations of the time is the monkey-eating episode. In the New World, there were none of the large primates, such as the African gorillas, which the French explorer Du Chaillu used to capture public attention in the 1860s, nor the orang-utans that would figure so prominently in Wallace's own later travels in the East Indies. But New World monkeys were various and attractive nonetheless, and they figured largely in European descriptions of the American tropics. In a poignant passage in his *Narrative*, Wallace describes the first monkey he saw close at hand, an animal wounded by a gunshot: 'The poor little animal was not quite dead, and its cries, its innocent-looking countenance, and delicate little hands were quite child-like.' But this affecting portrait of the near-human animal is followed by a brisk sequel: 'Having often heard how good monkey was, I took it home, and had it cut up and fried for breakfast; there was about as much of it as a fowl, and meat resembled rabbit, without any very peculiar or unpleasant flavour.'[16] Contrast this account with that of Bates, who ate a spider monkey when absolutely desperate for food: 'Nothing but the hardest necessity could have driven me so near to cannibalism as this,' he wrote.[17] Since cannibalism was taken by Europeans to be the defining mark of Indians' exclusion from civilization, Bates's reference to monkey cannibalism effectively distinguishes him from the savagery of backward tribes by articulating an appropriate distaste for the whole subject. Wallace, on the other hand, had not learned how to sentimentalize, in a period when sentimentalism was the very stuff of nature writing.

Natives in the tropical scene

Another gap concerns the 'natives'. It has become almost a commonplace of recent critical interpretations of imperial and colonial writing to point out that the native inhabitants who made the enterprises of journeying, collecting and surveying possible by working as boatmen, cooks, haulers of boats, skinners of animals and guides into nature, rarely appear as actors in the text. The European naturalist enters unknown, unexplored lands 'alone', to discover, identify and collect plants and animals whose meanings as natural-history items supposedly baffle the local inhabitants.[18] Natural-history and explo-

64

ration texts are therefore monologic, and the erasure of the encounters between European travellers and indigenous peoples, or their relegation to chapters on ethnology or anthropology, has the effect of merging them with nature itself.

Wallace at times participates in this disparagement of 'the natives'. Like Bates, he believed that harsh climates spurred the human intellect to higher civilization, and though he had respect for Amerindians as 'true denizens' of the forest, he believed that the mixed breeds and acculturated population he met in the Amazon were incapable of developing the meadows and cultivated fields he thought the Amazon should be converted into (an opinion he later gave up).[19] But in his everyday dealings with people, Wallace was unpretentious, and his writings in this instance and later contain several dialogic moments that upset the convention.[20] In one such example, the native is revealed to be a scientific naturalist himself, who has a name and who speaks, instructs and imparts his knowledge to the ignorant European visitor. The episode concerns the old free Negro, Isidora (as Wallace calls him; to Bates he is, correctly, Isidoro), whom they had hired early in their stay to cook and keep house for them. But Isidoro, it turns out, is quite a naturalist himself; as Wallace says, Isidoro 'had worked much in the forest, and was well acquainted with the various trees, and could tell their names, and was learned in their uses and properties'. One day, Wallace and Bates ask Isidoro whether he knows the Caripé tree. He answers that he knows it very well; as they set out on an expedition of 'discovery', they are given a lesson by him on the tropical nature around them, Isidoro imparting information 'by a series of parenthetical remarks on the trees as he passed them, appearing to speak to them rather than us ...' ' "This," he would say, "is Ocööba, very good medicine, good for sore throat ..." and showing us that a watery soap issued on the bark being cut ...' ' "This," said he, "is good wood for houses, good for floors; call it Quaröóba," ' and so on.

Wallace ends his account of this expedition with a last lesson, the naturalists' introduction to the rubber plant that, decades later, would transform (and then ruin) the Amazonian economy:

Just as we were returning, we were startled by a quiet remark that the tree close by us was the Seringa, or India-rubber tree. We rushed to it, axe in hand, cut off a piece of bark, and had the satisfaction to see the extraordinary juice come out ... Catching a little in a box I had with me, I next day found it genuine india-rubber, of a yellowish colour, but possessing all its peculiar properties.[21]

Thus Wallace lets the reader know that the native sometimes knows more than the European, and that the species naturalists claim to name and discover have long been known and named by others.

The two books that Wallace managed to salvage from his four years in the American tropics, the *Narrative of Travels*, from which I have quoted extensively, and the short *Palm Trees of the Amazon*, were neither well received nor widely reviewed. *Palm Trees*, privately printed in an edition of 250 copies for a scientific audience, was judged unkindly by Sir William Hooker, Britain's pre-eminent botanist, to be 'more suited to the drawing room than to the library of the botanist'.[22] The *Narrative of Travels*, designed for a general audience, lacked tropical flair and good illustrations. A review in *Gardener's Chronicle* said that the author's knowledge of natural history was superficial and that the book lacked precise facts.[23] Wallace later called it absurd and confessed in his autobiography that the 50-50 financial arrangement he had entered into with the publisher netted neither of them any profits, since on his return to England after eight years in the East Indies he found 250 copies of the original printing of 750 still unsold.

We can see the problems of crafting a representation of tropical nature for popular consumption by comparing the relative failure of Wallace's first travel book with the great success of the book by Henry Walter Bates. After Wallace's departure, Bates stayed on for eight more years, returning to England in 1859 (by this time, Wallace had gone off again, to collect in the eastern tropics). Bates, like Wallace, had expressed an initial disappointment in tropical nature. In his letters home in the 1850s, some of which were published for a scientific audience in the popular journal *The Zoologist* (which gave many a young, poor or poorly connected collector an entrée into publishing), Bates complained, like Wallace, of the monotony of the scenery and the absence of the expected flowers and animals: '... the tediousness of wandering through the same track of woods day after day, at times scarcely seeing an insect for a mile or two, almost exhausts my patience.' He, like Wallace, chastised nature writers for giving misleading impressions: 'Mr. Doubleday has an erroneous idea of the appearance of this country and the habits of the insects ... there are naturally *no flowers* in the country, except for a few parasites way up the lofty trees ...' Indeed, '... the whole country originally is a lofty uninterrupted and gloomy forest, without flowers and almost without the sounds of life.'[24]

In writing his account ten years after Wallace, however, Bates had the advantage over Wallace of time and hindsight (as well as Darwin's

support – Bates was an admirer of Darwin, who reciprocated by reading draft chapters as Bates finished them and who arranged for his own publisher, John Murray, to bring the book out). Bates eliminated most of the negative remarks about tropical nature from his book, articulating a wonderfully Arcadian picture instead. His descriptions in the second chapter of his daily routine as a collector in Pará, for instance, is a brilliant piece of prose, expressing the novelty and exuberance of nature his readers expected. His book is also well served by brilliant illustrations, vivid visual narratives of nature in a far-away place (see illus. 6).

The Malay Archipelago

Just as Wallace had to learn to spot tropical nature by looking for it in the right places in the right way, so seeing the tropics, in a larger perceptual and metaphorical sense, meant looking at nature through the proper affective, scientific and colonial lenses. The charms of a district or a country, remarked Wallace, grow on an individual 'in proportion as our education and habits lead us to understand and admire them. This is particularly the case with tropical countries'. Only in time would the peculiarities of vegetation and people 'form a connected and definite impression on the mind'.[25] His eight years of travel through the East Indies would give him this time, and the definite impression would be evolutionary. These years, said Wallace, 'constituted the central and controlling incident of my life'.[26]

Wallace's East Indian travels began in 1854, less than two years after his return to England from the Amazon. His reasons for resuming the life of a travelling naturalist were largely financial and social, though the scientific attractions of the eastern tropics were many. He may have chosen the Malay Archipelago as his destination because of his long-standing interest in human evolution and because he knew that orang-utans were unique to the area.[27] Sir Roderick Murchison, President of the Royal Geographical Society and a great imperialist of science, secured Wallace free passage to the south-eastern tropics, and Sir James Brooke, the British Rajah of Sarawak, provided hospitality in Borneo.[28] The latter drew Wallace into a world of direct colonial rule very different from the informal imperial relations he had experienced in South America. Wallace's friendship with and admiration for Sir James, and his praise for the Dutch East Indies, are somewhat surprising in light of the radicalism of Wallace's politics, possibly less so when we consider that he was treated as a gentleman, a member of the superior white race, while in the East Indies,

not as a young man of low social status who made his money in the trade of nature.

On the islands of the Malay Archipelago, Wallace focused his mind on the origin of species, studied their geographical distribution, took notes on ethnology and became a theoretical biologist. His 1858 paper on evolution by natural selection, as I have said, prompted Darwin to complete the work on which he had been labouring in secret for years.[29]

Wallace returned to England for good in 1862. The wandering life of a collector had palled yet again; he wanted to settle down, perhaps marry and rejoin the stimulating world of science. Even tropical scenery paled in comparison to the remembered scenery of home: 'I really believe the whole series of birds of the tropical islands of Timor are less beautiful and bright-coloured than those of Great Britain,' he wrote.[30] This time, his reputation in science had preceded him; he was immediately invited to meet Darwin and other luminaries in biology (Huxley became a fast friend) and to participate in the activities of the leading scientific societies of the day. He became a fellow of the Royal Geographical and Linnean societies and set to work on his collections and scientific publications. He eventually married, and happily, the daughter of a botanist.

He also decided, with some reluctance (believing, on the basis of his earlier effort, that narrative writing was not his forte), to turn his hand once again to writing a popular account of tropical nature. This time round, he succeeded brilliantly. Yet the success of *The Malay Archipelago*, subtitled *The Land of the Orang-Utan, and the Bird of Paradise*, depended less on its being an original account of evolutionary biology than on its being a brilliant travel book. It is full of the kind of material – the wanderings through forests, the hunting of rare animals, the descriptions of exotic species, the encounters with savage animals, and the hints of danger, such as human head-hunting – that had become established as critical to the genre of popular non-fiction. A classic work of tropical depiction by one of the Victorian era's most successful tropicalists, it was widely translated and constantly in print; Wallace had indeed learned to describe the tropics well.[31]

The Malay Archipelago was also lavishly illustrated, with 51 pictures and ten maps, which added greatly to its impact (Darwin, to whom Wallace dedicated it, praised them for their beauty). Yet the pictures are also, I think, in interesting tension with the verbal depictions in this, the most popular of Wallace's works. The wood engravings, based on Wallace's actual specimens, his own sketches and photographs he had purchased, are graphic and vivid, but also very

compressed means of conveying a sense of their subjects; they are in several respects more schematic than Wallace's subtle verbal expressions. The illustrations draw on pictorial conventions of the time, giving, as it were, a more simple and selective picture of tropical nature than Wallace's words. They are, in short, more 'tropical', than 'anti-tropical'.

Many of the pictures showing natural-history specimens, for instance, emphasize the unusual or bizarre in nature, a feature common in tropical representations of the period. Several employ the technique of close-focus, or foregrounding of objects, that tends, as we have already seen, to give an intensified sense of the alterity of nature in the tropics, or a sense of its enormity or strangeness, as in a picture of a 'Strange Forest-Tree' (illus. 17).

The most powerful of Wallace's illustrations, however, are visual narratives, which, much like those in Bates's book *The Naturalist on the River Amazons*, provide the text with a sense of adventure, but also run the risk of exaggeration and unreality. The best known of these is the engraving used as one of two frontispieces; entitled 'Orang-Utan Attacked by Dyaks', it shows a violent battle in which the natives'

17 'Strange Forest-Tree. Tree Fern', from Alfred Russel Wallace, *The Malay Archipelago* (London, 1869).

18 'Orang-Utan Attacked by Dyaks', from Wallace, *The Malay Archipelago*.

ferocity is matched by the primate's, so that it is unclear who is attacking whom (illus. 18). As Donna Haraway has argued, primates are extremely potent sources of narrative myths in Western nature writing; standing at the boundary between human and animal, their likenesses to, and differences from, human beings fascinated naturalists long before the idea of evolution gained currency.[32] Orang-utans, known locally as *mias* or 'the great men of the woods', are found naturally only on the islands of Borneo and Sumatra, and Wallace made a point of collecting several specimens because they had great curiosity value and because he hoped to make good money by selling their skins and skeletons (which indeed he did). He devoted an entire chapter of his book to these animals, and a bloodthirsty chapter it is, a gruesome tale of pursuits, killings and dissection (cutting off the head of a male orang-utan for its skull, for example).

Wallace does not emphasize the apes' evolutionary implications (throughout the book he touches on evolutionary themes only lightly and indirectly); more important is *how* the orang-utan is described and illustrated. A circumspect creature in real life, in Wallace's account it appears very fierce and aggressive. Indeed, Wallace's visual picture is not very different from the representation of the gorilla that got the French-American explorer Du Chaillu into trouble with naturalists in 1861, because of his exaggeration of its size and ferocity.[33] Yet after offering plenty of visual and verbal excitement, Wallace's realism reasserts itself when he gives the results of his physical measurements of orang-utans and points out that most naturalists indeed greatly overestimated the beasts' size.

Wallace's account of his 'adoption' of a baby orang-utan whose mother he had shot likewise borrows from existing conventions and symbolic meanings. His description of the infant primate's human-like qualities, its pathetic dependency, Wallace's vain efforts to keep it alive and his mourning of its death is very different from his earlier account of eating a monkey and connects, implicitly perhaps, to his speculations concerning human evolutionary closeness to primates. Yet it also draws on older associations and racial meanings; in his private letters home, for example, he pretends that he has adopted a 'little half-nigger baby', revealing in this 'joke' the common (pre-evolutionary) association between apes and the supposedly lower black races (Wallace wisely kept this 'joke' out of the published version).[34]

The representations of apes in *The Malay Archipelago*, then, are at most only indirectly evolutionary in content, and in my view largely reflect pre-existing styles and pictorial conventions. The same might

19 'Natives of Aru Shooting the Great Bird of Paradise', from Wallace, *The Malay Archipelago*.

be said to be true of the beautiful pictures of birds of paradise, Edenic images that contrast with the savage picture of the orang-utans. 'Natives of Aru Shooting the Great Bird of Paradise', the second frontispiece in the book's first British edition, makes a wonderfully elegant image (illus. 19). Birds of paradise were surrounded by mythology; it was said they were born without feet and flew without ceasing, trailing their miraculous tails. Even when this myth was exploded (local hunters, looking for the gorgeous tail-feathers, cut off the birds' feet), they kept their allure. Wallace spent several weeks hunting specimens in the eastern Aru Islands (the sale of these, including an entirely new species known today as Wallace's Standard-Wing, bought him five more years of travelling and collecting time in the East Indies) and gave them a prominent role in his book.

The Aru islanders shown hunting the birds in Wallace's frontispiece seem to share in their natural beauty. Wallace was in fact filled with admiration for the physical perfection of the Aru bowmen: 'What are the finest Grecian statues to the living, moving, breathing men I saw daily around me?' he asked. 'The unrestrained grace of the naked savage as he goes about his daily occupations, or lounges at his ease, must be seen to be believed.'[35] The Dyaks shown hunting the orang-utan, in contrast, seem to share the savagery of the animal they are attacking.

This division serves as a kind of visual echo of the well-known 'Wallace's line', a geographical concept Wallace discovered while travelling through the archipelago comprising present-day Singapore, Malaysia and Indonesia. He realized that there were striking differences between the species of animals found in the western half of the archipelago, on the Indian side, and those on the eastern side, looking towards Australia.[36] For example, the bird species he saw on the island of Bali he did not meet up with on Lombock to the east, though only twenty miles separated the two islands. The same was true for other animals; on the western side of the divide, Wallace found tigers, monkeys and orang-utans; on the eastern side, cockatoos, birds of paradise and tree kangaroos. Generalizing the notion of division to include all organic species including human beings, he posited a geographical line that separated two different sets or ensembles of living things. Wallace thus took the already well-established idea of distinct geographical nations or zoological provinces and gave it a very specific exemplification in the tropics, as well as an implicit evolutionary explanation.[37]

Wallace represented these ideas in a number of illustrations in his later groundbreaking book, *The Geographical Distribution of Animals*

20 'A Brazilian Forest with Characteristic Mammalia', from Alfred Russel Wallace, *The Geographical Distribution of Animals* (London, 1876).

(1876) (illus. 20). Here, he placed in a single frame all the animals found in a single location; in the context of this work, as in *Island Life* (1880), which David Quammen calls the first major compendium of island biogeography, the pictures economically convey scientific information about how species form distinct clusters or groups in different environments. But to anyone unfamiliar with the theory of species divergence and adaptation, and approaching the image naïvely, thinking it showed the animals one might expect to see, all together and at the same time, the result was bound to be disappointment (as Wallace himself knew from reading descriptions that piled everything into a single frame). It also gave a static view of nature that could not do justice to the complexities of overlap and exchange between species in different localities.

Wallace was extremely interested in human evolution, and *The Malay Archipelago* contains numerous ethnographic observations. He believed that human groups, like the other animals in the archipelago, divided into two distinct, original types. In the western half was found a Malay type, which was linked to Asia; in the eastern, the Papuan type, which was taller, blacker, more Negroid and similar to the aborigines of Australia. The anthropologist James Boon has explored the ways in which Wallace's line might be seen to stand as a metaphor for the shifting matrices of similarity and difference in nature and the human species through which European naturalists have perceived the East Indies historically. Each faunal type on the

74

two sides of Wallace's line seems to pull its human counterparts to its own side, with bestial might on one side and lyrical grace on the other.[38]

And yet the line between the bestial and the divine, east and west, or savage and civilized was never that straightforward in Wallace's mind. His belief that tropical nature was both unlike and like nature elsewhere – that it had its own inherent value, even though he missed his native British landscape intensely, that in some respects it was superior while in others inferior to what he knew at home – appears as an ambiguous motif in his book.

Wallace was, more than most naturalists, a sympathetic traveller, with a complex appreciation of the human and natural world; he was aware of the constant flux and variation in nature, of the fact that lines of division, between species and varieties, between species separated in space and time, between different human groups, are not fixed, but are constantly being broken down by migration and reproduction – an awareness that was fundamental to the evolutionary insight. Balanced against this was the desire to bring a sense of order to bear on the tropics, to establish clear boundaries between things, between the temperate and the tropical worlds, or between himself and nature.

So while Wallace found much that was admirable in tropical nature, especially the great tropical forests, he also continued to believe that their colourfulness had been greatly exaggerated and that the beauties of European nature far outshone the tropics unvarying splendours. Though he admired the natural grace of native savages, his pictures of the men of the East Indies are often disparaging. His illustrations especially seem to follow the conventions of the racial science of the day, which often analogized men of so-called inferior races to the female sex (thereby associating them with the body, lesser strength and fewer mental powers than European men).[39] For example, the Timorese men pictured in *The Malay Archipelago* are startlingly female, hinting perhaps at the lack of the masculine vigour that Europeans considered necessary for civilizing the wilderness (illus. 21). The tropical environment, though rich and often beautiful, still, to Wallace, was less productive of human excellence than the harsher northern and temperate climates, thus confirming a long-standing European view of the tropics as 'other', more primitive and belonging more to nature than culture when compared to temperate regions.

Again, though Wallace thought that Europeans were necessary to take civilization to the tropics, he regretted the inevitable extermination

of indigenous races that European agriculture and industry would bring in their wake. Though he praised the order and control that the Dutch had brought to the Dutch East Indies, he also believed that, on balance, Europeans were morally inferior to natives of the tropics. The concluding section of *The Malay Archipegalo* is in fact a sermon on the human misery that mastery of nature and the accumulation of wealth had produced in Victorian Britain: 'Our whole social and moral organization remains in a state of barbarism.'[40] In contrast, among people at a very low stage of civilization, he often found a perfect social state.

Wallace's book, then, though a wonderful account of tropical nature which fulfilled many of the visual conventions of the genre, also contained the germs of radical new ideas. We might say that in the 1860s, Wallace's views made up a somewhat baffling mixture of the conventional and the unconventional; they resist easy categorization, much as the populations he encountered in the East Indies did. We should, then, perhaps settle on Boon's description of Wallace's attitude towards tropical nature in *The Malay Archipelago* as one of 'unsettled ambivalence'.[41]

Tropical environmentalism

The Malay Archipelago probably represents the high point of Wallace's rapprochement with the scientific and social establishment in Britain. In 1866, he began a series of house moves which led him deeper and deeper into the countryside; he finally settled in Dorset. As he moved geographically away from the centre, so he also moved away intellectually; his views diverged more and more from those of his evolutionary colleagues, especially on social issues.

In 1869, for instance, Wallace announced that he no longer believed that natural selection applied fully to the human species. Departing from Darwin's view that humans differ only in degree, not kind, from other animals, Wallace argued that the human species had a unique and higher destiny, that some unknown but higher power or spirit could lift humans, in a moral sense, into a realm beyond or outside nature.[42] These ideas, shocking and upsetting to Darwin, who feared apostasy from the evolutionary creed, derived from Wallace's growing dissatisfaction with ruthless, competitive, Darwinian struggle as a model for or guide to human society. More radically, it was based on his newly acquired faith in spiritualism, to which he converted in 1865.

Table rapping and communing with the dead may seem odd pursuits for a scientist, but they had their serious as well as their farcical sides. Many distinguished Victorian scientists, suffering from the

21 'Timor Men', from Wallace, *The Malay Archipelago*.

crisis of traditional religious faith caused by Darwinism, turned to spiritualism as a middle way between the harsh materialism of science and the old dogmas of religion.[43] In Wallace's case, faith in a spirit-world beyond death was a means to place moral development at the centre of human existence. Once back in England, observing the horrors of competitive capitalism and industrialization made him re-evaluate the kindness and morality of the tropical peoples among whom he had travelled safely for years; he had come to realize that happiness and social good did not reside in Europe or in the possession of material goods. For Wallace, spiritualism was a universal philosophy which taught 'that the world and the whole material universe exist for the purpose of developing spiritual beings ... and that our happiness and the degree of our progress will be wholly dependent upon the use we have made of our faculties and opportunities here'.[44] To spiritual-ism, Wallace later added beliefs in the need for land nationalization (the only policy, he argued, that would eliminate the gross social inequalities brought about by unequal land ownership) and in femi-nism, the latter being necessary to give women the freedom to make their own moral choices (not the least choice being the careful selec-tion of a mate independent of purely economic considerations).

Tying all of these radical social views together was Wallace's faith that it would only be in a socialist society that the moral and spiritual development of which the human species was capable would find fruition. This was obviously not the socialism of Marx but rather a utopian, spiritualized dream of human perfection, and a rejection of the reductive social Darwinism that was being used to explain industrial Britain's supposed superiority in the 1870s and '80s. To argue that this society, with its child labour, destructive diseases, dangerous workplaces and poverty, represented an example of Darwinian 'survival of the fittest' seemed to Wallace a gross distortion of the truth. But his vision of the possibility of true social evolution was won at the cost of adopting a quasi-theological view of the world with which most of his fellow scientists were extremely uncomfortable. For this reason, he found few converts, and his scientific reputation suffered. 'I hope you have not murdered too completely your own and my child,' wrote Darwin to Wallace in some despair as he prepared to spell out in the *Descent of Man* what had been implicit in his theory of evolution all along, namely that human beings, like animals, were the material products of the natural processes of variation and selection, and had descended from apes.[45]

Similarly connected to his social and ethical views, and similarly unconventional in his immediate scientific circles, was Wallace's tropical environmentalism.[46] The literary critic Lawrence Buell has described the emergence of environmentalism as a new kind of sympathetic understanding of nature and has provided a convenient checklist of some of its key ingredients. These include the notions that human history is implicated in natural history; that it does not represent the only legitimate interest in the environment; that human accountability is part of our ethical orientation to nature; and that the environment is a process, rather than a static feature of the world. These factors emerged in nineteenth-century nature writing, Buell suggests, as a new perception of the fragility of the environment developed in response to Western industrialization.[47]

Evolutionism was itself, of course, another component in the development of environmentalist thought. Evolution brought with it a new awareness of the interdependency that exists between organisms and their environments. In the third chapter in the *Origin of Species*, for example, Darwin describes the 'Complex relation of all animals and plants to each other in the struggle for existence', showing in numerous examples how, when the environment changed, the complex of species changed. He cited as an example of this the effects of land enclosure in Britain; because the enclosure of heathland in

England prevented cattle from browsing the commons, tiny seedlings previously destroyed by them survived to produce new woodlands.[48] Yet Darwin drew no larger conclusions from this knowledge of interdependency, remaining unconcerned about conservation issues.[49] It may be that Wallace's insistence that human beings were moral agents who could and should choose to act to make the world a better place gave him a larger sense than Darwin possessed of how they could act for good or ill *on the environment*, and how this fact, more than biological evolution by itself, would determine the future shape of nature.

The third, and perhaps the most interesting, factor in the development of Wallace's environmentalism was empire. It may appear paradoxical to place empire and ecology (in our contemporary sense, meaning a concern for environmental destruction) together, since at first glance they seem antithetical. However, recent research suggests that ecological awareness emerged as a consequence of, and prescription for, the environmental destruction that scientists and colonial officials observed empire had wrought overseas, especially in tropical colonies.[50] This is much the same argument made by historians of medicine when they suggest that tropical medicine emerged in the late nineteenth century as a discipline to solve the problems of tropical disease that tropical colonization had produced.

The historian Richard Grove, for example, in his pioneering study of the imperial origins of 'green' ideas, shows that the observations made between roughly 1780 and 1850 by a relatively small group of colonial scientists, of the extraordinary environmental degradations brought about by human activities in the tropics, were the critical element in shaping new conservationist and protectionist ideas.[51] Many of these scientists worked on small tropical islands, where the balance of nature was easily destroyed when forests were cleared for plantation monoculture, and the effects on species reduction or even extinction were readily apparent. Thus it was not at the European centre but in the imperial periphery that the alarm about long-term climatic changes and environmental deterioration was first sounded; it was the agents of empire, living in the tropics, who propagandized the notion of the connections between colonial rule and deforestation, the depletion of natural resources, drought, disease and famine. These threats to the environment became credible, says Grove, as the crisis of the environment was discerned as a global problem at mid-century – in the Cape Colony, in India, in Ceylon, in Mauritius. For example, the problem of desiccation in South Africa was debated at the Royal Geographical Society in Britain in the mid-1860s; the Great Famine in India (1877–9) was also widely discussed (and led to

a Famine Commission in 1880). The conservation and environmentalist policies that emerged from these developments (feeble though they may have been in application) were therefore 'embedded in the needs and practices of imperial rule'.[52]

Wallace fits this third tradition of environmentalist thought very well (though he never served as an employee of any colonial government or of the East India Company, as many of the scientists studied by Grove did). While Darwin had walked in the tropical forests and visited Tahiti, he had not immersed himself in tropical environments for many years as Wallace had done. It was in the tropics, especially the islands of the East Indies, that Wallace first became aware of the ambiguities of the human presence in nature, the fragility of the evolutionary balance and the threat posed to it by overweening domination for purposes of commerce and gain. In his mature writings, he expressed the ideas that nature had not, in fact, been created just for human appreciation or consumption; that plants, animals and human beings formed a network of mutual interdependence; and that it was Europeans' actions that had the most profoundly negative effects on nature and culture, effects which could not be repaired easily.

As early as 1869, in various passages in *The Malay Archipelago*, Wallace had already placed his descriptions of tropical species in the larger contexts of their natural and human environments. In one well-known passage describing birds of paradise, Wallace's observations led him at first to the regret that such exquisite creatures should live out their lives in a place where they had 'no civilized eyes to gaze upon their loveliness'. But he followed these sentiments with the acknowledgement that,

should civilized man ever reach these distant lands, and bring moral, intellectual, and physical light into the recesses of these virgin forests, we may be sure that he will so disturb the nicely-balanced relations of organic and inorganic nature as to cause the disappearance, and finally the extinction, of these very beings whose wonderful structure and beauty he alone is fitted to appreciate and enjoy.

He went on to remark:

This consideration must surely tell us that all living things were *not* made for man. Many have no relation to him. The cycle of their existence has gone on independently of his, and is disturbed or broken by every advance in man's intellectual development; and their happiness and enjoyments ... their struggles for existence ... would seem to be immediately related to their own well-being and perpetuation alone, limited only by the equal well-being and perpetuation of the numberless other organisms with which each is more or less intimately connected.[53]

Ten years later, this critique was given a more systematic exposition in Wallace's *Tropical Nature*. Written, as we have seen, against a background of discussions in Britain about the human causes and costs of environmental destruction, the intention behind this book was, Wallace said, to define what was 'essentially tropical' about tropical nature. In the introduction, he remarked that the luxuriance of tropical nature was so well known that there was little new to say about it; '… the traveller and the naturalist have combined to praise, and not unfrequently to exaggerate the charms of tropical life.'[54] Repeating something he had said in *A Narrative of Travels* 25 years earlier, he noted that, contrary to common perceptions, nature in the tropics lacked colour, mammals, noise; its chief characteristics were silence, darkness and an almost oppressive monotony. What the tropics did have, though, was an extraordinary number of different species, each with a very local distribution. Wallace combined this 'anti-tropical', or realistic, representation with his 'tropicalism' – that is, his deep sense of the value of tropical environments and their vulnerability to human destruction. Thus his sceptical and appreciative views of the tropics came together in what we today would call an environmentalist's understanding.

This position was spelled out in the first essay of *Tropical Nature*, where Wallace drew the reader's attention to the negative effects that the removal of tropical vegetation could have on the climate and therefore on organic nature and humanity. He described an environment in the state of Ceará in Brazil, situated only a few degrees south of the equator, that was the opposite of what most people think of as tropical nature – not lush jungle but bare hills, a terrain made into a desert by the destruction of the Atlantic forest cover. Another example he mentioned was Central India, where torrential rain, falling on land stripped of vegetation, resulted in the destruction over the course of only a few years of the fertility of the soil.[55] Knowingly to produce such destruction, Wallace believed, would be a far more serious offence against morality than any destruction of property which human labour had caused. Yet in India and Ceylon, Europeans were doing just that – clearing large areas of forests in order to establish coffee plantations, in the process destroying fertile soils that it would take generations to replace. Wallace argued that, if not checked in time and without reforestation, plantation agriculture would lead to a deterioration of the climate and the permanent impoverishment (and starvation) of the indigenous inhabitants. In a footnote, he drew attention to a chapter in George Perkins Marsh's *The Earth as Modified by Human Action* (1874), a prophetic book on the environ-

mental degradation brought about by human action that today is recognized as a fundamental work in the history of environmental thought.[56]

The environmental and human costs of the destruction of nature were also the theme of the concluding chapter in Wallace's *Our Wonderful Century: Its Successes and Failures* (1898). This wonderfully idiosyncratic assessment of the highs and lows of Victorian Britain's intellectual and technical inventions lists among the century's failures the neglect of phrenology, the opposition to psychic research and the embrace of vaccination! The last failure described is 'the plunder of the earth' – the wastage of resources, destruction of natural beauty and frequent failures of the very crops for which forests had been cleared. Wallace compared this devastation of the earth to the devastation of human society by despots.[57]

Picturing evolution

Wallace's critical ideas about humanity and nature, involving notions of ecological balance, cycles of growth and decay, the interconnectedness of all living things and human involvement in nature, could not easily be given visual form. In the context of this study of the visual imagination, of the power of images to convey complex ideas about reality, it is important to be aware that there are limitations to visual images – that they may, as a system of communication, be inadequate to our perceptions, or less adequate than words, or incomplete without words. To take a modern example, we might look at the marvellous pictures by the English botanical illustrator Margaret Mee. Mee first went to Brazil in the 1950s; there she took up botanical illustration and met all the major figures in botanical science (becoming particularly close to Roberto Burle Marx, the landscape designer whose brilliant tropical gardens I examine in Chapter 7). Mee's particular interest eventually became the plants of the Amazon, which she painted from life in the course of numerous field trips in the 1970s and '80s. Mee, like Burle Marx, was passionately concerned about the conservation of rain-forest wildlife, and this passion infused her work.

But can we discern the ecologist's idea of the co-evolution and mutual dependency of species in the way she showed her plant specimens – in the use she made, for example, of the background environment in many of her pictures? In her illustration of the striking *Gustavia pulchra* plant, a white flowering species which can reach a height of 18 metres and which was first identified scientifically by the

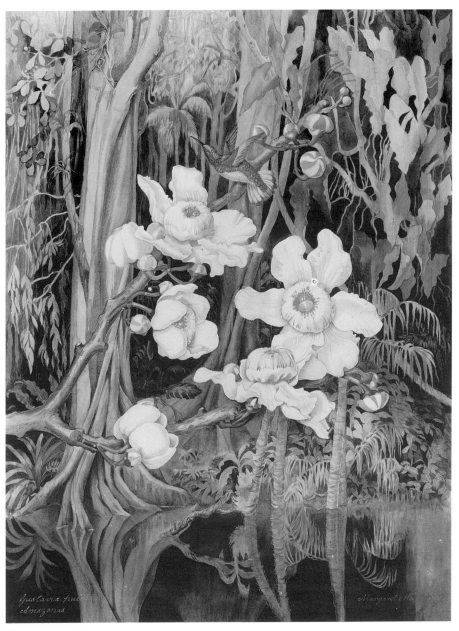

22 Margaret Mee, *Gustavia pulchra*, 1979, pencil and gouache on paper. Royal Botanic Gardens, Kew.

nineteenth-century botanist Richard Spruce, Mee placed the flowers in the *igapó* (the seasonally flooded forest environment) and showed them in association with numerous other plants and a hummingbird (illus. 22). That is, she placed the plants in their correct scientific connections with other species, seeking thereby 'to impress on the observer the interdependency of forest species and the importance of preserving their native habitats'.[58] It has to be said, however, that it is the pre-existing knowledge of the shared habitats of plants and of evolution that we bring to this picture that gives it its ecological meaning, as much as anything in the compositional structure of the picture itself. Many other features of evolutionary ecology, such as the numerous insects involved in plant fertilization, or the cycle of flooding and its effects on the seasonal changes in forest vegetation, which are critical to an ecological perspective, are not represented visually in the picture, and probably cannot be, because an ecological framework is about processes taking place over time.

The repertoire of visual images of tropical nature available to Wallace were of course more limited than ours today, living as we do in an age of film, video, television and especially computer-assisted simulations, technologies of representation that allow us to manipulate a multiplicity of images and diagrams at once and to make images unfold before us in speeded-up time. But in Wallace's day, visual images could probably not do justice to his views on tropical environmentalism. It is therefore in his mature writings, far more than in his tropical pictures, that we begin to get a sense of the interdependence among the various forms of life about which he learned from his studies of tropical nature. It was a humane, environmentalist and sensitive view of life that was, in some respects if not always, far removed from the simplifications in the accounts of tropical nature found in many of the popular books written by his contemporaries. Despite his limitations, Wallace's evolutionary view was, perhaps, the best that could be done with tropical nature at the time.

3 Racial Degenerations

I open this chapter on race in the tropics with a scene in the heart of the Amazon in 1865. There, in some excitement and secrecy, in an anthropological 'laboratory' set up for the occasion, a number of Brazilians were persuaded by Louis Agassiz, Professor of Geology at Harvard University and head of the Museum of Comparative Zoology, to be photographed in various states of undress. The young William James was also present, to record in his diary the air of sexual titillation surrounding the proceedings, and the scepticism of a visiting Brazilian politician who, happening on the scene, expressed his reservations at the goings-on, a Brazilian who, without his own clothes, might perhaps have been shown to be somewhat similar to the supposedly degenerate tropical bodies Agassiz believed he was capturing on his photographic plates (illus. 23).[1]

The series of photographic images to which this photograph belongs constitutes the key documents analyzed in this chapter. Critical to the story told here is the fact that the representations are *photographs* and, moreover, *photographs of racial hybrids*.

When Agassiz went to the tropics in 1865–6, he did so as America's leading anti-Darwinist looking for the evidence about species which he believed would disprove the upstart theory of evolution. His journey, paid for by a wealthy friend, may indeed have been the best-funded anti-Darwinian expedition of its kind. Agassiz was committed to the idea of the fundamental difference between tropical and temperate zones; race figured in his anti-Darwinian project since – believing that different human races were as distinct and fixed in their physical characteristics as different animal and plant species – he hoped to collect data on race in the tropics to prove his point. If human races were like animal species, however, the existence of 'half-breeds' or mixed races posed a problem, for different animals do not easily reproduce across the species barrier (the common example of this being the cross between a horse and an ass, which results in a sterile mule).

The fact that crosses between different races in the human species were common therefore needed explaining, or explaining away. Agassiz particularly wanted to show that, even in the tropics, where races had apparently mixed much more freely than anywhere else, the different 'pure' races in fact did not easily loose their 'primordial' features, nor did the different types of 'half-breeds' easily mix or amalgamate among themselves in an endless process of hybridization and racial 'dilution'. For this would have meant merging what God had intended to be separate and unequal types of humanity.

Measuring racial hybrids therefore became one of Agassiz's scientific goals. The fact that slavery had not yet been abolished in Brazil (and would not be until the extraordinarily late date of 1888), the great variety of races in that country, the amazing character (to Agassiz) of the racial crossings there, and Agassiz's belief in the tropical sensuality of the people and the absence of bourgeois standards of decency all seemed to open up the tropical body to scientific scrutiny to a degree not possible in post-Emancipation America.

Rather than measure human races by the laborious methods of anthropometrics (in which he had no training), Agassiz measured them by means of a camera. He attached 'epochal importance' to this invention as a scientific tool and pioneered its use in the area of race, being responsible for producing some of the few surviving daguerreotypes of North American slaves.[2] The much more extensive collection of albumen prints of race produced in the tropics by his student Walter Hunnewell under his supervision extended this anti-Darwinian photographic project much further, more particularly in the pursuit of representing race mixture.

Though crude, amateurish and disagreeable to our eyes (because of their reductive poses and stark nudity), Agassiz's photographs pleased him; he considered that his collection made up a 'very complete series' on race and race mixture (though in fact it involved photographing at the most 50 different individuals who were supposed to represent millions).[3] It is possible that the collection is unique in what Elizabeth Edwards calls the 'the incunabula' of photographic visual anthropology (that is, photographs from the 1860s) in their deliberate focus on representing racial hybrids.[4] Agassiz announced several times his intention of publishing them.[5] He never did. But since he went to Brazil to collect the data, a good case can be made that he would have done, had the images provided the visual evidence he needed. True, the nakedness of his subjects, which Agassiz, along with other scientists at the time, considered essential to a proper evaluation of the physical differences between racial types,

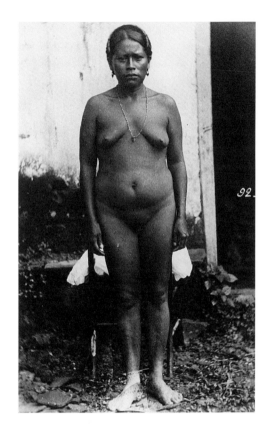

23 'Inhabitant of Manaus', photograph by Walter Hunnewell for Louis Agassiz, 1865. Peabody Museum of Anthropology and Ethnology, Harvard University, Cambridge, MA.

might have prevented their being printed in a public forum such as a book; the first appearance of a similar anthropological image, showing a naked man, appeared in a British anthropological journal in 1869, very close to the publication date of Agassiz's own book about his Brazilian journey.[6] But the fact that Agassiz chose to illustrate the book he wrote on the tropics not with his own photographs but with other images, some of them semi-nudes, and some of them based on photographs that he had purchased for the purposes of racial representation, suggests that his own presented conceptual and interpretive difficulties rather than purely practical ones.

As we know, photographs are both like and unlike other kinds of images. Current critical fashion leads us to emphasize their likeness to non-photographic representations, to think of them as cultural artefacts like any other. But it is important to consider the difference between the photographic image and other kinds of representations.[7] A photograph, for example, cannot capture something that does not exist in the world – an image of an elf or of a water-sprite.[8] It can, however, capture traces of the surface phenomenology of things that

really do exist. Of course, the social or cultural *meaning* we attach to these photographic traces lies outside the image itself, in the larger verbal and visual (and often unstated) systems of signification and communication to which we relate it. Nevertheless, this literalness of the photographic image, its surface 'fullness' and detail, was precisely the undoing of Agassiz's hybrid project. For rather than showing a limited number of categorical hybrid types as Agassiz's theory demanded, his photographs revealed the surface phenomenology (visual features) of great and continuous human variation – the reality of imperceptible gradations of difference between individuals (just as Darwin indicated in his theory of evolution).

How to render this surplus of visual information, this minutely graded spectrum of visible difference and similarity, into stable representations of race via the supposedly realistic and objective medium of the photograph became one of the chief questions of anthropology of the day. Though Agassiz's racism is certainly germane, it is not the main focus of my story here (and has been discussed by several historians in any case).[9] Rather, my question is: How was the tropicalized, hybrid body to be represented? Agassiz's photographs, dating from the 1860s, stand at a critical juncture in the *process* of making photographs useable for scientific purposes. Eventually, as we shall see, to make of the photographic image what Agassiz and his contemporary racial theorists wanted to be made, the image's maker had to subject it to manipulations that revealed the photograph's artificiality as a representational device, as well as the artificiality of the very racial truths the photograph was supposed to denote.

More generally, these early photographs of race mixture in the tropics speak to the crisis in optical realism that occurred just at the very moment when a new ideology of objectivity and realism was being inscribed in science, in part through the new visual device of the photograph itself.[10]

The tropical body

Representations of the human body often serve as a kind of litmus test of a culture's preoccupations, responding to all sorts of contradictory projections and anxieties. Among these representations, the image of the frankly erotic, sexually available body (almost always female and partially nude), situated in a tropical landscape, is among the most alluring in the European tradition. It is a very old representation, originating in classical and medieval myths about the mystery and fertility of faraway places, of Eden and the Fall. The notion of

the erotic tropics was given new life by the New World discoveries of the sixteenth century, when the nakedness of the indigenous inhabitants of such places as the island of Hispaniola, where Columbus made landfall, and their ease with their own physicality as well as their unfamiliar sexual customs, simultaneously fascinated and shocked Europeans.[11] Vespucci, for example, in his sixteenth-century report about tropical Brazil addressed to the Portuguese Crown, described the Amerindian inhabitants as both innocent and lewd – innocent in their nakedness, lewd in their sexuality. In a complete misunderstanding of what he saw, he wrote, 'They take as many wives as they like, and the son has intercourse with the mother, and the brother with the sister, and the male cousin with the female cousin, and the one who is out walking with the first woman whom he meets.'[12]

As contacts with the Other broadened during the Enlightenment, tropical people and their customs served as utopian and anti-utopian models which could be used by philosophers and naturalists to criticize the jaded manners of Europeans and provide images of noble savages, free and open in their sexuality. Some of the most sustained philosophical ruminations on the supposed eroticism of the tropics resulted from visits to Tahiti by the French navigator Bougainville and then by Captain Cook in his first round-the-world sea voyage.[13] The vision of tropical natives as children of nature, at home in their bodies and physical appetites, fitted in with the contemporary theory of climatic determinism; tropical heat and sun were believed to produce a lazy sensuality and precocious sexuality, while colder climates calmed the passions and stimulated the use of reason, as human beings struggled against the elements in order to survive.

By the late nineteenth century, the image of the tropical beauty, usually shown scantily clad against a backdrop of palm trees, was circulating in the thousands in the form of photographic postcards, forming what Raymond Corbey has called an 'anthropology of bosoms' (men, as he notes, remaining largely unrepresented in this 'pretend-science').[14] Such images have received a lot of critical attention from historians because of their exploitative and reductive view of the female, colonial body.[15]

But Agassiz's photographs are not like these. They shock in a different fashion, as medical photographs do; indeed, they are closely connected *to* medical photographs, in their deliberate attention to the materiality or physicality of the human body, their exposure of the body to close viewing, and their objectification and quasi-pathologizing of the body. In these regards, they reflect, in extreme form, the shift in attitudes towards race that took place in science and politics in

the middle of the century. A new racialism was in the air, as commerce, colonial conquest and rapid industrial developments within Europe created feelings of physical and intellectual superiority among Europeans. Enlightenment faith in the family of man was being replaced by a less cosmopolitan and more pessimistic view of human beings; in the process, a less universal and sympathetic human body emerged in European representations.

Agassiz (1807–1873) was known not as an anthropologist but as a geologist and expert on fish classification when he made his first visit to America in 1846, to deliver a series of lectures at the Lowell Institute in Boston. His warm reception convinced him to leave behind the Old World, where money was short and his marriage failing, and to cast in his lot with the New. Appointed Professor of Geology and Zoology at the Lawrence Scientific School at Harvard, within a few years he managed to raise funds for a scientific kingdom of his own, the famous Museum of Comparative Zoology. Following the death of his first wife, he remarried well, to Elizabeth Cary, who connected him to the best families in Boston, socially and intellectually. From there, he widened his scientific network by throwing himself energetically into scientific politics, until he had by the 1860s established himself at the centre of the scientific institutions in his adopted country. Charming and supremely confident, his fluent English tinged with a French accent, a devotee of Nature and God in Nature, Agassiz proved practically irresistible to educated Americans. By mid-century, at any rate, he had made himself America's pre-eminent philosophical naturalist.

By 1865, however, Agassiz's enormously energetic career had taken its toll. He was 58 and not well. To physical was added mental exhaustion, brought about largely by his embattled position as America's leading anti-Darwinist. A holiday in the tropics, long a dream of his (as a young and ambitious student he had travelled to Paris to hear Humboldt lecture, and he had also worked on classifying the huge collection of Brazilian fish collected by Johann Baptist von Spix and Karl Friedrich P. von Martius), was proposed as a journey of renewal. The projected holiday soon turned into a scientific expedition, however.[16] A wealthy benefactor stepped in (as so often happened in Agassiz's life) to send him and his wife, together with an assortment of friends, scientists and self-paying students, collecting along the waterways of the Amazon. A well-funded, anti-Darwinian trip to the tropics was thus organized.

Among the students on this expedition was William James, who at 23 was looking for his own escape from the disheartening and embar-

rassing in life (such as his failure to volunteer for the Union Army in the Civil War, as his two younger brothers had done). Having spent the previous two years restlessly seeking direction, trying first painting and then medicine, landing up in Agassiz's classes in natural history at the Museum of Comparative Zoology, James went to Brazil to see if the naturalist's life was for him. He found it was not: 'If there is anything I hate it is collecting,' he told his family.[17] Many years of searching were to pass before he found his metier in philosophy and psychology; the diaries he kept in Brazil, and the many sketches and drawings he made while there, as well as his letters home, document James's journey towards self-knowledge, as well as provide an ironic commentary on Agassiz's entire tropical project.[18]

In Agassiz, James found a worthy target for his irony and humour, for Agassiz was an exceptional figure, given to bold ideas, a man whose intellectual energy James admired but whose bombast amused him ('His charlatanerie is almost as great as his solid worth').[19] Among Agassiz's bold notions was the idea of a great Ice Age in the recent geological past; following the publication of Darwin's *Origin of Species*, Agassiz put this Ice Age to work in his anti-Darwinian schema, claiming that it had acted as a great destroyer, a climatic catastrophe, which had extinguished all life forms at a stroke, and with them the biological continuity essential for evolution to occur. Determined, or more correctly, predetermined, to find evidence of an Ice Age in the humid tropics, he did (never mind that Bates, who had spent years in the Amazon never saw a trace of it).[20] Similarly with geographical distribution. This topic of topics in biology – both the facts and their causes – was another of Agassiz's specialties; he was convinced that careful study of the distribution of tropical fish in the waterways of the Amazon would prove the limited geographic ranges of distinct species and their fixed characteristics, thus proving the creationist position.

In fact, Agassiz was unable to stem the tide of pro-evolutionary feeling (most of his students deserted his creationist cause). For this reason, perhaps, the book that resulted from his expedition, *A Journey in Brazil* (1868), which appeared under the joint authorship of him and his wife, is often treated as a sideline in his career or dismissed scientifically because so many of its ideas were later judged to be erroneous. Its joint authorship, with Mrs Agassiz supplying a jaunty, overall narrative of events and her husband inserting short scientific 'essays' along the way, to give authenticity and male reason to the whole, was also unusual. It may be that serious scientists found this hybrid form as unconvincing as Agassiz found human hybrids

inauthentic. Taken as a book of popular science, however, it is readable and in many regards representative of the genre (it went through nine printings between 1868 and 1875).

Agassiz's journey to the tropics was also significant in another sense, in that it was a sign of the growing psychological, aesthetic and commercial involvement of North Americans in the tropical lands to their south.[21] From the 1830s on, Latin America was considered part of the 'manifest destiny' of the United States, as well as a potentially rich place for commercial extraction, North American enterprise and even settlement (for example, for free blacks from the US, an idea Brazil rejected). Agassiz went to the tropics as a self-appointed ambassador of science, an intellectual explorer, helping to impose scientific order on an unruly place of nature and culture.[22] He took with him official letters from the US government to the Emperor of Brazil, Dom Pedro II, with whom he had already opened a scientific correspondence. The Emperor, an unusually well-educated monarch with a passionate interest in science, put a government boat at Agassiz's disposal to carry him along the Amazon, as well as a trained and experienced Brazilian scientist, a Major Coutinho, to help him plan his route and whistle up the necessary servants and personnel. Agassiz took pride in the fact that, as a result of his Amazon journey, he had helped persuade the Emperor to finally open up the waterways of the Amazon to international trade (the announcement was made in 1867, the year after Agassiz returned to Boston).[23]

Then there was the racial issue. Agassiz embarked for the tropics in April 1865, in the last month of the Civil War and as the emancipation of slaves became a reality (his party heard the news of Lincoln's assassination while in Rio de Janeiro). A recently naturalized American (he became a citizen during the Civil War), and a Northerner connected by marriage to the élite of Boston, Agassiz supported the causes of abolition and unity of the States, but like many Northerners was far from being a believer in racial equality. On the contrary, he held extreme views which carried weight because he was a scientist. His intervention in Brazil just when slavery was abolished in the US and abolition in Brazil was being recognized as inevitable, placed the issue of race and national identity squarely on the scientific and political agenda, with lasting effect on nationalist and tropicalist discourses in both places.

Everything in Agassiz's scientific training and philosophical outlook led him to believe in the fixity of animal and plant species. And though the human race was not a subject in which he originally had taken a scientific interest, playing the 'race card' was very much

in the spirit of the times. In Agassiz's case, once he found himself in the US, his contact with free blacks and slaves convinced him of the permanent inferiority of non-European races.[24] By 1850, he had become associated with a group of mainly Southern naturalists who maintained that the human family was divided into many different 'primordial' races, analogous to separate animal species, each one created for, and destined to live in, different geographical regions.[25] Agassiz, that is, was a 'polygenist'.[26] Africans were, according to this theory, not truly at home in the temperate world of the US but belonged to the hot areas for which they had been created. They were, in short, tropical.

These ideas flowed from the model of nature that dominated all of Agassiz's scientific work – the creationist, classificatory, taxonomic model based on the fixity of species. Central to this model was the concept of the type – a Platonic essence that underlay superficial variation and supposedly constrained it within delimited parameters, thus guaranteeing the distinctions between species, and the order and stability of the natural world. Of course, as Mary Winsor says in her excellent study of Agassiz's classificatory approach to the living world, his understanding of the stable type that he believed could be observed in every individual was itself a product of interpretation – interpretation of the classificatory schema through which he saw the world. The taxonomic model, in common with all classificatory models, sees or makes order where, phenomenologically speaking, order is not obvious; it is in this respect a highly abstract way of viewing the world.[27] It was this focus on the type to which individuals supposedly could be reduced, instead of the continuous flux and variation seen in all living things, that blinded Agassiz to the evidence that led Darwin and Wallace to formulate the theory of evolution in the first place (and that made Agassiz's photographs of race so confusing to him).[28]

Like all classifiers, however, Agassiz was faced with the problem of how to secure the fixity of the species against the outward appearance of flux that constantly threatened to blur distinctions between types and so break down the classificatory grid. The problem was especially acute in respect to the classification of types or species in human populations, since wherever human beings had travelled, they had apparently reproduced across all kinds of physical, linguistic and cultural boundaries. Scientists recognized, that is, the multiple factors of human migration and interbreeding that were constantly altering the features of populations, 'confusing', as the French anthropologist Paul Topinard put it, the supposedly distinct races of

the world.[29] Nevertheless, most of them continued to believe that the initial confusion they might experience when viewing an unfamiliar population could be resolved into the certainty of identifiable, distinct races that could be clearly labelled and placed appropriately in the hierarchically organized living museum that was humankind.[30]

Visualizing races: drawings, diagrams and photographs

To secure the racial types, to materialize them visually as scientific images according to the demands of contemporary racial theory, various representational devices were resorted to. Anthropology had become, by mid-century, above all a science of the visible, physical body as it manifested itself in the marks of racial distinction, and therefore visual representations were crucial to the racial enterprise. One visual technique employed was simply to represent two 'races' by means of images of two different individuals selected precisely because they stood at the opposite ends of a spectrum of visible bodily features considered diagnostic of racial identity. In the US, for example, racial distinctions were based strictly on skin colour (the one-drop rule of ancestry translating into the classification of anyone visibly 'not-white' as 'black'), so that a white and a black image instantly conveyed to an American viewer the idea of the supposed inherent and deep-seated biological differences between two races. In the albums of racial types that Agassiz assembled for his scientific use (now housed in the Peabody Museum at Harvard), he interpolated among frontal and profile photographs of the naked bodies of other races images of classical statues: the semi-draped torsos of the *Venus de Milo* and *Apollo Belvedere*, the most idealized versions of womanhood and manhood in the Western canon (illus. 24). Without the implicit connection suggested between lightness, Classical learning and Classical ideals of beauty, on the one hand, and darkness and nakedness on the other, the racial album could not work well as a map of racial difference.

Race, in short, was a contrastive concept. Any representation of one race could only be understood in explicit or implicit relation to the representation of another, through a process that highlighted the signs of difference. Such racial contrasts were often expressed with the greatest visual clarity via diagrams, precisely because in them points of difference could be emphasized, distracting 'noise' (variation) eliminated and essential contrasts made visible. This was one reason why race diagrams appeared at the same moment that the concept of race difference became embedded in science in the eigh-

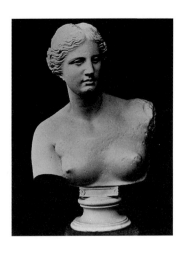

24 Photograph of the *Venus de Milo* inserted into Louis Agassiz's Brazilian photographic albums. Peabody Museum of Anthropology and Ethnology, Harvard University, Cambridge, MA.

teenth century, for example in Peter Camper's infamous 'facial angle' (a measure of the protuberance of the face which he illustrated in a European, a Negro and a chimpanzee).[31] I would argue, indeed, that racial science was a visual and diagrammatic science *par excellence* – that is, it depended on an elaborate visual language to make its points. Moreover, diagrams of race could not be compared to the 'real things' of race, since the races became coherently visible only as a function of the representations themselves.[32]

A good example would be two lithographs of skulls, one of a Peruvian, the other of a European, which appeared in one of the most influential craniological atlases of the mid-nineteenth century, Samuel Morton's *Crania Americana* of 1839 (illus. 25, 26). Morton was the founding member of the polygenist school, and the purpose of his book was to illustrate the fundamental differences between races. Stephen Jay Gould has drawn attention to the many assumptions, and information based on those assumptions, that are encoded within these representations.[33] Choices were made in them, the first being to make the essential feature of the human species the skull (the home of the brain and the supposed source of mental differences in races); another one was that a skull of a single individual could be treated as representative of a whole group or race. The lithographer, John Collins, singled out via lines and letters the areas of the white skull considered especially important in distinguishing its brain power (thereby giving the appearance of greater brain power to the 'white male' skull). Gould has pointed out that, to reinforce this latter point, Collins, probably unconsciously, tilted the Indian skull backwards from the normal plane, so that the Indian's cranium seems less vaulted and therefore less advanced intellectually than the Euro-

95

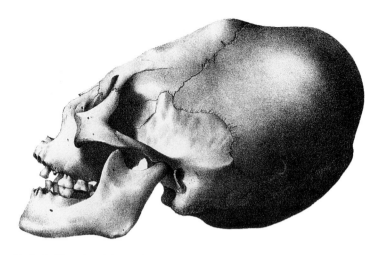

25 Skull of a 'Peruvian of the Ancient Race', lithograph by John Collins, from Samuel Morton, *Crania Americana* (Philadelphia, 1839).

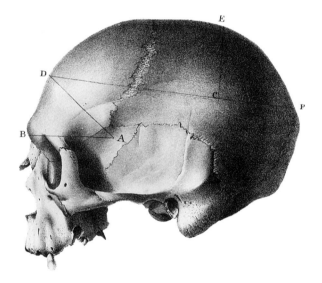

26 Skull of a ('Swiss') European, lithograph by John Collins, from Morton, *Crania Americana*.

pean's.[34] An effective contrastive schema and *imaging* of racial difference has been constructed.

Yet scientists also recognized that such drawings, engravings and lithographs had serious limitations. However detailed and seemingly accurate they were, they were considered to be works of art and therefore susceptible to subjective bias. Such biases are especially common

in the sciences of ourselves, where the tendency to see what we want to see, to create a homogeneous Other in place of human heterogeneity, is very marked. This indeed was the main charge made against illustrations of racial difference, that they lent themselves to exaggeration. Josiah C. Nott and George Gliddon's *Types of Mankind* (1854), the most important work on race by the American polygenist school at mid-century (and a book to which Agassiz contributed a chapter), is a case in point. The authors claimed that the drawings and diagrams they used to illustrate the different races had been made with the greatest care for accuracy and were unprecedented in number and detail.[35] Yet many of them were recognized by other scientists at the time to be gross caricatures of racial difference, a fact that marred a scientific book which otherwise received respectful attention on both sides of the Atlantic.[36]

It is against the background of these racial assumptions and representational conventions in anthropology that photography made its appearance. The truth-value of photographs seemed very different from that of drawings or paintings. This promise of truthful representation spoke with special force to scientists, because of their concern for objectivity and detail in their illustrations.[37] Compared to other forms of illustration, the photograph appeared a huge advance, because it was mechanically produced and seemed causally connected to the physical world in a way other forms of representation were not. The photograph seemed not just a picture of the world but the world itself. In a frequently cited statement on the difference between a photographic picture and artistic representations, Edgar Allen Poe remarked that

If we examine a work of ordinary art, by means of a powerful microscope, all traces of resemblance to nature will disappear – but the closest scrutiny of the photographic drawing discloses only a more absolute truth, or more perfect identity of aspect with the thing represented.[38]

Poe's 'homage to the daguerreotype', Lorraine Daston and Peter Galison have observed, 'seems to capture the dream of such perfect transparency'.[39]

Of course, historians and critics today tend to dismiss such belief in photographic realism and to consider photographs to be more like than unlike other kinds of representations. But this is to fail to acknowledge the novelty of the photographic image when it was first introduced and the fact that, whatever else it is, it is not identical to non-photographic images in cultural and historical meaning. Certainly, many scientists in the nineteenth century, including

Agassiz himself, but also such figures as Alfred Russel Wallace, expected that photographs would be especially valuable in anthropology and medicine because they would check the tendency to rash generalization so common in the study of race and in disease portraits.[40] Photographs, the British medical journal *The Lancet* claimed, were 'free altogether from the painful caricaturing' that disfigured so many portraits as to render them 'nearly valueless for science'.[41] And it was in fact in portraiture that photography found its special niche. It soon became the most common means of 'catching a likeness', thus democratizing a previously aristocratic form of representation (in the US, within a decade of the announcement of the invention of the daguerreotype, there were nearly a thousand professional daguerreotypists at work, 90 per cent of whose pictures were portraits).[42]

But photographic portraiture was also pulled in the opposite direction to that of the democratization and individualization of the image, as Allan Sekula, John Tagg and several others critics have noted – in the direction, that is, of the type portrait, surveillance and control.[43] Sekula gives an especially compelling account of how the photograph became a crucial element in the bureaucratic archives of criminology. Photography was also used in psychiatry, medicine, anthropology and social work, both to fix the image of the individual and to inscribe it within the larger category of the type to which that person supposedly belonged – 'the mad', 'the criminal', 'the racial type'. By the end of the nineteenth century, photography had become an essential part of the administration of the modern state.

Photographing races in the tropics

It is in regard to the problem of the representation of the individual and the type, in relation to different concepts of reality, that Agassiz's photographs are historically interesting; not because they are polished anthropological documents, but because they are rough, unpleasant efforts at anthropological representation that belong to the beginning of the process of making the photographic image acceptable or useable, at least according to the contemporary theory of race and definition of realism of the time.

Some of the earliest surviving photographs of slaves were in fact taken for Agassiz in 1850, only eleven years after the daguerreotype process had been announced, when he commissioned a professional photographer called T. J. Zealy to photograph subjects on a plantation in South Carolina. Agassiz's idea was that the photograph would

reveal the persistence of 'the African race' across two or more gener-
ations in the United States, thereby providing evidence of his theory
of the fixity of race. Never published in Agassiz's lifetime, these
daguerreotypes (fifteen of them remaining) were only discovered in
1976; what was controversial about them when discovered was not so
much the racial theory that led to them (now discredited) but the fact
that the sitters had been photographed naked.[44] Ever since Foucault,
of course, we have been interested in the different ways the human
body has been disciplined; rendering it naked (when it is normally
clothed, and others around it are clothed) has been potentially one of
the most devastating and problematic. In the European tradition of
which Agassiz was a part, being dressed was the sign of civilization,
and clothes a significant marker of place, status and gender. Causing
people to be naked, except in carefully designated places and circum-
stances (e.g. a doctor's office) robbed a person of dignity and
humanity.[45] For Agassiz, removing his sitters' clothes was possible
because they were slaves.[46]

In Brazil, Agassiz went further than he had fifteen years earlier,
picturing many men and women in states of complete nakedness.
Brazil drew him not only because the country contained the vast trop-
ical rain-forest of the Amazon, teeming with fish and other species
unknown to science, but because it seemed a vast laboratory of race, a
tropical experiment in race mixture on a grand scale. Though the
traffic in slaves had been legally banned in 1850, they continued to be
imported until well into the 1870s, and African-born slaves were
commonly seen in the cities. In 1870, Rio still had 50,000 slaves, a
figure no city in the US had ever approached. The 'Indian' and the
'European' made up the other two 'types' in Brazil's population.
Lastly, but most important of all to Agassiz, there were the many
people of mixed racial descent who, by the time he arrived, made up
the majority of the population. He believed that the country had
invaluable, if negative, lessons for North Americans, especially in
relation to the physical and moral degeneration that occurred when
two or more distinct race types hybridized. In the circumstances,
Brazil represented to Agassiz a frightening image of what might
occur in the United States, should the barriers between the races not
be maintained in the new conditions of racial freedom following the
Civil War.[47]

On their arrival in Rio, the impression the American visitors
received was of a black, almost African, country, with only the small-
est veneer of European civilization. The lack of tidiness, compared to
American towns; the 'indolent' expressions on the faces of the popu-

lation; the 'monotonous' songs people sang in the streets – all of these aspects seemed to the Agassizes to place Rio very far away indeed from what they knew. Altogether, the city seemed disorderly, irregular and decaying, with picturesque aspects, but generally an appearance 'half southern, half oriental'.[48] William James said that '... it realized my idea of an african [sic] town in architecture and effect ... Almost every one is a negro or a negress, which words I perceive we dont [sic] know the meaning of with us ...'[49] Particularly striking was the fact that race was not, apparently, a barrier to public office or careers in medicine, education and the civil service.[50]

After several weeks giving lectures on natural history (to which women were invited, on the Agassizes' insistence) and making excursions into the surrounding countryside, where they admired the tropical scenery, Agassiz and his party set off by boat for the tropical forests in the north, arriving there in mid-August. Once they had travelled many miles up the Amazon to the town of Manaus, situated at the confluence of the Rio Negro and the Amazon (where Bates and Wallace had spent time collecting long before), a six-week delay when the supply of pickling alcohol ran out gave Agassiz the time to set up a temporary photographic laboratory and carry out the investigation of tropical races he had been planning. With the help of his student Walter Hunnewell (whom he had sent while in Rio to Leuzinger's, the leading photographic establishment in Brazil, to learn photographic techniques), Agassiz proceeded to take numerous photographs of Brazilian women and men, pictured dressed, then undressed, in frontal, profile and rear views.

The more than a hundred images which they made and which were later incorporated into Agassiz's photographic albums (now housed in the Peabody Museum at Harvard University) make up, as I have said, what may be a unique photographic collection dedicated to recording the character of racial hybrids in the tropics (illus. 27–9). Few of these images have been reproduced to date.[51] One cannot but be struck by the starkness of the images, especially their crude nakedness. Being able to represent the naked body was essential to the way racial science worked, so we find that in the many schemes that were put forward by scientists in the 1860s and '70s to collect and measure the races of the world, photographing people naked was often recommended or even demanded.[52] For example, Thomas Henry Huxley, President of the Ethnological Society in 1869, in drawing up guidelines for photographing all the different races in the British Empire for the Colonial Office, specified that the subjects be presented naked, full-length, in standardized poses, with arms outstretched, so that

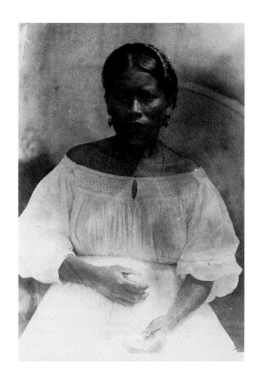

27 'Inhabitant of Manaus', photograph by Hunnewell for Agassiz, 1865. Peabody Museum of Anthropology and Ethnology, Harvard University, Cambridge, MA.

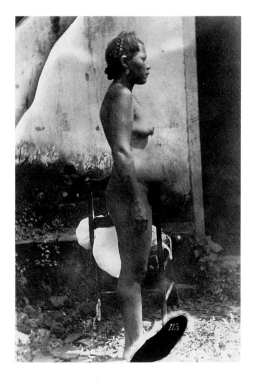

28 'Inhabitant of Manaus', photograph by Hunnewell for Agassiz, 1865. Peabody Museum of Anthropology and Ethnology, Harvard University, Cambridge, MA.

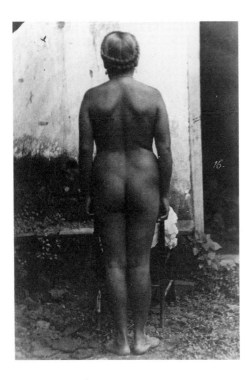

29 'Inhabitant of Manaus', photo-
graph by Hunnewell for Agassiz,
1865. Peabody Museum of
Anthropology and Ethnology,
Harvard University, Cambridge,
MA.

exact comparisons could be made from pictures. He also asked that
women's breasts not be concealed, since he believed that they had
characteristic sizes and shapes in different races. Other scientists
suggested that the heads of individuals being measured be shaved, the
better to reveal the contours of their skulls.[53] Few of these ambitious,
and scientifically and morally dubious, schemes were actually carried
out (missionaries in Africa, for example, objected to persuading
people whom they had converted from 'savagery' to remove their
recently acquired clothes). The exceptions tended to occur where
people were reduced to the status of objects by slavery or imprison-
ment – they were people who could be photographed because they
did not in fact possess, or have rights to, their own bodies.

Agassiz claimed that his own studies were easy to conduct in a hot
country like Brazil, where 'the uncultivated part of the population go
half naked, and are frequently seen entirely undressed.'[54] Certainly, a
degree of consent on the part of his sitters is implied by the account
given by William James, who in his diary describes how he was
cautiously admitted into the darkroom, where he found Agassiz

engaged in cajoling 3 mocas [*sic*; young girls] whom he called pure indians
but whom I thought as afterwards appeared, had white blood. They were
very nicely dressed in white muslin and jewelry with flowers in their hair ...

Apparently refined, at all events not sluttish, they consented to the utmost liberties being taken with them and two without much trouble were induced to strip and pose naked.[55]

The phrase 'utmost liberties' (liberties apparently additional to the removal of clothes) indicates that James, at least, was surprised and made uneasy by Agassiz's procedures. Mrs Agassiz, too, stayed away from the photographic laboratory. In the book she wrote with her husband, she refers to the photography mainly in terms of the (as she thought) 'childish' superstitions held by 'natives' about the soul-theft that occurred when their pictures were taken.[56] Yet it is clear from the context, and from the images themselves, that all of these photographs are of *caboclos* – that is, acculturated men and women from Manaus, which even had its own photographic establishment; they were hardly forest Amerindians, but rather people who ordinarily wore clothes and who were now being asked to take them off. Agassiz's photographs represent the process of undressing them by showing the subjects first dressed, then standing next to their clothes in a heap on the floor or a chair; any pretence that nakedness was their natural state is thus visually contradicted (anthropologists soon learned to eliminate this evidence of the process of 'un-civilizing' people).

The photographs reveal that undressing did not return the subjects to a more 'natural' condition; rather, it highlights the unnatural, scientific unmasking of the human body. Whether these subjects were slaves is impossible to say. Usually, bare feet indicated slave status (colour alone not distinguishing free from non-free in Brazil, where white slaves were not unusual), but in the warm and poor Amazon, this may not have been the case. The issue of slave status is germane to that of consent, but consent is always a relative matter. In some of the photographs, the women appear to express distress and a reluctance to remove their clothes. At least this is a plausible explanation of the pained expression of the woman shown in illustrations 30 and 31, whose elegant dress suggests a higher social status than that of the other subjects and who only undressed down to her drawers. That there was something not quite nice (or socially acceptable) about the enterprise is suggested by the remark made by the young Brazilian deputy from Alagoas, Tavares Bastos, with whom the Agassizes had become acquainted during their Amazon visit and who happened upon a photographic session. 'While we were there,' recorded William James in his diary, 'Sr. Tavares Bastos came in and asked mockingly if I were attached to the Bureau of anthropologie [sic].'[57]

30 'Inhabitant of Manaus', photo-
graph by Hunnewell for Agassiz,
1865. Peabody Museum of
Anthropology and Ethnology,
Harvard University, Cambridge,
MA.

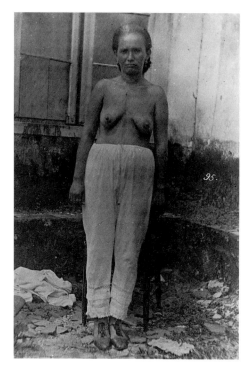

31 'Inhabitant of Manaus', photo-
graph by Hunnewell for Agassiz,
1865. Peabody Museum of
Anthropology and Ethnology,
Harvard University, Cambridge,
MA.

Racial uncertainties

What were Agassiz's photographs meant to show, as an ensemble? The stated aim was to represent the pure racial types found in the tropics, and the hybrid-types that crosses between the pure types had produced. But Brazil astonished Agassiz by the complexities of its racial map, which threw his pre-existing perceptual and conceptual schema into confusion (a confusion still experienced by visitors from the US today). Instead of the rigid white/non-white dichotomy used to classify race in the US, the Brazilian system had many in-between categories (reflected in an extensive vocabulary of terms such as *pardos*, *cafuzos*, *mestiços* and *morenos*) which encompassed a huge range of physical appearances, social positions, economic roles and other variables.[58] Such racially mixed individuals in the US were dealt with by means of a perceptual and legal denial; since mixed individuals undid the logic of clear-cut racial divisions, they were all seen and classified as black, 'in effect', says Winston Jordan, 'denying that intermixture had occurred at all'.[59]

But to someone from the United States, the defining feature of Brazil was precisely the *lack* of clear racial definition – the lack of a simple descent rule and clear colour line. This does not mean, as Brazilians often claim, that therefore their country is one of racial equality; nevertheless, compared to the United States, the system of racial and social stratification in Brazil was (and is) much more subtle. Deciding who was what was not easy for outsiders, especially if they did not speak Portuguese or the 'general language' ('lingua geral', the lingua franca then in use, based on a mix of Portuguese and Tupi). Relying on visual clues of physical appearance was simply not enough. The Agassizes' book, and James's diary, are full of examples of the mistakes they made in their pursuit of 'pure' Indians and other racial types, and especially in interpreting the social positions or racial ancestries of mixed-race individuals. Agassiz, James thought, was especially prone to making racial judgements that others found wide of the mark. In photographic terms, he was at a loss, because in Brazil he lacked a secure, non-photographic grid or classificatory (or signifying) system against which, or within which, to check or place his pictures, with the result, that they seemed to float outside the framework of racial meaning. Unadorned by verbal or other markers external to the images themselves, the photographs could not confirm the racial 'types', when the classificatory grid of race was itself unknown. Thus both the visual representations, and the signifying system that could give them meaning, were inadequate. This,

incidentally, is a nice historical example of how culture-bound our systems of racial classification are.

In this respect, Agassiz's tropical photographs foreground especially clearly an issue that historians of photography have begun to explore recently, namely that the optical realism expected of the photograph was from the beginning undermined by photographic representation itself. Historians are finding that although scientists expected the photograph to record reality with a degree of accuracy impossible in any other representational form, the results were often disconcerting. In anthropology, far from being obvious in the unadorned photographic image, the type turned out to be elusive. The formal or inherent properties of the photographic image were not enough, by themselves, to make the image readable as a type, because early photographic technique, as Chris Amirault says, did not provide a way to limit the flood of surface detail of an object, to select and discipline visual phenomena and contingencies.[60] Instead of selecting the visual evidence of the body so that it could be pared down to a recognizable type, the camera produced a plethora of visual detail without selection, and therefore a multiplicity of plausible meanings.[61] In short, photographs gave scientists a surplus of visual information which disrupted the visual convention of the type; it was this excess of detail, or rather the lack of *useable, scientific detail,* that made the early anthropological photograph a more complicated representation than scientists themselves expected.

To make the photographic image readable as a type, then, it had to be joined to verbal or diagrammatic markers which tacitly called into question its presumed superiority as a direct transcript of reality and the epistemological claims associated with it. Agassiz's early anthropological photographs are interesting in this regard, because the narrative or signifying system of race he was familiar with, and by and through which he perceived the visible world, was already so highly articulated in a pre-existing, non-photographic, visual (and verbal) language.[62] Racial diagrams, as we have seen, articulated the idea of difference by highlighting precisely those features that represented 'difference'. To make a photograph suitably scientific, to create a recognizably 'anthropological' representation out of it, it had to be made to engage with, and integrate into, this pre-existing, non-photographic system of racial meaning. It had thereby to acquire some of the characteristics of the diagram – that is, non-photographic elements which pared, selected and marked the image and made of it something other than a mechanically produced mimesis of reality, carrying its own empirical meanings unconnected to human manipulations or larger systems of communication.

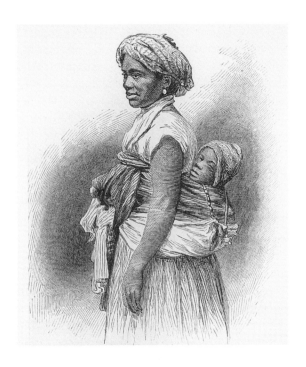

32 'Mina Negress and Child' (Negress and Child from Minas Gerais), from Agassiz and Agassiz, *A Journey in Brazil*.

And so we find that, between the mid-1860s and the 1880s, thus right in the period when Agassiz was making his photographs, scientists were trying out all manner of manipulations to pull the individual photographic image into the general and to secure its adequacy as a scientific representation of the type – to make the race type an observable reality. One technique was to introduce some kind of measuring device as a backdrop; such a grid was first proposed by John Lamprey in 1868–9. This signalled a body that was to be viewed as a quantifiable object and comparable to other bodies. Photographing the subject in a sequence of staged poses (usually full frontal, rear and profile views, as Agassiz had done) also indicated that the image was to be approached not as an individual portrait but as a scientific document. Alternatively, all sorts of cultural props were introduced, such as palm- or banyan trees, hoola-hoops, musical instruments such as drums, or 'savage' weapons like spears, whose function was to inform the viewer of the place or culture into which the image had to be fitted.[63] Of course, the easiest non-photographic element to add was a caption, which supplied the 'correct' racial identification and reduced interpretative uncertainties (as in an engraving of race based on a photograph from Agassiz's account) (illus. 32).

Such representational techniques were developed to make the photographic image more diagrammatic, to enfold it in a disciplinary

grid of meaning.[64] Of course, such techniques of props, posing and cropping were also used in portrait photography more generally to indicate the sitter's profession and class (for instance, a professor would be photographed with a book in his hand). But the stakes were much higher in science, since its authority depended on its claims to superior empirical veracity, as did the status of the photograph itself. Such manipulations of an image originally thought of as a slice of reality, *in order to make 'real' the real*, exposed the fact that the photograph itself, and the racial theory for whose purposes it was being used, were both artefacts of a specific culture.

The ability of the photograph to turn an individual into a racial type – an object, a specimen – is often taken by historians as an example of the disciplinary power of Western photography; the type photograph is therefore taken to be a crucial image in the development of anthropology. Yet as the historian of photography Christopher Pinney, remarks there is another history to be told here – not the Foucauldian one of the image's power but one of the viewer's inability to interpret the photographic image if the signifying practice or narrative to which it is connected is unknown.[65]

Types and in-betweens: picturing tropical hybrids

All of these problems surrounding the photographic racial image were compounded in Agassiz's tropical pictures because of his obsession with racial mixture. Why did this seem such an urgent issue to him? Historically, anxiety about social and/or physical mingling between peoples, or *metissage*, tends to come to the foreground politically when rapid social changes threaten to destabilize established social and political boundaries.[66]

In Europe, the settlement of overseas colonies such as Algeria (acquired by France in 1830) led politicians to think about whether and how the French and other Europeans would become used to the alien climate of North Africa, and whether amalgamation between Berbers and Europeans would help or damage the biological process of adaptation. Another place where the mixing of different 'kinds' of humans was discussed, whether as a positive process of amalgamation or as a negative one resulting in degeneration of native or European stock (or both), was in New Zealand (faith in positive amalgamation did not long survive the realities of colonial competition for land and fierce Maori resistance). The movement to abolish slavery in the United States was another such moment; it raised the question already asked in relation to the post-emancipation West Indies: What

would relations between ex-slaves and whites be once the political conditions of freedom had come to pass?

Hybridism was of great concern to Agassiz because he was sure, as were so many scientists at the time, that its results were extremely negative. In 1863, he was asked by the Freedman's Bureau in Washington, DC for his opinion on the matter; in a letter, he said that such amalgamation was morally repugnant, analogizing interracial unions to a kind of 'incest'.[67] But the more that scientists insisted that the different human races were analogous to mutually antipathetic species, the more racial mixture became problematic. For it was difficult to deny that, in this respect, humans did not behave like separate species of animals. Scientists nonetheless tried to defend the hypothesis of hybrid degeneracy by claiming that 'half-breeds', 'half-castes' and 'mulattos' were unnatural, and, like the mule, infertile. Or, if they were fertile, they were not as fertile as they seemed at first and/or were marked by signs of degeneracy.

In Brazil, as compared to the United States, for complicated historical reasons having to do with the conditions of conquest and settlement, Europeans had in fact mixed freely with the indigenous Amerindians and slaves brought from Africa. Faced with this reality, Agassiz argued strenuously that the effects were altogether bad. 'Let anyone who doubts the evil of this mixture of races ... come to Brazil,' he wrote. 'He cannot deny the deterioration consequent upon an amalgamation of races, more widespread here than any other country in the world, and which is rapidly effacing the best qualities of the white man, the negro, and the Indian ...'[68] To Mrs Agassiz, the population appeared 'enfeebled' by mixture.[69] Looking to the future needs of the Amazon, her husband hoped for a larger population but also a better population; since those who 'passed for white' were Portuguese (rather than, say, English or American), they had a negative tendency to become 'Indianized' in their habits.[70]

Yet while acknowledging the fact of mixing, Agassiz wanted at the same time to prove that the differences between the primordial races were deep and could not easily be obliterated. He therefore struggled to reduce the apparent visual chaos to some kind of scientific order, by imposing on it his classificatory grid of species and hybrids. The fact that the offspring of two different races was not exactly like either but intermediate between both, he believed 'was of the utmost importance in estimating the value and meaning of differences between the human races', because this was what was found in crosses between different animal species. For Agassiz, whether one called the different human races 'species' or not was not as important as the recognition

of the constancy in race and interracial forms. 'In these various forms of humanity,' he argued, 'there is as much system as in anything else in nature, and by overlooking the thoughtful combination expressed in them we place ourselves at once outside the focus from which the whole may be correctly seen.'[71]

'Correctly seen', then, instead of a continuous spectrum of blending, an apparently endless proliferation of mixed individuals, of every conceivable visible appearance and often differentiated from each other by very small differences, Agassiz maintained that the situation was one of constant self-limitation. There were, that is, only a restricted number of hybrids possible, each one situated biologically at the precise halfway point between two distinct, pure, parental race-types. These hybrid or in-between types were, Agassiz thought, biologically unviable on their own, because they were not truly fertile among themselves in the long term, and could only be kept going by back-crosses with the pure parental types. Hybrids were, if you like, the terminus points of the tropical experiment in the transgression of the biological order, caused by sexuality across racial lines.

Selecting only three as Brazil's 'pure' foundational races – 'the Indian', 'the European' and 'the African' (a huge over-simplification, of course) – Agassiz associated each of them with a limited number of in-between races, which he posited as constant 'hybrid-types'. Thus an Indian crossed with a European produced one type, called the *mammeluco* [*sic*], which he characterized as ' pallid, feeble, lazy and rather obstinate'; an African crossed with a European produced the half-breed mulatto, which though handsome was indolent; and an African crossed with an Indian, yet another, the *cafuzo* type, which had the 'jolly disposition of the Negro and the energetic, enduring powers of the Indian'. Continued crosses between these crosses, in an endless departure from the original types, Agassiz insisted, were hindered biologically, because each hybrid mingled much more readily with a pure parental type than with other hybrid mixes. There was therefore in nature a constant pull away from chaotic mixture to the original parental or 'pure forms' of race.[72]

These 'in-between types' were grounded, theoretically, in the supposed stability of the 'pure' parental types themselves. The scientist's ability to identity the limited number of hybrid types and assertion of the impossibility of the endless melting of types into each other in a continuous regression away from 'purity' were both dependent on the theory of the fixity of the original pure races. At the same time, they were proofs of that same theory, in a wonderfully circular and wish-fulfilling argument.

I interpret this fantastical racial schema as a kind of dream of 'purity', a verbal and intellectual rejection of imperceptible grada-tions, a way of limiting the number of 'in-betweens' to a few diminishing and self-limiting forms, in order to impose an intellectual order on a world of flux that Agassiz found deeply threatening. The fact that he was struggling to counter the flux and flow of the evolu-tionary model at the same time that he was studying racial variations in Brazil is, I think, suggestive of the deeper unconscious need he had to reduce the physical world to a stable and manageable order.

We can see now why Brazil both drew Agassiz and confounded him. Three of the world's supposedly 'pure' races were found there. But not only was he confused about who was 'pure' and who was not; the 'in-betweens' seemed to have crossed with 'in-betweens', who had crossed with yet other 'in-betweens', producing a bewildering picture that could not be reduced to three hybrid types or in any way match his extraordinary racial schema. 'It was as if,' Mrs Agassiz said in their book, 'all clearness of type had been blurred.'[73] This is what Agassiz's photographs showed. Bridging the gap between his verbal account of hybridization and his visual evidence by a reduction of the images to anything approaching the three-type schema he suggested (itself based on a strict descent-rule) was virtually impossible. Paradoxically, by removing people's clothing, Agassiz removed some of the few signs he might have used to secure the subjects' supposed racial identities, at least according to the Brazilian system of identity, which sorted people by social as well as biological criteria. By remov-ing the outward signs of social differentiation, even this system of racial identification was removed.

One last point about Agassiz's unpublished photographs needs comment: their gender. What are we to make of the fact that almost two-thirds of the photographs he took were of women? One possible answer is straightforward: the greater availability of female subjects. Brazil was at war with Paraguay throughout the period of Agassiz's expedition, which led to the forcible conscription of many of the young men in the Amazon (something Agassiz and his wife witnessed for themselves). However, Agassiz did find several men to photo-graph, so this explanation seems unconvincing (and is not something he himself remarked on). I put aside here another possible reason for the emphasis on naked women, namely the potential for sexual voyeurism that the tropical female has historically offered the Euro-pean male. A sexual scandal of sorts was connected to Agassiz when he first arrived in Boston (a highly puritanical town), and there was a hint of scandal during the voyage which may have referred to the

photographing episode (and may have led one member of the party to leave the expedition early). A lack of evidence prevents me from confirming this supposition, however.

I believe that the reason for the emphasis on women lies elsewhere. As Stephen Jay Gould has remarked, Agassiz had argued himself into a corner. For if hybridization in human populations was so unnatural, why did it nonetheless occur?[74] His answer was: Because of the excessive sexuality of black women. According to Agassiz, the close and early contact between black female slaves and white boys was responsible for the early awakening of male sensuality; the seduction of the white male by the black female led to the breaking down of the natural barriers to racial mingling, and to the racial chaos he saw before him.[75]

Woman was by convention the reproductive sex, and thus was considered the key to the biological reproduction of the race and the nation. She was critical, that is, to the maintenance of the boundaries between races, by engaging or not engaging in sexual activity; equally, she was critical to transgressions of these boundaries through her ungoverned sexuality. Since the tropics were perceived as a place where the constraints of civilization were loosened, and the heat of the climate created an unbridled sensuality, 'tropical woman' was the sign of sexual excess and of the fatal disorganization that so threatened Agassiz's sense of racial order. This was, of course, to reverse the reality of the power relations of race – to blame slave women for the reality of their sexual bondage to white men. But in focusing on women, Agassiz positioned the black female body as the sign of tropical degeneration, in an implicit contrast with the clothed white body of the man and woman of his own temperate world.

William James pictures the tropics

The bold, disturbing and equivocal photographic images which Agassiz brought back from Brazil hardly confirmed his theoretical speculations about hybrids, nor perhaps could they easily be accommodated to American standards of public viewing, photographic nakedness conveying the 'real' in a way non-photographic images did not. Probably for both reasons, they remained private documents. To illustrate the 'realities' of race in the tropics in his book, Agassiz therefore turned to wood engravings, which, as we have noted, lent themselves to the more diagrammatic form of representation necessary to his racial science. Four wood engravings, based on photographs Agassiz purchased in Brazil, were used to represent 'pure' Africans and Indian types; these schematic type portraits rely

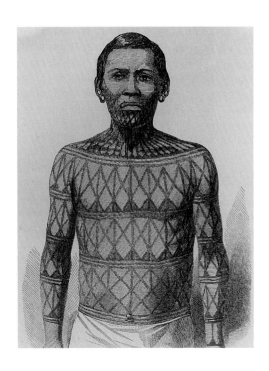

on dress, tribal and other bodily markings, and poses to indicate the races they represent. They also rely on captions. In effect, they work as photo-diagrams, allowing Agassiz to use the reality effects of the photographs (for the message they convey that 'this phenomenon really exists') along with the diagrammatic lines of the wood engravings to delineate the features of race by highlighting certain details at the expense of others. Thus an individual portrait is turned into a type, and in doing so sense is made of the image in terms of the narrative of race (illus. 33).[76]

Only one of the five racial images used in the book was of a racial hybrid. This was an engraving based not on a photograph but on a drawing made by William James according to Agassiz's specifications. James had a talent for drawing, and his diary and letters from the Brazilian expedition are liberally embellished with sketches, doodles and caricatures. The drawing of the hybrid shows the young girl called Alexandrina who served as Mrs Agassiz's maid in Manaus, and whose agility in scaling trees to collect fruit (Mrs Agassiz described her as 'nimble as a monkey') and skill in drying and preparing specimens for Agassiz fascinated them both.[77] Alexandrina reluctantly agreed to be pictured (this reluctance seems evident in the harsh facial expression), and it was as a physical specimen of the hybrid that she was portrayed. A line diagram of racial peculiarity, James's picture

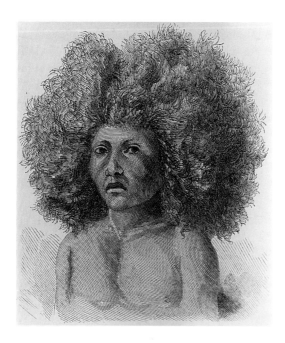

34 'Head of Alexandrina',
engraving after a drawing
by William James, 1865,
from Agassiz and Agassiz,
A Journey in Brazil.

was made in order to emphasize the sitter's mixed Indian–African character, especially her frizzy hair, which stood out when combed. Agassiz believed that this was the chief visible sign of her mixed ancestry, and James demonstrated it by means of a deliberately exaggerated halo of frizziness around her head (illus. 34).

This drawing may be contrasted with several other pictures James made for himself in Brazil, some of which are subtle portraits of people he met. It has to be said that James in the tropics presents a somewhat incongruous picture. With a few exceptions, his trip of fifteen months, the first of many departures from America that he would make in the next decade or more of his life, has been little commented on by historians.[78] Yet it can be seen as a journey of self-discovery, an immersion in a strange place, attractive and repellent at the same time, which helped move him a step along the path of negation, telling him at least what he was *not* called to do in life, if not exactly clarifying what was to be his life's work. Reading Humboldt on the boat from New York to Rio, he discovered how glad he was to find that others were available to do the work of collecting and describing nature:

On the steamer I began to read Humboldt's Travels. Hardly had I opened the book when I seemed to become illuminated. 'Good Heavens! When such men are provided to do the work of traveling, exploring, & observing for humanity, men who gravitate into their work as the air does into our lungs,

what need, what *business* have we outsiders to pant after them and toilsomely [*sic*] try to serve as their substitutes? There are men to do all the work which the world requires without the talent of anyone being strained.[79]

Once in Brazil, James found that he was not immune to the charms of tropical scenery; describing Rio de Janeiro (which he called the 'Original Seat of Garden of Eden'), he remarked that

[T]he brilliancy of the sky and the clouds, the effect of the atmosphere ... make you admire the old Gal nature. I almost thought my enjoyment of nature had entirely departed, but here she strikes such massive and stunning blows as to overwhelm the coarsest apprehension.[80]

A short while later, however, James became seriously ill from an acute eye infection (probably varioloid, a mild kind of smallpox less severe than the regular and often fatal kind), which sent him to the isolation hospital for nearly three weeks and left his face temporarily scarred. For a time, he even feared he might go blind. Lonely, isolated, relatively uncared-for while ill (the Agassizes were away from the city, collecting), the romance of the tropics faded, and he announced to his parents that he had decided to abandon the expedition before it even left the capital.[81]

He changed his mind, and, as he recovered his health and spirits and tried to settle down to the hard grind of collecting, in his letters home and in his occasional diary (where he practised his Portuguese, doodled and tried his hand at a couple of essays that just might be publishable), he began to express a more balanced appreciation of what the tropics did and did not mean to him. On the whole, James kept an ironic distance from tropical nature; missing home intensely, he constantly compared the sights in front of him to remembered scenes of New England, and only sometimes allowed himself the pleasure of an immersion in tropical otherness. In a letter he wrote from Europe much later, thanking Mrs Agassiz for a copy of *A Journey in Brazil* (which he found dull reading), James praised her for not overdoing the romantic side of the tropics, though said he wished she had laid even more stress on their inherent sadness. Perhaps, he wrote, the dark glasses that he had worn throughout his time on the Amazon (to protect his eyes following his infection) had something to do with his dark and ironical view of tropical nature.[82] The photograph of James with dark glasses in Brazil, in a self-consciously enigmatic pose, might serve as a metaphor for his unromantic view of Agassiz's entire tropical adventure (illus. 35).

Yet if James's perception of the tropics was unromantic, it was not unromantic in Agassiz's style. Though some of James's sketches verge on the stereotypical, the most fully realized drawings suggest a

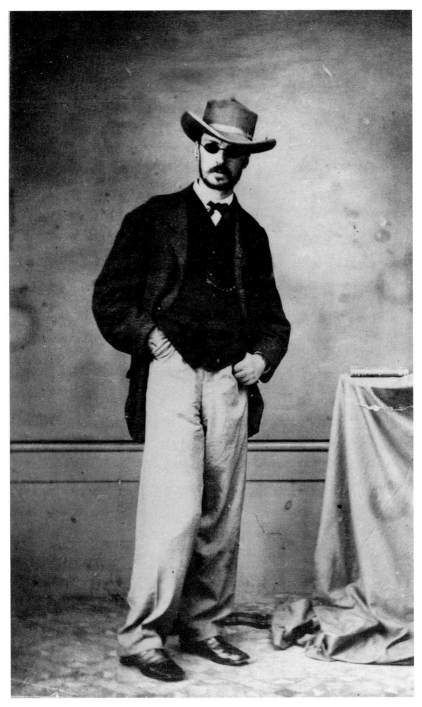

35 Photograph of William James in Brazil, 1865. Houghton Library, Harvard University, Cambridge, MA (shelfmark pfMS Am 1092).

sympathetic and alert response to individuals. In an uncompleted diary fragment, describing a collecting expedition on which he had been sent by Agassiz along one of the tributaries of the Amazon, and which he made 'alone' (that is, in the company of a black guide and some Amerindians), he presents a narrative that moves from scepticism about the merits of the natives to a growing appreciation of their individual worth and dignity. His black guide, especially, whom he at first finds 'stiff and queer', comes to impress him:

> I now feel perfectly domesticated in this place and with these people. Old Urbano especially, by his native refinement, intelligence and a sort of cleanliness and purity is fit to be the friend of any man who ever lived, however elevated his birth and gifts. There is not a bit of our damned anglo saxon [sic] brutality and vulgarity either in masters or servants. I am always reminded when the neighbors come to visit Urbano of our family and the Tweedy family at Newport. Urbano and his gossips talk with just as much beauty and harmony and perhaps a good deal more than Tweedy and Father did, in an easy slow monotone as if all eternity were before them.[83]

'Is it race or is it circumstance,' he asked himself, 'that makes these people so refined and well bred?'[84]

James's Brazilian drawings, many of them no doubt of 'hybrids', showing individuals at work and leisure, are contemplative and attractive, as, for example, in this portrait of a boy examining something in his hand (illus. 36). His drawing of two men seated, shown from behind, is particularly striking, in that it represents people of apparently contrasting racial identities without resorting to stereotypes, depicting instead two individuals at apparent ease with each other and unconcerned with the illustrator (illus. 37). These drawings already seem to contain within them the interest in individual psychology and the self, and the appreciation of contingency as opposed to absolutes, that would become hallmarks of James's later contributions to psychology and philosophy.

Agassiz's racial representations, of course, pointed in the opposite direction, towards stereotypes and group identities. Within a decade or less of his death, the type photograph had become a standard feature of books of anthropology – recognizable as such by its reliance on props, poses, cropping and captions, which positioned human beings within the framework of the primitive and the exotic. Many of these photographs, aesthetically embellished to make them into acceptable 'nudes' (instead of the more crudely naked images of Agassiz's photographic albums), escaped from the disciplinary confines of anthropology, to be consumed as erotic fantasies of tropical sexual availability. The photograph, as an analogue of reality, was

36 William James, drawing of a boy holding something in his hand, 1865/6. Houghton Library, Harvard University, Cambridge, MA (shelfmark fMS Am 1092.2).

37 William James, drawing of two men seated, 1865/6. Houghton Library, Harvard University, Cambridge, MA (shelfmark fMS Am 1092.2).

a very powerful cultural representation in an era of scientific racism; it was easy to forget that the anthropological outlook itself was a specific world-view, shaped by time and place and in turn shaping representations, and that many scientists recognized that the photograph by itself was an unreliable document of the world. Eventually, if very late, human variation came to be viewed in less typological terms. And just as scientific goals shifted away from race and physical anthropology to culture and cultural anthropology, so did the cultural representations in anthropology change. The type photograph itself became a relic of the past which we find upsetting to view today.

4 Racial Transformations

This chapter opens with some enigmatic photographic portraits which at first glance appear far removed from the stark pictures made for Louis Agassiz. We see a man standing, hat and umbrella in hand, dressed in a rather formal white shirt and flyaway collar, and also wearing some kind of medal. Who is this? We are not told. The caption reads only 'December of 1911' (illus. 38). Another picture, untitled, shows a family – mother, father and daughter (illus. 39)? These and similar images, from a large photographic archive in Brazil assembled in the first decades of the twentieth century, are used as the key visual documents in this second chapter on the representation of tropical peoples, my first view *of* the tropics from *within* the tropics.[1]

Brazil may seem an unlikely source of high-quality scientific photographs until we remember, first, the rapidity with which the new visual technology was taken up there, and second, the importance of science and positive knowledge to the Brazilian élite at the turn of the twentieth century. Daguerreotypes were in fact produced in Brazil within a few weeks of the announcement of the new medium in 1839. The Emperor of Brazil, Dom Pedro II, made photography fashionable; well educated and passionately interested in the natural sciences, as we have seen, he soon acquired his own equipment, commissioned daguerreotypes of his family and encouraged photography both as an art form and for documentary purposes. By the turn of the century, numerous commercial establishments had been set up in the major cities, producing pictures for tourists, state agencies, the police and private individuals. Some of this photography was much more than routine and conventional; Marc Ferrez, whose work spans the period between 1865 and the First World War, may be little known outside Brazil or beyond specialist circles, but his images match in aesthetic and technical skill those by the best European and American photographers of his day.[2]

Brazilian scientists took a special interest in photography and for the same reason as Agassiz; they believed, that is, that 'to collect

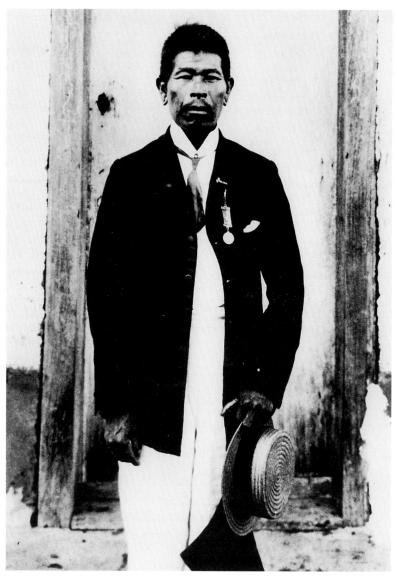

38 João Stamato, 'December of 1911', photograph. Casa de Oswaldo Cruz.

photographs is to collect the world'.³ The emphasis in science on the importance of accurate observation, on the distinction between the knower and the known, and on the way in which knowledge could be obtained by inventorying and ordering objects of the natural world within classificatory schemas, all made photography seem not merely an ally of science but an enactment of it. This belief in the photograph's documentary power fitted in well with the positivist outlook

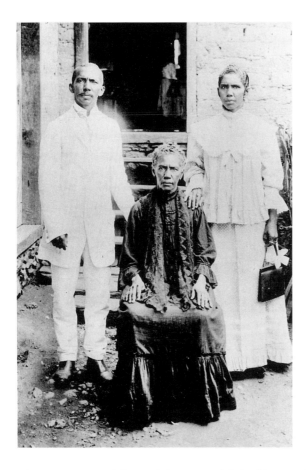

39 João Stamato,
untitled photograph,
1912. Casa de
Oswaldo Cruz.

of the New Republic, which was established in Brazil in 1889 with the fall of the monarchy and the system of slavery on which Brazilian society had been based hitherto. Photographs were used especially to chart the country's 'Order and Progress' (the new Republic's motto) in the form of pictures of engineering works, new roads and railways, urban improvements and sanitary campaigns.

The images shown here were part of this documentary effort. Made by a professional film maker from Rio de Janeiro called João Stamato, they are only two of a collection of portraits created during a scientific investigation into conditions in the Brazilian interior in 1911. Yet they do not appear to be scientific in any obvious sense of the term. Their interest lies precisely in their not being obviously 'legible' within the scientific framework to which they nonetheless ostensibly belong. In this respect, they raise all sorts of questions about photographic interpretation in relation to historical context. Why, for instance, on a scientific and medical expedition, were so

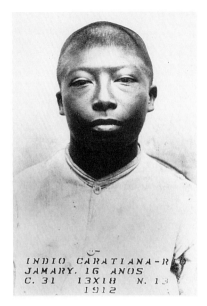
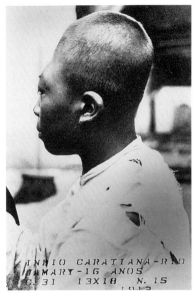

INDIO CARATIANA-R
JAMARY. 16 ANOS
C. 31 13X18 N. 1
 1912

INDIO CARATIANA-R
JAMARY-16 ANOS
C. 31 13X18 N. 15
 1912

40, 41 'Indian: Caratiana, Rio Jamary, 16 years old', 1912. Casa de Oswaldo Cruz.

many pictures taken of apparently healthy people? How and why were these people represented? Does the absence of identifying names indicate that these are anthropological pictures, offering the viewer an inventory of ethnic and racial types? Does the very fact that a photograph of a person is taken by an expert for scientific purposes inevitably objectify that person, as Susan Sontag maintains?[4] Or could there be a degree of self-representation involved?

Other photographs taken by Brazilians in this period certainly rely on the distancing and decontextualizing techniques used to transform a subject into an anthropological object in late nineteenth- and early twentieth-century science. Compare Stamato's portraits, for instance, with two carefully posed photos from the Amazon, depicting the head of a young man, portrayed frontally and in profile, printed against a white background, abstracted from any natural or social setting (illus. 40, 41). Though not as crude as Agassiz's racial pictures, the format, and the caption, which simply reads 'Indian: Caratiana, Rio Jamary, 16 years old, 1912', makes these images purely ethnological and typological.[5]

The portraits by Stamato do not seem to fit into this objectifying, anthropological mould. Indeed, they do not seem ostensibly to be about race. It is nevertheless my argument that it is to race that we must turn if we are to make sense of them in a historical context. They can indeed be seen to be part of a visual and verbal story of race

123

in the tropics, recounting a tale of racial transformation that served as a kind of reverse or mirror-image of the European thesis of racial degeneration. How would so-called 'tropical' people try to represent themselves in an era of scientific and political racism?[6] What, if any, strategies of transformation were available? How were they used? Race and environment were, as we have seen, *the* signifiers in late nineteenth- and early twentieth-century thought, and I believe it is to race, and to the connections between race, the tropical environment and national identity, that we must turn if we are to begin to make sense of the elegantly attired individual who looks gravely out at us from the past. As we have seen, photographic meaning derives not from the subject matter depicted *per se* but from the larger web of meanings and practices within which images are implicitly or explicitly embedded.[7] In this chapter, I explore some variations on the themes of race and hybridization in the tropics to which I suggest Stamato's representations are implicitly connected.

Myths of origin in the tropics

Brazil is a particularly good place in which to explore the meaning of tropical peoples, precisely because historically, to European eyes, it has been seen as exemplary in its 'tropicality'. Dr Afrânio Peixoto, a Brazilian physician and prolific novelist (whose role in tropical medicine is examined in Chapter 6), commented that 'the theme of racial and national doubt constitutes a leitmotif' in Brazilian representations throughout the country's history.[8] From the transfer of the Portuguese Crown in 1808, and especially after 1840, when national consolidation began under Dom Pedro II, two frameworks dominated interpretations of the 'imagined nation': the tropical environment and race mixture.[9]

Race was especially significant because of the increasing emphasis given it as an explanatory concept in European political and scientific discourse as the nineteenth century wore on, and because of the huge scale of the slave trade in Brazil. Nine to twelve times more Africans were brought there as slaves than to the United States; by the time of independence from Portugal in 1822, Brazil had twice as many slaves in its population as North America.[10] Of particular interest, as we saw in Chapter 3, was the fact that Brazil also had an enormous population of mixed racial descent (outnumbering resident Europeans) and, before abolition, also had many more legally free individuals than did the contemporary United States.[11] Following abolition in 1888, the country remained fundamentally black and mixed. According to the

national census of 1890, 65 per cent of the population was estimated to be black or various shades of brown; by North American definitions of race, this figure was assumed to be a great underestimation. Thus Brazil in no way approximated the white norm considered essential in Europe to civilized development.

Pejorative views from abroad about Brazil's ethnic make-up were hard for the Brazilian élite to ignore. In a world of efficient packet ships (by the 1870s, steamships were taking 28 days to reach Brazil from the major European ports), book imports and rapid travel, the small class of educated Brazilians were part of a trans-Atlantic circuit of ideas. In the books they read and in political discourse, they knew that their country was held up as a prime example of the degenerations that supposedly occurred in a racially mixed, tropical nation. The British social determinist Henry Thomas Buckle, the social evolutionist Herbert Spencer, the French anthropologists Paul Broca, Armand de Quatrefages and Paul Topinard, the American polygenists Samuel Morton, Josiah Nott and George Gliddon, as well as any number of other racial theorists from Gobineau to Lapouge, hammered home the thesis of negro inferiority, mulatto degeneration and tropical decay. And these were not merely theoretical statements made from afar. Louis Agassiz, as we have seen, lectured the Emperor and the public on the dangers of racial crossing.[12] So did J.-A. de Gobineau, the European apostle of the theory of hybrid decay, who served as French Minister in Brazil in 1869–70, and hated it. He spent his short time in the tropics complaining bitterly at having been sent to such an out-of-the-way, hot, humid and backward place, and finding every reason to confirm the prejudices about the evils of racial mixing that he had expressed in his famous (or infamous) *Essay on the Inequality of Races* (1853–4).[13]

Views like Gobineau's caused the Brazilian élite profound anxiety. Wanting to be thought of as a tropical branch of European stock, they feared that they in fact were not. They despised their own black population and avoided the representation of their cultural and biological blackness while nonetheless using race as an ever-salient point of reference and term of social analysis. Early on in the country's history as an independent nation, as an Empire in the tropics, the foundation myth of Brazil's unique national character was established in racial terms; the country's most important history, the intelligentsia said, was one of the mixture of race, the fusion of the world's three major geographical races – the Indian, the European and the African – which conquest, colonization and slavery had brought together in an unprecedented way in the New World. This 'three-race merger'

theory received a quasi-official seal of approval in the 1840s, when the Brazilian Institute of History and Geography sponsored a competition entitled 'How Should the History of Brazil be Written?' The winning entry, by German naturalist Karl Friedrich P. von Martius, who had spent 1817–21 studying natural history, ethnology and linguistics in the country along with the botanist Johann Baptist von Spix, argued that a truly Brazilian national history should be written not in terms of politics, but in terms of the mingling of the three distinct races that made up its population. This was essentially the racial narrative that Agassiz was to put forward twenty years later, but with a critical difference – von Martius's picture was closer to one of positive amalgamation than of 'miscegenation'. Drawing a direct analogy with the English nation, whose energy and strength von Martius attributed to its mixture of Celtic, Norman, Anglo-Saxon and Danish stocks, the German author predicted that the mixture of races far more divergent than those in Europe would result in the creation of a new and unusual nation in the tropics.[14]

If this now seems a very reductive, and reductively racial, theory of history, we have to remember that von Martius's approach did not differ from the racial approach to national-history writing favoured in Europe at the time. What was more unusual was his view of race amalgamation in Brazil as analogous to Europe's own ethnic mix, and his opinion that each race (including the African slave population) had contributed something positive to the country's cultural formation and had to be taken into consideration in evaluating its destiny. His attractiveness to Brazilians as a national theorist was that he told the élite that their country possessed the necessary elements to be a part of the universal history of civilization, and that its racial composition was not necessarily a check to a positive future. This was a quite different scenario from that sketched by Agassiz, who managed to assert the contradictory thesis that racial mixture would both self-terminate in infertility, because fundamentally unnatural, *and* somehow produce an ever-extending and terrifying chaos of humanity.[15]

Not until the abolition of slavery was finally accepted as inevitable in Brazil did the intellectual élite begin to elaborate upon von Martius's view of the *mestiço* as the most profound narrative of the country's history, and give it new scientific and representational rationales. As long as slavery existed to separate the 'not free' from the free, intellectuals and scientists (several themselves of mixed-race origin) preferred to concentrate on the more manageable 'Indian' element. This 'race' seemed less threatening to the national image than the black and brown mixtures, since the majority of

Amerindians had already been marginalized politically, socially and geographically by mid-century through decimation by disease, through acculturation and absorption into the Brazilian nation or by being pushed farther and farther away from European settlements into the rapidly disappearing forests. They formed the colonial Others of the Brazilian élite, available to be made over in the political imagination into objects of scientific curiosity rather than being, as free blacks and mixed-race members of the population more clearly were, at least potentially, proper subjects of the polity.

In the middle decades of the century, a degree of romanticism even attached to the Amerindians (much as the American Indians could be represented romantically in the US, once they had been effectively exterminated or corralled onto reservations). Some Brazilian nationalists even promoted the 'general language' (a creolized or standard version of Tupi) as the national language instead of Portuguese (the Emperor, for instance, spoke this general language fluently). Visually, the Indian was represented as a noble if often tragic figure. For instance, in the first National Exhibition, held in 1860 under the patronage of the Emperor (in modest imitation of the Great Exhibition in London of 1851), whose goal was to promote an image of his country as a manufacturing nation and not just a tropical place of nature and raw products, one of the very few images of the Brazilian population to appear in the catalogue (which mainly pictured rather elementary or crude machinery, such as steam engines) was a highly idealized image of Indians. Shown living at one with the bounteous jungle, they were almost like Europeans without clothing, even down to the romance of the bourgeois family (illus. 42). This representation was not very different in style from late eighteenth-century European images of Pacific Islanders.[16]

But as Brazilian intellectuals and politicians began to take up and respond to the European sciences of race, romance tended to be replaced by the more negative judgements and hard facts of 'nature'. By the time the first Anthropological Exhibition was held in Brazil at the National Museum in Rio in 1882, again in the Emperor's presence, Indians had become something to be put on public display; witness the sad sight of a group of Botocudos Indians, whose distinctive lip- and earplugs (and reputed cannibalism) made them striking objects of representation (illustration 43 shows the Botocudos displayed in a 'race table' by the German painter Rugendas in which he employs the format of the racial sciences, with the heads shown frontally and in profile). On the basis of the comparison of the cranial capacity of a few ancient Indian skulls with a few modern ones, Dr

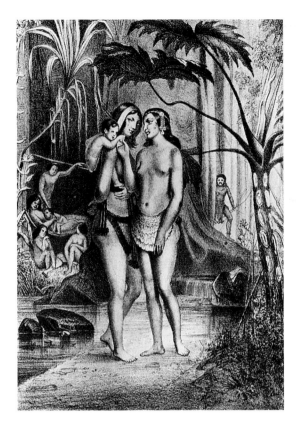

42 Barandier, 'Indigenas' (Indians), engraving of oil painting shown at the 1860 First National Brazilian Exhibition, from *Recordações da Exhibição Nacional de 1860* (Rio de Janeiro, n.d.).

João Batista de Lacerda, the head of anthropology at the National Museum who had trained himself in the most up-to-date methods of French craniometry, announced that in the course of centuries the Indian had not advanced a single degree in mental ability or position on the scale of evolution. The inability of the Botocudos to adapt or assimilate to civilization derived from their primitive brains and doomed them to extinction as a pure race within 50 years.[17] A journalist reporting on the exhibition got the message: 'What's going on here?' he exclaimed. 'It's these cannibals who are in fear of being devoured by public curiosity!'[18]

Racial silences

But if Brazil's Indian element could increasingly be relegated to the margins of Brazilian nationality by scientific analysis, the representation of the black and *mestiço* population remained a more sensitive issue. The *mestiço* was the doctor, the lawyer, even, on occasion, a member of the nobility (these facts astonished visitors like Agassiz, of

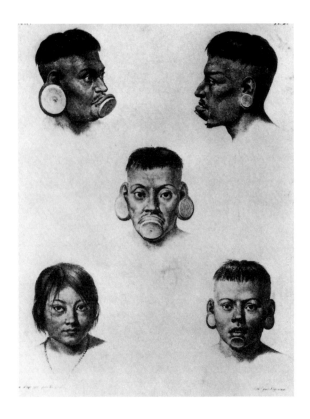

course). On the issue of this 'blackness within' the country, the élites preferred to maintain a certain visual silence. Racial cartoons and caricatures of slaves and poor blacks were all very well for Brazilians to enjoy (and were in fact commonly used in the popular press), but foreigners' representations of the country's racial make-up was another matter, and a highly troubling one at that. No feature of Brazilian society was commented on more frequently, or more negatively, than slavery; no slave city in the American South before abolition had as many foreigners criticizing it on this account as did Rio de Janeiro. In turn, Brazilians were quick to take umbrage at any European traveller who depicted them in an unflattering light or overemphasized their blackness. They disliked especially insistent representations of the barbarities of the slave market and the cruelties of slave punishments, such as those made by the French painter Jean-Baptiste Debret (illus. 44).

Representing the character of the Brazilian population abroad in the international exhibitions that became ubiquitous in the second half of the nineteenth century was especially tricky. One suggestive example is the case of the Brazilian photographer José Christiano de

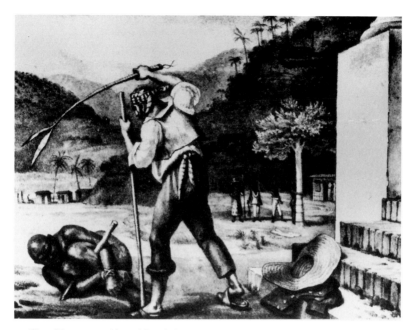

44 'Slave Manager punishes a Negro', from Jean-Baptiste Debret, *Voyage pittoresque et historique au Brésil* (Paris, 1836–9).

Freitas Henriques Jr. Christiano Jr was unusual in Brazil in taking pictures of slaves (these images, made largely for the foreign market, form one of the largest collections of its kind in the country). On the whole, his portraits are deliberately 'benign', in the sense that they do not draw attention to the horrors of slave status, but show slaves in their various costumes and with reference to their various ethnic origins (some being white), and on the whole sympathetically. In 1866, Christiano Jr took part in a photographic competition to represent Brazil at the huge Universal Exhibition in Paris to be held the following year. In a much-disputed decision, the judges decided not to award a gold medal; the bronze medal Christiano Jr received was not sufficient to win him a showing in Paris, and one can only speculate whether officialdom preferred not to represent Brazil abroad in such a public way as the slave society it was.[19]

Portraits of the Braganças, the Brazilian royal family, whose members were entirely of European descent and white, were obviously much more useful in conveying a public image of European culture in the tropics than were slaves. Dom Pedro II could even afford to signal a tropical identity for his empire, for example by using palm-trees as backdrops in his portraits, and Indian names for the many noble titles he conferred on worthy members of the élite.[20] But

once the symbol of European-ness was removed, with the termination of the monarchy in 1889, new ways had to be found to represent the country as a civilization in the tropics. If anything, the requirements for a European identity became more stringent, especially given the ambiguities of racial identity once slavery no longer separated free people from slaves. European fashions in reading, music, architecture, gardens and foods were taken up in middle-class circles as well as among the élite, including even the adoption of the European black suit and top hat, so unsuitable in the tropical heat. In the political symbols of the new Republic, too, as José Murilo de Carvalho has shown in a fascinating study of political iconography, the country's blackness was almost completely erased.[21]

Even the category 'race' was removed from the national census after 1890. Since no census was held in 1900 or 1930, and race was not counted in the censuses of 1910 and 1920, this meant that it was not counted as a factor in the Brazilian population for 40 years. This should not be taken as a sign of racial tolerance or indifference to racial identities, but as its opposite – an intense concern not to have to represent in official statistics the population's colour or racial composition in case too black a result would frighten away the European immigrants who were now actively being sought to replace slave labour and increase the country's whiteness.

The wilderness within

This was the very period in which a new narrative of national identity was elaborated that allowed Brazilians to reposition the blackness within their country. Thomas E. Skidmore points out that it was much too late for the élite to reverse the long-standing practice of large-scale intermixture between races; no legislation was introduced to draw a sharp line of colour between groups, as in the United States. This led the élite to opt for an assimilationist policy, 'an ideology to rationalize a de facto multiracial society', even if it faced severe challenges from European scientific racists along the way.[22] In the circumstances, the absence of hard data on race provided a political and cultural space in which phantasmatic ideas about national identity could be projected into political and scientific discourse. With the formation of the New Republic, the Brazilian government was determined to shake off the country's reputation as a place of tropical insalubrity and racial degeneration and reposition itself as a new civilization in the tropics – progressive, scientific, technological. Brazil entered a period of new optimism, based on the expectation that a

rapid expansion of the export economy based on coffee and rubber (between 1900 and 1910, Brazil exported 50 per cent of the world's rubber production) would launch the country as a world power, commensurate with its huge potential in tropical resources and great geographic size.

Between 1884 and 1903, 1.7 million Europeans entered Brazil as immigrants (the majority of them from Italy), a larger number than entered the US in the same period. Most settled in the south, in the states of Rio de Janeiro and São Paulo, visibly increasing the European 'look' of those areas. With the help of British bank loans, the government began a massive public-works programme to rebuild Rio de Janeiro. The port was modernized, old houses knocked down, new boulevards in the grand French style pushed through old neighbourhoods, and a National Library, School of Fine Arts and Opera House erected. The first systematic public-health campaigns in the federal capital were also organized at this time against yellow fever, the plague and smallpox, in a concerted effort to overcome Brazil's reputation as a place of intense tropical disease.

In this period, too, educated Brazilians began to reorder their relationship towards the wilderness within their country. Their attention turned from the cities to the vast hinterlands, which to the majority of the population, settled on the coast, were still virtually unknown spaces, open to fanciful speculation and disdain. In a series of geographical, anthropological, technological and medical expeditions, Brazilians opened up their backlands to their own scientific scrutiny and new development projects. Already in 1902, Euclides da Cunha, in his masterly book *Rebellion in the Backlands*, riveted the reading public with his account of the land and mixed-race people in the drought-stricken north-east. In 1905, da Cunha went to the Amazon to witness the boom in rubber and the region's hoped-for transformation. Two years later, the Brazilian geographer and explorer General Rondon began the first of his many military-engineering expeditions into the Amazon, in order to join the region telegraphically to the rest of Brazil, to mark out the country's frontiers and to entice unassimilated Amerindians into the Brazilian nation. Between 1900 and the 1920s, numerous medical teams were sent into rural areas to survey and classify the diseases found there. The period was therefore one of social change and movement of populations, but also of expectations that the hinterlands would finally be developed and the population drawn into a national unity.

If few of these expectations were met, the exploration of the wilderness was not without political and ideological effects. Especially

important were the photographs brought back from the expeditions, which served to widen knowledge among the urban population of the appalling conditions in which people lived and worked. These images survey places and people, subsuming them within the wider framework of environment and race. The viewer's eye is not passive here; many of the photographs can be interpreted as overtures to social intervention – pictures of dilapidated mud houses, puddles of water in unpaved streets and chickens scratching the earth, or of people in the north-east grinding cane sugar with equipment no more advanced than that which had been used by the Dutch in their seventeenth-century tropical colony there. These images can be said to fit the genre of documentary photography popular in Europe and the US at the time. The same might be said of the many pictures of police barracks – they represent the forces of order necessary for the country's development.

But these pictures are more than just documentary tools in the service of an exposé of the poverty of the people, the backwardness of their technology and the violence that was endemic in rural areas. At the time, there was a desire on the part of many educated Brazilians to depict their country in terms that avoided both the exaggerated fantasies of a country of tropical luxuriance and wealth and the negative stereotypes of tropical degeneration and inevitable backwardness – a desire to represent Brazil as a country on the march to modernity. Often, what is being represented is not so much the landscape *per se* as the landscape as an impediment or invitation to progress. The juxtaposition of a photograph of the Quixádá hydroelectric dam (the first of its kind in the north-east) and an artful picture of three huge clay water-storage jars makes exactly this point; it directs visual attention to the future resolution of the crisis brought on by drought through developmental and engineering projects (illus. 45, 46).

Photographs are, of course, open to many interpretations. Thus, although many of the images taken on expeditions into the interior seem to suggest a social exposé, other readings tell tales of rural strength and adaptation to a hostile environment. Indeed, both readings are possible, even of the same image. The portrait of an old backlands cowboy, for example, sitting on his horse in a bare landscape devoid of human habitation, dressed in characteristic leather clothes designed to protect the body from prickly shrubs, can be interpreted both as a sign of the loneliness and poverty of life in the interior and as a sign of the hardiness, vigour and courage of the mixed-race, rural population (illus. 47). So, too, the picture of a schoolteacher and nine boys, many of them without shoes and almost without books, can be

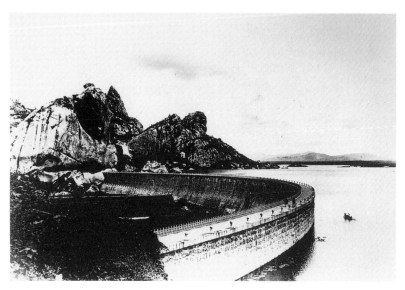

45 Quixáda dam, Ceará, Brazil, *c.* 1912. Casa de Oswaldo Cruz.

46 Three clay water-storage jars, *c.* 1912. Casa de Oswaldo Cruz.

read as signalling the poverty of the hinterland as well as the determination to achieve literacy. And how shall we understand the images of churches in rural areas, many of them in a state of apparent disrepair, others undergoing apparent renovation – as a sign of the decay of religious belief and the absence of Catholic authority in the countryside, or as a sign of the presence of institutions of spiritual help?

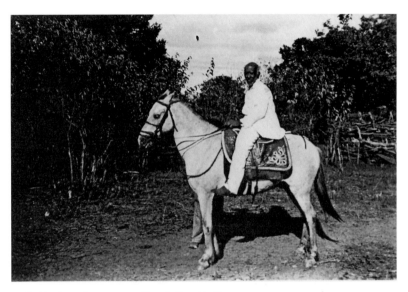

47 Backlands cowboy, 1912–13. Casa de Oswaldo Cruz.

National identities and racial transformations

These difficulties of interpretation are highlighted by the series of remarkable photographic portraits with which I opened this chapter. Here we have a number of quasi-formal studies of fine-looking, elegantly dressed people, posed alone or in groups in their houses or places of work. One portrait shows a young woman in elegant dress and hat, handbag and handkerchief in hand (illus. 48). A particularly engaging picture shows the members of the Recreation Club in the town of Porto Nacional, the main city in the state of Goiás, arranged in rows outside one of the few newspaper offices to be found in all of north-central Brazil, dressed in black suits and cravats, some wearing honorary sashes and medals (illus. 49). Two Club members are also portrayed by themselves, dressed in their best and presenting them-selves, perhaps, as young blades (illus. 50). Several other portraits appear to represent local dignitaries and officials and their family members, servants and retainers. Some are perhaps of 'colonels', the term used for the local bosses who ruled informally but powerfully over rural areas where the state barely existed as an institutional structure.

What might these photographs tell us about the racial composi-tion, or racial ideology, of Brazil? How have the images been constructed by the photographer? Chief among the narratives being constructed by the Brazilian élite at the time, and one that by the 1930s would become enshrined as the quasi-official ideology of the

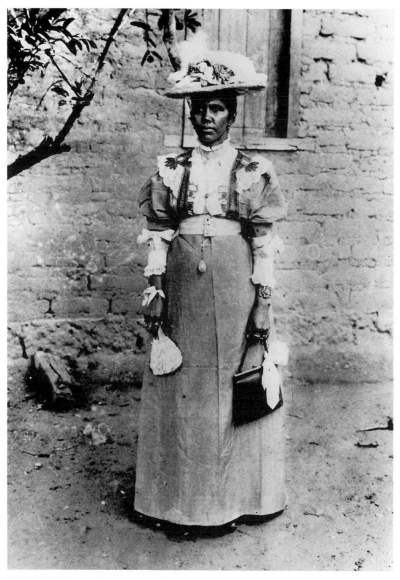

48 Untitled photograph, *c.* 1912–13. Casa de Oswaldo Cruz.

modern state, was the thesis that Brazil was undergoing a process of racial transformation and regeneration by the very process of mixing so denigrated by European politicians and scientists. Against a background of anxiety that the country had failed to achieve a homogeneous national type, and that the nation was menaced by racial degeneration, people began to think of Brazil's racial mixture in positive rather than negative terms.

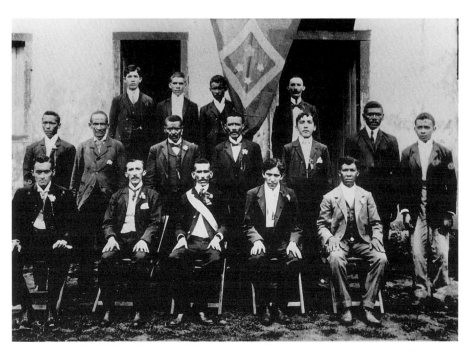

49 Members of the Clube Recreativo, Porto Nacional, Goiás, Brazil, December 1911.
Casa de Oswaldo Cruz.

The political and intellectual élites convinced themselves that in
their tropical country, race and race relations were different in kind
and quality from those in the United States, the country to which,
because of their joint histories of slavery and their large geographic
extent, Brazilians most compared themselves. How different, and
why, are subjects of controversy to this day; but the absence of legal-
ized segregation based on race, and especially the large size of the free
black and mixed-race population in the era of slavery, led Brazilians
to maintain that their racial tradition was based on the warm, cordial
and sensual man, at ease with himself and with others and not given
to racial intolerance. From this cordiality had supposedly come the
easy social association and biological fusion of races, a kind of 'racial
democracy' unknown in the US, whose effects had been not degener-
ation of nationality but its regeneration through the steady, unilinear
absorption by the 'higher' European races of the 'lower' black ones.
Through ethnic fusion, blackness was turned into whiteness.[23]

Viewed retrospectively, such a theory seems fantastical. On the face
of it, as George Reid Andrews has commented, it certainly seems
paradoxical that the country that was the *last* in the West to abolish
slavery should be the *first* to declare itself a racial democracy.[24] The

137

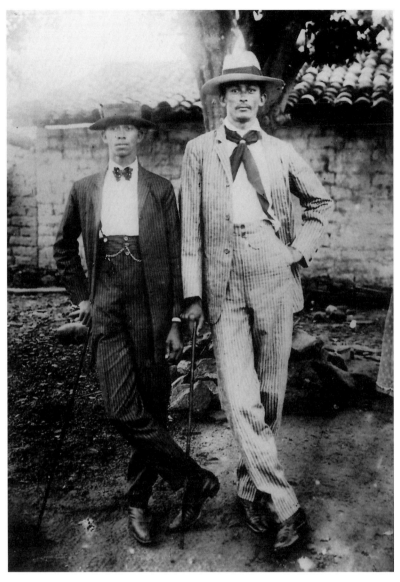

50 Untitled photograph, 1912. Casa de Oswaldo Cruz.

illusory nature of this racial democracy is increasingly apparent to Brazilians today and is rightly mocked by historians and sociologists. By the 1960s, especially, when the black-power movement and the historic Brown decision in the United States making segregation in education unconstitutional had led to a new emphasis on the political rights of racial minorities, Brazil's claims were attacked as a self-serving ideology of white élites, an ideology which successfully masked

138

the realities of discrimination and inequality. It was itself a myth – and a racist one at that, predicated as it was on the assumption that whiteness was best.[25]

But if it conceals as much as it reveals, the enduring appeal of the thesis of racial democracy to Brazilians themselves needs explaining. The narrative of national improvement via hybridization, or *mestiçagem*, needs to be placed in its historical and visual context. As Sander L. Gilman has recently remarked, one of the promises of the Enlightenment is that we can remake ourselves, whether through the reform of our political institutions, our education or our morality. In the nineteenth and twentieth centuries, this dream of transformation was applied to the body as well as the mind. Thus, transformation could also mean the manipulation of the body to meet norms and ideals of racial perfection. Gilman, for instance, has brilliantly situated the history of aesthetic surgery (the Jewish nose job, or the surgical Westernization of the Asian eyelid) within this context of racial 'normalization' by which individuals aim to match their bodies to a particular standard of racial beauty – fair-skinned, regular-featured, gentile – presented as a universal norm.[26]

Gilman's racial interpretation of aesthetic surgery is especially suggestive when applied to Brazil, because the country today is one of the world's leaders in plastic surgery; there, carving up the body to meet idealized norms of youth, sexual beauty and racial ideals (breast reductions, nose jobs) is common. Is it not likely that the prominence of this surgical speciality, in a country where many of the most basic public-health needs are still barely met, is connected to the extraordinary importance that historically has been attached to the aesthetics of the racial body? Is this not also the case with the earlier Brazilian myth of racial transformation by whitening? Are not both to be understood in relation to the persistent theme of racism in Western thought?

One way for the Brazilian educated class to rescue itself from the fate of inevitable tropical and racial decay was to turn to science in order to recast racial intertwining as a process of constructive amalgamation that would produce a new, ideal body type. Such an idea had long been part of racial thought. In eighteenth-century Spanish America, for instance, the idea of moving up or down on a racial scale of body type and social worth by means of racial intermarriage was well established.[27] In the US in 1815, Thomas Jefferson drew up a 'descent chart' to show how, by the third cross with whites, a mulatto 'clears the blood' and returns to a white identity.[28] To most Europeans, of course, the Indian–Negro–European crosses that were

so common in tropical Brazil did not at all meet the standards of 'closely allied races' believed necessary for positive results.[29] But closeness was in the eye of the beholder; it was not based on well-established biological tests of the degree of departure from objectively agreed-upon norms but on subjective, aesthetic, political judgements that were represented as natural. If, then, Latin American scientists turned to the notion of constructive mixing, it was because it served their political and representational needs in an era of extreme negative racial stereotyping.[30]

By the late 1880s, the potential of the crossbreed, or *mestiço* (especially the beautiful 'mulata', the warm, brown, sexual woman praised in verse and song), to provide a solution to Brazil's national destiny was being articulated in terms of the theory of biological evolution by one of the leading intellectual figures of the New Republic, the literary historian Sílvio Romero. Romero, founder of the Brazilian Academy of Letters, a well-known teacher, avid collector of Brazilian folk tales and folk poetry, author of the first general history of national (i.e. Brazilian) literature, ferocious social critic and supporter of the idea of democracy, provided a new scientific gloss on the already-established thesis of national mingling as the clue to Brazil's future identity as a European culture in the tropics. Like many in his generation, Romero knew his British, German and French social and biological theory well; with it, he absorbed the basic tenets of scientific racism. Nonetheless, applying European theories of superior and inferior races wholesale to Brazil was difficult, given the huge size of the non-white population and the ambiguities of racial identity there. An alternative casting of science and race in the tropics was therefore called for. On the basis of extensive reading, Romero rejected Henry Thomas Buckle's environmental approach to national history as too deterministic, and von Martius's as too purely ethnographic. Plumping instead for a bio-social and evolutionary interpretation of national history along the lines of Herbert Spencer, Romero maintained that Brazil would not just be a prolongation of Iberian culture in America but something new, indeed unique, because based on the cumulative biological, psychological and cultural effects of centuries of racial mixing. Mixture and assimilation thus became the keys to Brazil's future identity.[31]

This, Romero believed, was Brazil's innovative means of biological and psychological transformation, a process which, through a linear absorption of the 'lower' black and mixed races into the dominant, superior Iberian stock, would naturally produce a new kind of 'whiteness' over a period of several centuries. Meanwhile, all Brazilians had

to recognize that they were, at the very least, psychologically and culturally mixed, a *mestiçagem* that accounted for the country's unique national traditions. We might say that, in effect, Romero took Agassiz's extremely negative story and produced (almost out of thin air, or wishful thinking) a unidirectional, slightly optimistic national story of racial transformation into civilization.[32]

It was this strange piece of racial futurology that came into its own in the first three decades of the twentieth century, eventually becoming a quasi-official doctrine. People began to think of the country's racial mixture in optimistic terms. This process of improvement through racial mixing, it was argued, was aided by continued white immigration.

In 1911, the very year in which Stamato produced his portraits of people in the backlands, Dr João Batistia Lacerda, Director of the National Museum of Brazil, provided new scientific 'proof' of the whitening thesis. This was the same Lacerda who, more than 25 years earlier, had participated in the first public anthropological discussions of Brazilian nationality. In the intervening years, Lacerda had turned from physical anthropology to bacteriology, searching for the supposed 'germs' of yellow fever and beriberi.[33] This shift is indicative, I think, of the more general shift among Brazilian scientists and intellectuals away from race and towards more universal explanations of Brazil's backwardness and tropical decay as the new Republic got underway. The real causes of Brazil's woes were not, it was now claimed, primarily racial or ethnological, but social, educational and medical, a product of infection and a woeful lack of sanitation and education.

The whitening thesis

In 1911, Lacerda's attention was redirected to issues of race when he was sent, as the official representative of the Brazilian government, to the Universal Races Congress in London. The ostensible aim of this Congress was to explore the possibility of harmonious relations between the races; its lofty idealism notwithstanding, it was frankly colonialist and racialist, with the West, and the white race, being held up as touchstones of progress and political mentors to the rest of the world. The British anthropologist Alfred C. Haddon even organized a photographic 'gallery' of racial types for the conference, an exhibition Lacerda found somewhat strange. At the conference, all the major races and race problems in the world were represented and spoken for, often by individuals taken to be representatives of their

race. Thus Israel Zangwill spoke on the future of the Jewish race, arguing strongly for a Jewish homeland in the Middle East. The African-American sociologist W. E. B. Dubois spoke for the so-called 'talented tenth' of the black race from the United States. This light-skinned, Harvard-educated delegate greatly impressed Lacerda by his intelligence and passionate condemnation of segregation in the US; Dubois might well, indeed, have served as the perfect example of Lacerda's own thesis of the potential of the *métis*, or mixed race, to whiten over time and thereby contribute positively to the intellectual development of a nation.[34]

Lacerda was at the conference to represent Brazil in Britain, which played a major financial and commercial role in Brazil's economy, and on a topic that the Brazilian government considered highly sensitive and important to its future ability to attract European immigrants. Lacerda spoke, therefore, very much as a public servant in a very public arena. In a prepared paper, he presented a radical and speeded-up version of the whitening thesis, arguing that, without resort to force or legal compulsion, and in the space not of several hundred years but of a mere one hundred, Brazil would transform itself into a white, European-style nation in the tropics. Using the racial terms commonplace in science at the time, he argued that although the *mestiço* was physically inferior to the negro, and intellectually inferior to the white, the best endowed was intelligent and ready to participate fully in the life of the nation.[35]

To the French version of his pamphlet, which he presented to the Paris Society of Anthropology before going on to London, Lacerda attached a reproduction of a well-known painting. Entitled *The Redemption of Ham*, this work by the Spanish-born Brazilian painter Modesto Brocos y Gomes is a dramatic representation of the Brazilian fantasy of racial regeneration in the tropics through whitening (illus. 51). Dominated by the triangle made by the three females (the signs of reproduction), the picture shows a black grandmother giving thanks to God, while her mulatta daughter, holding her white child in her lap, points to her black origins and the miracle of the transformation of blackness into whiteness in three generations through crossing (the white father looks on benignly from the side). This visual narration thus states what Lacerda was arguing verbally. Making his point absolutely plain, he attached a caption to the picture: 'The Negro passing into white, in the third generation, by the effect of the crossing of the races'.[36]

Back in Brazil, Lacerda's thesis was promptly attacked in the press, not for being wrong but for unpatriotically portraying Brazil abroad

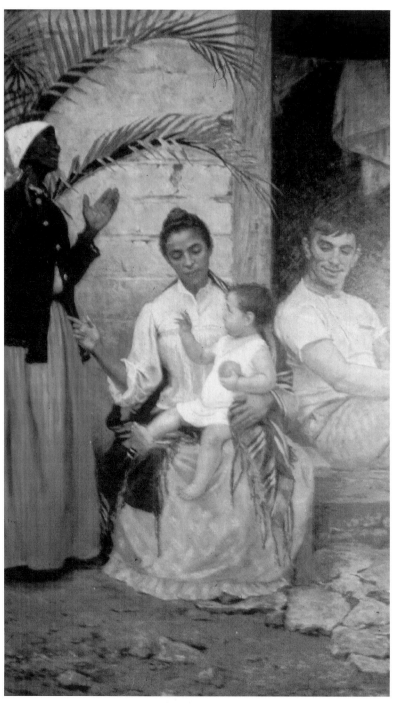

51 Modesto Brocos y Gomes, *A Redenção de Cãn* (The Redemption of Ham), 1895, oil on canvas. Museu Nacional de Belas Artes, Rio de Janeiro, Brazil.

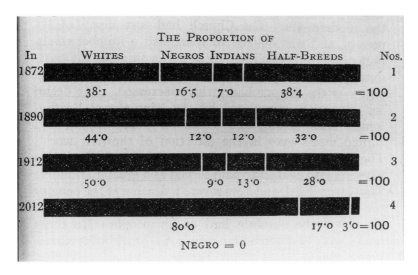

THE PROPORTION OF					
In	WHITES	NEGROS INDIANS	HALF-BREEDS		Nos.
1872					1
	38·1	16·5 7·0	38·4	=100	
1890					2
	44·0	12·0 12·0	32·0	=100	
1912					3
	50·0	9·0 13·0	28·0	=100	
2012					4
	80·0		17·0 3·0	=100	
		NEGRO = 0			

52 Table of Whitening ('The proportion of Whites Negros Indians Half-Breeds'), from guidebook entitled *Brazil in 1913* (London, 1913).

as too black, and for taking too long to whiten the country! Lacerda, defending himself vigorously in print, added an ingenious scientific table to his argument. On the basis of statistical data drawn from the censuses before 1890 and projected forward into the future, he was able to prove the complete disappearance of the black element in the country by the year 2012 (illus. 52).

This national narrative clearly rested on the wishful thinking of an élite in an age dominated by racism, a yearning for unity in a society divided by class and race, a reassurance that 'aryanization', a word popularized in Brazil in the 1920s, could be a reality in the tropics. It was also a formulation of the race problem by an élite confident that its own dominance and control over a black country was secure. Brazil was in the 1910s and '20s an extremely hierarchical country, with a very limited franchise. The large white immigration to the southern, least black parts of the country in the last decade of the nineteenth and first two decades of the twentieth centuries played a role in indicating that Brazil would whiten over time, as did the extraordinarily high mortality rates among the black poor. The intelligentsia's faith in the power of whiteness to dominate blackness was reinforced by the continued use of informal mechanisms of social control over black mobility, as well as more institutionalized forms of repression such as the use of the police to maintain social and racial order.[37]

Even many Afro-Brazilians, who knew racial discrimination at first hand, accepted the thesis that the best way to advance their own social

and political standing was not to emphasize their race but to absorb middle-class, white cultural and ethnic norms (e.g. by marrying 'up' with white partners). It is much remarked that even today, the ambiguities of race and racial classification in Brazil, ambiguities that so bothered Agassiz, prevent the formation of the black solidarity considered critical to the political process of overcoming discrimination in the less ambiguous, and harsher, racial organization of society in the US. Even now, the gap between the national mythology of racial democracy and reality is not widely acknowledged. Brazil, after all, has not whitened along the lines of Lacerda's projection (in the 1980 census, for instance, just under half the population called itself black or mixed, making Brazil the second-largest black country in the world after Nigeria). Nor has racial discrimination gone away (the introduction of the first federal law against such discrimination, in 1951, refuted the idea that the country was without racial prejudice). Nevertheless, even today most individuals refuse to use the colour classification employed by the official census office, especially the harsher terms for blackness, preferring the more general and neutral category of *moreno*, thus positioning themselves racially somewhere in the middle, whatever their outward physical appearance may be. As the Brazilian sociologist Simon Schwartzman says in a recent essay, '... the demarcation lines among different ethnic or racial groups are blurred, and it is relatively easy to "pass" from one ethnic category to another.'[38] In short, the belief remains among Brazilians that in their multiracial country something unique has been made.

In the 1930s, in a series of books that are considered classics of Brazilian social and historical reinterpretation, the sociologist Gilberto Freyre pushed the thesis of racial mingling much further than Lacerda, while at the same time de-emphasizing the overall importance of race in social history. Freyre constructed for Brazil a truly innovative history, one of 'racial democracy' before political democracy – a 'new world in the tropics' as he called it (this being the title of one of his best-known books).[39] Critical elements in this history included the notion of historically low levels of racial prejudice on the part of the Portuguese colonists; widespread racial mixture between Europeans and slaves; and the creation of a highly mixed, tolerant society which Freyre described as 'one of the most harmonious unions of culture with nature and of one culture with another that the lands of this hemisphere have ever known'.[40] On the basis of this supposedly unique and harmonious union, Freyre championed the concept of tropicalism, proposing that it become the basis of a special science called 'tropicology', which would study the

environment to which the population had adapted through racial mixture, a science which would embrace both the universalism and the singularity of Brazilian civilization in the tropics. [41]

Many writers, artists and scientists, responding to the same intellectual, social and aesthetic currents as Freyre, also turned away from racial pessimism, taking up instead the causes of social reform, sanitation and education. Like Freyre, too, they discovered a new authenticity in Brazilian culture and its roots in popular traditions – in Afro-Brazilian religion, Amerindian and Afro-Brazilian folklore, and popular poetry. Samba, the music of poor Afro-Brazilians, became the music of the nation, symbolizing the racial and cultural mixture that Brazilians believe defines their special civilization in the tropics.[42]

Artists also followed the scientists into the hinterlands, to find the authentic wellsprings of their distinctive tropical nationality for themselves. The leading writer of the modernist movement in the 1920s, Mário de Andrade (himself a light-skinned mulatto), made his own 'Journey of Discovery of Brazil' in 1924, camera in hand; he followed this with a second trip in 1927, during which, describing himself as 'An Apprentice Tourist', he travelled through the Amazon and west all the way to Iquítos in Peru, and on to the frontiers of Bolivia. Like the scientists who travelled into the interior, Mário de Andrade was not looking for, nor did he find, a tropical paradise, but neither did he find Agassiz's disagreeable portraits of racial degeneration. He found poverty and disease, but also the bedrock of Brazil's real nationality in the ordinary people he encountered. *Macunaíma*, the title of his 1928 masterpiece , and the name of its fictional hero, is a Brazilian Everyman, a black man who could transform himself into a white, a person who belonged to the Amazon and to the city, a universal hero of modern times.[43]

Emblematic of this new orientation was another literary figure, Jeca Tatu (literally 'backwoods hog', a term used for an armadillo and hence slang for a country hick), who appeared in the work of the popular writer of essays, novels and children's books Monteiro Lobato. Jeca Tatu was introduced to readers as an ignorant, poor and dirty character whose incompetence was due to his racially mixed origins. By 1918, however, Monteiro Lobato, inspired by developments in bacteriology and sanitation, had changed his mind. In a book called *The Vital Problem*, published in 1918, he revised his essay on the degenerate condition of his fictional hero to declare that 'Jeca Tatu is made, not born.' His poverty and backwardness, Lobato now said, were products not of race mixture but of bad food, lack of

education and the absence of public sanitation.[44] With progress, he would be transformed into a hard-working, healthy and wealthy citizen (illus. 53, 54).

Portraits of a possible nation?

I return, finally, to Stamato's pictures, to position them in relation to the ideology of race regeneration in a country stereotyped as second-rate because of its racial mixture and tropical environment. In the context of the ideology of whitening, we might say that the well-appointed, elegantly turned-out people captured on photographic plates by Stamato represent, as it were, the other side of the racially degenerate tropical nation; they stand for the reformed Jeca Tatu, for what afflicted, ill, poverty-stricken, ignorant people could also become once social conditions redeemed them. In effect, we have here

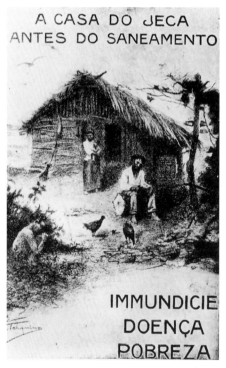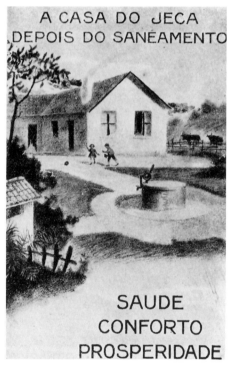

53 The transformation of Jeca Tatu ('The Home of Jeca before sanitation – dirt, disease, poverty'), from Belisário Penna, *Amerellão e maleita: Hygiene para o povo* (Hookworm and Malaria: Hygiene for the People) (São Paulo, 1924). Casa de Oswaldo Cruz.

54 The transformation of Jeca Tatu ('The Home of Jeca after sanitation – health, comfort, prosperity'), from Penna, *Amerellão e maleita*. Casa de Oswaldo Cruz.

a portrait of a 'possible nation', a nation, that is, of potential Brazilian citizens who, though of every conceivable ethnic or racial mix, are nonetheless self-regarding and capable. These individual and group portraits defuse anxiety about tropical degeneration caused by racial intermingling by representing the population not as strange and Other but as potentially like the 'best' inhabitants of urban Brazil. These portraits, then, both partake of the ethnic inventory and subvert its political and racial meanings.

It could be argued, of course, that Stamato's portraits are meant as ironic commentaries on the pretensions of backlands people to civilization when they lived in houses without water and towns without sewers; that in their fine clothes they only parodied, but did not successfully embody, the modern Brazilian. Or they could be interpreted neither as representative types of a nation nor as ironic commentaries, but as pictures of people who are not known to us by name, but who had their own individuality and dignity and who, we feel, wished the viewer to know this. Like many old black-and-white still photographs, Stamato's pictures attract us by their irreducible indecipherability. The faces in these photographs look out at us from the past, silently, mysteriously and poignantly. They compel our attention because, as Alan Trachtenberg suggests, they evoke for us the mystery of their individuality, their 'pastness' and their death, and remind us of our own inevitable passage into history.[45]

5 The New Tropical Pathology

My theme in the next two chapters is the role of disease in the emergence of the *tristes tropiques*, to use Claude Lévi-Strauss's famous expression. The translators of his book have commented on the fame of the its title, Lévi-Strauss's desire to retain it in French in the English edition and the difficulty the translators had in attempting to render it adequately in English. 'The Sad Tropics', 'The Sadness of the Tropics' or 'The Tragic Tropics', they have said, do not quite correspond in meaning to the original, nor do they capture the alliteration or the irony of the French title, the suggestion implied of 'Alas for the Tropics!'.[1]

The diseased tropics would certainly seem to qualify as a place about which to cry 'Alas', especially those areas colonized by Europeans in the nineteenth and twentieth centuries. Lévi-Strauss, whose book grew out of an extended stay in Brazil in the 1930s, was studying the remnants of indigenous Amerindians whose once large populations had been drastically reduced by disease, one of the most tragic consequences of European incursions, incursions that, though to a far lesser extent, paid back the Europeans in kind, by introducing them in turn to many new and often frightening illnesses.[2]

Visually, too, the representations of people with tropical diseases are sad and disturbing – people with horrific skin eruptions or malignant tumours caused by exotic parasites (illus. 55). Some diseases, like the terrifying haemorrhagic Ebola virus, seem like something only a horror-film director could have invented. Such images stand at the opposite end of the spectrum of tropical representations from the beautiful landscapes so admired by Humboldt. Coming to terms with such representations means coming to terms with some of the most negative images of the tropics that we have.

Yet coming to terms is exactly what historians of medicine have not done. Until very recently, medical images in general have in fact been almost completely ignored as historical and cultural resources, even though, as we know from looking at any medical textbook, images

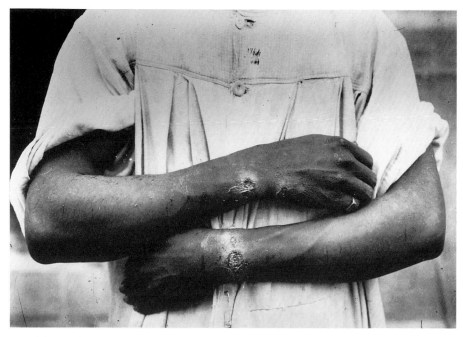

55 'Leishmaniasis, Manaus, 1912'. Casa de Oswaldo Cruz.

(anatomical diagrams, clinical pictures) have been essential to the very practice of medicine in the Western tradition and to the construction of its medical objects. To a large extent, in fact, without its images, the diseased body itself, as an object of medical understanding, would not exist for physicians as a cognitive entity. Nonetheless, with very few exceptions, medical historians have not examined such images critically and historically, looking to see how they change over time, as the conceptual frameworks of the body also change.[3] Even in some very recent illustrated histories of medicine, the pictures tend to be treated as mere illustrations, supplements to what is written, rather than as cultural constructs requiring examination in their own right. The authors do not evaluate them in compositional terms or ask how they constitute the objects they presume to represent, rather than merely translating them from the verbal to pictorial in self-evident fashion.[4] The condensation of visual information necessary to making an image 'medical', the selection and abstraction involved in making images work as pictures of illness – the fact that they depend on *conventions* to represent the material reality of the human body in different fashions in different historical periods – are topics rarely addressed.

This neglect pertains especially to clinical portraits of disease. Such images are intended to make as visible as possible the signs of

150

pathology in a human being, as an aid to medical diagnosis. The trouble with such pictures, and probably one of the reasons for their neglect, is that they are not designed to give visual pleasure, and are therefore different from pictures of aesthetically pleasing tropical landscapes, which are meant to infuse exotic locales with a sense of adventure, or from the quasi-anthropological or painterly portraits of tropical people, which often serve to satisfy the Western erotic imagination. In comparison to these, the picture of a person with a disease is not attractive to us, at least in any straightforward sense of the word. I emphasize here, then, the sheer *difficulty* of viewing that attaches to disease portraits, and ask how this affects the visual construction of diseases we call tropical.

One person who has shed light on this troubling aspect of images of disease is the historian of medicine Sander L. Gilman. In a series of broad-ranging and innovative studies, using a psychoanalytic perspective, he has turned our attention towards the hidden messages, the deep anxieties, but also the fascination we experience in viewing such representations. He has probed the unconscious connections we make between disease and other perceptual and interpretative frameworks that structure the way we organize our visual understanding of the world. Disease, and its opposite, health, are linked, for example, to other binary oppositions between the beautiful and the ugly, the young and the old, and the civilized and the uncivilized.[5] Visually, the diseased body is a kind of catalogue of horrors, an almost unbearable sight and site of pathology, which lies outside our normal visual experience and which pulls us towards it even as it repels.[6] The fact that the diseased body is often displayed naked – until recently another taboo outside the realm of high art – further complicates our response.

Photographic images of disease are particularly problematic, largely because of the aura of the 'real' that attaches to them. Of course, as we have seen, photographs are partial and highly contingent images of the world, which do not just record diseases in straightforward empirical fashion, but which construct them by giving them definition within a particular medical and historical context.[7] From the beginning of photography, physicians found photographs to be a troubling as well as a very useful addition to the available technologies of representation. They worried, for instance, that medical photographs of women, often shown without their clothes, could introduce a new element of sexual voyeurism to medicine, precisely because of the strong fact/reality message the photographic image carried.[8]

Eventually, doctors developed a number of visual conventions in clinical photographic pictures, conventions whose purpose was to

make the images serve therapeutic and not simply voyeuristic ends. Close focus on the diseased parts of the body, the use of special medical poses (bringing a diseased part into view, for example) or the positioning of the body against a white background devoid of normal social content like furniture, as well as the convention of blacking out the individual's eyes (so that the person did not seem to look back at the viewer) were all means by which a portrait of human suffering could be transformed into an image of a medical 'case'.[9] The objectification, classification and fragmentation of the image of the human body that is part of the medical photograph is critical to how medical photography works as a visual genre but also an objectionable feature in an image, especially when viewed outside strictly professional circles. Representations of diseased people, then, are complicated images to the modern Western eye. Looking at them, we try to see the sick person as unlike ourselves while nonetheless suffering from the problem of projection and identification, which creates the anxiety that we too could be ill, like the person pictured.

Historically, such anxiety has often been countered visually by pictures detailing the march of medical progress and conquest over disease – doctors in their white coats, in their hospitals and laboratories, with their arsenal of therapeutics and laboratory technologies.[10] Such images, of course, need to be analyzed carefully, in their own terms, but they are, relatively speaking, unproblematic for the viewer. But perhaps the most interesting way in which the anxiety surrounding images of disease has been allayed, Gilman suggests, is through the displacement and projection of the signs of disease away from the self and onto classes of people categorized as different from the viewer – 'the Jew', 'the black' or 'the old woman'.[11]

Such processes of displacement are fundamental to the construction and visual representation of tropical diseases – to the way in which such images have been produced, viewed and circulated, especially beyond the immediate confines of professional medicine. The privacy of the body has historically been reserved for the middle and upper classes.[12] In the last third of the nineteenth century and first decades of the twentieth, images of people with tropical diseases proliferated in medical textbooks, journals, newspapers, exhibitions and, eventually, films, not just because the cost of making such images had been sharply reduced by technical innovations (such as the rapid-lens camera) but because tropical medicine had emerged as a new medical speciality, with its own schools, laboratories and faculties.

Tropical medicine, as its name indicates, differentiated tropical diseases from other kinds and largely defined them as belonging to

tropical people and places – to Indians and Africans, Brazilians and Pacific islanders. The political power that colonial officials had over their colonized subjects, the worries Europeans had about the spread of disease from the tropics to temperate areas, or to European populations in tropical colonial settlements, as well as their faith in the ability of modern science to control infections all contributed to the production of images, and their quasi-public display, in forms and in ways that would have simply been unacceptable had they involved diseased Europeans. These images intertwined with anthropological images and those of landscapes so that race, place and illness converged visually in the concept of the tropically different and pathological. This form of visual representation continues to be present today in books on tropical diseases. Its historical roots, in a particular style of medical image-making, and the selective frameworks that produce it, are what is explored in this chapter.

Of course, for someone born to, or belonging in, the tropics, tropical pathologies could not always be so easily distanced from the self by being projected onto the racial Other. The racial Other was the self. When such racialized portraits circulated beyond medicine into the public arena of newspapers, international health conferences and exhibitions, they could cause a negative backlash against the whole identification of a disease as tropical. Exactly such a dispute is the subject of Chapter 7.

From the medicine of warm climates to tropical medicine

We tend to associate tropical medicine with European colonial history; images of knobbly-kneed medical officers, in long shorts and pith helmets, heroically carrying out medical missions to the natives in darkest Africa, perhaps come to mind. There is an element of truth in this picture, as we shall see.

Yet the idea that the spaces and places of the tropics influenced disease and its control is far older than the nineteenth century. There was, that is, a medicine of warm places long before there was a 'tropical' medicine, a medicine that cannot be treated by historians as a conceptual blank preceding the bacteriological era. Such a medicine was critical to the darkening of the image of the tropical environment over time. The dominant framework for understanding disease in the pre-bacteriological era was, after all, broadly speaking environmentalist, using the term here not in its current, ecological sense but in a much older sense, to refer to the myriad ways in which factors in the environment or milieu, from climate, to latitude, to topography, to

soil conditions, to changes in the seasons and to meteorological events, could affect the course and outcome of human illness. Such an environmentalist approach had long been part of the Western medical tradition; it was part of the Hippocratic corpus of Classical Greece, for example, as exemplified in the well-known work *On Airs, Waters and Places* which, as the title indicates, attributed many diseases to the impact of factors external to the body.[13] Already in this Hippocratic tradition, temperate climates were considered to be more favourable to human health than warm or hot ones. In the Hippocratic writings, too, as the historian David Arnold, notes, excessive heat and humidity were considered to cause negative deviations from the ethnic norm, as defined by the ideal Greek body. Thus environment, disease and race were tied very early on in the Western tradition to the idea of the climatically different.[14]

This Hippocratic/environmental approach to disease, and medical geography more generally, was revived in the seventeenth and eighteenth centuries, spurred on by many of the same political and economic factors that had led to the European appropriation of tropical nature for aesthetic and commercial purposes in the first place. Just as the European voyages of exploration and conquest stimulated geography, natural history and landscape painting, so they changed the view of the disease environment in far-away and exotic places.

Among the many consequences of exploration and contact were the globalization and unification of the world by disease, notably a 'disease exchange' brought about by the European practice of human slavery on a large scale.[15] Diseases long known in Europe travelled with the conquistadors and colonists to the New World, with devastating effects on the Amerindians, who lacked immunity to Old World pathogens. Europeans also found themselves vulnerable to diseases in new and strange places.[16] Endemic infections from Africa and Asia spread into Europe, and into new places of European settlement in the West Indies, India and, later, Africa. Yellow fever, for example, was an old and probably relatively mild disease in Africa that was unknown in the New World before the seventeenth century. By the eighteenth century, slavery had made it epidemic and endemic in the West Indies, and by the nineteenth in large parts of the US and Latin America. Baffling in its manner of transmission, frightening in its rapid fevers, black vomit and jaundice, a yellow-fever epidemic could result in the death of as many as 30 per cent of the non-immune Europeans it infected (many imported slaves had immunity to yellow fever based on mild, childhood cases). Another disease brought with the slave trade was a deadly form of malaria (*falciparum*), whose

morbidity and mortality were quite unlike the mild *vivax* form known in Europe.[17] In the first half of the nineteenth century, too, cholera spread for the first time outside Asia through the channels of European trade and communication, causing a series of frightening epidemics in the major European cities and eventually crossing the Atlantic to invade North and South America.[18]

A more specifically articulated 'medicine of warm places' was a product of these new disease experiences. One could say, in fact, that the encounter with disease made physicians some of the more important investigators of tropical places (though historians rarely treat them as such). By the end of the sixteenth century, Portuguese physicians and travellers had already produced an extensive literature on diseases in their tropical colonies.[19] Doctors' reports from colonial outposts on the brutal epidemics and on symptoms of disease unknown in Europe, or not known in such intensity, became more and more frequent, as medical and scientific observers moved inwards from the coastal areas of interest to the European navies and as short-term exploration gave way to long-term settlement. By the end of the eighteenth century, three hundred years of European experience with disease in hot climates was crystallizing into a notion of the radical difference between the disease environment in temperate and tropical areas.

The new environmentalism in medicine was also influenced, as was Humboldtian physical geography, by the development of new precision instruments, especially thermometers and barometers, which allowed comparisons of temperature and atmospheric pressure to be made across time and space. The belief was that the careful collection of physical data, together with information about the habits, predispositions, sex and age of individuals, would explain disease. External environmental factors were especially relevant to explaining diseases that affected large numbers of people in particular locations – epidemics, for example, which did not seem to fit the mould of well-known contagious diseases that spread by direct contact between people.[20] The often baffling patterns of epidemic eruptions gained some coherence when viewed in terms of the subtle poisons, or miasmata (from the Greek for bad air), thrown off by rotting vegetation or associated with seasonal changes or unusual atmospheric events. In the late eighteenth century, regular measurements of atmospheric temperature and pressure therefore became standard practice in medicine, especially in extreme climates like those of the tropics that were considered unusually challenging to human powers of adaptation.

The historian of medicine William F. Bynum, points to another reason why the climatic and environmental medicine of the eighteenth

century led to a new sense of the distinctiveness of the tropics. This was the fact that by far the largest category of illness in contemporary European medical classifications of diseases (or nosology) was 'fevers', symptoms, that is, which seemed most clearly related to variables in climate and geography.[21] Many of the physicians who wrote on fevers in the 1700s had spent part of their working life in tropical colonies or in the naval and military service in hot climates; they therefore knew at first hand the blistering high fevers and sudden chills to which tropical environments subjected the body. The first major British work on diseases of hot climates, *Essay on Diseases Incidental to Europeans in Hot Climates* (1768), was, for example, written by a naval surgeon, Dr James Lind (of scurvy fame). In his book, he tried to correlate the dysenteric and other fevers prevalent among Europeans in Africa, India and the West Indies with the environmental conditions found there.[22] The phrase 'tropical disease' was first used in an English medical work in 1787, *Treatise on Tropical Diseases*, by another naval surgeon, Benjamin Moseley. [23]

Such a medicine went by many names in the nineteenth century: tropical hygiene, medical climatology, medical topography or medical geography. Whatever it was called, it was a medicine *of* the tropics *from* Europe, in which the tropics were conceived as special places of alterity from the temperate world. The most prolific contributors were physicians from Britain and France, reflecting these countries' larger involvement in overseas colonies compared with other European countries.

Historically, too, different parts of the world were drawn into the category of the medically tropical at different moments. Arnold suggests that the West Indian islands were the first to be so categorized in the eighteenth century, as the initial promise of a delightful, benign climate gave way to a perception of a special tropical morbidity.[24] A similar process of recognition brought India into the field of the medically tropical by the 1840s.[25] Disease played a large part in the genealogy of Africa as the 'dark continent', as European exploration and military campaigns were set back by disease and death.[26] In Brazil, some Portuguese physicians believed that the equator would act as a barrier to the importation of devastating epidemics. However, the cholera epidemic of 1855–6, which killed 200,000 people, checked such hopes, and by the end of the century ships avoided putting in at ports in the tropical Americas for fear of tropical infection.[27] By the late nineteenth century, even Algeria was considered by European doctors to be tropical in its environmental pathology, indicating that what constituted 'the tropical' in medicine was more than a merely

geographical description; it connoted a place of a marked climatic, ethnic and disease difficulty.[28]

In the second half of the nineteenth century, two interconnected developments helped draw the line more firmly between the diseases of the temperate world and those of the tropics. The first was the move away from climate as an explanatory variable among European physicians trying to understand variations in mortality and morbidity in populations close to home. The public hygienists in Paris in the 1840s, for example, concluded that nothing in the temperature or atmospheric conditions could explain why the poor of Paris were so much less healthy than the rich.[29] In general, they tended to think that the poor got ill much more frequently because they were poor – because they worked in unhygienic professions like tanning, in places with poor ventilation, and could not afford decent food.[30] Where climatic and metereological concerns remained strong, however, was in the medicine of overseas places, especially very hot places, where the sheer difference between the climate and that in northern Europe seemed so evident. Thus the medical environmentalism of the two areas of the temperate and tropical began to diverge, such that climate defined one and not the other; the temperate world became the silent norm against which the medical deviancy of the tropics was measured.

The second development to intensify the idea of special tropical insalubrity was the mortality and morbidity revolution that occurred between roughly the 1860s and the 1920s in the richer, industrialized countries of northern Europe. Historians and epidemiologists refer to this revolution as marking the epidemiological transition away from the most common infectious diseases as the chief causes of death in a population towards the chronic and degenerative diseases characteristic of advanced economies today.[31] The importance of specific public-health interventions in bringing about this transition is still a matter of intense debate. Its effect, however, was to separate the richer countries, largely found in the temperate, northern areas of Europe and in the US, from the poorer, hotter countries found in Africa, Asia and Latin America, where a similar epidemiological transition would not occur for another hundred years or more. [32]

The European mortality and morbidity revolution led to a re-conceptualization of many diseases that had once been familiar in Europe; they now came to be considered fundamentally tropical and alien. Leprosy, for example, had already been virtually unknown in northern European countries for centuries except in rare pockets (it was while studying lepers in Norway, after all, that G. H. Armauer Hansen discovered the leprosy bacillus), while plague had almost

disappeared from large parts of Europe by the end of the eighteenth century (for reasons that are still not entirely clear). The incidence of malaria in northern Europe declined steadily in the first decades of the nineteenth century, though it remained endemic in large parts of southern Italy and Greece, as well as in the American South, until well into the twentieth century.[33] Over time, it came to be seen as the major impediment to improvement in hot places. By this time too, yellow fever, never a major disease in northern Europe but the source of repeated epidemics and high death rates in the northern US, had also gone; the last major epidemic in the north occurred in 1878. Thereafter, in the New World, the disease was confined to the southern, hotter states of the Union, and to Central and South America. By the late nineteenth century, therefore, plague, malaria, leprosy and yellow fever all seemed, according to political and epidemiological criteria, fundamentally tropical diseases, and India, Africa and the New World tropics had come to stand for all that was pathogenic.

Such historical redefinitions of disease suggest the flexibility and instability of the category of the 'tropical' in disease. This was acknowledged by Sir Patrick Manson, who is considered in Britain to be the founder of the modern discipline of tropical medicine. The phrase 'tropical disease', he said in 1898, was 'more convenient than accurate', since very few diseases indeed were in fact confined to the tropics.[34] A hundred years later, the difficulty of knowing what is tropical about tropical diseases remains; the editor of the recent *Wellcome Trust Illustrated History of Tropical Diseases* (1996) admitted that he found it hard to decide what to include (he included a chapter on AIDS, for example).[35] 'Diseases found most commonly in poor or developing countries' might best describe the medical speciality today. But since poverty is a condition of so many countries found in tropical latitudes, our current tropical medicine keeps intact the now old notion in Western medicine that tropicality itself is a barrier to health and civilization.

Mapping tropical diseases

The result of these epidemiological and conceptual changes was to transform differences in *degree* in illness, within a universal nosology, into differences in *kind*. There was a retreat from any kind of tropical romanticism. Indeed, the very feature of the environment that to Humboldt was exemplary of tropical beauty – the super-fertile vegetation – was now implicated as the source of tropical ill health, since it was considered to be the origin of the tropical miasmata that gave

rise to infection and death. Thus the jungle itself was the image of disease (illus. 56).

Visually, though, the new medicine of warm climates was represented most forcefully through geographical and climatological maps of disease, which called attention to the tropical zones of illness distributed across the world in the areas situated close to the equator. Maps are, of course, very particular kinds of visual artefacts; as historians of cartography have shown, though we tend to think of maps as objective depictions of the earth's surface (and valuable for this very reason), they are in fact extremely variable in form and in the cartographic techniques they employ. Maps also serve many different political agendas and intentions which often go unnoticed because of maps' abstract, diagrammatic character and our assumption that they are very scientific.[36]

Disease maps, based on particular conceptual frameworks and visual conventions, and carrying a number of political as well as medical messages, are good examples. Medical cartography originated in the eighteenth century with 'spot maps' charting the movement of specific diseases like yellow fever from place to place within a single locality. By the middle of the nineteenth century, such maps had become global in scope.[37] An informal network of data collecting and information exchange about disease distribution in far-away places had come into being which allowed European physicians to map

56 'A Mosquito Curtain for the Soldier's Rest', wood engraving, c. 1873. Wellcome Library, London (videodisc no. 10778).

diseases across the world in relation to latitude, temperature and other environmental features. Military medicine was especially important in gathering medical intelligence about disease and death rates, as European troops were sent out to the West Indies, India and Africa, and the costs of keeping them overseas, or relocating them back home, were calculated in relation to the death rates in different localities.[38]

Thus there developed not just maps of specific diseases in limited areas of the world but maps embracing the entire globe, and aiming to chart the position of the major infectious and epidemic illnesses across different geographical and climatic zones. In many respects, these maps were analogous to Humboldt's maps of plant distribution (in the case of some German medical maps, Nicolaas Rupke points out, the physicians actually borrowed Humboldt's technique of isothermal lines and his Chimborazo mountain diagram). The purpose of such maps was to show in visual form

an integrated picture of the global occurrence of human diseases, with the intent of uncovering the general laws of distribution. By taking physical geography into account, the medical geographers meant to acquire a framework for organizing dispersed observations in a way that would yield general results.[39]

Medical geography was especially strong in France. French public hygienists may have played down climatic factors in explaining variations in health within a large city like Paris, but not when it came to their overseas colonies, where the hot climate seemed so clearly connected to disease distribution and responsible for locking the tropics in climatic fatality. A good example is the work of Dr A. Bordier, Professor of Medical Geography in the School of Anthropology in Paris. In his *La Géographie médicale* (1884), Bordier mapped plague, yellow fever and many other diseases along Humboldt's isothermal lines, showing how such diseases are largely limited in distribution and confined by geophysical factors to the tropics (illus. 57). Another map maker was H.-C. Lombard, whose *Atlas de la distribution géographique des maladies dans leurs rapports avec les climats* (1880) Rupke calls a classic of its kind. Lombard mapped diseases according to latitude, supplying as well detailed tables showing monthly variations in temperature in relation to altitude, latitude and longitude for many of the cities in equatorial regions, again suggesting the importance of these physical factors in determining disease. The climatologist J.-C.-M. Boudin, in his *Traité de géographie et de statistique médicales et des maladies endémiques* (1857), experimented with even more sophisticated cartographic projections to show how mortality was influenced by time, season and place.

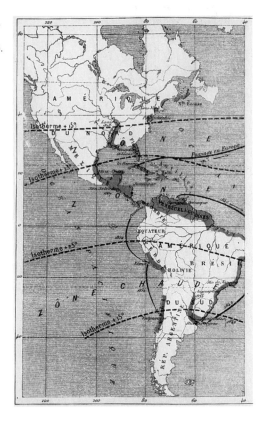

57 'Fièvre Jaune' (Yellow Fever),
map 5 from A. Bordier, *La
Géographie médicale* (Paris, 1884).

The British seemed to go in for medical maps somewhat less than the French, as far as I have been able to tell. An interesting example from the same period is by R. W. Felkin, lecturer on the diseases of the tropics and climatology at the School of Hygiene in Edinburgh. His book *On the Geographical Distribution of Some Tropical Diseases, and their Relation to Physical Phenomena* (1889) is unusual in that, following the logic of the medicine of hot climates, it dispenses with diseases in temperate areas altogether, in order to focus entirely on mapping some of the major diseases considered tropical, something that Felkin claimed no other maps had done.[40] Visually, his maps highlight the physical-environmental determinants of tropical illnesses, compared to economic or social ones, in line with the medical-geographical perspective (illus. 58, 59). By expressing so clearly in a graphic language the way certain endemic and epidemic diseases clustered in tropical areas, these medical geographical maps produced a visual picture of tropical peculiarity. As I have said, many of the diseases once familiar in Europe had, by the time these maps were being made, been pushed out of Europe and redefined as classic

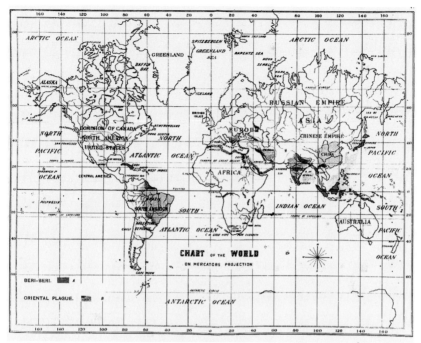

58 'Map of the world showing distribution of Beri-Beri and Oriental Plague', map V from R. W. Felkin, *On the Geographical Distribution of Some Tropical Diseases, and their Relation to Physical Phenomena* (Edinburgh and London, 1889).

tropical diseases. Now, in the maps, yellow fever seemed to cling to Brazil, while malaria defined India. The fact that infectious measles in infancy, or tuberculosis, were often just as, if not more, important sources of morbidity and mortality in the populations native to the tropics than, say, yellow fever, was not visually registered; the maps' aim was to select for visual display precisely those diseases that demonstrated a temperate-tropical contrast and that showed the diseases in the tropics most threatening to Europeans. Maps evidencing more generally the sources of morbidity and mortality among poor populations around the world were not the point.

Felkin's short book on medical climatology is also useful in giving us a snapshot of the diseases defining the 'medicine of hot climates' in the 1880s, before 'tropical medicine' emerged as an institutional discipline. It demonstrates, especially, how far the idea of disease specificity in the tropics had been established in medical geography by this time. His list of tropical diseases – malaria, dengue fever, asiatic cholera, oriental boils, beriberi, tropical dysentery, leprosy, yaws, fungus diseases of India, elephantiasis, Guinea-worm, scurvy and tropical abscesses of the liver – is very similar to that of Sir

162

Patrick Manson, who less than ten years later would define tropical diseases in terms of specific parasitical causes, and use the existence of such parasites to establish a new laboratory-based discipline of tropical medicine. This similarity suggests the lines of continuity linking what are often taken to be two dissimilar approaches to disease – the climatological-geographical and parasitological-vectorial. Climate did not disappear as an explanatory framework of disease in twentieth-century medicine; it was connected with too many topics of interest to scientists concerned with the tropics, such as human races and acclimatization (and indeed to the new parasitology itself), to be put aside as an explanatory variable. As several historians have commented, such links and continuities are evident in Manson's well-known book of 1898; called *Tropical Diseases: A Manual of Diseases in Warm Climates*, its subtitle gestures backwards to the medicine of warm climates, while its title points conceptually forward.[41]

Medical geography was tied especially to race, and to the problem of human acclimatization in the tropics. Paradoxically, as more and more exotic species from the tropics were successfully transported to, and grown in, temperate countries; as acclimatization societies were founded in Paris and London; and as more and more Europeans trav-

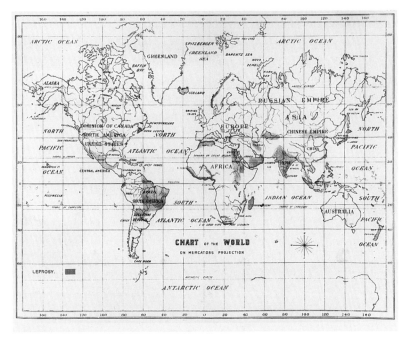

59 'Map of the world showing distribution of Leprosy', map VII from Felkin, *On the Geographical Distribution of Some Tropical Diseases.*

elled to, and settled in, the tropical colonies, doctors became less and less certain that human beings could thrive in climates and regions far from the ones they were born into.[42] The suggestion that the human race was not one but many, which owed their origin, and belonged by nature, to different climatic or geographical zones, merged with the idea of the geographical basis of disease.[43] Many of the geographical maps produced from midcentury on were therefore race maps, showing the global distribution of race-types and positioning the Caucasian or white race as superior in achievement, health and civilization, as well as firmly located in the temperate parts of the world, with the darker races, with their lower civilization and disagreeable or dangerous diseases, located in the tropical zones. David N. Livingstone shows that this climatic-racial geography had a lasting impact on the discipline of geography in Europe and the US. He gives several British and American examples from as late as the 1920s in which medical, racial and acclimatizational concerns came together in geographical maps to produce a profoundly pessimistic view of tropical peoples and places and prove the climatic superiority of white civilization. A nasty example is Ellsworth Huntington's *Civilization and Climate* (1924), in which energy (meaning civilization) was mapped against climate in order to demonstrate the superiority of the northern European and northern American areas (illus. 60).[44]

Picturing pathogens and vectors: the new tropical medicine

Even before the revolution in medicine brought about by bacteriology and parasitology, medical geographers had found themselves frustrated by their inability to pinpoint, through the use of their maps, what the actual laws controlling the distribution of disease were, just as Humboldt, decades earlier, had been unable to uncover the physical laws governing plant and animal distribution from his. In both cases, the multifactorial approach to the distribution of living species (animals, plants, diseases) left the number of physical factors in the environment that might *conceivably* play a part simply too many and too confusing to yield the kinds of epidemiological and causative insights needed. Only with the Darwinian revolution would the problem of the distribution of species through time and across space be solved. A similar resolution of medical geography seemed to be offered by the microbiological approach. With both approaches, a new visual grammar of the natural world came into being.

A great deal has been written about the microbiological revolution in medicine. It was in fact many things: conceptual, methodological,

experimental, practical; it involved far more than bacteria. What impresses us most is the extraordinary speed with which invisible micro-organisms were identified as 'causes' of many of the most important infectious diseases in human populations.[45] A hitherto unknown and invisible geography was opened up to view by the microscope. The perspective of the medical scientist shifted downwards, from the geography of disease writ large on a world map to the pathogens of disease in the form of microscopic living organisms, and to the tiny insects that were often found to be involved in the transmission of the organisms to their human hosts. Now diseases were defined not in terms of temperature or geography as such but by their tiny biological causes. Malaria kept its old name ('bad air'), rooted in miasmatic theory, but many other diseases were renamed to give recognition to this new conceptual and perceptual framework; thus the old disease of elephantiasis, a disease of hot places whose symptoms were elephant-like swellings of the limbs and genitalia, in the 1880s was named filariasis after the microscopic filarial worms that Manson first identified in the 1870s as the cause of the infection.

And indeed, as this example suggests, the tropics had a crucial role to play in the microbiological revolution in medicine, because the hot and humid climate of the tropical colonies, along with their dirt, decaying vegetation and pools of stagnant water, were now seen as providing the perfect environments for the production of a hitherto unsuspected universe of dangerous pathogens. Following the 1885

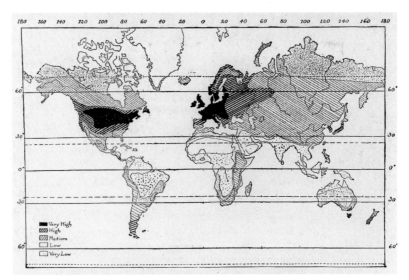

60 'The Distribution of Human Health and Energy on the Basis of Climate', from Ellsworth Huntington, *Civilization and Climate* (New Haven, 1924).

165

carve-up of Africa among the major European powers, Europeans settled in the tropical colonies in ever-increasing numbers as plantation owners, resource exploiters, missionaries and doctors. In 1895, Sir Joseph Chamberlain was appointed Secretary of State for the Colonies in Britain, in which position he promoted the idea of constructive imperialism, in other words the scientific and rational exploitation of colonial resources. This was a call for the establishment of modern botanical gardens, for new engineering and sanitary works and for the recruitment of colonial officers of health. Already by the 1870s, the tropics had become a desirable destiny for bright young doctors who found themselves closed out of careers in Europe by an overcrowded medical profession.[46] This was where something new might be done in medicine, and medical reputations might be hazarded. Manson, for example, spent 23 years as a medical officer in the British Customs Service in British Asia before returning to England to become the chief proponent of the new discipline of tropical medicine. Manson's words in 1884 to Ronald Ross, who was then serving in the India Medical Service, alerted him to the possibility of a mosquito transmission for malaria, something Ross was finally able to prove in 1897–8 after years of experiments overseas.[47] The German bacteriologist Robert Koch was also in and out of tropical Africa and India between 1896 and 1907, carrying out research on the microscopic sources of cattle diseases, malaria and African sleeping sickness.[48]

In the tropics, medical scientists and physicians had the opportunity to observe the horrors of illnesses largely exotic to Europeans, to obtain the experimental animal and human materials necessary for laboratory work and to experiment boldly with new chemical therapies, such as the toxic arsenicals. Despite often rough and ready facilities, the techniques of the laboratory and the experiment proved especially rewarding in the tropics. It was in the tropics, too, that some of the boldest programmes in disease control were undertaken. In Havana, for instance, under American military occupation, William Gorgas eliminated yellow fever in a few months by eradicating the *Aedes aegypti* mosquito's breeding places, after the Reed Commission had proved Finlay's theory of transmission in 1900 (an eradication Gorgas repeated successfully in Panama a few years later). With Ross's proof of mosquito transmission of malaria already in hand, the hope of the complete eradication of one of the worst tropical diseases known to humanity, by interrupting the chain linking humans to insects, seemed realizable.[49]

The fact that eradication often proved to be much more difficult to achieve than had been expected – that the 'dream of conquest' of

disease in the tropics was repeatedly challenged by the 'nightmare of return' – is not the issue here.[50] My point is rather the swiftness with which the new tropical medicine, based on the new microbiological understanding of diseases and their vectors, was consolidated in medical practice and new institutions. In 1899, the Liverpool School of Tropical Medicine and London School of Tropical Medicine were both founded. They were followed by the establishment of an Institute of Tropical Medicine in Hamburg in 1901, an Institute of Colonial Medicine in Paris in the same year, the Koch Institute in Berlin in 1904, the School of Tropical Medicine in Brussels in 1906 and so on.[51] The Pasteur Institute of Paris, which had been funded by public subscription as a result of the huge excitement generated by Pasteur's announcement in 1885 of a cure for rabies, and which opened in 1888, was already to all intents and purposes a new command centre of tropical medicine in French overseas colonies; many of its bacteriologists went out to French North Africa and Indochina, fuelled by the same missionary zeal as Pasteur himself, to set up Pasteur Institutes in the tropics.[52] After the First World War, the Rockefeller Foundation in the United States entered the Latin American field, and later Africa, to promote the new tropical medicine.[53]

The visual iconography of the new medicine was quite different from the older environmentalist medical geography. In place of worldwide maps of disease distribution, images of the pathogens understood to be 'the' causes of infectious diseases were highlighted. Maps did not entirely disappear, but they could not compete with the interest doctors had in the pictures of the extraordinarily intricate evolutionary cycles which so many of the tiny parasites causing disease in humans were found to go through, as they made their invisible way through their insect or animal vectors and human hosts. These stages were made visible to the human eye by means of the microscope; finding the pathogen became equivalent to finding the disease.

Aiding in the visual representation of pathogens were technical improvements in photography; the camera's ability to make the invisible visible through magnification meant that representations of the small insects and their larvae that bred in the grasslands of Africa, or in small pools of water, and of the otherwise invisible pathogens carried in the insects' bodies, could be made available to human perception. These are the images of the tropics that dominate books in tropical pathology from 1900 on. In effect, the pathology of the tropics was visually literalized; the tropics *became* the pathogens.

I single out here, as an example of the visual conventions of the new tropical medicine, the illustrations used in the book that for decades served as the English-language bible of the new parasitological-vector theory of tropical medicine: *Tropical Diseases: A Manual of the Diseases of Warm Climates*, written by Sir Patrick Manson. First appearing in 1898, by 1907 it had been through nine printings and four different editions, each larger than the last. The book was lavishly and superbly illustrated; the first edition, for example, had 90 pictures altogether, encompassing line diagrams, drawings and photographs.

The frontispiece to the first edition announces the new discipline's visual style; it is a beautiful coloured plate, based on photographs, showing the three major kinds of plasmodia causing the three major kinds of malaria in human beings – the quartan, the benign tertian and the malignant tertian (falciparum) (illus. 61). Malaria was the first disease to be analyzed in the book, the most important fever of the tropics and in many respects the model disease of the new tropical medicine, owing to the complexity of the plasmodium's evolutionary cycle and the role of insect vectors in transmission, which was worked out between 1880 and 1900. Another factor in the emphasis on malaria was its devastating impact on life and work in the tropical colonies, and the belief that systematic extermination of the mosquito vectors would eventually lead to the extermination of the disease.

In effect, Manson's frontispiece announced that henceforth, parasites themselves would be considered as the central actors in disease.

61 Malaria parasites, plate I from Patrick Manson, *Tropical Diseases: A Manual of the Diseases of Warm Climates* (London, 1898).

The book was crammed with similar images, some in colour, others in black and white, demonstrating in detail all the different forms of pathogens known to be involved in tropical diseases, and all the different stages they pass through, each stage with its own characteristic morphology. Finding methods to make these forms and stages evident visually in ways that would allow physicians in the field to understand what they were seeing, through often inadequate lenses and in unsatisfactory laboratory conditions, was not easy. Learning to see such tiny organisms was an acquired skill, since what was being represented was normally beyond the vision of the unaided human eye.

Robert Koch, the German bacteriologist, was a great proponent of the usefulness of photography in giving accurate magnified images of the different species of micro-organisms, but he acknowledged its challenges as well.[54] The fact was that many photographs of micro-organisms were hardly adequate, in themselves, to the task of distinguishing different species of pathogens from each other, or showing the micro-organisms' internal structures. For this reason, photographs could not usually be used without the aid of captions. In many cases, a photograph of a pathogen was combined with a line diagram to form a photo-diagram in which the image's photographic basis served to signify the actual existence of the impossibly small biological entity, while diagrammatic aids were used to highlight the morphological features of the image salient to medical knowledge (illus. 62).

Along with the magnified images of pathogens there appeared in Manson's book many magnified images of the insect vectors involved in tropical diseases. Illustration 63, for example, is a wonderful coloured illustration of African tsetse flies which first appeared in 1907 in the book's fourth edition. The role of these flies in transmitting African sleeping sickness to human beings had not been understood at the time of Manson's first edition, nor had that of the pathogen, the protozoan called a trypanosome. The character of the insect vector and the trypanosomal pathogen was worked out in the first few years of the twentieth century during a series of medical investigations carried out largely by British doctors into the dreadful sleeping-sickness epidemics that had erupted in British, German, Belgian and French colonial Africa.[55] These epidemics, which affected thousands of Africans and caused the strange lethargy, coma and eventual death which gave the disease its name, were largely the result of the intense ecological disturbances and human exploitation that colonial 'development' itself had brought to Africa. Many

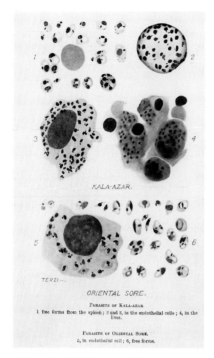

62 Parasites of Kala-azar and Oriental Sore, plate from Manson, *Tropical Diseases...* (London, 1909 edn).

63 'Tse-tse Flies', plate III from Manson, *Tropical Diseases...* (London, 1909 edn).

historians would say, in fact, that tropical medicine was invented to control the spread of diseases that tropical colonialism produced.[56] In Manson's picture, the two species of blood-sucking tsetse flies that were discovered to be the main agents in transmitting sleeping sickness to humans through their bites, *Glossina palpalis* and *G. morsitans*, are shown greatly enlarged in a way that seems to underline the menace to health represented by an otherwise small and seemingly innocuous creature. The picture shows clearly the tsetse's long proboscis, the blood-sucking mouth-parts responsible for conveying the deadly trypanosome to human beings.

My purpose here is to draw attention to a whole new visual configuration of disease, a configuration that was visually so far removed from everyday perceptions of the world as to have to be largely taken on trust by the non-specialist or lay public. I stress here, then, not so much the scientific details of such pictures but the more general, symbolic associations they set up between pathogens and the tropics. Visually, of course, pathogens and flies together gave a very condensed, highly selective representation of what was in fact a

170

complicated set of interactions between human populations, living conditions, the environment and pathogens, a representation that could not do otherwise than omit many of the most important factors actually resulting in disease in tropical countries.

Portraits of tropical diseases

And what about the human element in tropical disease? There is no doubt about the extraordinary fascination with depicting, in as realistic terms as possible, the tropical diseases borne by the 'natives' of the tropics. With such portraits I come, finally, to the issue raised at the opening of this chapter, namely the mixture of fascination and fear that portraits of humans with strange diseases and deformities generally hold for us, and the displacement of that fear onto someone other than ourselves. The shift in medicine from geography to parasitology, from maps to disease portraits, as a means of communicating visually the horrors of tropical disease, reflected more than changes in medical theory; it meant a new kind of attention to and representation of the diseased population being portrayed. By the late nineteenth century, the image of the leper, the malaria victim, the person with yellow fever, was not European but largely tropical and colonial.

Tropical medical literature from the 1880s on is filled with pictures of natives in tropical lands, either positioned alone, in order to highlight the external signs of disease, or shown in the presence of European colonial medical officers, who are often shown carrying out what seem now to be painful and intrusive medical tests. The invention of light-weight, small pocket cameras allowed doctors to carry them into the field and use them for documentation purposes. In the past, the sheer bulk of cameras, the cumbersome procedures that had to be followed to make photographic prints, and the damage to heavy photographic plates that tropical heat and humidity could cause had limited the medium's use in the tropics. Another factor was conceptual; until tropical diseases were clearly separated out from other kinds and located above all in the tropical native, a special genre of tropical medical pictures did not develop. The invention of prepared film and fast lenses also contributed to this change. The camera was seen as an invaluable modern tool because of the photograph's ability to convey with realistic clarity the terrible skin diseases, the distended bellies, the horrific deformities and tumours now thought of as defining tropical pathology.

Megan Vaughan is one of the very few medical historians to address, if briefly, the character of such tropical-disease portraits. In

an analysis of colonial medical practice in Africa in the early twentieth century, she uses the letters and diaries of Dr Hugh Stannus, a Medical Officer working in Zomba, Nyasaland, to explore the extraordinarily diverse interests a medical life in the bush encompassed. Stannus, for example, was engaged in research on tsetse flies and investigations of cattle diseases, pellagra in prisoners and congenital abnormalities; he studied native paintings and collected photographs of an anthropological character. He was, typically, a great user of the camera, and in his photographic albums we find, says Vaughan, 'the common tropical medic's catalogue of horrors, from elephantiasis of the scrotum to advanced cases of leprosy and yaws'.[57] Vaughan points out that interpreting such images is hazardous. But she draws attention to their relentless empiricism, their classificatory and evolutionary framework, the objectification of the people photographed and Stannus's general fascination with the characteristics of African race and environment.

I propose to look more closely at some portraits of one of the tropical diseases mentioned by Vaughan, namely elephantiasis, because I believe that its visual representation is exemplary of the processes of displacement of disease onto the colonial Other and of the complicated intertwining in disease representations of place, race and gender. In what follows, I try to steer a path between the voyeurism that reproducing such images always risks and the need to analyze what are not only significant disease images of the past but significant disease images even today. A close look at them can tell us a good deal about how images construct the 'tropical' in 'tropical disease' and about the circumstances of their making and use.

These pictures are once again taken from Manson's *Tropical Diseases*. So interested was Manson in portraying pathogens like the malaria plasmodium and its developmental stages that relatively few images in his book are given over to clinical portraits as such. But it is precisely in contrast to Manson's visual emphasis on pathogens and vectors that his clinical portraits of elephantiasis in humans stand out. These portraits are just as exemplary of the new tropical medicine. They suggest, too, that much more was at stake, in depicting this particular tropical disease, than merely providing an accurate medical guide to diagnosis.

Elephantiasis is a very old disease, and a very strange one. Its chief clinical symptoms are the enormous swelling of the legs and genitalia which, as I have said, called to doctors' minds the huge size and rough skin texture of the elephant. This disease was also referred to in European medicine as Cochin leg, Barbados leg or *elephantiasis*

Arabum, after the different locations in India, the West Indies and the Middle East where it was observed. Europeans were viewed as just as susceptible to it as non-Europeans if they moved into risky environments like the West Indies, Barbados leg in English planters being well known to London doctors.

In the 1870s, elephantiasis became almost paradigmatic of the new tropical medicine. From being a disease caused by something in hot and humid climates, it was reconceptualized as a parasitic disease in which the minute nematode worms called filaria, identified by the microscope and encountered in the human body, were finally connected to the elephant-like condition of the limbs. Elephantiasis was the disease on which Manson developed his parasitological science in China, where he had many Chinese patients with the disease (his Chinese servant indeed provided his arm for a mosquito to bite on, by which means Manson was able to obtain infected human blood and find the filarial worm in it). Manson was led to implicate the filaria in the blocking of the circulation of lymph that caused the massive swellings. In advanced stages, the huge elephantoid tumours could only be treated by surgery (which Manson undertook on his Chinese patients).[58]

Of the few clinical portraits Manson included in his book, by far the greatest number was given over to depicting elephantiasis. The seven pictures of the disease, several of people from Samoa (not China, perhaps because Samoans were viewed as more obviously tropical?), make up a striking photographic album of human misery and exotic pathology (illus. 64–6). Perhaps the terrible plight of the victims, the disease's recent reconceptualization as a parasitic illness and Manson's own scientific contribution to its understanding were sufficient grounds for giving it such a prominent visual exposition. I would argue, though, that there is something else about elephantiasis that explains the almost obsessive way in which it is visualized in Manson's work, something that makes it, from the point of view of visual history, an iconic image of the diseased tropics.

Filiariasis was no respecter of race; Barbados leg referred as much to the British plantation owner as it did to the native West Indian or to the place they both acquired it. But by the late nineteenth and early twentieth centuries, filiariasis, owing to its relative rarity in Europeans in the tropics (because of their better housing and social conditions), had come to be viewed as largely a disease of the tropical native. Moreover, the massive enlargement of the genitalia, which was one of the most striking signs of the disease, was something that *could* be shown pictorially, and photographically, when it was encountered in

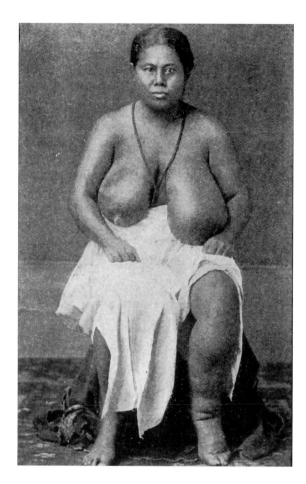

64 'Elephantiasis of Mammæ; right leg and foot also affected. *(From a photograph by Dr. Davies, Samoa)*', from Manson, *Tropical Diseases...* (London, 1909 edn).

native people, who often had little choice but to live with its disfigur-ing effects or to allow the European physicians treating them to take their pictures. The male scrotum especially, which was more often affected than the female genitalia, became the focus of medical scrutiny; Pelletier, in Senegal in 1910, apparently weighed a scrotum of 100 kilograms.[59]

The appalling deformations of the human body caused by filiariasis infection lent themselves to photographic representation. Manson's photographs have the shock of the real; they are constructed so as to draw the eye inexorably to the genitalia, to the extraordinary size of the elephantoid tumours and their peculiar surface texture. One is struck by the fact that of the seven photographs, there are more pictures of the genitalia (some in full-length portraits, some in part-body pictures) than of the massively swollen lower limbs evoked by the old name Barbados leg.

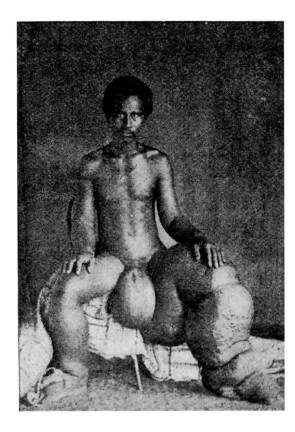

65 'Elephantiasis of legs: scrotum and right arm slightly affected. *(From a photograph by Dr. Turner, Samoa)*', from Manson, *Tropical Diseases...* (London, 1909 edn).

Two other illnesses that are part of Manson's clinical portrayal of tropical diseases contrast visually in interesting ways with his depiction of elephantiasis. One is beriberi (from a Singhalese word meaning 'very weak'), now known as a nutritional deficiency disease. Beriberi had long been familiar to physicians in places like China, and was considered in Mansonian medicine to be an essentially tropical condition of native populations. It could result in extreme weakness and atrophy of the legs, fatal anaemia and general emaciation, and was often shown photographically. Manson, however, chose to illustrate beriberi by means of three very schematic drawings, showing apparently Asian patients with the condition, one standing propped up by a stick, another sitting and the third lying down. Beriberi did not present the dramatic, almost grotesque tumours seen in elephantiasis, and in this regard was not a disease that lent itself easily to visual dramatization, but so schematic are Manson's drawings that without their captions and the supporting text, the viewer would be hard put to guess what clinical condition he was representing. In fact, in later editions of his book, Manson added the word *paraplegic* to the caption

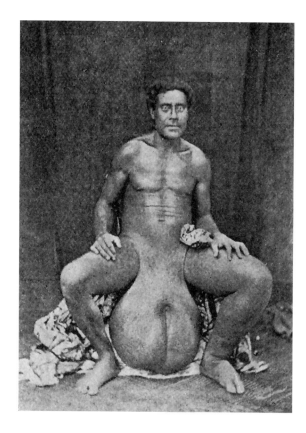

66 'Elephantiasis of the scrotum; left leg slightly affected. *(From a photograph by Dr. Turner, Samoa)'*, from Manson, *Tropical Diseases...* (London, 1909 edn).

under the picture labelled 'beriberi', no doubt in order to give clarity to the images as aids in diagnosis.

Also very different from Manson's photographic images of elephantiasis is his depiction of leprosy, a disease whose horrendous effects on the skin and especially the face were often painfully displayed in photographs of tropical afflictions. Manson's most dramatic depiction, however, was once again not a stark photograph but a more restrained image, an engraving loosely based on a photograph and possibly meant to show leprosy in someone from the Middle East. The portrait was designed to display the 'leontine' appearance of the face caused by the nodular lepromata, in which, Manson says, the 'bloated, dusky, wrinkled, greasy, passive countenance acquires [a] repulsive appearance' (illus. 67). Repulsive the appearance may be, yet I would argue that it has a certain dignity; the fact that the engraving does not try to convey the surface detail and realism of a photograph softens its visual impact. The picture lacks the clarity, the shocking power of the real – the 'reality effect' of Manson's photographs of elephantiasis.

176

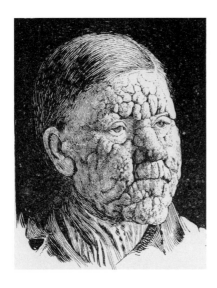

67 'Nodular leprosy. *(After Leloir.)*', from Manson, *Tropical Diseases...* (London, 1909 edn).

These latter images are, in comparison to the pictures of beriberi and leprosy, far more dramatic depictions of tropical and racial pathology. They give the viewer a direct, hyperreal and immediate sense of tropical enormity, in its literal as well as metaphorical senses. The portraits are partial and yet extremely full; partial in that they present the body purely as a medical specimen, full in offering the entire naked body to our sight. As images, they lie outside the range even of most medical pathologies; to the non-medical viewer they are both riveting and disturbing.

I would argue that the value attached to providing a relentless photographic guide to this particular tropical disease in Manson's book is not entirely self-evident. It is visually disproportionate to the verbal attention he gives the disease, and also to the visual attention he gives to other diseases and conditions. Nor do I think that this emphasis on the photographic representation of elephantiasis can be explained by the fact that it was the disease on which Manson's claim to originality in tropical medicine rested. Too many other books, by other medical authors, without any such claims to medical fame, contain photographs of elephantiasis to convince me of this. In many cases, authors in fact borrowed Manson's photographic portraits wholesale, and without acknowledgement, for their own publications.[60]

Rather, it was the involvement of the genitalia in elephantiasis, especially the deep if unconscious connection made in the European imagination between blackness, sexuality and pathology, that explains the almost obsessive attention to portraying the disease

photographically that we find in Manson's book. Elephantiasis signed itself on the body in an obvious and dramatic fashion; it was a frightening condition, largely of people faraway, who *could* be shown naked. Elephantiasis, in short, showed all that was believed to be pathological about the tropics: its environment, its racial make-up and its sexuality.

The gender aspects of this representation are also interesting. Elephantiasis was known to affect male genitalia more readily than female, and in Manson's book, men do indeed receive more visual attention than women. Very often, however, it was the black female, even more than the male, who was taken to be the key sign of excessive sexuality and pathology in the Western imagination. Many years ago, for instance, Gilman drew attention to the way in which, in medi-

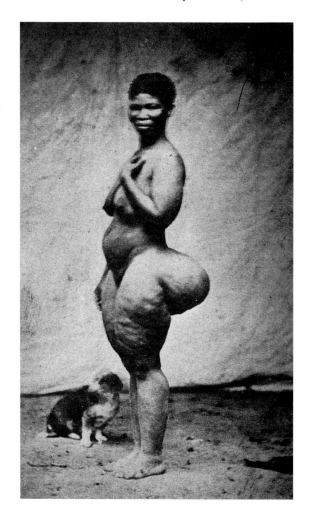

68 'Standing Woman, Full-length side View, with Elephantiasis of the Lower Regions', undated photograph. Wellcome Library, London (videodisc no. 30185).

cine and art, the image of the female Hottentot was the iconic image of pathological sexuality in nineteenth-century European representations.[61] How interesting, then, to come across, in the collection of medical images in the Library of the Wellcome Institute in London, a photographic image of a Hottentot woman that does translate sexuality into tropical pathology. The image is one familiar to medical historians from nineteenth-century anthropological and medical texts, because, as Gilman has shown, it was often reproduced, since the large, protruding buttocks (known as *steatopygia*) and large thighs often found in Hottentots women were taken by European scientists as *the* signs of black, depraved sexuality. Here, however, the image has been labelled as a case of elephantiasis (illus. 68).

I have been unable to trace the source of this image, or its identification as a case of elephantiasis (the information is missing from the catalogue to the collection, and the reference librarian has been unable to discover it). But whether the picture was so identified in the 1890s, as seems likely, or by one of the curators of the Wellcome collection today, which is also possible, it would seem to represent an extraordinary transformation of human sexuality into a sign of tropical pathology. Once again, it suggests that with tropical disease, especially its visual representations, we are dealing with signs that go way beyond the strictly empirical to encompass a large but enduring set of associations concerning tropical places, diseases and racial difference.

6 Appearances and Disappearances

As we have seen, Sir Patrick Manson, the founder of tropical medicine as a speciality in Britain, had some difficulty in explaining exactly what the rationale was for separating out the 'tropical' from the temperate in disease. Tropical diseases, defined politically as much as empirically, were the ones of greatest concern to colonial authorities abroad. Many, it is true, were vector-based infections caused by complicated micro-organisms which had been recently detected by medical scientists and were therefore of enormous research interest; many, too, were infections that, though not confined to the tropics, were particularly prevalent there, though often for social as much as geographical reasons. But as a set of diseases, tropical diseases lacked biological or even geographical unity.

This new tropical medicine was enormously appealing, but also problematical, to many physicians native to, and working in, tropical countries, who had good reason to try to determine for themselves what was tropical about their diseases. Their relationship to the new tropical medicine was complicated by the fact that gross stereotypes of the tropical were often applied to their countries. Though most were thoroughly European in medical outlook, following the latest fads and fashions in medical practice closely, and always eager to get their work published in European medical journals, they were conscious of the fact that their research was often ignored in Europe or appropriated by others, and that they were often the objects of European cultural and racial condescension because they lived and practised in places which Europeans held to be far from the centres of scientific excellence. They had, that is, reason to be suspicious of the new tropical speciality, and to worry that it was just a newer version of tropical uniqueness and fatality. Sometimes, as we shall see, the burden of being designated a tropical country, at the mercy of exotic diseases, was sufficient to lead physicians to deny the existence of specifically 'tropical diseases' or the need for a medical speciality to deal with them. It is

this involvement of tropical medicine in the projection of national identity and the politics of knowledge that makes tropical medicine in countries called 'tropical' so interesting.

These issues are examined here through the story of Chagas's disease, which was discovered in Brazil in the heyday of tropical medicine. Identified in 1909 as a disease completely new to medicine by the Brazilian medical researcher Carlos Chagas – hence its popular name – Chagas's disease has been characterized as 'one of the most important infectious diseases in the New World'. It currently infects between sixteen and eighteen million people in Latin America, putting some 90 million at risk (it is also slowly moving into previously unaffected regions, such as the Amazon, and southern areas of the United States). [1]

The disease's scientific name, *Trypanosomiasis americana*, draws attention to the role of the parasitic organism known as the trypanosome in the disease's causation, while suggesting an analogy with another illness, *Trypanomiasis africana*, or African sleeping sickness. This is why some people still refer to Chagas's disease as the American form of sleeping sickness. But the sleepiness and coma that precede death in the African illness and that give it its common name are not part of the American disease, and the character, and certainly the history, of the two diseases are quite different.

The trypanosome that causes Chagas's disease is widely distributed throughout Latin America; it infects a wide range of animals, from which it is transmitted to human beings by large, blood-sucking insects called Triatomas. Clinically, Chagas's disease is unusual in having an immediate, acute phase followed by a much later, chronic phase. In the acute phase, there may be few symptoms, though the entry point of the parasite, often near the eye, sometimes results in a characteristic swelling, or *chagoma*; there is also sometimes a feverish condition, with severe anaemia, which may result in death, especially in children. This acute phase is followed much later (sometimes years later), in a certain percentage of people, by a chronic stage, involving strange and diverse symptoms, especially of the digestive and nervous systems. Infection of the heart muscle by the parasite may greatly enlarge that organ, causing arrhythmic heartbeats which can be associated with sudden heart attacks and death (which sometimes strikes young men such as footballers, when it makes the news).

We are dealing here with a major public-health problem. Yet the disease has hitherto escaped the notice of most historians of tropical medicine, whose interests have focused largely on tropical diseases of concern to the major imperial powers in Europe. Some historians may

have a vague idea that Charles Darwin's chronic ill health, which developed after he returned to England from his voyage on the *Beagle*, was a result of Chagas's disease, but retrospective diagnoses of this kind are notoriously difficult to make, and almost impossible to verify, especially when we are talking about a disease whose symptoms are so diverse and so easily confused with those of other illnesses.[2] The real interest of Chagas's disease as a historical subject lies elsewhere, namely in the disparity between its public-health significance and the sparse historical attention it has received. The disease's story points to an alternative tale of disease and the tropics.

From a scientific viewpoint at least, the disease's discovery should have aroused great interest among medical researchers, since it closely fit the classic parasitological model. And initially it did. Subsequently, however, its celebrity in Brazil, and Carlos Chagas's with it, underwent a decline. Indeed, we can say that the history of Chagas's disease is a history of a disappearance as much as of an appearance. Since, as I have said, the disease is very real, this disappearance is apparent, historical and conceptual; it is a matter, that is, of how the disease was originally understood and interpreted in a particular cultural context.

The discovery of a human disease hitherto unsuspected by physicians, right at the moment when other parasitic and vector-born diseases like malaria and African sleeping sickness were defining the new discipline of tropical medicine, was originally seen in Brazil as a major medical event.[3] It catapulted Chagas to prominence. In short order, he was made department head and then Director of the Oswaldo Cruz Institute, arguably South America's pre-eminent medical-research institution at the time; became a member by acclamation of the National Academy of Medicine; in 1912 won Germany's prestigious Schaudinn Prize in Protozoology (named after the scientist who discovered the spirochete of syphilis); and in 1920 was appointed head of the expanded National Department of Public Health, a job he joined to that of running the research institute. Finally, in 1926, Chagas became the first person to hold the first chair of tropical medicine in the country, a position he held until his death in 1934. National scientific prestige and personal fame thus seemed to converge on Chagas and his disease.[4]

Yet within a few years of Chagas's apotheosis as a hero of tropical medicine, his work, and the disease itself, became embroiled in controversies which threw the identity of the disease into doubt and changed its status from being the exemplary illness of tropical Brazil, as Chagas claimed it was, to being a disease of uncertain identity

whose contribution to rural ill health in Brazil, let alone the American continent, was highly debatable. For these and other reasons, Chagas's years as Director of the National Department of Public Health were turbulent, and the establishment of his chair in tropical medicine, whose rationale depended to a considerable extent on his work on Chagas's disease, took place in the face of open hostility to the idea of a separate speciality of tropical medicine expressed by the faculty members of the Rio Medical School, where the chair was situated. By the time Chagas died in 1934, new research into Chagas's disease had dwindled. To some, its very existence was in doubt. Not until the 1950s and '60s did there develop a true appreciation of the wide extent of trypanosome infection rates in human beings in Latin America. What went wrong?

Existing accounts of Chagas's disease, many of them by medical scientists involved in its research, are scientifically excellent, but they downplay or ignore altogether the illness's curious history and the controversies affecting Chagas's reputation.[5] To the extent that these controversies have been addressed more recently (primarily by Brazilian specialists, whose work is often not known outside Latin American circles), they have been analyzed in terms of the very real scientific and clinical difficulties that the disease presented, as well as the personal rivalries between researchers.[6] Most discoveries in microbiology are, after all, long and often drawn-out affairs, involving many participants and rivalries. And certainly the Chagas myth – the myth that everything about Chagas's disease was discovered at once, by one person, in a single and brilliant moment of scientific deduction – is easy enough to dent.[7] As we shall see, Chagas made many mistakes and often claimed too much, for himself, as a researcher, and for the disease. Indeed, nearly every aspect of the disease and its discovery – who really saw the causative trypanosome first, whether the life-cycle of the parasite was as Chagas said it was, what the mode of its transmission from insect to human really was, what the disease's chief clinical symptoms were, how widely the disease was distributed – eventually became open to challenge and reinterpretation.

Underlying these conflicts, which spanned more than twenty years and which, as I have said, resulted in doubt being cast on the reality of Chagasian infection, were profound disagreements over the meaning of tropical diseases and medicine. Existing analyses miss, in my view, some of the underlying symbolic, ideological and representational meanings of Chagas's disease in its historical context, and the ways in which disease was part of a wider discourse of tropical nationality.

The analyses miss especially the relevant problem of public representation, photographic realism and medical referentiality. Here I

refer to some unusual visual images that stood as some of the key representations of the disease. In the controversies over Chagas's disease, medical photographs, a stark form of *visibilization* of disease, with the weight of empirical authority behind it, played a part – only a part, but an interesting part nonetheless – in the disease's strange history of construction and de-construction. My argument is that the equivocal status of the images mirrors the equivocal history of the disease itself.

The new tropical medicine: the view from the tropics

All that we know of Brazilian medicine in the nineteenth century shows us that physicians, conscious of the ambiguities inherent in the notion of medical tropicality and of their own place in European medicine, tried to make a virtue of their expertise in their distinctive milieu while avoiding the charge of being doomed to climatic, geographic and racial fatality. Such strategies, consciously adopted or not, fitted in well with the assertion of a Brazilian medical identity (as opposed to either a Portuguese colonial or European one). In exploring their tropical milieu, doctors claimed that many conditions in the country, such as tropical anaemia, were especially or even uniquely Brazilian, and that their control was possible through the application of superior Brazilian medical skills acquired locally.[8]

Given the increasingly negative and fatalistic account of tropical climates and diseases found in medical geography in the nineteenth century, however, we can understand why many of the younger generation of Brazilian physicians, trained in the 1880s and '90s, turned with such enthusiasm to the new microbiological sciences developed by Pasteur, Koch and others. Ross's discovery of the mosquito transmission of malaria in 1897 and, even more relevant to Brazil, the Reed Commission's confirmation of the mosquito transmission of yellow fever in 1900, followed by the successful control of the disease in Havana and Panama, had a galvanizing effect on public health. For the first time in Brazil's history, it became a clear political objective. As the Director of Public Health in the fast-growing city of São Paulo remarked in 1900, if illnesses like yellow fever turned out to be microbiological in origin, this would prove that disease 'was not the daughter of climatic agencies that are peculiar to our country, but the result of factors affecting all countries and upsetting all nations'.[9] Microbiology thus offered a new universal paradigm of disease causation, within which Brazil would find itself in company with the rest of the world, freed from a long history of climatic stigmatization.

And indeed, the microbiological sciences had a decisive impact on public health. Within two years of the Reed Commission's proof of the mosquito theory, Brazil's federal government funded its first systematic public-health campaign in the capital against yellow fever (and plague and smallpox as well). Led by Oswaldo Cruz, who had recently returned from two years training in Paris, including a spell at the Pasteur Institute, the campaign succeeded in eradicating yellow fever in three years by means of the systematic elimination of the *Aedes aegypti* mosquito. For the first time since the 1860s, European immigrants could find in Rio freedom from the deadly yellow jack.[10]

Cruz's success in controlling yellow fever was instrumental in consolidating the new experimental microbiology as a research science as well as an instrument of practical public health. At a farm called Manguinhos situated several kilometres outside the city, a small laboratory producing vaccines and anti-serums expanded under his management. In 1905, he hired an architect to design a Pasteur Institute for Brazil, which the Brazilian Congress approved as an Institute of Experimental Pathology in 1906. Architecturally some-what bizarre yet imposing, in extravagant Moorish style copied from a scientific institution in Paris, with baroque cupolas and expensive patterned tiling, the finished buildings, which were opened in 1907, housed some of the most modern laboratories in South America. Photographs of the young medical researchers at work at their micro-scopes, in their white coats, presented a scene of up-to-date experi-mentalism at odds with the stereotypical picture of the Latin American doctor as a lettered gentleman of the most old-fashioned kind. Manguinhos was the image of a new 'city on a hill', literally and figuratively a palace of scientific modernity – clean, orderly, a site of knowledge production and experiment, far in its airy brightness and calm from the confusion, chaos, dirt and pulsing humanity of Rio. Cruz himself was pictured as a hero of Brazilian public health, and the institution was named after him (illus. 69).[11]

Constructing Chagas's disease

It is against this background of scientific modernization and labora-tory medicine that we can appreciate the importance initially attached to Chagas's discovery in Brazil.

Born in 1879, Carlos Chagas came from the state of Minas Gerais to Rio de Janeiro for his medical training, from there joining the Oswaldo Cruz Institute. In 1907, he was sent back by Cruz to his home state to investigate the severe epidemics of malaria that were

ravaging railway workers. There, in a rural community called Lassance (made temporarily famous by Chagas's work), Chagas was introduced to a large biting insect, a Reduviid bug known locally as the *barbeiro* (the barber), because of its tendency to bite people's faces (illus. 70). The insect, which resembles a large bedbug, infested the mud walls of the houses of the poor, coming out at night to feed on their blood.[12] In the hindgut of one specimen of this bug, Chagas noticed the presence of a microscopic organism similar to, yet different from, other trypanosomes with which he was familiar. Sending the bugs back to the Oswaldo Cruz Institute, Cruz and Chagas were able, in a series of experiments, to identify the trypanosome as new to science, and through experimental inoculations of laboratory animals to prove that the parasite was pathogenic.

Naming the parasite *Trypanosoma cruzi* after his mentor, Chagas quickly claimed priority for his discovery by publishing a short article in a German medical journal and elsewhere (illus. 71).[13] Suspecting that the trypanosome might cause disease in human beings, he then returned to the town where he had set up scientific camp and there, after some difficulty, was able to detect the presence of the trypanosome in the peripheral blood of a child called Berenice, who

69 A newspaper cartoon showing Cruz as the hero of Brazilian public health, 1908. Casa de Oswaldo Cruz.

70 *Triatoma megistus*, the vector of Chagas's disease, plate 9 from *Memorias do Instituto Oswaldo Cruz*, 1 (1909).

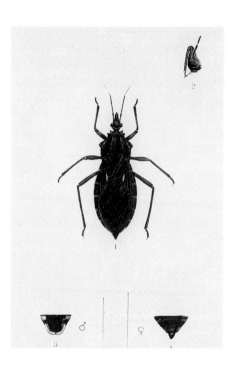

71 *Trypanosoma cruzi*, the parasite causing Chagas's disease, plate 12 from *Memorias do Instituto Oswaldo Cruz*, 1 (1909).

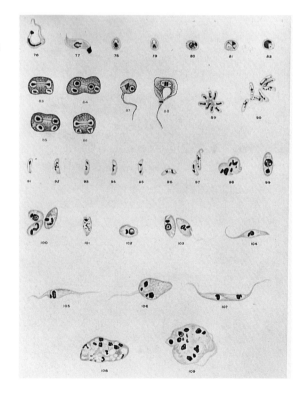

suffered from facial swelling (oedema) and an acute fever, which Chagas believed were the effects of a bite by the *barbeiro*. A new human disease was thus identified (illus. 72). Chagas proceeded to widen his understanding of the clinical signs of the disease – to incorporate into the disease category many chronically ill adults showing a diverse collection of odd and nasty clinical symptoms, such as profound anaemias, oedemas of the face and glands, irregular heartbeats, strange motor ataxias and paralyses, infantilism, idiocy and cretinism (illus. 73).[14] Many of these symptoms had been seen before, but they had never been drawn together to form a single clinical entity.[15]

It has been said of Chagas's disease that its discovery is unique in the annals of medicine in that Chagas first found an insect vector without a disease, proceeded to identify a parasite, still without a disease, and only later connected both to a distinct disease entity which had not been recognized as such before then. Later, Chagas said that the extreme signs of morbidity in the local population had puzzled him from the first, though the record is not clear on this point. Many of the clinical signs were common to other diseases (motor ataxias in syphilis, anaemia in hookworm disease), but Chagas maintained that in his case they were symptoms of a quite different disease, which was the consequence of trypanosomes invading the human heart muscles, lungs, endocrine organs and brain. He separated out the disease, then, as a unitary entity, adjusting his clinical definitions of it as his research proceeded.

The apparently unusual sequence of discovery was, however, precisely the weak point in the disease's conceptualization and the source of many later confusions and disagreements. The links between parasites and disease were loose, not tight; it was as though there were signs looking for parasites, and parasites chasing signs. It has to be said in Chagas's defence that the disease that bears his name *is* very odd; to this day it is difficult to diagnose because of its variable symptoms. Moreover, on many aspects of the disease, Chagas was very astute in his judgements. For example, he correctly distinguished between the acute and chronic stages. He also realized that, on the one hand, the acute stage often goes unnoticed by its victim or the doctor because it most often occurs in the young and can be symptomless, but that, on the other hand, it can involve fevers and intense anaemia and is sometimes fatal. He also realized that in the acute stage, the parasites can sometimes be detected in the victim's peripheral blood.

Chagas also recognized the significance of heart irregularities to the chronic condition. He predicted that the disease would be found

to have a widespread incidence in the Americas in general. He discovered, too, that the trypanosome parasites were carried by several different species of triatome insects, and in addition were harboured by many wild and domestic animals, such as the armadillo (today, we know of eight different mammalian orders which can be infected by the parasite). This means that there exist vast reservoirs of the pathogen in animals, raising serious obstacles to disease control.

72 'Carlos Chagas with Berenice at Lassance'. Berenice was the child in whom Chagas first discovered the trypansome in the peripheral blood, thereby establishing the existence of the disease that bears his name. Casa de Oswaldo Cruz.

73 'Paralyzed child', one of the key representations of Chagas's disease in Chagas's day, from *Memorias do Instituto Oswaldo Cruz*, 8 (1916).

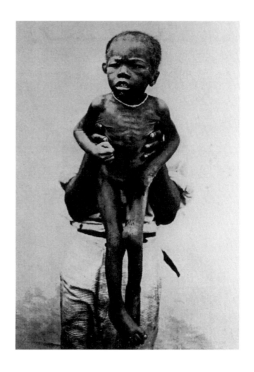

But Chagas's conceptualization of this illness was wrong in several respects. He was wrong, for example, in his interpretation of aspects of the evolutionary cycle of the parasite, and about the mode of its transmission from the insect to humans.[16] He was, crucially, quite wrong in some of his ideas about the chronic symptoms. Looking for clinical signs to tie to a vector and a parasite opened up a Pandora's box of possibilities. And being a stubborn man, proud of his scientific accomplishments and inclined to think criticisms of his work were politically motivated and partisan (suspicions not entirely without substance), he clung tenaciously to his views, thus blocking alternative insights.

In 1909, however, such difficulties lay in the future. At this time, Chagas's surprising discovery electrified Oswaldo Cruz; here, it seemed, was the kind of fundamental scientific work that Cruz dreamed his Institute would carry out, something that would make Brazilian scientists partners in tropical medicine, not merely the often-despised and marginal recipients of knowledge from abroad. When Chagas announced that he had finally been able to see the trypanosome in children with acute fevers and associated clinical symptoms, Cruz quickly announced the fact at the National Academy of Medicine and organized a committee, composed of many of Rio's medical luminaries, to go to Lassance to see the disease for themselves. It was at this point that it was proposed that the disease be named 'Chagas's disease'. In 1910, Cruz promoted Chagas over other, longer-serving members of the Institute, because of his scientific publications and European reputation (a reputation greatly enhanced by his close collaboration with two European scientists, Prowaseck and Hartmann, both protozoologists who happened to be at the Institute in 1909 when he first worked out the developmental cycle of the trypanosome).[17] In effect, Chagas's disease became critical to the Institute's scientific identity, with Chagas identified by Cruz as his scientific heir.

Consciousness of the importance of Chagas's disease to Brazilian pathology intensified in the period leading up to the First World War. Chagas himself became more and more alarmed at the social and economic costs of the illness, and used every opportunity to speak out about its terrible consequences. Expressing himself with great pungency and forcefulness, at times the language he used to describe its effects bordered on the apocalyptic. At a medical conference in 1912, for example, he portrayed the Brazilian interior as a hecatomb of illness – a 'necropolis' he called it. Chagas's disease, he said, rendered people in rural areas cretins, idiots, 'miserable creatures' of horrid aspect who were a reproof to the 'moral greatness of a nation-

ality'. He contrasted the majesty of nature and exuberance of the flora in the backlands (a cliché of tropical romanticism that was wearing thin) with the meagre, diseased population, which, lacking all productive energy, was doomed to morbidity. Chagas's disease, he believed, was a disease of the mixed, poor, semi-civilized Brazilian race; it was a 'monstrous' element in the tropics.[18]

This alarming picture was given apparent validation between 1911 and 1913, when the Oswaldo Cruz Institute sent a series of medical expeditions into the interior to document health conditions and assess the barriers they posed to economic development and European immigration. For the first time, perhaps, city-based physicians got some measure of the truly appalling conditions in which the rural poor lived, a sense of the major diseases from which they suffered and of the sanitary barriers to development.

Most important to the Chagas story was the seven-month, seven-thousand-mile-long journey through the north-east made by two young doctors from the Institute, Artur Neiva and Belisário Penna, in 1913. (The fact that Penna had been with Chagas when he had first discovered Chagas's disease may have predisposed Penna to find so many cases of the disease on his travels.) Journeying mainly on horse-back and by mule across some of the poorest states in the country, the doctors were shocked by what they saw. In many villages, they said, almost the entire population was paralyzed, mentally degraded or cretinous from infection with the trypanosome. The diary and scientific report of their journey, eventually published in 1916 along with more than a hundred photographs of the topography, houses and medical and social conditions they encountered, formed a savage indictment of the extreme poverty in which so many of their fellow citizens lived. The geographical, medical and mental distance separating these places from the cities on the eastern seaboard was immense; the extent of illness revealed how thin the veneer of sanitary modernity really was. 'Except for the capitals and a few towns,' wrote Neiva and Penna,

most of the other areas [of Brazil] are vast, abandoned territories, forgotten by our leaders, with populations vegetating in misery and ignorance ... If we were poets we would write a tragic poem, with descriptions of the squalor of our unfortunate inhabitants forsaken in the wilderness ... Our children, who learn in school that the simple life in our wilderness is full of poetry and enchantments, due to the health of the inhabitants, the abundance of our soils and the generosity of nature, would know instead that these regions are better described as a hell on earth, which could only be adequately described by a Dante.[19]

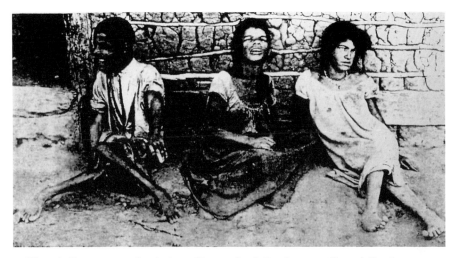

74 'Chagas's disease, nervous form', pictured in an asylum in Brazil, *c.* 1912. Chagas believed Chagas's disease caused mental retardation. From Belisário Penna, *O Saneamento do Brasil* (Rio de Janeiro, 1918). Casa de Oswaldo Cruz.

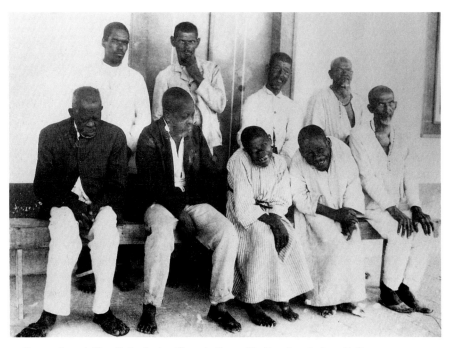

75 Group of people identified as having Chagas's disease, São Francisco Asylum, Goiás, Brazil, 1912. Casa de Oswaldo Cruz.

The journey made Penna a propagandist for rural sanitation. During the First World War, in popular books, illustrated pamphlets and newspaper articles and radio broadcasts, he reiterated his theme: Chagas's disease infected some 15 per cent of the country's population (i.e. over six million people). It therefore checked all fantasies about tropical rural health and beauty. The reality was one of the 'dolorous morbidity of the Brazilian population'. Together with numerous other physicians, Penna formed and joined new pro-sanitation organizations and political pressure groups, which merged with other nationalistic and eugenic societies to urge the government to take up the cause of sanitation and extend the benefits of public health to rural areas. At the end of the war, he published a devastating account of sanitary conditions, identifying hookworm, malaria and Chagas's disease as the three great scourges of the rural population, using many of the same phrases to describe the paralyzed creatures of Chagas's disease as Chagas himself had earlier.[20] Penna's striking photographs provided visual evidence for his argument (illus. 74, 75).

Seeing photographs

From early on, such photographs were important in bringing home the significance of Chagas's disease. I say 'bringing home' deliberately, because Chagas's was a disease of the rural population in a vast country whose interior geography and inhabitants were as unknown to the urban élite as the disease itself. Photographs of the *chagasicos* (as those suffering from the illness were called in Portuguese, the name seeming to incorporate both Chagas's name and the sense of a 'wound', which is what the word *chaga* means) were first utilized in professional addresses and journals. Chagas also took photographs to medical congresses and exhibitions in which Brazil participated, such as the International Exhibition of Hygiene and Demography held in Dresden in 1911. On this occasion, which overlapped with a meeting of microbiologists, more than two thousand people visited the Brazilian pavilion during a period of two months. Chagas's disease, which was still completely unknown to most European physicians, attracted considerable attention, because of the great interest doctors had in African sleeping sickness at the time. A short movie showing some of Chagas's paralytic and retarded patients met with particular applause; the disease was seen as an exotic condition special to hot, tropical climates, and Chagas's work as a great contribution to tropical science.[21]

But as the photographs (and verbal representations) moved outwards to the larger and more public domain of popular journals and newspapers (which assiduously followed every event in Europe involving Brazilians), they began to provoke negative reactions and struggles over meaning.[22] From taking pride in Chagas's scientific achievement, some doctors and politicians began to attack him – his priority in discovering the causative organism, his claims about its wide distribution and, above all, his ideas about its clinical manifestations. Some critics almost went so far as to deny that the disease existed at all. The photographs could not, of course, be made to disappear, but they could be reframed or reinterpreted to tell a different tale, one that minimized their claims to reality.

Medical photographs draw attention to suffering, and in so doing can enlarge our sympathy for disease victims. But, as we have seen, they are also often disturbing and may limit rather than engage our capacity for empathy. The medical photographs of Chagas's disease were caught in this web of potentialities; on the one hand, they were part of a medical inventory which increased Brazilians' awareness of the suffering of the poor and sick in the interior; on the other, they showed deformed racial 'others' presenting disagreeable portraits of a tropical nation that many preferred not to see.

As I have said, Chagas's disease was unusual, in that it assembled in one disease a miscellany of clinical symptoms and conditions that had hitherto been disarticulated. The clinical symptoms were often bizarre and ones to which great stigma was attached – paralyses, huge goitres, mental retardation and idiocy.

The strange impression made by Chagas's disease was described by a medical clinician who had gone to the countryside in 1909 to witness what Chagas had found; he was shown, he said, a 'museum of rarities of Chagas's disease – several dozens of ill people of all ages, some idiots, others paralysed, others with heart disease, all with thyroid conditions ...'[23] It is important to note that, though Chagas's disease affected the fewest people of the three endemic illnesses identified by doctors by the time of the First World War as the chief diseases of the rural population (15 per cent, compared to 90 per cent for hookworm disease and 40 per cent for malaria), its chronic stage appeared to mark itself on the body in ways that the other two diseases did not. Most peculiar of these visible symptoms were the huge goitres seen in some of the first patients identified with Chagas's disease (a particularly dramatic one used to illustrate the disease is shown in illustration 76, based on an autopsy). In 1909, Chagas had mentioned the involvement of the thyroid (to which goitres are

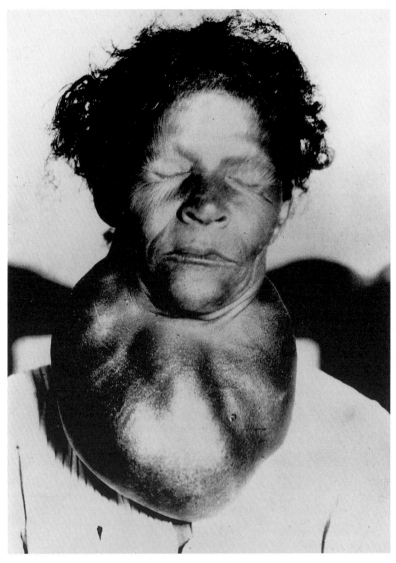

76 'Woman with goitre, based on autopsy'. Chagas believed that goitrous conditions like this were a result of trypanosome infection. From Chagas, 'O Mal de Chagas', *Archivo da Soc. Med. Cir. S. Paulo*, 3 (1912), pp. 34–64. Casa de Oswaldo Cruz.

connected) in passing, but goitres were not signalled as significant clinical signs. But as he turned his attention from the parasites to the clinical symptoms, endemic goitres, the disfiguring growths in the neck that were well known in certain areas of rural Brazil and that had long been associated with mental retardation, were folded into the disease as an outcome of parasitic infection.[24] Why Chagas rejected

the more familiar iodine-deficiency theory of endemic goitre is very puzzling. He may have got the idea that the goitres were parasitic in origin from the local inhabitants, who apparently believed that there was a connection between goitre and the blood-sucking *barbeiro*.[25] In addition, the aetiology of goitre was not entirely settled at the time, several medical researchers maintaining that goitre might be due to an infectious agent.[26] It may also be that Chagas had in mind an analogy with African sleeping sickness, which affects the nervous system and produces glandular tumours in the neck.[27]

In his writings about Chagas's disease, however, Chagas made no reference to these possible sources for his ideas, but instead justified the incorporation of goitre into Chagas's disease, and the separation of 'his' goitre from endemic goitre found in Europe, on the basis of the overlap in the geographic distribution of endemic goitre and triatome insects in Brazil, thus suggesting a different aetiology for goitre in the tropics than in Europe. He also believed that differences in the iodine content of the water did not differentiate the regions where endemic goitre was found from those where it was not (whereas the distribution of the *barbeiro* insect did). Lastly, he was probably persuaded by the results of the autopsies carried out in 1911 on ten patients who had died in the acute phase of trypanosomal infection, which seemed to confirm his clinical insights by showing pathologies and disturbances of the thyroid.[28]

So important did goitres become to the identity of Chagas's disease that within a few years of his discovery, the name 'parasitic thyroiditis' (*tireioditis parisatária* in Portuguese) was perhaps the most common one used in Brazil for the illness. Since acute cases (involving fevers) were hard to spot while the chronic condition apparently involved goitres, which anyone could see, goitres became a defining visual element of Chagas's disease.[29] They lent themselves to the photographic visibilization of disease processes in the body that was so much a part of scientific medicine.

Given the long association between goitre, mental backwardness and racial degeneration, however, the portraits of the goitrous *chagasicos* were very disturbing, especially if their numbers were as Chagas stated, and especially to non-medical eyes. As I have noted, Sander L. Gilman has shown that images of beauty and ugliness are closely tied to Western ideas about health and disease, and the representation of Chagas's disease barely avoided stereotyping the entire Brazilian nation with exaggerated signs of racial deformation and tropical pathology.[30] Chagas did not help matters by his constant use of the adjective *monstrous* to characterize the symptoms and the diseased population.

Some of Chagas's supporters recognized that the way Chagas's disease *looked* was indeed part of the problem. Dr Miguel Couto, a prominent clinician in Rio, a member (and later President) of the prestigious National Academy of Medicine and a defender of Chagas, took the view that the disease was a national scourge that made his tropical country a 'vast hospital' of paralytics and idiots.[31] When the newspapers attacked this negative picture, Couto commented that his view was not based on mere opinion but on objective scientific facts, that he was simply saying out loud what was normally kept quiet. In an ironic reference, he remarked that 'a refined urban civilisation prohibits the exhibition of Chagas's and repellent diseases that make the fortunate people who live in cities feel disgust at seeing them.'[32] In 1911, the Minister of Agriculture, after attending a lecture by Chagas himself, was moved to comment that it was a national disgrace, and one which he feared would put Brazil in an invidious position in relation to other countries, especially where attracting European immigrants was concerned. Would Chagas's disease prove to be exclusive to Brazil, he asked? Did it not present a picture of a country at the mercy of an illness that destroyed that country's intelligence?[33]

Such worries intensified after the First World War, a period of growing nationalism. Chagas's disease, lacking a medical cure, presented a new challenge to the programme of sanitary improvement.[34] It also seemed to come uncomfortably close to undoing the goal of racial whitening, which, as we have seen, was being elaborated as a nationalist objective at the same time. In effect, the ethnic character and strange deformities of the population with Chagas's disease seemed to threaten to submerge Brazilian national identity once again in blackness and pathology. Because Chagas made endemic goitre a central fact of a widespread parasitical disease and maintained therefore that goitre in Brazil was different in kind from European endemic goitre, Brazil seemed to stand out in its cretinous, black peculiarity. Portraits of the disease, in the circumstances, were seen as an embarrassment to national self-representation. The importance of this was evident, for example, in 1923, when word got back to Rio about the materials Chagas had taken to demonstrate his disease at an international medical conference at Strasbourg. Newspapers accused the country's leading medical scientist of a lack of patriotism – of detracting from Brazilian nationality by representing the country in terms of the 'national monsters' of Chagas's disease.[35]

Even before the Strasbourg meeting, Chagas had found himself having to answer for his characterization of Chagas's disease in an intense and drawn-out debate at the National Academy of Medicine, a debate with many charges and countercharges, a year-long medical commission of inquiry and the active involvement of the newspapers, which the protagonists used to score points. It signalled the most public manifestation of doubt and disagreement about Chagas and his disease, and its effect was to deconstruct the narrative of tropical illness on which he had pinned his entire scientific life.

Of the many political and medical figures who participated in this debate, I single out the physician whose provocative remarks in November 1922 precipitated the inquiry into the disease: Dr Afrânio Peixoto, Professor of Public Hygiene at the Rio Medical School. I choose Peixoto because I believe that his part in the dispute highlights particularly well the issue of the representation of Chagas's disease. In effect, to Chagas's narrative of Brazilian disease and identity, Peixoto offered a sharp counter-narrative. Without an understanding of this counter-narrative, Peixoto's role in the debate over Chagas's disease is somewhat puzzling. The essence of his message was simple. Tropical diseases, he said, did not exist. To claim, as Chagas did, that Chagas's disease was the paramount expression of Brazilian identity, and the exemplary disease of the new tropical medicine, was, to Peixoto, an affront to Brazilian aesthetic and intellectual sensibilities.

Ironically, it is in relation to the burdensome connotations of 'tropicality' that we can situate the extraordinary enthusiasm with which Peixoto, along with many doctors in the tropics, initially greeted the new sanitation sciences of microbiology. Peixoto, Chagas's exact contemporary, had gone, like Chagas, to make his medical career in the federal capital, where he arrived in 1902. Instead of joining the Oswaldo Cruz Institute, however, Peixoto competed successfully for a position in the faculty of hygiene at the Rio Medical School, and it was as a hygienist that he made his name, defining the field more broadly than Chagas, and in less technical and experimental terms. In 1916, Peixoto succeeded to the Chair of Public Hygiene, where he lectured on the subject to medical students. A prolific and extremely successful author of essays, literary romances, medical textbooks and popular medical commentary, a member of the Brazilian Academy of Letters and as much a figure in Rio's literary and social life as in medicine, Peixoto enjoyed controversy and provoking his medical colleagues with his criticisms of their exaggerated faith in the power

of medical science to prevent disease at the expense of a wider view of preventative hygiene.[36]

Peixoto's defence of his tropical milieu was connected to both climatic and racial issues, especially his fear that Brazil's racial destiny, without European immigration, would indeed be black. He was therefore concerned to present his country as a place suitable for whites. Welcoming the new microbiology, he was wary of seeing the notion of tropical distinctiveness resurrected in its name.

The title of his medical pamphlet, 'Climat et Maladies du Brésil' (1907), highlighted the crux of the matter for Peixoto. Published in French (still the preferred language of the educated élite) as well as Portuguese, and written as a piece of medical propaganda about the country's attractions for immigrants and investment, the pamphlet made the point that the health problems of tropical countries were no different from those of temperate ones. If anything, Peixoto said, Brazil was potentially better situated than many other places, because it had no major indigenous diseases, and all the important epidemic illnesses were imports.[37] He compared the coefficient of mortality in Brazil's major cities favourably with those of Rome, Dublin, Marseilles and Madrid. Peixoto's life work was therefore to defend the Brazilian tropical milieu against criticism, and to negate the idea of specific tropical diseases understood climatologically.

In the pre-microbiological period, Peixoto said, diseases in temperate areas were considered to be independent of climate, whereas in the tropics the climate was considered to be their essential cause. This reasoning was deeply entrenched and had justified passivity towards disease in the tropics. Now, however, the new orientation made possible by the microbiological sciences meant that diseases such as cholera and yellow fever had a known aetiology independent of climate. They invaded countries in all latitudes and fell back where hygiene was used to vanquish them. The truth implied by this, a truth he considered to be very simple but with obvious consequences for the ability of countries to master their environments and develop economically, was that tropical diseases did not exist. The new formula of tropical illness could be summarized as follows: 'There exist only preventable diseases, against which hygiene has the means of defence and reaction.'

Since specifically tropical diseases did not, in his view, exist, a specifically *tropical medicine* was not required; Peixoto therefore worked with his colleagues at the Rio Medical School to block, successfully, the government's effort to establish a new Chair in Tropical Medicine there in 1905 (the first such chair to be proposed in the country).[38] This denial of the object of investigation – the tropical disease – just as it was

being created by a new scientific speciality suggested that tropical medicine, a fundamentally European and colonial discipline, would not necessarily be well received by physicians from tropical countries situated outside the formal colonial structures of Europe.[39]

Initially, Peixoto did not seem to find Chagas's disease to be a threat to his own story of preventive hygiene, sanitation and racial purification. But as the claims about Chagas's disease grew, and its representations began to circulate beyond medicine, the disease appeared to Peixoto to enfold the country once more into the category of the tropically and racially peculiar that had dogged Brazil for so long. Over time, his enthusiasm for microbiology itself began to decline, as he came to believe that the advent of the microbiological era, far from encouraging a more universal application of broad, preventive hygienic principles, was instead leading its proponents to an exaggerated sense of tropical environments as teeming with harmful micro-organisms inherent in tropical spaces.[40] In contrast, in Chagas's inaugural lecture on assuming the Chair of Tropical Medicine which was finally established in 1925–6 with the help of the Rockefeller Foundation, he defended the speciality of tropical medicine on the grounds that Brazil's climate did in fact play a significant part in providing the kind of environments in which specific types of parasites and vectors that caused disease could survive. While this was not a return to the old climatology and tropical raciology, the specificity of parasitical diseases, Chagas argued, was sufficient to justify a specifically 'tropical' medicine.[41]

Given Peixoto's long opposition to tropical medicine as a separate medical discipline, it was not surprising, perhaps, that as the new speciality rose to prominence, as the Oswaldo Cruz Institute acquired resources and established its autonomy from the more traditional Medical School where Peixoto himself held the Chair in Public Hygiene, as Chagas's disease was promoted by Chagas as perhaps *the* most interesting aspect of Brazilian ill health, and as Chagas personally gathered positions and garnered fame, Peixoto began to snipe at him. He attacked what seemed to him and to many of his colleagues too hasty an embrace of a medical speciality whose fundamental identity was colonial. In addition, the racial blackness of the Chagasian representations, and the extraordinary and deforming goitres giving visually a horrible representation of the Brazilian population, was attacked as insulting to national pride.

Almost from the first, Chagas's identification of goitre with parasites had seemed wrong to some doctors. As medical scientists began to look for Chagas's disease outside Brazil, his disease ran into diffi-

culties. Most significant here was the criticism voiced at the Pan American Medical Congress in Argentina in 1915, which Chagas was invited to address (this was in fact his first trip outside Brazil). To his surprise, he found himself under attack. Dr Rudolph Kraus, a European-born immigrant to Argentina who headed the Bacteriological Institute in Buenos Aires, and who had been carrying out studies of the *barbeiro* vectors and the trypanosomal parasite for some time, reported to the Congress that though the triatome insects were commonly found in Argentina and showed high rates of trypanosomal infection, the human disease, at least as described by Chagas, could not be found. Endemic goitre, and its associated idiocies and nervous paralyses, Kraus maintained, had nothing to do with the parasite. Kraus therefore raised doubts about both the clinical character of the disease and its extent.[42]

Kraus's intervention came as a bombshell. But Chagas clung to his goitre theory, answering Kraus as best he could. He accused Kraus of lacking clinical experience and therefore of not being in a position to spot clinical cases of the disease; he suggested that perhaps goitre in Brazil had a different aetiology from that elsewhere, proposing that the trypanosomal parasite had not fully adapted to human hosts in Argentina (and therefore was not found in them). On his return to Brazil, Chagas's friends rallied in his defence. It is probable that the doubts raised by Kraus were the reason why, three years after their journey through 'Chagasian country', Neiva and Penna's report was finally published. This account seemed to provide abundant clinical and photographic evidence of the widespread distribution of Chagas's disease in Brazil, especially of the disfiguring goitres that gave it visual definition (illus. 77, 78).

At the time, the effect of Kraus's criticisms was paradoxical. So tied was goitre to the perceptual framework of Chagas's disease and its representations that many physicians, looking for goitres as signs of the existence of the disease in their countries and not finding them, came to the conclusion that Chagas's disease was not present. Meanwhile, those who, like Kraus, were sure that goitres had nothing to do with the disease also dismissed it because other indications, such as parasitic infections in the blood, were often difficult to detect. In either case, seeing was believing, and goitres were the critical sight in the conceptual confusions surrounding the illness. The fact that Chagas infection is both widespread and has nothing to do with goitres was not established until after Chagas's death, when systematic analysis of populations in non-goitrous areas was undertaken and the disease redefined.[43]

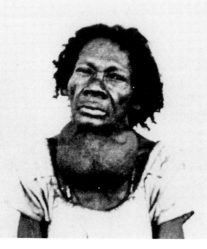

77 'Woman with goitre', 1912. Casa de Oswaldo Cruz.

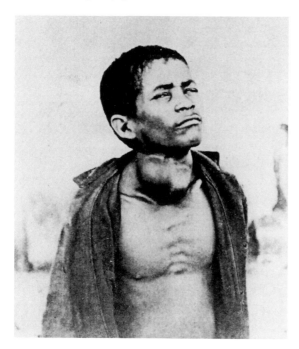

78 'Man with goitre', 1912. From Artur Neiva and Belisário Penna, 'Viagem científica pela norte da Bahia, etc.', *Memorias do Instituto Oswaldo Cruz*, 8 (1916).

A number of political factors as well as scientific questions played their part in the dismantling of Chagas's disease that followed the First World War. Among them was Chagas's alliance with the federal government between 1919 and 1926, these being the years he served as Director of the National Department of Public Health under a deeply unpopular President. Restive under federal control, the more powerful Brazilian states refused to direct their policies, for example in such matters as health, according to federal dictate. The 1920s saw the breakdown of the old system of governance of the Republic, preparing the way for its complete collapse and the eventual emergence of a semi-fascistic regime in the late 1930s. The period witnessed a number of military and regional revolts against the federal authorities, and the use of repression and censorship to suppress political opponents of the government (including the jailing, for political reasons, of several outspoken physicians, whom Chagas failed to defend). The result was the alienation of many of Chagas's colleagues from him. His close dealings with the American Rockefeller Foundation (which took over the organization and management of yellow-fever control, the area of public health in which Brazil had achieved its greatest success and had the greatest pride) was another source of resentment and resistance among some Brazilian physicians, who found themselves and their ideas about how to achieve public health marginalized.[44]

Thus, to scientific uncertainty about the true character of Chagas's disease were added political and social disagreements about the meaning of the tropics, the nature of Brazilian nationalism and the representation of the nation, all of which helped to unravel Chagas's construction further. Chagas's critics began to question the incidence of the disease – to insist it was not common, but rare; that endemic goitre was not Chagas's disease, an exotic pathology special to tropical Brazil, but the same as the condition found in Europe. They questioned the disease's visibility; if it was so visible, they asked, why was it so hard to find? They placed the visible signs of disease and degeneration, which could not be simply wished away, in a different framework less threatening to national pride. Among these critics, Afrânio Peixoto played the part of agent provocateur, using innuendo and subtle insults to bring the criticisms of the disease into more public view.[45] Peixoto's opening salvo was a veiled reference to Chagas in a lecture to the Rio Medical and Surgical Society in 1922. You have, he implied to Chagas, 'invented a rare and unknown disease, a disease

about which people speak a great deal, but whose victims almost no-one knows, sequestered as they are in a distant place in your home state', a disease, moreover, 'which you magnanimously distribute to some millions of your compatriots, accusing them of being cretins'.[46] Furious at this apparent slur on his intellectual honesty and his science, Chagas demanded that the National Academy of Medicine immediately set up a scientific commission to decide on the reality or otherwise of his discovery, threatening to resign from the Academy if it did not. Since Chagas was the most famous medical scientist Brazil had – even, rumour had it, a possible nominee for the Nobel Prize in medicine – the charges against him threatened to create a scandal. The quarrel quickly spilled over into the press.

During the debates, in contrast to Chagasian gloom, Peixoto presented Brazil as a potentially hygienic society, minimizing Chagas's disease on grounds of aesthetics (it was too black and too ugly), intellect (it made Brazilians into cretins) and patriotism (it defamed Brazil abroad) rather than rejecting it altogether.[47] According to Peixoto, Chagas, in his zeal to win international recognition, had grossly exaggerated the importance of the disease at the expense of Brazilian nationality. Peixoto's story was that the number of cases of the disease investigated and actually documented by Chagas (40, claimed Peixoto, or perhaps 80, but certainly not the four or five million implied by Chagas), were *all* the cases there were in the country; that the disease was not *Trypanosomiasis americana*, or *Trypanosomiasis brasiliana*, or Chagas's disease, or *barbeiro* disease, or *parasitic thyroiditis* – all names used for Chagas's disease and suggesting the epistemological uncertainty about its identity – but, at the most, 'the disease of Lassance', a disease, that is, of the little town where the patients had first been studied and photographed. In this fashion, the story of tropical disease in Brazil was retold and the photographs of Chagas's disease reduced to a minor place in Brazilian identity; *they* were not Brazil, but represented only some few sick and poor people in the distant backlands, who could be looked at with pity, or with disgust, as racially diseased objects that could not threaten the hygienic and potentially European destiny of the tropics. Chagas's disease was in this manner spatially localized and visually quarantined.

Chagas's representation was quite different. During the 1922-3 debates at the National Academy of Medicine, and until his death in 1934, he defended the extent, character and seriousness of Chagas's disease in Brazil (and the place of goitre in it). The number of acute cases established medically, he claimed, ran into the hundreds, the

chronic ones into the thousands. He was, he said, a scientific patriot concerned with scientific truths. *Trypanosomiasis americana* was, he believed, the most indicative disease in Brazilian tropical medicine, a morbid entity probably affecting some 15 per cent of the population. It was *essentially* Brazilian, not because it would prove eventually to be exclusive to Brazil, but because its existence had been discovered, its epidemiology clarified and its clinical signs studied in the country. It was therefore, in his words, a 'new chapter in tropical pathology'.[48]

Though the year-long medical inquiry into Chagas's disease set in train by Peixoto's attack came to the conclusion that Chagas had indeed identified the parasite and vector of a new illness in humans, it left open (as lying beyond the scope of its investigative powers) the two questions at the heart of the dispute: the place of goitre, and the extent of the disease's distribution. Chagas's scientific honour was thus narrowly vindicated by a scientific vote, but the disease's status and extent – its real significance to Brazilian tropical medicine – were left completely open.[49] Such was the doubt about Chagas and his disease throughout the 1920s that his reputation was probably greater outside Brazil than within; parasitologists abroad were sometimes surprised to learn from Brazilian visitors that questions existed in Brazil itself about the disease's existence. In 1926, Chagas gave up his post as Director of Public Health and returned to his research at the Oswaldo Cruz Institute; but in many ways, he can be said to have died (of a heart attack, possibly the result of Chagas's disease) a harassed and saddened man.

Representing tropical diseases

What, if anything, can we say in conclusion about medical photographs in the contested narratives of tropical medicine?

The medical context is an especially powerful one for photographs, with strong reality effects. We invest in them, psychologically. Because one way of representing Chagas's disease had huge referentiality effects for people as individuals and as a collectivity or nation, the photographs of the *chagasicos* played a part in awakening Brazilians' concern for rural sanitation. However, they also led to the denial that the sick individuals *were* themselves or the nation, to distancing techniques that reduced the visibility of the *chagasicos*, and their meaning, for the urban population.

Ironically, the Chagasian portraits drew attention visually to the very aspect of Chagas's disease, the goitre, that was most contentious and scientifically misleading. With Chagas's death, the most important

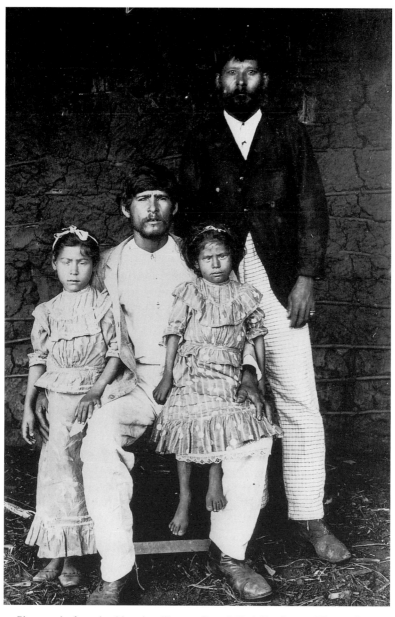

79 Photograph of people with various illnesses, Caracol-Piaui, Brazil, 1912. The standing man is suffering from 'entalação' ('frozen condition'), the seated man from 'mal d'engasgo' ('choking illness'), names given to conditions that prevented normal swallowing and speaking and which were connected much later to mega-oesophagus in Chagas's disease. Casa de Oswaldo Cruz.

barrier to its removal from the disease syndrome was gone, namely Chagas himself. Shortly thereafter, several physicians, Chagas's son among them, proved definitively that endemic goitre was not part of the syndrome of Chagas's disease. The same was true of infantilism and motor paralyses.[50] With the removal of an endocrinological identity to the disease, indeed, most of Chagas's chronic stages were also removed from the disease concept (which signified that nearly everything that Chagas had seen as chronic symptoms had been signs of something else).

Not so surprisingly, perhaps, given the power of the mind to structure what we see and how we see it, other signs of Chagas's disease were not recognized as such in Chagas's day. Among them was the infrequent, though characteristic, swollen eyelid indicating the bite of the *barbeiro* and known as 'Romaña's sign'.[51] Another was the very peculiar physical symptom of 'mal d'engasgo' (an obstruction or paralysis of the throat, which prevents swallowing and speaking for periods of time, causing strange periods of silence); this last symptom had long been recognized as very puzzling condition, and was one which Neiva and Penna themselves had described and even photographed on their journey through the Chagasian backlands. Today, it is considered to be the only clear, unequivocal clinical sign of chronic Chagas's disease, one that can be observed in the body but that is difficult to convey visually without the use of verbal descriptions (illus. 79).[52]

In his own lifetime, Chagas's disease passed from being a highly visible illness, signed on the body, to one that was virtually invisible, not only in its outward, bodily signs but in the larger world of medicine. Today, it is recognized that millions of people have the disease (five million in Brazil alone). But to this day, no effective treatment or drugs exist for those infected with the parasite. Eradication of the insect vectors by insecticides, or improvements in the quality of housing to prevent infestation by the triatomas, are the best hopes of its prevention.[53]

But the 'invisibilization' of Chagas's disease had already been carried out in Brazil in the 1920s, when it was removed as a central narrative of a tropical nation, and the patients with Chagas's disease turned into specimens of a rare illness, who represented only themselves, and not the viewer, nor tropical Brazil.

7 Tropical Modernism

In this final chapter, I return to the broad theme of tropical nature with which I started. My aim is to suggest some of the complexities of the notion of tropicality when it is examined from within a domestic or local setting. My focus is on the work of Roberto Burle Marx, a pioneer of landscape modernism whose marvellous and original landscape designs and tropical public parks are almost as characteristic of the city of Rio de Janeiro today as are the Sugarloaf and Corcovado mountains.

Intellectually, Burle Marx was heir to the evolutionary and ecological approaches to the natural world that Alfred Russel Wallace and others helped establish. He was one of Brazil's first well-known environmentalists, speaking out against the destruction of tropical biodiversity long before it became fashionable to do so in his country. Burle Marx was also known, like Humboldt and Wallace before him, *as* a 'tropicalist' – that is, as someone concerned and knowledgeable about tropical nature.

As a landscape designer, Burle Marx was among the first in his country to incorporate tropical plants into his parks and gardens as their signature elements. But in so doing, he created a radically different sense of the aesthetic and social possibilities of 'tropical nature'. Indeed, the impression made by his parks and gardens are about as far from the expected 'tropical' as we can imagine.

As an example, I begin with a picture of the small, urban roof-top garden Burle Marx built in 1936–8 for the new Ministry of Education and Health, the first building erected in Brazil in the new international, modernist style (illus. 80). Here, the plants have been subdued to fit a free-flowing but stylized and tightly controlled space. There is no attempt to recreate the feel of a jungle or to provide the experience of an immersion in a tropical Eden. The austere design challenges traditional views of tropical nature of the kind described in this book, as well as the European conventions of landscape aesthetics of Burle Marx's time. This garden offers a radical vision of what we might call

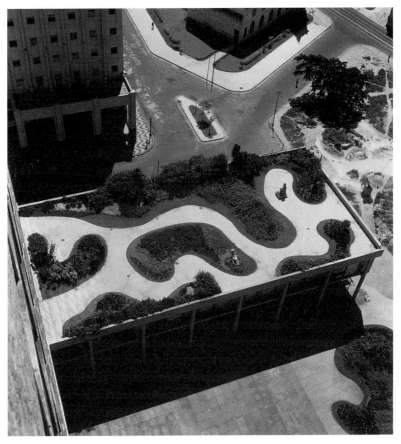

80 Roberto Burle Marx's roof garden at the Ministry of Education and Health, Rio de Janeiro, *c.* 1945. Instituto Moreira Salles.

'tropical modernism', a space that eschews tropical illusionism while nonetheless containing within it an appreciation of the tropical.[1]

At the same time, the immense effort required to maintain Burle Marx's deliberately achieved, minimalist effects is often not forthcoming from the state or his private patrons, so that his gardens, along with the modernist concrete buildings to which they are often connected, frequently fall into disrepair. The abstract patterns become obscured or lost due both to neglect and the fertile growth of the tropical vegetation. As a result, his gardens sometimes inadvertently recreate the very image of shabby disorganization and tropical super-fertility to which Burle Marx's designs might in several regards be said to be opposed.

I have chosen the garden as a way into the problematic of tropical nature, understood from and in the tropics, for several reasons. Since

tropical nature is, in the European tradition, often imagined as 'pure' if overabundant, unspoiled by or resistant to human activities, it seemed interesting to look at how nature has in fact been manipulated in the tropics to create a particular kind of controlled space. In his analysis of the garden in Western history, the landscape critic John Dixon Hunt proposes that we think of the garden or park as a way of processing the so-called natural or physical world for our consumption and aesthetic pleasure. Through the manipulation of space and vegetation, and through art, a 'first nature' (a supposedly unmediated nature, or wilderness) and a 'second nature' (a nature based on utility and containing built objects such as houses, bridges and roads, as well as worked fields) are transformed into a 'third nature', an artificial landscape that responds to what is seen as wild. A garden is thus, he says, an artefact, an artistic achievement and a milieu of control over space and nature and, as such, 'the most eloquent expression of complex cultural ideas'.[2]

The designed landscapes of Burle Marx are excellent examples of such complex cultural ideas, but also underexamined ones. Dixon Hunt comments that the marked emphasis in most writings on modernist gardens on form over content, or on style at the expense of history, context and meaning, has resulted in few such landscapes receiving the critical attention they deserve.[3] This is the case with Burle Marx's designs and completed landscapes; critics generally approach them in relation to the formal, ahistorical, stylistic terms in which they seem to present themselves to the viewer.[4] What is needed is an evaluation of how Burle Marx's modernist landscapes, in their specific geographical locale and historical context, can be interpreted as an expression, or representation, of a culture or nation's position *vis-à-vis* nature. The historical and contextual meaning of a modernist abstraction of nature, in relation to a particular view of the tropics, is what at issue here.

In what is, I think, the best critical commentary on Burle Marx, the catalogue essay 'Roberto Burle Marx: The Unnatural Art of the Garden' written to accompany the exhibition held at the Museum of Modern Art, New York, in 1991, the author, William Howard Adams, suggests that in the intense skill and manipulation demanded by his gardens, it seems as though Burle Marx was 'defying nature to rebut the artist's argument'.[5] But what was the nature the artist was trying to defy, and why did it need defying at all? What significance did tropical nature have in a tropical country such as Brazil? What symbolic meanings did it have in the formation of the modern Brazilian cultural imagination? My point is that Burle Marx's construction of

the landscape as a space of modernity needs to be understood in relation to the history of the construction of tropical nature as a special kind of alterity to a temperate norm, and to how that history has affected the imagined nation of Brazil.[6] How might our understanding of tropical nature as a historically constructed idea, as described in this book, alter the terms in which the analysis of Burle Marx's strange and wonderful landscapes might be carried out?

Being tropical: Nature and nature appreciation in Brazil

The fifth-largest country in the world, Brazil's entire eastern seaboard was once covered in forests; it still contains a huge area of the Amazonian jungle. Unlike Mexico and Peru, the European conquest of Brazil revealed no remnants of ancient civilizations, no grand monuments that could be interpreted as distant or faint analogues of those of ancient Greece or Rome.[7] Nature, it seemed, was the country's most important sign.

Even today, visitors to Brazil are inclined to view the country as a glorious scene of nature (with exceptions granted for samba and bossa nova, Carnival and football). The sights by which the country is best known are of nature; perhaps no other city in the world can be so quickly identified by a snapshot of its natural landmarks than Rio de Janeiro – Sugarloaf mountain, the glorious beaches of Copacabana and Ipanema, celebrated in postcards and songs. To the architectural historian Norma Evenson, Brazil immediately evokes an image of nature, 'not nature in the raw, but nature alluring, abundant, and shamelessly beautiful'. To her it is evident that in Brazil, 'Nature is not a benign servant of man, but a power still dominant' (echoes of Humboldt here!).[8] This in a country with some of the largest cities in the world, where nature has been ruthlessly dominated (destroyed, turned into commodities) for centuries! It is not that Evenson is completely wrong; the scenery of Rio has, after all, long been celebrated for its beauty (illus. 81). It is, rather, a question of emphasis and interpretation.

Even to Brazilians themselves, the country is a place of imaginative speculation, full of rumours of still hidden riches (valuable radioactive sand, one rumour once had it, that Americans were trying to steal for reasons that no one could quite say) and fabulous marvels. Evenson puts her finger on this element of the 'unknowability' of Brazil, when she refers to the quality of 'romantic unreality' that clings to the country, associated with its huge size and untapped wealth.[9] Brazil is, it is often said, the 'world's oldest land of the future'.

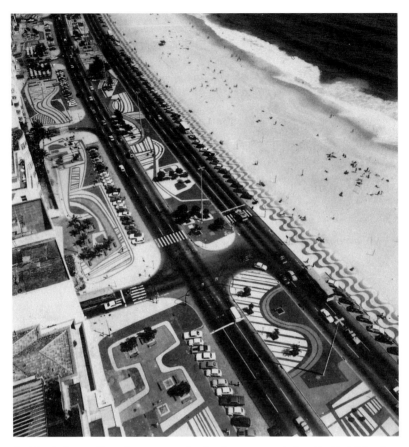

81 Atlantic Avenue, Copacabana, *c.* 1970, showing the pavements designed by Burle Marx in 1970. Instituto Moreira Salles.

Historically, too, Brazilians have taken their tropical identity very seriously, another reason why the use that Burle Marx made of tropical plants is so intriguing. As we have seen, politicians, writers, artists and scientists have been engaged in an almost continuous process of assessing what Europeans think of their tropical country, what their tropical milieu signifies and how it might affect the health of its population or place constraints on national progress. In the 1950s and '60s, these themes still preoccupied the famous Brazilian sociologist Gilberto Freyre when he promoted the need for a special science called 'tropicology' (see Chapter 4). In the 1970s, the Brazilian composer and singer Caetano Veloso labelled his movement celebrating the popular music and rich ethnic diversity of his country *tropicalismo*.[10]

The appeal and also the ambiguities of a 'tropical' identity are felt to this day. In 1992, for example, the United Nations Conference on

the Environment and Development, better known as the Eco-Summit, was held in Brazil. For this event, the country claimed for itself the very tropicality it at other times refused. For months beforehand, the streets of Rio were cleaned, unsightly garbage removed and its famous beaches raked, in preparation for the arrival of hundreds of environmentalists and reporters from around the world. The city's poorest inhabitants were confined to their hillside *favelas* (slums) and even prevented from entering the city centre during the conference, so that the authorities could present Rio as the tropical capital of the world, stunning in its natural setting by the sea, surrounded by its famous mountains, yet at the same time urban, clean, orderly, progressive and modern. This was a national identity long dreamed of by educated Brazilians – the dream of a European civilization in the tropics, nature *and* culture in balance.

But it was only for a moment. The real history of the last five hundred years in Brazil is one of the massive destruction of its natural environment and the chaos of many of its cities. The Atlantic forest, which once covered the entire eastern coastal seaboard, has been cleared successively for commodities – sugar, wood, coffee – until today, it is a mere 10 per cent of what it was in 1500, when Cabral first saw the country and gave it the name of a tropical tree (the red tree, *ibirapitanga* in Tupi, *pau-brasil* in Portuguese).[11] (In the late twentieth century, the process of destruction of the tropical rainforests goes on at the rate of 3.7 to 4.9 million acres a year.[12]) I do not mean, however, to chastise Brazil for doing to its environment what Europeans and North Americans have already done to theirs – that is, destroying much of nature in order to turn it into useable things. I intend, rather, to use Burle Marx's representations of tropical nature as a counterpoint to European ones. The terms by which the tropics have been understood, whether as geography, landscape, population or tropical diseases, have been woven into the myths and counter-myths of national identity, in a complicated and dynamic exchange and challenge to views of the tropics from elsewhere.

Dreams of modernity

A point of entry into Burle Marx's landscape designs is the dream of modernity itself that has structured so much of Brazilian national self-making – the dream, that is, of ordering the world through reason and, by extension, through machines and technology. The significance attached to modernity, as the architectural historian William Curtis says, depends on 'particular national histories and

nationalist mythologies'.[13] The idea of modernity acquired special urgency in Brazil in the early twentieth century as the country was drawn into an international world of capital and trade, and began its urban and industrial development (today, Brazil has the eighth-largest economy in the world). Historically, sugar, diamond mining, coffee, rubber and manufacturing, in succession, transformed the country's rural environments. Between 1889 and 1930, three million Europeans entered the country; there was a very rapid growth in the size of the cities, and all sorts of new intellectual currents in science and arts were absorbed and digested. The most important nineteenth-century guidebook to Brazil in English, *Brazil and the Brazilians* by Kidder and Fletcher, had already protested in its 1857 revised and expanded edition that the image of Brazil as a spectacle of exotic nature was out of date, and had to be replaced by one of an independent empire in the tropics and a potential 'commercial emporium'.[14] But as the authors themselves admitted in their introduction, their 150 engravings (many based on photographs) nonetheless delineated the popular notion of Brazil, in terms, that is, of its mighty rivers, virgin forests, palm-trees, jaguars, monkeys, parrots and so on. In the circumstances, we can understand the Brazilian fantasy of leaping into the future by means of steam engines, machinery, railways, roads and the telegraph.

But though the motto of the Brazilian Republic was 'Order and Progress', both were in short supply. The gap between aspiration and reality was painfully apparent. The environmental historian Warren Dean has noted that the Brazilians realized that the manufactured implements they sent to the world's fairs and exhibitions in the second half of the nineteenth century were in reality almost embarrassing signs of the old-fashioned character of their agricultural economy.[15] Efforts to modernize the country by technology were constantly being checked by the difficulties presented by Brazil's geography, topography and climate, difficulties symbolized in the 1880s by the failure of the Madeira-Mamoré railway after its workers were decimated by malaria; years later, its abandoned locomotives were discovered, rotting and overgrown with vegetation.[16] The fear was that Brazil would be a terrible sublime of nature, not a technological sublime of modernity. The continued problems of disease, and the long-standing preoccupation with race and race mixture, were other factors shaping the national outlook, as we have seen.

In contrast to the vertigo of excitement that the prospect of modernity and technology induced among the élite, nature in the raw had an ambiguous place in the Brazilian national imagination before

the late twentieth century. Colonial visions of tropical paradise did not last; from the Portuguese the Brazilians inherited an attitude of ruthless utilitarianism in relation to natural resources that left little space for nature sentimentality.[17] The information that Brazilians got from the indigenous Amerindians, who knew a great deal about the vegetation and wild life around them, was slight (though two-thirds of the common names of trees of the Atlantic forest were Tupi-Guarani). Nor was there a Brazilian equivalent to the passionate interest Europeans showed in the scientific study of the natural world, or to the stream of European naturalists who went to the tropics to study its fauna and flora. Even when Brazilians managed to get trained in natural history, they found little support for their interests and activities, owing to the absence of middle-class culture in a highly stratified slave society and the sparseness of institutions of higher education.[18]

True, the 'greatness of Brazil', based on its natural splendours, has been an enduring part of the country's social imagination since colonial times, a constant refrain, part of Brazil's *ufanismo* (a Portuguese word meaning 'exaggerated pride'), a Brazilian equivalent to the belief of North Americans in the superiority of everything in the United States, based on the country's great size and the dramatic scale of its nature.[19] In the abstract, and as a rhetorical resource, wild nature in Brazil was appreciated; but in the concrete and aesthetically, much less so. The pride that nationalists expressed about their country's huge extent and supposedly fabulous natural wealth, or the delight some painters, writers and composers showed in their nation's exotic features, were countered by the fear that God had assigned Brazil an unruly and overpowering nature that was barbaric and non-European.[20] Dean, the author of one of the most eloquent (and despairing) accounts of the destruction of the Atlantic forests in Brazil ever written, quotes a Brazilian who in 1917 described nature in the tropics as

... an orgy of forms, an unimaginable surfeit of climbing plants, a tragic disorder of trunks, of branches, of carpets of greenery and parasites, of mortal combat among trees and species ... In the South American forests one sees man imprisoned in a labyrinth of demented vegetation.

The forest, especially, was viewed as a wilderness, a backland, a hinterland, towards which there was, says Dean, almost a 'cult of hostility' not unlike the hostility Europeans had shown to their own wilderness before it had been tamed, cut down and domesticated: 'Upon their forests members of the Brazilian élite projected uncom-

fortably their ambiguities concerning their society and their culture.' In the circumstances, he writes, nature in Brazil remained 'exotic in the psychic as well as the botanic sense'.[21]

The words of the English writer Henry Thomas Buckle on the limits tropical nature placed on the development of civilization resonated especially painfully. Buckle's comments were translated almost in their entirety into Portuguese in 1880 by the literary historian Sílvio Romero, who found his judgements hard but 'essentially correct'.[22] 'Nature's products have long been thought to be vaster in Brazil than anywhere else,' Romero commented. 'Which is an advantage say the [Brazilian] patriots; which is a hindrance, says Buckle; which is an error, say I.'[23]

It is an indication of the negative power of the European concept of nature and culture in the tropics that so many of the significant works of interpretation of Brazil's political and social history have been written in their terms. In the famous work by the writer Euclides da Cunha called *Rebellion in the Backlands* (1902), for example, the account of an armed revolt among the poor in the north-east (at the same time a masterly reinterpretation of Brazilian national identity and destiny) opens with two long chapters on 'the land' and 'man', thus locating the rebellion in environment and race. In detailed descriptions of the climate, topography, geology and ethnology of the *sertão* (backlands), the author gives a brilliant reportorial, yet almost hallucinatory, picture of the hinterlands of Brazil, an anti-Paradise in which the poor find themselves pitted against a hostile environment and the forces of encroaching civilization in a struggle for survival which can only end in their extermination. It was as though geography, geology, natural history and ethnology provided both a burdensome narrative of Brazil *and* the necessary terms in which the country could be imagined.[24]

Compared to the US, then, where images of untamed nature became positive components of national identity in the nineteenth century, natural equivalents of the ancient buildings and soaring church steeples of Europe, the tropical jungle was implicated in Brazilian myths of nationhood largely negatively.[25] We see this in visual representations of the country produced in Brazil. According to Dawn Ades, Latin American painters were in general not very responsive to the European landscape genre, preferring to paint historical scenes, portraits and pictures of everyday life in picturesque, or *costumbriso*, style.[26] Few paintings produced for Brazilian consumption (rather than for foreign purchase) in the late nineteenth and early twentieth centuries were of rural landscapes. An

analysis of 801 nineteenth-century Brazilian paintings and photographs, for example, shows that only 6.1 per cent were of untamed nature; just over a quarter were of productive landscapes, meaning plantations and worked land; and by far the largest category was urban scenes.[27]

Thus Brazilians preferred (as did, after all, many Europeans and North Americans at the time) to represent their country in terms of technology and progress – by means of images of railways, roads, bridges, busy ports, trams and urban life. An outstanding example is Marc Ferrez's brilliant photographic oeuvre, consisting in the main of studies of urban Rio. Ferrez was in fact an innovative photographer of Rio's natural scenery, but the market for such pictures within Brazil was small. His most ambitious project was a photographic record of every new edifice built on the new Central Avenue between 1903 and 1906 during a massive programme of beautification. This programme involved the destruction of several hundred colonial houses and narrow, cobbled streets to make way for wide European avenues and handsome new buildings in the flamboyant Second Empire style imported from France (illus. 82).[28] Ferrez's photographs depict the city's transformation from an imperial capital to a republican one – a symbol of a nation on the march to modernity.[29]

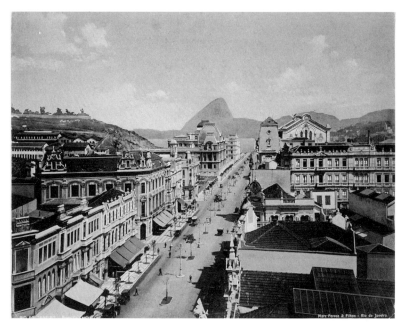

82 'Avenida Central', from Marc Ferrez, *Album da Avenida Central 1902–1906*. Instituto Moreira Salles.

This embrace of 'the modern', and of 'modernism' as an aesthetic and intellectual movement, intensified in Brazil in the 1920s, when the country entered a new phase in cultural orientation following the First World War. In a period of both optimism and pessimism about the future, when politics, as we have seen, was saturated with nationalist questions, a spate of literary, artistic and sociological works were produced, interrogating the 'national problem', and repudiating the old frameworks of naturalism and realism; there was a search for new cultural forms that would be responsive to Brazilian realities and reposition the country internationally.

This was when modernism as an artistic movement burst onto the Brazilian scene. In a familiar process of cultural appropriation, Brazilians turned to Europe for new ideas in art, architecture and literature, which they proposed to remake in Brazilian terms. In 1922, a Modern Art Week was held in the city of São Paulo, as part of the hundredth-anniversary celebrations of Brazil's independence from Portugal. In art exhibitions, poetry readings, concerts and manifestos, artists and intellectuals embraced the new artistic styles while attacking European stereotypes in order to declare their artistic independence.[30] The tone was set by the 'Pau-Brazil Poetry Manifesto', put out by the poet and leader of the modernist group, Oswald de Andrade, which asserted the identity between the tropical and the modern. Andrade called for a Brazilian poetry 'for export' (like *pau-Brasil* or brazil-wood itself, the wood that gives the country its name), a poetry that would be, he said, like the country, barbaric and modern, sceptical and naïve, 'of the jungle' and 'of the school'.[31] A second manifesto, 'Antropofágico' (The Cannibalist Manifesto), published in 1928, famously asked, 'Tupy or not tupy, that is the question.' To be Tupy (i.e. to be Amerindian and complicated, to be something other than European), said Andrade, meant cannibalizing the European colonizer 'in order to appropriate his virtues and powers and transform the taboo into totem'.[32] This manifesto was illustrated by a portrait by Tarsila do Amaral of a dusky woman with enormously exaggerated breasts and limbs sitting in front of strange vegetation, and depicting the sun in the form of an orange; here was visual cannibalization of a European stereotype (the black, sensual woman in the tropics) and a reimagining and repossession of what it was to be tropical (the picture shown here is a later sketch) (illus. 83).[33]

The other Andrade, Mário (no relation to Oswald), whose journey of apprenticeship into the tropical jungles was described in Chapter 4, produced what is now recognized as the masterpiece of literary

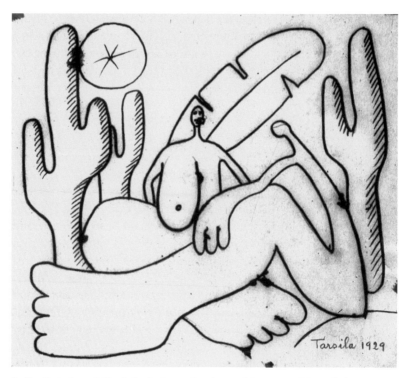

83 Tarsila do Amaral, 'Study for Anthropophagy', 1929, ink on paper. Museu de Arte Moderna do Rio de Janeiro (Gilberto Chateaubriand Collection).

modernism, in which he also addressed the problematic of the primitive and the modern in Brazil. The novel, *Macunaíma: A Hero Without Any Character*, published in 1928 just three months after the anthropophagite manifesto, is an extraordinary work of magical realism *avant la lettre*. It tells a picaresque tale and, at the same time, an epic story of a Brazilian Everyman, a dark Indian who travels across time and space from the heart of the Amazon where he is born, to the modern city of the machine and the motor-car, and back to the Amazon, ending his life as a star shining brilliantly in a constellation above the jungle. Written in rhapsodic, parodic and fragmented style, a *bricolage* of Tupi words, folk tales and everyday expressions, the novel abandons straightforward narrative and naturalism, and valorizes the creative character of indigenous Brazilian nature and culture. The book, by the way, is also a wonderful parody of the 'Brazil as natural history' genre, the author drawing on academic studies of ethnology, linguistics and natural history to stuff his text with the names and lists of Brazilian rivers, animals, plants and Indian vocabularies.[34] Brazil, like the novel's hero, is pictured as an Indian

primitive, a dark man born in the Amazon, but also modern, a man of the city – a cunning and naïve trickster, a liar, a sensual charmer, a multiple, unstable being (a being 'without any character') who is also a new universal of modernity. Brazil cannot choose between these different selves, can only accept their contradictions; this is what it means to be modern.

Designing the tropics

Roberto Burle Marx came out of this historical moment of national interrogation and self-conscious acceptance of the contradictions of Brazil, produced out of the country's historic trajectory and socio-economic situation. From modernism, Burle Marx acquired an ironic, sceptical, anti-mimetic aesthetic, which he combined with a search for an authentically Brazilian form. His chosen medium of artistic expression was not literary, of course, but visual. This is important, because in a largely illiterate country (80 per cent of the population in the 1920s), the visual arts could have a far greater audience than books could.[35] More than just turning to the visual arts, though, Burle Marx made the designed landscape critical to his modernist aesthetic. He was one of the very few people in Brazil, therefore, to combine artistic modernism and nature in a direct, tangible way – not as a literary or intellectual conceit but in the form of real plants, which became the material and expressive substance of his artistic vision.[36] This was a highly unusual choice, since at the time tropical plants as decorative elements in garden design were largely despised.

Burle Marx knew Brazil's tropical plants very well. He travelled across the country collecting them (some he discovered were named after him, such as *Heliconia burle-marxii*, a banana-like plant with huge, paddle-shaped leaves and bright red flowers); he studied their habitats and ecological features; and he later worked with them on his own farm (the Sítio Santo Antonio da Bica, which he acquired in the 1950s and eventually bequeathed to the nation), where he acclimatized and hybridized plants, devising new associations which he used in his parks and gardens. William H. Adams correctly points out that in Burle Marx's work, parks are not 'texts' to be decoded by the cognoscenti but highly visual spaces to be seen and experienced on an everyday basis.[37]

Burle Marx's discovery of the force of tropical nature was a key episode in his life, to which he returned often in interviews. It occurred on a cold and gloomy day in 1928 – in Berlin. As Lawrence

Fleming says, it was as though only by going away from his country that Burle Marx could begin to see tropical nature in a new light and appreciate its aesthetic possibilities. Out of tropical plants he would 'organize and interpret nature' in a strange hybrid of art and nature which implicitly comments on the complex and problematic meanings the tropics had in his own country.[38]

Burle Marx was born to a German-Jewish immigrant father and Brazilian mother of French descent; he grew up in a cultured family (where German was routinely spoken at home). In 1913, the family had moved to Rio de Janeiro, where his mother kept a garden; it was from her that Burle Marx acquired his early love of plants. The fashion in gardening and park design was at the time mainly European. Sometimes, native plants were employed along with European ones in public parks, but it was French designers who were responsible for the major public parks in the capital (many of these were soon overwhelmed by the rapid growth of plants in the tropical climate). Remnants of the parks designed by the French landscapist Glaziou, who employed strong formal but flowing lines, had some influence on Burle Marx's more abstract designs.[39]

Another tradition relevant to Burle Marx's work was that of the botanical garden, a storehouse of plant knowledge. Brazil had established its own Royal Botanical Garden in Rio in 1808, when the Crown moved there from Portugal. Like its colonial counterparts elsewhere, such as the botanical gardens established by the British in India, Ceylon and the West Indies in the nineteenth century, the Royal Botanical Garden in Rio was meant to serve as a collecting point and acclimatization centre for plants from all over the world that might benefit the country commercially, such as tea plants brought from China.[40] A number of knowledgeable botanists were associated with the Botanical Garden, but its finances were always fragile, and many books on native flora remained unpublished. The garden's most striking visual feature was the impressive avenue of Royal Palm Trees, many of them 80 feet tall, which nearly every traveller to Rio saw and commented on; Louis Agassiz and his wife, who included two illustrations in their book *A Journey in Brazil*, described the alley as suggesting a 'dim vision of colonnades in some ancient Egyptian temple' (illus. 5).[41] These palms were not in fact from Brazil, but had been brought to the country from Barbados decades earlier, and by the time of the Agassizes' visit were one of the few items that still could be described as impressive, the rest being unkempt and in a state of decay. In private gardens, the English style was favoured, so that English roses, carnations and dahlias were far more familiar to

the middle class than their native plants. Native plants were viewed as too commonplace, too disorderly and too representative of the jungle to appeal to the élite and middle class.

In 1928, the Burle Marx family went to Germany, for medical reasons, to visit relatives and to engage in various educational and artistic pursuits. Settling in Berlin, they spent eighteen months enjoying the art and music of Weimar Germany. Burle Marx described the shock he experienced when he saw the new contemporary art – Cubism, Surrealism, Dadaism – for the first time; this is what decided him on a career as an artist and inspired his lifelong devotion to the free-flowing, abstract principles of modern design.[42] It was in Berlin, too, that he encountered in the hothouses of the Berlin Botanical Garden at Dahlem a collection of tropical palm-trees, beautiful orchids and cacti. With another shock, he realized that these astounding plants, so carefully displayed and validated by Europeans, were *his* plants, were in fact all Brazilian (yet unknown in Brazilian gardens) – and, as his biographer Fleming says, that *he* too was Brazilian.[43] From this moment came the decision to use his native plants as fundamental elements in his designs; he would, that is, apply to nature itself 'the principles of plastic composition, in accordance with the aesthetic sentiment of my time. The garden, in short, was a manner of organising and composing my pictorial works using non-conventional materials'.[44]

On his return to Brazil, Burle Marx enrolled in 1930 in the National School of Fine Arts to study art and architecture. This is when he became part of the group of artists and architects surrounding Lúcio Costa, who was briefly Director of the School and, later, the designer of the overall plan of Brasília (Oscar Niemeyer was the architect). Burle Marx also met the botanist Henrique Lahmeyer de Mello Barreto, head of Rio's zoological garden, who became his mentor and scientific teacher, taking him on botanical trips into the interior. In 1934, at the age of 25, Burle Marx was appointed director of parks and gardens in the north-eastern city of Recife, where he spent the next eighteen months or so.[45] Recife was important for two reasons: he designed his first ecological gardens there, and he began to introduce native plants, which were novelties in garden design at the time. He started experimenting with tropical plants, massing them to achieve new visual effects; studying the ways different plants worked, ecologically, in association with each other; and generally acquiring a scientific feeling for nature. He made his first excursions into the Amazon valley and designed a water garden using the giant water-lily, *Victoria regia* (today called *V. amazonica*) – the first time, apparently,

that this plant was used deliberately in the design of a Brazilian garden.[46] He also explored plants from the *caatinga*, the scrubby, desert-like savannah of the interior of Pernambuco state. These plants, at the time viewed as nothing more than tangled undergrowth without any ornamental value, became important features in Burle Marx's designs.[47]

In 1936, Burle Marx was back in Rio when the progressive Minister of Education unexpectedly assigned the job of building a new Ministry of Education and Health to Lúcio Costa and his team of young architects and engineers. Costa invited Le Corbusier to come to Brazil to advise on the design. This was not the first time Le Corbusier or other pioneers of architectural modernism had been to Latin America (he had himself first been in Brazil in 1929, and Frank Lloyd Wright and Eero Saarinen had been there in 1930), and their impact in Latin America was enormous. Le Corbusier had a naïve faith, says William J. K. Curtis, in the ability of a well-ordered environment 'to reunite man, nature, and the machine in an unalienated harmony'. This vision – that through modern architecture the human/natural/mechanical could be brought into balance – was naïvely utopian, says Curtis, but had great appeal in a country like Brazil, which wanted to put a new human stamp on urban spaces.[48] Out of the process of collaboration came Brazil's first monumental, modernist building, whose success 'spearheaded the acceptance of Corbusian modernism in Latin America'.[49] A tall, white block eighteen storeys high, the Ministry was built on stilts (pilotis) in downtown Rio; it included the famous *brises soleils* (horizontal adjustable blinds) to screen out light and alter the circulation of air, colourful azuela-tile wall panels, a monumental piece of sculpture and gardens by Burle Marx. These latter were among the building's most innovative features, since in general modernist architects paid scant attention to the immediate surroundings in which their buildings were placed (illus. 80).

The most famous expression, and adaptation, of Corbusian modernism in the tropical Americas is of course Brasília, the city that replaced Rio as Brazil's federal capital in the 1960s. Described by Curtis as 'something akin to a cosmic gesture for marking out a symbolic space on the vast virgin landscape of the Brazilian interior', the visually spectacular architecture (by Oscar Niemeyer), and the ferocious speed with which it was laid out on the high plain in the western part of the country, has made it a symbol of technological modernity, the conquest of empty space and the ritual power of the modern state.[50] It is also, to many people, a dystopia that represents

'the grip of man on nature ... a human operation directed against nature' (one of Le Corbusier's definitions of the modern city).[51]

Burle Marx designed several gardens and parks in Brasília, but for a number of reasons he was not a member of the original design team responsible for the city, and his ideas never received the scope and support they needed for his landscape vision to be realized. In my opinion, though, the most successful complex in Brasília is the Ministry of Foreign Affairs, in which Burle Marx's gardens play a key role. His other parks, gardens and designs, of which there are thousands, ranged from huge public projects, such as the designs for Atlantic Avenue along the five-kilometre beachfront of Copacabana, where he introduced the famous wave-pattern mosaic tiles on the pavements separating the beach from the buildings, to the huge Flamengo Park, to small gardens for individual clients (illus. 81). The style of these instantly recognizable, radically abstract gardens has been dubbed 'o estilo Burle Marx'.[52] But if the landscapes are instantly identifiable by their visual elements, evaluations of them in terms of their aesthetics and/or meaning are extremely divergent. Some people consider them too austere, and too artificial, to serve as gardens properly speaking; to them they seem the opposite of refuges from the machine age.[53] They seem to have no 'meaning' or reference point, to be purely aesthetic and formal inventions which, while relying on tropical nature for their visual effects, are nonetheless oddly indifferent to, or disconnected from, their tropical settings. To such people, these parks are best approached as ahistorical artefacts of a modernist sensibility. Other critics, on the contrary, see in Burle Marx's use of abstract lines a responsiveness to, even an imitation of, aspects of Brazil's tropical topography. On the one side, there is a sense that the gardens are perversely unnatural; on the other, that they are wonderfully natural.[54]

Adams views Burle Marx's designs, for instance, as deliberate negations of what he calls the 'naturally stupefying and forbidding reality' of nature in the tropics, its 'seething excess': 'Imposing aesthetic order on a scale demanded by the turbulent, spectacular, at times harsh and cruel environment of Brazil required an equally powerful, uncompromising vision.'[55] Adams is on to something very important here. But in my judgement, he also comes close to taking the terms of the well-established, historical dichotomy between the disorder and excesses of tropical nature, and the order and restraint of temperate nature, at face value – that is, on its own European and literal terms, without questioning those very terms. Burle Marx's gardens, in offering an alternative view of nature, played with a

number of different oppositions and dichotomies, not to confirm them but to destabilize and recombine them. He was in effect experimenting with different ways of presenting and representing the tropical world and indicating its heterogeneity and complexity. Nature is implicit in myths of nations in particular contexts, and modernist abstraction as a style does not necessarily have the same significance in one place as it does in another.

In the analysis that follows, I concentrate on just a few of the thousands of Burle Marx's designs, arranging my comments around several interrelated themes. In addition to their merits as designed spaces, the gardens selected are of interest because they span Burle Marx's creative life, and because they serve public functions, and so are responsive to more than purely private visions of space. The analysis of them that follows gives me the chance to examine the possibly utopian and/or social aspects of his designs, as well as their symbolic aspects. Wherever possible, I illustrate the gardens with photographs by Marcel Gautherot, which were taken roughly when they were made or were in their heyday, and so show them as Burle Marx conceived them rather than in their current state, which is often one of decay.[56]

My first garden is the roof-top garden Burle Marx built for the Ministry of Education and Health (illus. 80). This garden was not an afterthought but an integral part of the plan from the start; it incorporates many of the elements making up the Burle Marx style.[57] Taking the form of a free-flowing, abstract pattern, overlooked and observed from above, its tropical plants are also only one element in the design, the others being stones and the flat surface of the roof itself.

Flamengo Park, my second example, is the largest completed park in Burle Marx's oeuvre. Covering 289 square acres in Guanabara Bay in the heart of Rio, this huge landfill park was the project of the state's ambitious Governor. It was a major undertaking, spanning a decade, a team project which involved filling in part of the bay to create land on which to build highways connecting downtown Rio with fast-expanding Copacabana; new, artificial beaches were constructed at the water's edge as the city pushed into the bay. Flamengo Park eventually included the new Santos Dumont airport, the Museum of Modern Art, walkways, roads and sports facilities. The overall design was the work of the Brazilian architect Affonso Reidy, while Burle Marx was responsible for landscaping the parks and parkways.[58] By means of a spare and imaginative use of native plants, stones, tiles and walls, Burle Marx created a park of abstract patterns, some wave-like,

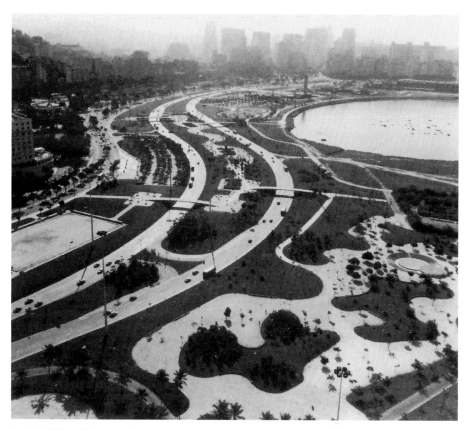

84 Aerial View of Flamengo Park, Rio de Janeiro, c. 1954. Instituto Moreira Salles.

others strictly rectangular, patterns that are best appreciated from a height, whether from the apartment buildings that overlook the sweeping parkways or from the planes taking off and landing in a steep swoop at the airport that juts out into the water (illus. 84).

Flamengo Park has provoked a range of reactions from different viewers. The architectural historian, Norma Evenson, viewing it early on, in the mid-1960s, disliked it and felt that it was a failure, 'more a landscaped freeway than a recreation area'. The trees struck her as underdeveloped, and the whole park seemed to be not a 'sheltered retreat, but a space for a machine'.[59] But this is really to miss the point. The park was not conceived in terms of a retreat from the city; it was, rather, designed as a particular kind of landscaped, urban facility, serving the needs of a poor population for places of recreation, sports and educational events – and so to be popular. Even now, though the park is run down, badly lit and not particularly safe, it is used by thousands of *cariocas* everyday.

85 Garden of the
Museum of Modern
Art, Flamengo Park,
Rio de Janeiro, 1954.
Instituto Moreira
Salles.

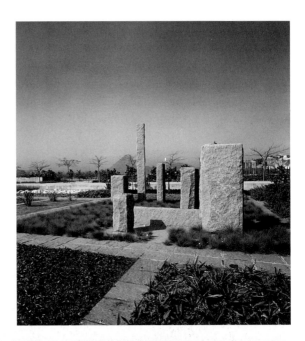

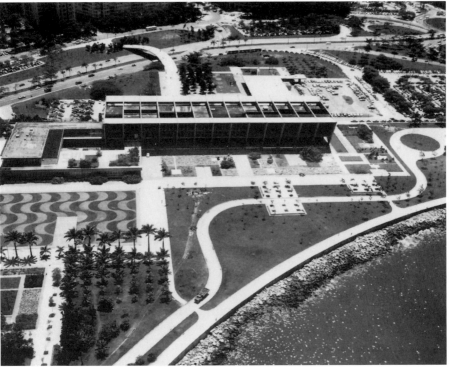

86 Aerial view of the Museum of Modern Art, Flamengo Park, Rio de Janeiro, *c*. 1961.
Instituto Moreira Salles.

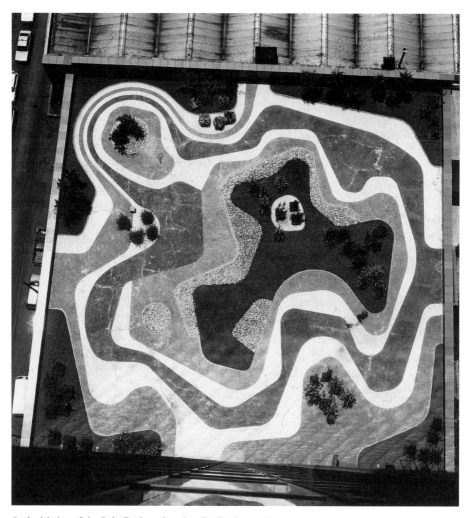

87 Aerial view of the Safra Bank roof garden, São Paulo, c. 1982.

Burle Marx's non-mimetic, non-Edenic intentions in Flamengo Park are clearly seen in the garden he created for the Museum of Modern Art, where he used stone walls to define a series of rectangular beds, each one boldly planted with a single and contrasting plant species, forming a geometric, chequerboard pattern (illus. 85). The severe rectilinear plantings were beautifully set off by the wave-like section nearby, made by alternating plantings of different kinds of grass (illus. 86).

Finally, there is the roof-top garden in the Safra Bank in São Paulo. Here, in the city often called the Chicago of Brazil, a huge, chaotic place lacking the stunning backdrop of mountains and beaches that

228

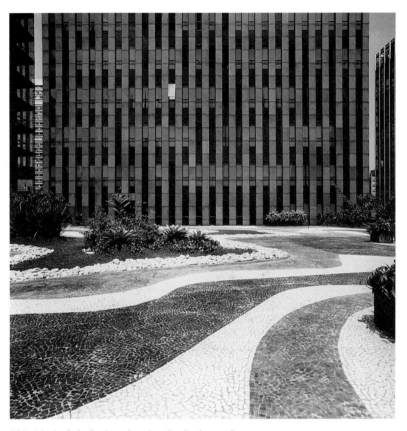

88 Inside the Safra Bank roof garden, São Paulo, *c.* 1982.

Rio enjoys, a small garden was laid out on the roof of a tall modern building (illus. 87). With plants placed in pots, and by means of stones and pebble-filled beds, Burle Marx constructed an extreme, pared-down space that almost has the effect of a Japanese garden in its reduction, austerity and careful attention to the balance between natural and manmade elements (illus. 88). We might call it a tropical version of the bonsai – a compressed reflection on nature and art in the form of the aesthetic manipulation of the natural. Adams has described it as a 'de-natured universe', a 'synthetic roof ecology', a 'twentieth-century version of a Zen monastery garden'.[60]

By definition, of course, a garden is a form of interference in nature. In the hands of Burle Marx, this interference is pushed to extremes. Plants from one region of the country are moved to another; mountains of earth are shoved aside; natural topography is ignored; plant associations are playful; colour combinations are strange (or seemed so when they were first introduced). The greatest

puzzle to many commentators is how to reconcile Burle Marx's love of the organic structure and presence of tropical plants with his love of abstract, geometric lines. Yet he was always very clear about this. His purpose, he said, was to 'transpose' nature (his term), in order 'to give a full place to the existence of man'.[61] Another of his formulations was that the garden is a means of making the ecological milieu or environment adequate to the natural demands of civilization. We might remember here that many naturalists had judged that there was no place for humanity in the tropics.

In making a garden, Burle Marx said, geometry is the most effective way to mark it as a human space because, whether symmetrical or asymmetrical, geometry 'is clearly a coherent body of man-made concepts, often based on nature's own forms'.[62] We hear in this statement echoes of Le Corbusier's manifesto *Toward a New Architecture* (1923), where he insists that in modern architecture, geometry should replace anecdote, realism and imitation; only geometry could give a perception of order, mass and harmony, which old architectural forms, produced by old, national schools of architecture ('those hot houses where blue hortensias and green chrysanthemums are forced and where unclean orchids are cultivated') could not.[63] Modern painting led the way in this regard, Le Corbusier said, by leaving realism and imitation behind for the pure world of geometry. Other sources of inspiration for Burle Marx were the flowing lines in paintings by Miró, Léger or Arp, which he very much admired (he was himself a painter who throughout his life made drawings, tile mosaics, jewellery and tapestries).

In interviews, Burle Marx showed his awareness that in European and Brazilian history, tropical nature had been represented as *mata* (forest or jungle), something generally disliked because disorganized, overexuberant, exhausting, unbalanced and excessive, especially in relation to human occupation and the development of civilization.[64] 'It seems that all that people encounter in our nature is designated jungle, and because it is jungle it is of no use.'[65] It was because of the close symbolic association between the tropical jungle and the primitive that Brazil's nature aesthetic was so European. Burle Marx's solution to the problem of tropical nature was not to Europeanize the garden but to question this view of tropical nature itself, by placing tropical nature in the setting of an artificial garden and then manipulating it to suggest alternative possibilities. Against the conception of an overwhelming tropical nature, the sign of cultural backwardness, human beings would *claim* a civilization through the artistic manipulation of nature. Human beings in the tropics would thus not be

merged into nature but made into something else, just as the plants Burle Marx transposed from their natural habitats into an alternative space, the garden, were made into something different than the expected 'tropical'.

A larger grammar of the tropical

But made into what? Tropical plants are, as we have seen, Burle Marx's design signature and landscape innovation. But as Adams points out, there is no intention in his gardens to compete in any way with the stupendous scenery of ocean and mountains that are found, say, in Rio; against such scenery, Burle Marx's gardens seem deliberately restrained. In the remarkable Odette Monteiro garden (now the Fazenda Marambaia) which he created in 1947 for a house in the mountains outside the town of Petrópolis, for instance, though some might say its curving beds imitate the line of the mountains surrounding it, others see, if not an effort to ignore the dramatic mountains, at least the goal of presenting the garden as an aesthetic object, which is complete in itself and into which the viewer is drawn. In this sense, we could call this garden 'anti-tropical', because though tropical in its plants, it is not of the jungle – its seems to reject any imitation of a jungle experience.

Many viewers find themselves uncomfortable with this apparent divorce between the gardens and their tropical setting. They try to find in them, therefore, echoes of the Brazilian landscape, references perhaps to the twisting path of a river through the jungle in his use of sinuous lines or to the drooping lines of lianas.[66] It is as if, even while accepting the novelty of his radical geometries, there is nonetheless a *wish* to connect them to their tropical setting as we normally define or understand it (as we learn it, say, from pictures of Rio or of the Amazon).[67] Otherwise, the gardens are too disconcerting, too unlike the expected tropics to make sense.

But rather than strain after these kinds of references and analogies, I would suggest that we take Burle Marx's anti-mimetic principle to heart, and think of the gardens as proposing an alternative understanding of the tropical itself. This is my second theme – the transformation of our visual understanding of tropical nature within the garden by the use of the oppositional play of signs of the natural and the artificial, the organic and the inorganic, the rural and the urban. Instead of viewing Burle Marx's landscapes in terms of a straightforward dichotomy between the site of nature (wild, unruly, disorganized) and that of the garden (tame, ordered, organized), we

might think of them as spaces in which the oppositions between the natural and the unnatural, the given and the made, the temperate and the tropical, the natural and the cultural, are elaborated, commented upon and also destabilized.

Burle Marx was unusual in being both an exuberant and inventive artist and a skilled botanist who understood plants in their natural settings. He knew a great deal, for instance, about how, in different ecological niches, plants formed different kinds of associations and groupings, such as the desert-type plants in the *caatinga*, Amazonian plants in the humid forests or forest plants from the *igapó* (periodically flooded woodlands). It was this knowledge that allowed him to take plants out of one setting and place them in another – to take plants from the Amazon and grow them in a garden in São Paulo. One notes his lack of interest in tropical or ecological purism, and his experimental approach to the world. Though he was largely responsible for making gardens tropical, he did not hesitate to move plants out of their native habitat to other, manufactured ones, or to alter their micro-ecological settings. Nor did he rely only on native plants, but happily incorporated European plants that had been long established in the tropics (he was also interested in tropical species from places like India). This mix-and-match approach to garden design might be viewed as a kind of acknowledgement and reflection on the long history of international plant exchange and adaptation that is part of the history of the modern world. In this sense, if there is any mimesis in his gardens, it reflects the heterogeneity of plant types that are already part of the landscape of a modern tropical country like Brazil. It is as though his gardens offer the viewer a larger visual vocabulary or grammar of the tropics than is offered by the historical idea of the tropical jungle.

Burle Marx also used his superb knowledge of plant ecology to create new and expressive associations (in terms of both form and colour) between tropical plants from different regions or ecological niches, associations that also challenge the limits of our ordinary understanding of the tropical, since they bring into contact plant types that are not normally found together. For example, he used the old gardening technique of bedding out to new and dramatic effect, by massing in large, contrasting flowerbeds single species of different colours, heights and textures. Sometimes, the patterns were on an exaggerated scale (rather as he used the traditional Portuguese wave pattern of tiles on an exaggerated scale in the pavement designs in Copacabana). By this means, he made large, dramatic bands of contrasting colours that are visually very powerful but also sometimes

strange; so popular has this technique become in garden design that it is hard to recapture how peculiar it seemed when Burle Marx first introduced it. Visually, the result is the opposite of what is seen in dense tropical forests, where characteristically one finds a few examples of plants belonging to many different species in a single spot. It is almost as though Burle Marx was deliberately creating the very 'social plants' (large tracts of the same) that Humboldt had described as being typical of the domesticated landscapes of Europe, in contrast to the 'unsocial plants' found in the landscape of the uncivilized tropical jungle (characterized by large tracts of the many and different), and in so doing making a witty reference to the constructed and symbolic meanings of the 'tropical'.[68]

The wide range of plants Burle Marx introduced into his gardens also fits this interpretation. He was especially interested, as I have mentioned, in the plants of the *sertão*, the name given in Portuguese to the austere, bleak, drought-stricken place of stone and stunted shrubs in the north-east which seems to lack the organization of a landscape. It takes time to get used to it, to see its aesthetic interest. Once again, Humboldt comes to mind, especially his opinion that humans give interest to landscapes, not vice versa.[69] Burle Marx's incorporation into his gardens of plants from the *sertão*, the *cerrado* (savannah or high plains), the tropical forests of the Amazon and the southern, temperate areas of Brazil forms a kind of visual commentary on the heterogeneity of nature in the tropics; it suggests that the construction of tropical nature as jungle gives us a very reduced idea of the possibilities of the tropical.

In this regard, we might consider how the principle of 'opposition' (as Jacques Leenhardt calls it) works in Burle Marx's landscapes aesthetically and conceptually to recast how we consider tropical spaces. This principle includes planting tall shrubs to set off short ones, employing different kinds of vegetation to make up contrasting bands of colours and textures, using verticality to set off horizontality, or man-made elements (e.g. sculpture) to oppose and highlight organic ones.[70] In the Museum of Modern Art in Flamengo Park, stone columns play against low-growing beds laid out in rectilinear squares. An extreme and striking example of this principle is Burle Marx's use of planted totems – upright pillars, constructed of wood, metal or even palm-tree stumps, onto and into which he attached or inserted tropical plants, often several examples of a single species such as a bromeliad or philodendron (illus. 89).[71] The totem is hardly meant to appear natural. We might say that Oswald de Andrade's exhortation to Brazilian artists to 'transform the taboo into a totem'

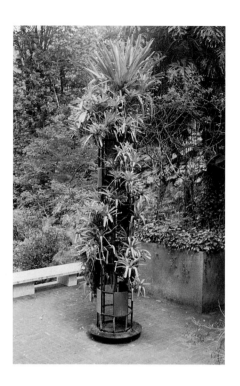

89 A totemic construction by Burle Marx, Rio de Janeiro, 1999.

(thus reversing Freud's formulation that by turning a kinship totem into a taboo civilization is achieved through the repression of primitive instincts) has here been literalized. The taboo (the tropical) has been transformed into a weird tropical totem (an icon of worship).

Leenhardt, who has made an excellent contribution in the book of essays on Burle Marx he edited, *Les Jardins de Roberto Burle Marx*, views the use of such artefacts in the designed landscape as a system for multiplying the signs of art in a field derived from nature, situating Burle Marx's gardens as sites of culture as opposed to nature.[72] In my view, however, the principle of opposition works not simply to reinforce a distinction between nature and art, or to negate tropical nature through artifice, but in a more complicated fashion, to call attention to the heterogeneity of elements in the environment of Brazil, both in the garden *and* in the landscapes beyond it, and to reconfigure both. Man-made or found objects of stone, metal or carved wood play against the organic forms of plants, but the organization of the stones and the plants together also plays against the disjointed character of the built and organic landscapes that lie outside the garden site.

Thus the garden gestures not just to a wild and excessive nature but to the complex features that are a real part of the complicated

landscapes of modern-day Brazil. Stones in Burle Marx's gardens, for example, have a solidity and permanence which play against the change, growth and instability of plants, but stones are also part of change as much as permanence in the constantly remade urban fabric of the city surrounding the garden (Burle Marx salvaged pieces of old Rio de Janeiro, such as walls and stones from razed buildings that were about to be dumped, and integrated them into his garden on his farm outside the city). The Zen-like Safra Bank roof-garden, which uses man-made elements and plants so brilliantly, extends the principle of opposition (natural/artificial, plants/stones) beyond the garden to gesture towards the odd, intensely urban landscape beyond – a garden/city contrast that may include, Adams suggests, the burned-out building next door.[73] Buildings change too, if more slowly than plants (a visit in 1998 showed that the building adjacent to the bank was still in ruins). Thus Burle Marx points to the heterogeneity of natural and man-made elements in the landscape of the tropics.

Urbanism and tropicality

This brings me to the urbanism of Burle Marx's work. Most of his parks are in cities or were designed in relation to modernist buildings. The urbanism of his gardens reflects, I believe, his sense of Latin America and modernism as intimately connected to urban realities. Latin America today has some of the largest urban conglomerations in the world; on average, cities there are much larger than their equivalents in Europe. Of the world's fifteen most populous cities, four are in Latin America (and two, São Paulo and Rio, in Brazil), and none are in Europe.[74] The process of urbanization was very evident in Burle Marx's birthplace, São Paulo; like New York, it was (and still is) forever being torn up and rebuilt. Visually, São Paulo and its surroundings presented a picture that Lévi-Strauss, when he visited it in the 1930s, found very different from the places in Europe which to him defined a landscape, properly speaking: a place that indicated a kind of harmony between land and humanity based on hundreds of years of careful management and utilization of nature.[75] Instead, the Brazilian landscape was a scene of chaotic clearing and deforestation matched by the chaotic clearing and transformations of the city. The city, then, like 'tropical nature', is a heterogeneous mix of things; it has buildings of many styles, wasted areas between places, a few Baroque churches next to dilapidated, turn-of-the-century apartment blocks, sleek modernist offices jammed up against slum tenements.

The majority of Burle Marx's gardens belong to this massified, urban form of living and seem to provide a comment on its character by marking off the site of a garden from the non-sites (i.e. differently organized spaces) of both the city and of nature beyond. He had a consistent vision of a park as an artificially created place of leisure and of communication and exchange for a variety of people. Parks serve, then, a public, rather than a purely private, function. Politically, Burle Marx was not given to big statements, always presenting himself as an artist, but there is no doubt that he shared the utopian orientation of the international school of modernism. In Flamengo Park, for example, the intention was to create a space for the poor to use, as well as for the car-owning rich to get from downtown Rio to Copacabana. Burle Marx particularly disliked suburbs (a term that in Brazil usually refers to an industrialized area peripheral to a metropolitan centre and given over to the poor, with slum housing and an inadequate infrastructure); he thought them aesthetically and socially degraded places, in their unreflective use of European plantings, their wasted spaces and their social distance and/or exclusion from the amenities of the city. In his urban parks, whose pedagogical aim, he stated, was to make understood and loved that which represents nature in a country which has never loved that which is planted, he made no effort to provide a 'tropical walk', aiming instead to awaken a new sensibility and transform mentalities towards an appreciation of nature as part of visual modernity. [76]

Burle Marx's well-known willingness to mould landscapes to achieve particular effects – to actually move mountains (or at least mountains of earth) – can be interpreted as part of this system of urban reference, rather than merely as a wilful demonstration of the power of his art to conquer nature and mould it to his ends. Rio's own famous mountains are, he seems to be reminding us, artefacts too, in that they have, since the nineteenth century, been bored through to make way for tunnels, physically removed to improve air circulation, chopped off and cleared of vegetation (all of the tropical vegetation that remains on the mountains around Rio is at best secondary, or tertiary, regrowth). Even our nature, then, his gardens seem to be saying, is always culture before it is nature.

Tropical design and modern environmentalism

The final aspect of Burle Marx's gardens that I wish to address is the relation between his built landscapes and his ecological beliefs. Most students of his designs make little of the connection, or lack of

236

connection, between the two, since they analyze his designs from within the framework of formalist aesthetics. To some modern-day ecologists, on the other hand, the almost wilfully constructed nature of his gardens can seem in almost flagrant contradiction to his well-known role as an outspoken critic of the destruction of natural plant habitats in Brazil.[77] But as the world in general has caught up with Burle Marx's environmentalism, new questions are being asked.

Burle Marx's environmentalism was acquired as he saw at first hand the extent of deforestation caused by development during his many botanizing expeditions across the different regions of Brazil. It became politically evident in the 1960s, when, under a military government, the country undertook a number of grandiose modernization projects, notably in the Amazon, which were extremely destructive of native fauna and flora (as well as of the health and lives of the indigenous Amerindian population). The realization of the fragility of the tropical rain-forests led Burle Marx, more than 40 years ago, to start speaking out against the wanton destruction of the Brazilian environment, the devastating loss of habitats and the risk to the biodiversity of the tropics that it posed. He proposed setting up nature reserves in different parts of the country which would reflect regional biodiversity and protect plants from further depredation.

The tropical, then, was a real environment that needed defending. But how could Burle Marx's ecological imagination connect, the French landscape designer and ecologist Gilles Clément has asked recently, to the extreme artificiality of his gardens? To someone like Clément, the slow, adaptive processes of evolution of plants in their natural habitats is the basic concept of modern biology and a fundamental part of the environmentalist's ethic. Respect for ecology implies that, to the extent that a garden can be made at all, it should, to the best of the landscapist's ability, reflect this ecological model.[78] A garden, in this sense, has to strive to be 'natural' within the confines of its 'un-natural' or designed space.

Clément recognizes that this was not Burle Marx's aim. It seems nonetheless paradoxical to him that, though Burle Marx had 'all the means necessary to enter the world of aesthetics through an ecological understanding of life', his gardens are so artificial. It astonishes him that Burle Marx, a master of ecological processes, 'had not wanted to make out of it an aesthetic. Perhaps he has deliberately reserved a place for ecology in nature, as he does in a nature reserve, but he does not think that ecology could be integrated into the garden'. In effect, the two dimensions, ecology and the constructed garden site, exist side by side, without interpenetration or integra-

tion. Clément adds that it is not even clear that 'plants are the point' of Burle Marx's gardens.[79]

Now this is very interesting and indicates the profoundly different aesthetic that at least one late twentieth-century ecologist and environmentalist brings to garden design when compared to Burle Marx (though other contemporary landscape designers may come closer to his landscape aesthetic).[80] Burle Marx, at any rate, reflects his own historical formation in tropical Brazil; he was, first and foremost, an artist, a maker of designed spaces. Whereas it is not clear, given Clément's view of the landscapist's responsibility to imitate the processes of evolution and ecology, or at least to not interfere with them, that there is much point to making a garden at all. Leenhardt, in his interrogation of Clément on this point, proposes that, according to Clément's own stated principles, a photograph of an ecologically balanced area of nature might do as well, if not better.[81] Perhaps Burle Marx recognized, more than many other ecologists, that we cannot choose between art and nature, that nature itself is neither stable nor independent of human perceptions and actions, and that nature and culture acquire meaning historically in terms of one another.[82]

To Burle Marx, the fact of creating an artificial landscape out of natural materials meant neither a rejection of nature nor its imitation. To him, plants were indeed natural products of a long process of evolution that was both social and natural; as marvellous productions they needed preserving and protecting. But the very colours and forms in plants that result from evolution also placed them, in his view, in a different category from nature, the category of the aesthetic, which is essential to the human spirit and to human culture. As an artist, his primary concern was to create a work of art through such plants; indeed, one of his reasons for wanting to see reserves of tropical nature established in Brazil was to make available a larger number of plant forms for artistic projects like his than would otherwise be the case, to make sure that Brazil's biodiversity was not reduced to a tiny and unrepresentative selection of species, which would limit both nature and art. Thus nature has its intrinsic value and does not exist only for humanity (the environmentalist's ethic). But nature also has meanings *for* humanity that are philosophical and aesthetic, and which are part of the evolutionary process that has produced the biome of human and plant.

The tropical, then, is more than tropical rain-forest, just as Burle Marx's gardens are more than jungle, more than a simple defiance of the jungle. His gardens are, like Macunaíma, the hero of Mario de

Andrade's novel, of the jungle and of the city, of the hinterland and of the littoral. Brazil has a huge variety of ecological regions – forests, savannahs, deserts, *sertão*, swamps. It is not one thing, or monolithic. Tropical nature as jungle is an artefact of history and culture, like Burle Marx's gardens. The historical understanding of the construct of 'the tropical' is thus necessary to understand how his artefacts of the tropical, and his love of the natural, go together. We can position Burle Marx's brilliant landscapes as spaces that are at one and the same time anti-tropical and tropical. His garden aesthetic, an aesthetic that relies on tropical vegetation, can in this context be interpreted as using metaphorical and material means to recast the symbolic possibilities of tropical nature.

Epilogue

As we look to the future, what place will tropical nature hold in the imagination? In an era of the commodification of nature on an unprecedented scale and of wholesale environmental destruction; when world travel and global networks make all places seem increasingly alike; when we can conjure up by technological means almost any image of place or environment we want, on a video or computer screen, and manipulate it in any direction we choose, so that the line between image and reality becomes hopelessly confused and blurred; in a world in which images are endlessly circulated and recycled, to the point where they become utterly familiar and banal – shall we then find that 'tropical nature', as an imaginative construction, has itself become banal and trivialized? If so, what will the consequences be for our empathetic understanding of the natural world, especially the tropical world that we are so rapidly destroying?

Certainly, 'tropical peoples', one of the three perceptual frameworks I have explored in this book, would seem to be outmoded, as well as smacking of colonial condescension. The preoccupation with hybridization would seem especially irrelevant (hybrid degeneration receiving no support in contemporary biology) – until, however, we take into account continuing political agitation over interethnic marriages or the immigration of dark-skinned people into Europe and the United States, as well as the significance some people attach to preserving supposedly pure ethnic and/or cultural traditions in an increasingly multicultural world.

'Tropical diseases' also have their place in contemporary medicine (to judge, at least, by the size of the grants being given to research in tropical medicine by the Wellcome Trust, Britain's largest private biomedical foundation).[1] But what constitutes a tropical disease is as unsettled as in the past; generally speaking, the term refers to diseases like AIDS and malaria in very poor countries, where poverty itself, civil and ethnic wars, political mismanagement or actual statelessness (the absence of a functioning state) make the burden of infection so

240

great and so difficult to control.

But it is as 'tropical nature', the third framework examined in this book, that the tropical world today perhaps commands the greatest popular attention. Indeed, interest in tropical nature has never been greater because of its central place in defining our current environmental worries about the 'end of nature' itself.[2] Images of the tropical rain-forests of Borneo, or of Costa Rica, fill our television screens, forming in the Western mind what Candace Slater has called 'Edenic narratives' of paradise, or of paradise lost.[3] The ecological recasting of jungle as 'rain-forest' (a term coined in 1898) would also appear to imply an abandonment of many of the old and negative associations of the 'jungle' (as a place of terror or impediment to civilization). The 'rain-forest' associates tropical places with rare environmental values, as well as potential world catastrophe, should they be destroyed forever. It thereby claims a more universal importance in our cultural imagination than the 'tropical jungle' ever did; it implies a kind of nature that belongs to all of us, because it is the entire world's lungs and therefore the entire world's patrimony, a nature that is worth protecting and saving, because if it is not, we truly will fall out of Eden.

Of course, just because we now call tropical nature a rain-forest instead of a jungle does not mean that we are now able to see it, and represent it, correctly, once and for all, as we could not do in the past. For *my* rain-forest may not be the same as *your* rain-forest, or an *Amerindian's* rain-forest. There are different visions of Eden, which often conflict with each other.[4] To some environmentalists, tropical rain-forests are the last remaining forms of wilderness, 'pure nature' which must be left alone at all costs. To others, tropical nature signifies biodiversity, or a genetic library, a rich and endangered source of genetic information, which must be actively harvested, extracted or 'read' before it disappears. To some, sustainable development is compatible with preserving the rain-forests; to others, it is not. To the remaining Amerindian populations, the Amazonian rain-forest is not a source of world commodities, or an aesthetic landscape in the European style, but rather a local, lived space and, perhaps, a land title.[5] To call something a rain-forest is not, therefore, to settle its significance, either scientifically or emotionally.

Many cultural critics go even further, of course, and reject the idea that 'nature' exists at all, as something with its own autonomy and meaning, independent of human perceptions and history. To postmodernists, especially, for whom everything is a representation or a text, there seems to be no room at all for William James's 'old gal Nature'.

But though environmental historians have, rightly, taught us to see that nature is indeed a human product shaped, physically and culturally, ever since the human species appeared on the earth, this does not mean that a rain-forest is *nothing but a text or representation*; nor does it imply that we cannot, and should not, think of forests, greenery, flowers, animals, rivers, mountains, deserts and heaths as belonging to a different order of existence from ourselves, with its own power to surprise or please us, practically or aesthetically, positively or negatively. Just because archaeologists, for instance, have uncovered evidence that the Amazonian rain-forest, which many people in the West assume to be the last remaining 'virgin' land, untouched by human hands, has in fact been shaped, and therefore produced, by Amerindians over the course of centuries (the pre-conquest populations being much larger in size than originally estimated), this does not mean that the Amazonian rain-forest does not have its own existence and is quite different from, say, a woodland in northern Europe.

It does mean, though, that when we look at a space as a habitat for human beings and other living things, as well as inanimate objects, we have to learn to decipher it, to see how, historically, it has been altered by human actions and how, too, the character of the vegetation, rivers, topography, climate and parasites have in turn shaped the activities and experiences of human beings. Today, 'development' in the Amazon is occurring at a staggering rate; the vast geographical terrain is filling up with new populations, much as the European naturalists in the nineteenth century imagined it would. New cities, roads, schools and clinics are sprouting up, along with mining, cattle ranching and other agrobusinesses that turn the materials of the world into commodities. All of these activities are destructive of the Amazon region as it once was; it is an aspect of the culture-nature exchange that is as old as human beings, though its pace is unprecedented, and its consequences are of a different kind than those experienced previously (because the land beneath the tropical canopy is relatively infertile, so that once the cover provided by the trees is gone, the soil cannot support agriculture for long, as deforested temperate land can).[6] But the human inhabitants of the tropical rain-forests (estimated at 50 million people across the globe) have their claim to a space in the world, and it is only as a human-nature hybrid that we can devise adequate policies towards the environment.

Tropical nature, then, like other kinds of nature, is a heterogeneous thing, a mix of the natural and the artificial, the human and the non-human, the organic and the non-organic, both a physical space of living and non-living things and a human invention, as the landscape

gardener Roberto Burle Marx grasped. Indeed, thinking of tropical nature as a tropical *garden* may be a useful way of rethinking the human relationship to the natural world in a period when concepts of untouched 'wilderness' and 'pure nature' have lost scientific credibility or possibility.[7] A short while ago, finding myself in Rio de Janeiro, I visited the City Park. Entering the cool and shaded garden, laid out rather formally and neatly as in a European garden, I first went to the little museum, with its veranda all round to let in the breezes and its lizards sunning themselves, to see an exhibition of wonderful old photographs showing Rio as it once had been. Then, leaving the museum, I struck off onto one of many rough and overgrown trails leading up the steep sides of the mountain surrounding the park, passing by bushes, vines and vast tree-trunks, stumbling across their giant roots (were these native trees or imports from other countries?). Hot and sweaty in the intense humidity, I pushed my way into more and more tangled spaces, when my shoe stuck on a mushy substance, the remains of food and damp paper, remnants of a *candomblé* offering someone had left days before, along with a bottle of wine, for the spirit world. Tropical nature in Brazil encompasses all of these natural and cultural objects.

The tropical heat, which left me dripping with sweat, certainly felt real enough to me. My reaction to it, and to the sight of the vigorous vegetation, which I could see threatened to invade and overtake the ordered garden if not cut back periodically, was not unlike the reaction described by the environmental historian William Cronon to the snails he encountered when living temporarily in southern California. Every night, they would emerge and crawl across the paved walkway in his otherwise impossibly manicured, planned and artificial garden. Although, Cronon says, he knew that the snails were no more native to the area than the succulent plants on which they depended, nonetheless, because they had not been planned by the designer of the garden, they seemed to him to be more 'natural' than the rest, and he took pleasure in this wayward element that made its presence felt. The natural world appears to be more than just a human invention or representation; it has its own reality, with its own capacity to escape our control, to surprise us.[8]

A garden, then, might be thought of as both an expression and a metaphor of the culture-nature nexus. As a human invention, it is an artifice, but as a human construction, it is also made out of the material, malleable stuff of the world, which is unpredictable and not always easy to control (which is why a gardener's work is never done). It provides aesthetic pleasure and an escape from the built environment

of the city (something increasingly important, as the city environment becomes everyone's). But as an invention and aesthetic escape, to be successful as well as environmentally sustainable, a garden has to respect the ecological interdependence of species, both vegetable and animal, and allow untidiness to be part of its achievement.

It also seems to me that the human *need* for at least some concept of nature (however unable we are to define what constitutes 'nature' precisely, or however indefensible our definitions may be) runs very deep, as we see in the great interest in 'green' objects today and in the greening of TV. As Jennifer Price shows wittily in her book *Flight Maps: Adventures with Nature in Modern America*, young people today want 'nature' along with everything else – they want hiking trails and the all-terrain vehicle to get them there, the shopping mall and 'natural' objects, McDonald's and environmental protection; the confusions we experience about what is 'real' and what is 'un-real' are 'real', and will continue to haunt our search for 'real nature'.[9] Yet however confused, I believe that we do need to hold on to *some* definition of 'real nature', in order be able to argue over whether the human actions that shape nature, and are shaped by it, are better in some places than others; to decide whether traditional Amerindian harvesting techniques in the rain-forests are better, more sustainable and healthier for human life and for the plants and animals that live there than, say, cattle ranching; to define which nature-human interactions are worth fighting for, and which are worth fighting against.

The same holds true for representations of tropical nature. We have to have some vantage point, some conception of the real, to be able to judge them, to be able to assess whether they are good representations or bad, aesthetically rewarding or not, scientifically misinformed or not. Though all representations are selective and partial, and different representations serve different purposes, I have nonetheless shown in this book some pictures of tropical nature that were so fanciful as to be downright misleading, and others that were aesthetically satisfying, if not meant to be very scientific, and I have evaluated still others that were verbally accurate (according to the scientific information available in their day), if not easily conveyed in visual form.

Today we live in an image-obsessed age, with pictures of nature and 'the natural' being used to sell every conceivable object, promote the most trivial pursuits and entertain us 24 hours a day. Some of these images are almost laughably or egregiously inaccurate; an example, provided by Candace Slater, is one used by the McDonald Corporation, as part of its campaign to promote its new-found envi-

ronmentalist conscience (its claim, that is, that it does not rely for its hamburgers on beef cattle raised in deforested rain-forests). In this picture, which emphasizes the forest as a radiant scene bathed in light (an image with an old lineage, as we have seen, going back to in the pictures by Rugendas and other nineteenth-century painters), an observant viewer spots that the trees selected to represent the environment which McDonald's claims to be protecting are temperate conifers, a species completely foreign to a tropical rain-forest.[10]

Nonetheless, despite our need to be cautious about how we look at and use images, I am sure that images of the tropics in books, films and television will continue to draw our attention, as a special kind of nature with its own characteristics and possibilities, even though people will disagree about what they are. Many will find in the contemplation of tropical nature an emotional satisfaction and/or scientific interest, without which our concern for the health of tropical environments would surely diminish. It may be, too, that for many people now, and for more in the future (as tropical nature becomes an endangered species, preserved *only* in gardens and theme parks), a picture or representation of tropical nature is all that we will have – a Disneyland version of a tropical rain-forest, or a rain-forest as manufactured in a greenhouse in a Las Vegas hotel, which even puts on a show of a tropical downpour for guests in its restaurant while managing to keep them dry. Such versions of tropical nature may give us some pleasure, in which case we will find ourselves not very differently situated from the women admiring tropical nature in a greenhouse in winter whose picture opened this book.[11]

References

Introduction

1 Titled *Un Jardin d'hiver*, the print is from Arthur Mangin, *Les Jardins: Histoire et description* (Paris, 1867). I first came across this image in William Howard Adams, *Roberto Burle Marx: The Unnatural Art of the Garden* (New York, 1991), p. 20.

2 Claude Lévi-Strauss, *Tristes tropiques* (London, 1973), p. 55. Lévi-Strauss's reference to Henri Rousseau is especially relevant, since the paintings were purely imaginative, Rousseau never having visited the tropics.

3 Comment in Adams, *Roberto Burle Marx*, p. 18.

4 Lévi-Strauss, *Tristes tropiques*, p. 106.

5 David Arnold, ' "Illusory Riches": Representations of the Tropical World, 1840–1950', *Singapore Journal of Tropical Geography*, 21/1 (March 2000), pp. 6–18.

6 Martin Kemp, '"Implanted in Our Natures": Humans, Plants, and the Stories of Art', in David Philip Miller and Peter Hanns Reill, eds, *Visions of Empire: Voyages, Botany, and Representations of Nature* (Cambridge, 1996), p. 201.

7 Charles Darwin, *Voyage of the Beagle* (London, 1989), p. 374.

8 Simon Schama, *Landscape and Memory* (New York, 1995), p. 9.

9 John Prest, *The Garden of Eden: The Botanic Garden and the Re-Creation of Paradise* (New Haven, 1981). Prest shows that the search for an actual site for the Garden of Eden in the New World tropics had been abandoned by the seventeenth century; in its place came the recreation and representation of Eden in the botanical gardens of Europe, where plants from the tropics were acclimatized and cultivated.

10 See John H. Eliot, *The Old World and the New, 1492–1650* (Cambridge, 1970); Anthony Pagden, *European Encounters with the New World: From the Renaissance to Romanticism* (New Haven and London, 1993).

11 William James, Letter to Henry James, dated 15 July [1865], in *The Correspondence of William James*, ed. Ignas K. Skrupskelis and Elizabeth M. Berkeley (Charlottesville and London, 1995), vol. IV, pp. 9–10.

12 Janet Browne, 'A Science of Empire: British Bio-geography before Darwin', *Revue d'Histoire des sciences et leurs applications*, 45 (1992), pp. 425-75.

13 Benjamin Mosely, *A Treatise on Tropical Diseases; on Military Operations; and on the Climate of the West Indies* (London, 1787).

14 Anne Marie Moulin, 'Tropical without the Tropics: The Turning-Point of Pastorian Medicine in North Africa', in David Arnold, ed., *Warm Climates and Western Medicine: The Emergence of Tropical Medicine, 1500–1900* (Amsterdam and Atlanta, GA, 1996), pp. 160–80.

15 Timothy Mitchell, 'The World as Exhibition', *Comparative Studies in Society and History*, 31/2 (April 1989), pp. 217–36.

16 W. J. T. Mitchell, *Picture Theory* (Chicago and London, 1994), esp. chap. 1.

17 An excellent early statement on the importance of visual images in science is

247

Martin J. Rudwick, 'The Emergence of a Visual Language for Geological Science, 1760–1840', *History of Science*, XIV (1976), pp. 149–95, in which the author draws attention to the abstract, formalized, theory-driven character of scientific images. See also Rudwick's later book, *Scenes from Deep Time: Pictorial Representations of the Prehistoric World* (Chicago, 1992); Michael Lynch and Steve Woolgar, eds, *Representation in Scientific Practice* (Cambridge, MA, 1990), and Michael Ruse and Peter Taylor, eds, *Pictorial Representation in Biology: Special Issue of Biology and Philosophy*, 6/2 (1991).

18 Mitchell, *Picture Theory*, p. 5.

19 David Quammen, *The Song of the Dodo: Island Biogeography in an Age of Extinctions* (London, 1996), pp. 33–4.

20 Six paintings by Post in the Louvre date from 1666–8 when he was in Brazil; the more than one hundred other paintings extant were all painted after he returned to Holland.

21 Bernard Smith, *European Vision and the South Pacific* (New Haven, 1985); see also Barbara M. Stafford, *Voyage into Substance: Art, Science, Nature, and the Illustrated Travel Account, 1760–1840* (Cambridge, MA, 1984).

22 See the introduction to Nicholas Green, *The Spectacle of Nature: Landscape and Bourgeois Culture in Nineteenth Century France* (Manchester, 1990).

23 In my book *'The Hour of Eugenics': Race, Gender and Nation in Latin America* (Ithaca and London, 1991), I discuss the varied processes of selection and reassemblage of ideas and practices, their creative elaboration and modification, undertaken by people in specific institutional, political and cultural locations in relation to the history of genetics and eugenics. See also the concept of auto-ethnography developed by Mary Pratt in her book on travel literature, *Imperial Eyes: Travel Writing and Transculturation* (London and New York, 1992), p. 7. Despite Pratt's interest in descriptions of the world by people in positions of unequal (and often colonial) power, her concept of the imperial eye strikes me as too generalized and unitary.

24 For a succinct scientific account of the New World tropics, see John Kricher, *A Neotropical Companion* (Princeton, 1997).

25 David Knight, *The Age of Science: The Scientific World View in the Nineteenth Century* (Oxford, 1986), p. 109. For an example of a literary approach, see Dennis Porter, *Haunted Journeys: Desire and Transgression in European Travel Writing* (Princeton, 1991).

26 Joseph Hooker, Wallace's contemporary and Director of Kew Gardens in the late nineteenth century, is the other contender for this title. A brilliant plant bio-geographer, great friend to Darwin and central figure in the Victorian scientific establishment, his character is far less engaging than Wallace's, and his social outlook far more conventional.

1 *Going to the Tropics*

1 Remark by the British naturalist William Swainson, a zoologist who published many illustrated books, as quoted in Lynn Barber, *The Heyday of Natural History, 1820–1870* (London, 1980), p. 64.

2 Susanna Hecht and Alexander Cockburn, in *The Fate of the Forest: Developers, Destroyers and Defenders of the Amazon* (London, 1989), p. 7, suggest that Humboldt, Darwin, Bates and Wallace were all engaged in 'genteel versions' of resource assessment.

3 See esp. Keith Thomas, *Man and the Natural World: A History of Modern Sensibility* (New York, 1983); David E. Allen, *The Naturalist in Britain: A Social History* (London, 1978); Raymond Williams, *The Country and the City*

(London, 1973).

4 Roderick Nash, 'The Exporting and Importing of Nature: Nature-Appreciation as a Commodity', *Perspectives in American History* 12 (1979), pp. 519–60.

5 Wilma George, 'Alfred Russel Wallace, the Gentle Trader: Collecting in Amazonia and the Malay Archipelago, 1848–1862', *Journal of the Society of the Bibliography of Natural History* 9/4 (1979), pp. 503–14.

6 Leonard Huxley, *Life and Letters of Sir Joseph Dalton Hooker* (London, 1918), vol. 1, p. 332.

7 Warren Dean, *With Broadax and Firebrand: The Destruction of the Brazilian Atlantic Forest* (Berkeley, 1995), p. 163.

8 John McKenzie, *The Empire of Nature: Hunting, Conservation and British Imperialism* (Manchester, 1988).

9 Nicolette Scourse, *The Victorians and Their Flowers* (London, 1983), p. 1.

10 Lucille Brockway, *Science and Colonial Expansion: The Role of the British Botanic Gardens* (New York, 1979). Sir William Hooker, Director of Kew Gardens, gives an account of the blooming of the Amazon water-lily in *Victoria regia* (London, 1851).

11 Professor and Mrs Louis Agassiz, *A Journey in Brazil* (Boston, 1868), p. 8.

12 Mary P. Winsor, *Reading the Shape of Nature: Comparative Zoology at the Agassiz Museum* (Chicago, 1991), p. 214.

13 William James papers, Houghton Library, Harvard University.

14 Alfred Russel Wallace, *A Narrative of Travels on the Amazon and Rio Negro* (London, 1853), p. 4.

15 E.g. the books *Central America, the West Indies and South America*, edited and extended by H. W. Bates (London, 1878), and *Illustrated Travels: A Record of Discovery, Geography and Adventure*, also edited by Bates (London, 1869–73), 6 vols in 3.

16 Quoted in John Tallmadge, 'From Chronicle to Quest: The Shaping of Darwin's "Voyage of the Beagle"', *Victorian Studies* 23 (1979/80), pp. 325–45.

17 Among many analyses, see esp. Michael Dettelbach, 'Humboldtian Science', in N. Jardine, J. A. Secord and E. C. Spary, eds, *Cultures of Natural History* (Cambridge, 1993), pp. 287–304; and Mary Pratt, *Imperial Eyes: Travel Writing and Transculturation* (London, 1992), pp. 111–37, for a post-modern literary critique. The best scholarly critical evaluation, which places Humboldt's work in the context of Europeans traditions and Creole patriots' responses, is David Brading, *The First America: The Spanish Monarchy, Creole Patriots, and the Liberal State, 1492–1867* (Cambridge, 1991), esp. chap. 23; also very useful is Anthony Pagden, *European Encounters with the New World: From the Renaissance to Romanticism* (New Haven, 1993). Clarence J. Glacken, *Traces on the Rhodian Shore: Nature and Culture in Western Thought from Ancient Times to the End of the Eighteenth Century* (Berkeley, 1990), is a pioneering examination of ideas about the relation between environment and human culture that includes a valuable discussion of Humboldt.

18 Edmunds V. Bunksé, 'Humboldt and the Aesthetic Tradition in Geography', *Geographical Review* 71 (1981), pp. 128-146.

19 Alexander von Humboldt, *Personal Narrative of Travels to the Equinoctial Regions of the New Continent during the Years 1799–1804*, trans. Helen Maria Williams (facsimile of 1818–29 edn), 7 vols in 6 (New York, 1966); *Cosmos*, 7th edn, 3 vols (London, 1849).

20 Brading, *The First America*, p. 514.

21 Tallmadge, 'From Chronicle to Quest'.

22 Humboldt, *Personal Narrative*, vol. 3, p. 354.

23 Bunksé, 'Humboldt and the Aesthetic Tradition'.

24 Humboldt, *Personal Narrative*: 'Nature in these climates', vol. 2, p. 206; 'vast continent', vol. 3, pp. 35–6.

25 Alexandre de Humboldt, 'Des lignes isothermes et de la distribution de la chaleur sur le globe', *Mémoires de physique et de chimie de la Société d'Arcueil* 3 (1817), pp. 462–602; see p. 465. This work was published in English within a few years.

26 Dettelbach, 'Humboldtian Science', p. 296, comment in caption to fig. 17.2.

27 Humboldt had already tried out the technique of profiles in a study of the geography of Spain. These are reproduced in Douglas Botting, *Humboldt and the Cosmos* (New York, 1973), p. 61.

28 Alexandre von Humboldt and Aimé Bonpland, *Essai sur la géographie des plantes; Accompagné d'un Tableau physique des régions equinoxiales* (Paris, 1805).

29 A later picture by Humboldt expanded this diagrammatic schema to show cross-sectional representations of three different mountains from the three main climatic zones in the world, the tropical, temperate and arctic, each with its own zones of plants, and each demonstrating that the changes in plants according to altitude matched the changes according to latitude. This diagram appeared in the first volume of Humboldt's *Nova genera et species plantarum* (Paris, 1815).

30 Humboldt, *Vues des Cordillères et monuments des peuples indigènes de l'Amérique* (Paris, 1810), pp. 34–5.

31 Humboldt, *Personal Narrative*, vol. 4, p. 117.

32 Humboldt, *Vues des Cordillères*, pp. 34–5.

33 Baron de Montesquieu, *The Spirit of the Laws*, trans. Thomas Nugent (New York, 1949), esp. pp. 14–17.

34 Humboldt, *Personal Narrative*, vol. 3, p. 14.

35 *Ibid.*, vol. 3, pp. 511–12, 161.

36 *Ibid.*, vol. 3, pp. 14–15.

37 Alexander von Humboldt, *Views of Nature: or Contemplations on the Sublime Phenomena of Creation*, trans. E. C. Otté and Henry G. Bohn (London, 1850), p. 231. Humboldt reiterated this theme in a long chapter on landscape painting and its influence on students of nature; see *Cosmos*, trans. E. C. Otté (London, 1886), pp. 440–57.

38 Franklin Kelly *et al.*, *Frederic Edwin Church* (Washington, DC, 1989), esp. the essay by Stephen Jay Gould, 'Church, Humboldt, and Darwin: The Tension and Harmony of Art and Science', pp. 94–125.

39 R. A. McNeill and M. D. Dean, *Europeans in Latin America: Humboldt to Hudson*, exh. cat., Bodleian Library, Oxford (1980).

40 Ann Shelby Blum, *Picturing Nature: American Nineteenth-Century Zoological Illustration* (Princeton, 1993), p. 18. A well-known example would be Charles Waterton's *Wanderings in South America* (London, 1825), based on a trip the author made in 1812 to present-day Guyana; his book combines many interesting facts of natural history and ethnography, but also fantastic tales and visual adventures.

41 Alfred Russel Wallace, *My Life: A Record of Events and Opinions* (London, 1905), vol. I, p. 321.

42 James R. Ryan, *Picturing Empire: Photography and the Visualization of the British Empire* (London, 1997), pp. 47–61.

43 Rugendas went to Brazil in 1821 as part of an expedition organized by Baron von Langsdorff into the interior. Rugendas left the expedition (the Baron

went mad) to paint on his own. He met Humboldt in Paris, as well as Delacroix and other artists, but on Humboldt's urging returned to Latin America, where he spent many years in Mexico and Chile, with brief visits to other countries in the region.

44 Peter Raby, *Bright Paradise: Victorian Scientific Travellers* (London, 1996), p. 19.

45 Lynn Merrill, in *The Romance of Victorian Natural History* (New York, 1989), analyzes the literary style characterizing much natural-history writing in Britain, emphasizing its language of close vision (seeing as a way of knowing), delight in detail, pleasure in the sheer enumeration of novelties and celebration of nature as a 'romance'.

46 Patrick Brantlinger, 'The Genealogy of the Myth of the "Dark Continent"', in *Rule of Darkness: British Literature and Imperialism, 1830–1914* (Ithaca, NY, and London, 1988), pp. 173–98.

47 Quoted in Scouse, *The Victorians and Their Flowers*, p. 60.

48 P. H. Gosse, *A Naturalist's Sojourn in Jamaica*, assisted by Richard Hill (London, 1851), pl. betw. pp. 362–3. Gosse spent eighteen months in Jamaica.

49 Heade's series of paintings known as the 'Gems of Brazil' was intended for publication, but he was unable to find sufficient subscribers in London to support the project. Later, between 1871 and 1902, Heade painted ten pictures of hummingbirds and passion flowers, and 55 of hummingbirds and orchids.

50 Heade eventually made three trips to the tropical Americas, to Brazil in 1863–4, where he met the Emperor, Dom Pedro II, and exhibited his first hummingbird pictures; to Nicaragua briefly in 1866, and to Colombia, Panama and Jamaica in 1870; he eventually settled in Florida. See Theodore E. Stebbins, Jr, *The Life and Work of Martin Johnson Heade* (New Haven and London, 1975); and *idem*, with contributions by Janet L. Comey, Karen E. Quinn and Jim Wright, *Martin Johnson Heade*, exh. cat., Museum of Fine Arts, Boston (1999).

51 Alfred Russel Wallace, 'Hummingbirds as Illustrating the Luxuriance of Tropical Nature', in *Tropical Nature and Other Essays* (London, 1878), pp. 124–57. The juxtaposition of large, exotic tropical flowers with hummingbirds caught in flight in Thornton's well-known, if overly dramatic (and not botanically accurate), *Temple of Flora* (London, 1799–1807), intended to demonstrate the Linnaean sexual system of plant classification, may have provided the model for later depictions.

52 Charles Darwin, *On the Various Contrivances by Which British and Foreign Orchids are Fertilised by Insects* (London, 1862).

53 The name of the plant is derived from the Latin for 'testicle', owing to the shape of the its tubers. Many sexual myths surrounded these plants.

54 There seems to be a growing consensus on the importance of Darwin to Heade, but the evidence is at best inferential, whereas in the case of Church, his debt to Humboldt was evident in his itinerary and the fact that he planned to take his famous painting *The Heart of the Andes* to Europe to show to Humboldt. See Stebbins, Jr, 'Picturing Heade: The Painter and His Critics', in *Martin Johnson Heade*, pp. 141–67, esp. pp. 155–7. David Knight, *The Age of Science: The Scientific World View in the Nineteenth Century* (Oxford, 1986), p.115, points out that many nineteenth-century illustrations which look 'Darwinian' to us may not have been intended as such.

55 David Miller, *Dark Eden: The Swamp in Nineteenth Century-American Culture* (Cambridge, MA, 1989), p. 155. Miller suggests that Heade's unconventional manipulation of landscape conventions was a radical solution to the

iconographic problem of giving visual interest to what otherwise appears as densely foliated, monotonous scenery. Though Heade may have been radical in painterly terms, he seems less so when we place him in relation to natural-history illustrations of the day.

56 Her pictures were nevertheless accepted as such by Joseph Hooker, then Director of Kew Gardens, and were used to identify several rare species.

57 Laura Ponsonby, *Marianne North at Kew Gardens* (London, 1991). See also *A Vision of Eden: The Life and Work of Marianne North* (Kew, 1980); Marianne North, *Recollections of a Happy Life: Being the Autobiography of Marianne North*, ed. Mrs John Addington Symonds, 2 vols (London, 1892); *Some Further Recollections of a Happy Life: Selected from the Journals of Marianne North chiefly between the years 1859 and 1869* (London, 1893).

58 Scouse, *Victorians and Their Flowers*, p. 101.

59 Henry Thomas Buckle, *History of Civilisation in England*, 2nd edn (London, 1866), quote from p. 75.

60 Barbara G. Beddall, *Wallace and Bates in the Tropics: An Introduction to the Theory of Natural Selection* (London, 1969), pp. 29–30.

61 Henry Walter Bates, *The Naturalist on the River Amazons*. With a memoir by Edward Clodd (London, 1892), quotes from pp. 117, 139. This is a reprint of the first edition.

62 John Mawe, *Travels in the Interior of Brazil* (London, 1812), p. 133.

63 Bates, *The Naturalist on the River Amazons*, p. 389.

64 Kelly *et al.*, *Frederic Edwin Church*, pp. 57–8 gives a detailed account of how the painting was shown and marketed.

65 Cited in Brading, *The First America*, p. 516.

2 *An Evolutionist's Tropics*

1 The reference is to Arnold C. Brackman's overly vehement account, *A Delicate Arrangement: The Strange Case of Charles Darwin and Alfred Russel Wallace* (New York, 1980), in which the author champions Wallace's claims to recognition.

2 The historical material on Darwin is now enormous. The best modern biography is Janet Browne, *Charles Darwin: Voyaging* (London, 1995); this first volume of an expected two-volume account ends before Wallace's paper of 1858.

3 Charles H. Smith, 'Introduction', in *Alfred Russel Wallace: An Anthology of His Shorter Writings*, ed. C. H. Smith (Oxford, 1991), p. 2.

4 Wallace has received nothing like the biographical attention Darwin has; to this day there is no complete edition of his correspondence. See, however, James Marchant, ed., *Alfred Russel Wallace: Letters and Reminiscences* (London, 1916), 2 vols, and Barbara G. Beddall, *Wallace and Bates in the Tropics: An Introduction to the Theory of Natural Selection* (London, 1969), a very useful anthology of selections of writings. Most biographers of Wallace have approached him as a theorist of biology. See esp. Lewis McKinney, *Wallace and Natural Selection* (New Haven, 1972); Martin Fichman, *Alfred Russel Wallace* (Boston, 1981); John J. Brooks, *Just Before the Origin: Alfred Russel Wallace's Theory of Evolution* (New York, 1984); Wilma George, *Biologist Philosopher: A Study of the Life and Writings of Alfred Russel Wallace* (London, 1981); Bert J. Loewenberg, *Darwin, Wallace, and the Theory of Natural Selection* (Cambridge, CA, 1959).

5 Jorge Luis Borges, 'Of Exactitude in Science', in *A Universal History of Infamy* (London, 1975), p. 131.

6 Alfred Russel Wallace, *A Narrative of Travels on the Amazon and Rio Negro* (London, 1853), p. 4.

7 W. H. Edwards, *The Voyage up the River Amazon, Including a Residence at Pará* (London, 1847). Edwards was a lawyer by training.

8 George Woodcock, *Henry Walter Bates: Naturalist of the Amazons* (New York, 1969), p. 29.

9 A reviewer in *Chamber's Journal* 8 (1864), pp. 166–9, calling Edwards a 'sportsman author', claimed that Edwards did not describe very well, did not philosophize at all and had a limited knowledge of science.

10 Wallace, *Narrative of Travels*, p. 9.

11 Darwin, in his *Voyage of the Beagle* (London, 1989), p. 374, denies that he felt any disappointment on viewing the tropics, which suggests that the issue was nonetheless on his mind. Did tropical nature match Humboldt's representations?

12 Wallace, *Narrative of Travels*: 'strange and unsightly', p.6; 'there is something wanting', p. 10; 'the vegetation was by no means', p. 154; 'and then not very remarkable', p. 16; 'not very rare or handsome', p. 88; 'a monotonous conversation', p. 16; 'there is nothing in this country', p. 67; 'nothing could make up', p. 175

13 John Tallmadge, 'From Chronicle to Quest: The Shaping of Darwin's "Voyage of the Beagle"', *Victorian Studies* 23 (1979/80), pp. 325–45.

14 Bates's letter, dated 16 March 1849, appeared in *Zoologist* VIII (1850), p. 2664.

15 Wallace, *Narrative of Travels*: 'the undulating *Morphos*', p. 25; 'the beautiful pavon', p. 42; 'we were not successful', p. 35; 'the next day we left', p. 75. The account of dropping the gun appears on p. 68, the narrow miss on p. 77.

16 *Ibid.*, p. 42.

17 Henry Walter Bates, *The Naturalist on the River Amazons* (New York, 1892), p. 238.

18 For example, see Mary Pratt, 'The Face of the Country', *Critical Inquiry* 12 (Autumn 1985), pp. 119–43. In fact, I have found many moments in natural-history writing when the author (sometimes unwittingly) reveals the natives' understanding of the world around them. The Indians who observed Wallace and Bates collecting butterflies, for example, disbelieved the naturalists' assertion that the butterflies were only useful for exhibition; they believed that they were to be used to provide patterns for calico cloth, a shrewd assessment of the commercialism that surrounded natural history. See Wallace, *Narrative of Travels*, p. 61.

19 Beddall, *Wallace and Bates in the Tropics*, pp. 29–30.

20 Wallace's descriptions of the Indian 'given' to him to work the canoe, and driven to his work by 'severe lashes, and at the point of a bayonet', can be interpreted as both a callous acceptance of the system of labour extraction in the Amazon and a critique of it. See Wallace, *Narrative of Travels*, pp. 160–61.

21 Wallace, *Narrative of Travels*, pp. 32–4.

22 Quoted in McKinney, *Wallace and Natural Selection*, p. 19. McKinney notes that Hooker praised Berthold Seemann's *Popular History of the Palms and their Allies*, which came out two years after Wallace's book; he suggests that the fact that Wallace dared to criticize one of Hooker's own plant identifications, and that Hooker's son, Joseph Hooker, was helping Seemann prepare his book, explains Hooker's criticisms of Wallace. However, one anonymous reviewer, in *Annals and Magazine of Natural History*, 2nd ser., 3 (1854), pp. 56–8, found much to praise in Wallace's book, especially the 48 portraits of palms

(engraved by Fitch) and its introduction, in which Wallace gives an account of the endless uses to which palm trees were put in the tropics.

23 McKinney, *Wallace and Natural Selection*, p. 15.

24 Bates, in *Zoologist*, VIII (1850), p. 2665.

25 Wallace, *Narrative of Travels*, pp. 4–5.

26 Wallace, *My Life* (London, 1905), vol. 1, p. 336.

27 John Durant, 'Scientific Naturalism and Social Reform in the Thought of Alfred Russel Wallace', *British Journal of the History of Science* 12 (1979), pp. 31–57.

28 On Murchison, see Robert A. Stafford, *Scientist of Empire: Sir Roderick Murchison, Scientific Exploration and Victorian Imperialism* (Cambridge, 1989); on Brooke, see Spencer St John, *The Life of Sir James Brooke* (London, 1879).

29 Wallace in fact wrote two seminal theoretical papers in the 1850s: 'On the Law which has Regulated the Introduction of New Species', *Annals and Magazine of Natural History*, 2nd ser., 16 (1855), pp. 184–96; and 'On the Tendency of Varieties to Depart Indefinitely from the Original Type', *J. Proc. Linnaean Society, London, Zoology*, 3 (1858), pp. 53–62.

30 Marchant, ed., *Alfred Russel Wallace*, vol. 1, p. 80.

31 The *Malay Archipelago* had fifteen editions in Wallace's lifetime. Eventually, too, his *Narrative of Travels* was reprinted (in 1889); very few changes of substance were made, but many verbal alterations. English names were substituted for the local Portuguese and Indian terms that, said Wallace, 'had been used too freely in the first edition'. The publisher also added woodcuts, some of which bore little relation to Wallace's actual experiences. Thus was his text brought into some conformity with the conventions of tropical writing and illustrating of his day. See Wallace, 'Preface', *A Narrative of Travels on the Amazon and Rio Negro* (London, 1889), p. xii.

32 Donna Haraway, *Primate Visions: Gender, Race, and Nature in the World of Modern Science* (New York, 1989).

33 Paul Du Chaillu, *Explorations and Adventures in Equatorial Africa* (London, 1861).

34 For the original letter, written in June 1855, see Alfred Russel Wallace, *My Life: A Record of Events and Opinions* (London, 1905), vol. 1, pp. 343–5; for the account in *The Malay Archipelago*, see pp. 53–7.

35 Alfred Russel Wallace, *The Malay Archipelago* (New York, 1989), reprint of 1869 edition, p. 467.

36 Jane R. Camerini, 'Evolution, Biogeography, and Maps: An Early History of Wallace's Line', *Isis*, 84 (1993), pp. 700–727; Wilma George, 'Wallace and His Line', in T. C. Whitmore, ed., *Wallace's Line and Plate Tectonics* (Oxford, 1981), pp. 3–8. Wallace repositioned the line several times to accommodate the distributions he found.

37 At the time, Wallace could point to the pattern but not the exact causes of the Bali/Lomstock line; the answer lay in very deep oceans. See David Quammen, *The Song of the Dodo: Island Biogeography in an Age of Extinctions* (London, 1997), pp. 25–6. Recently, David Taylor, in 'A Biogeographer's Construction of Tropical Lands: A. R. Wallace, Biogeographical Method and the Malay Archipelago', *Singapore Journal of Tropical Geography*, 21/1 (March 2000), pp. 63–75, has criticized Wallace for overdoing the idea of categorical divisions between areas, and more generally for representing tropical environments as fixed and stable in biota when compared to temperate ones. This tropical reductionism, Taylor has argued, has affected tropical environmentalism negatively by creating the tropics as a stable 'other' instead of as an unstable

environment. This has misled environmentalists in their discussions about 'native' tropical species.

38 James Boon, *Affinities and Extremes: Crisscrossing the Bittersweet Ethnology of the East Indies: History, Hindu-Balinese Culture, and Indo-European Allure* (Chicago, 1990), pp. 12–23.

39 On the race/sexual analogy, see Nancy Leys Stepan, 'Race and Gender: The Role of Analogy in Science', *Isis*, 77 (1986), pp. 261–77. On the tropics as sensual/sexual, see Richard Parker, *Bodies, Pleasures, and Passions: Sexual Culture in Contemporary Brazil* (Boston, 1991).

40 Wallace, *The Malay Archipelago*, p. 598.

41 Boon, *Affinities and Extremes*, p. 20.

42 Wallace's shifting positions on evolution, society and race, as they emerged in the 1860s, are analyzed in Nancy Stepan, *The Idea of Race in Science: Great Britain, 1800–1960* (Oxford, 1982), pp. 65–77.

43 Frank M. Turner, *Between Science and Religion: The Reaction to Scientific Naturalism in Late Victorian Britain* (New Haven, 1974).

44 Smith, *Alfred Russel Wallace*, p. 66–7, quoting from Wallace's entry on spiritualism in the 1892 edition of *Chamber's Encyclopaedia*.

45 Darwin's remark is quoted in *Alfred Russel Wallace: Letters and Reminiscences*, ed. James Marchant (London, 1916), vol. 1, p. 240.

46 This was not a term Wallace used. At the time, 'environmentalism' referred to the way in which the environment influenced or determined the distribution of species; only later did it acquire our modern conservationist and ecological meaning.

47 Lawrence Buell, *The Environmental Imagination: Thoreau, Nature Writing, and the Formation of American Culture* (Cambridge and London, 1995), esp. 'Introduction'.

48 David Pepper, *The Roots of Modern Environmentalism* (London, 1984), p. 102.

49 As noted by Richard Grove, *Green Imperialism: Colonial Expansion, Tropical Island Edens and The Origins of Environmentalism, 1600–1860* (Cambridge, 1995), p. 484.

50 Tom Griffiths, 'Introduction', in Tom Griffiths and Libby Robin, eds, *Ecology and Empire: Environmental History of Settler Societies* (Edinburgh, 1997), p. 1.

51 Grove, *Green Imperialism*, esp. pp. 428–73. Grove also has interesting comments on Humboldt's account of the results of deforestation in Venezuela, which appeared in the fourth volume of his *Personal Narrative* (1819); Humboldt's ideas slowly diffused into the professional circles involved in conservationist and environmentalist issues (pp. 364–79).

52 D. McKenzie, ed., *Imperialism and the Natural World* (Manchester, 1990), p. 3.

53 Wallace, *The Malay Archipelago*, p. 448. Peter Raby, in *Bright Paradise: Victorian Scientific Travellers* (London, 1997), also singles out this passage as an example of 'the connectedness of all organisms, including "civilized" man' (p. 159).

54 Wallace, 'Preface', in *Tropical Nature*, p. vi.

55 Wallace, 'The Climate and Physical Aspects of the Equatorial Zone', in *Tropical Nature*, pp. 18–21.

56 *Ibid.*, p. 21. This was the second edition of Marsh's work, which first appeared in 1864 as *Man and Nature*.

57 Wallace, 'The Plunder of the Earth', in *Our Wonderful Century* (London, 1898), pp. 367–79.

58 Comment made on the picture in Ruth Stiff, *Margaret Mee: Return to the Amazon* (London, 1996), p. 42.

3 *Racial Degenerations*

1 William James's Brazilian diary and drawings, to which I will return several times in this chapter, are in the Houghton Library, Harvard University, Cambridge, MA.

2 Remark by Agassiz, as quoted in Ann Shelby Blum, *Picturing Nature: American Nineteenth-Century Zoological Illustration* (Princeton, 1993), p. 265.

3 'Very complete series', quote from Professor and Mrs Louis Agassiz, *A Journey in Brazil* (Boston, 1886), p. 296. All further quotes are from this edition.

4 Elizabeth Edwards, 'Photographic "Types": The Pursuit of Method', *Visual Anthropology*, 3 (1990), p. 236.

5 On his intention to publish the photographs, see Agassiz and Agassiz, *Journey*, Appendix V, 'Permanence of Characteristics in Different Human Species', p. 529.

6 This was a tipped-in photograph of a naked man posed in front of a grid, which illustrated the photographic system of race measurement by John H. Lamprey, in 'On a Method of Measuring the Human Form for the Use of Students of Ethnology', *Journal of the Ethnological Society of London*, 1 (1869), p. 84.

7 W. J. T. Mitchell, *Picture Theory* (Chicago, 1994), p. 283, refers to the 'stubbornness of the naïve, superstitious view of photography' (meaning the belief in the photograph's objectivity and reality), and the paradox that the photograph is both like a language (and always in exchange with verbal communication) and also not like one.

8 Though efforts were made to make such photographs.

9 Agassiz's life and scientific work are described in detail in Edward Lurie, *Louis Agassiz: A Life in Science* (Chicago, 1960), and *idem*, *Nature and the American Mind: Louis Agassiz and the Culture of Science* (New York, 1974). See also Stephen Jay Gould, *The Mismeasure of Man* (New York, 1981), pp. 30–72, where Gould deals specifically with Agassiz's racial views.

10 Lorraine Daston and Peter Galison, in 'The Image of Objectivity', *Representations*, 40 (Fall 1992), pp. 81–128, explore the relation between different conceptions of scientific objectivity and realism in the nineteenth century, especially in relation to the photograph.

11 G. S. Rousseau and Roy Porter, eds, *Exoticism in the Enlightenment* (Manchester and New York, 1990).

12 Quoted in Richard G. Parker, *Bodies, Pleasures, and Passions: Sexual Culture in Contemporary Brazil* (Boston, 1991), p. 12. This is an excellent analysis of the way in which the sexuality of the tropical, racially mixed population has been woven into Brazilian national culture.

13 Roy Porter, 'The Exotic as Erotic: Captain Cook at Tahiti', in Rousseau and Porter, eds, *Exoticism in the Enlightenment*, pp. 117–44. The most famous of the Enlightenment writings is Denis Diderot, *Supplement au Voyage de Bougainville* (1792), a dialogue on sexuality between a Tahitian wise man and a Catholic priest. See Porter, 'The Exotic as Erotic', pp. 120–21.

14 Raymond Corbey, 'The Colonial Nude: Photographic Essay', *Critique of Anthropology*, 8/3 (Winter 1988), pp. 75–92. There was an underground circulation of homoerotic photographic images (though in numbers the female nude predominated in the genre of photographic pornography); see Peter

Weiermair, *The Hidden Image: Photographs of the Male Nude in the Nineteenth and Twentieth Century* (Cambridge, MA, 1988).

15 Malek Alloula, *The Colonial Harem*, trans. Myrna and Wlad Godzich (Mineapolis, 1986).

16 Mary P. Winsor, *Reading the Shape of Nature: Comparative Zoology at the Agassiz Museum* (Chicago, 1991), pp. 68–80.

17 'Here on the ground the romance [of natural history] vanishes and the misgivings float up.' Quoted in Howard M. Feinstein, *Becoming William James* (Ithaca and London, 1984), p. 174.

18 James's letters from Brazil are published in *The Correspondence of William James*, ed. Ignas K. Skrupskelis and Elizabeth M. Berkeley (Charlottesville and London, 1995), vol. IV, 1856–77. The relation between Agassiz and James has intrigued several scholars, notably Feinstein; see *Becoming William James*, esp. chap. 11. Feinstein approaches the Brazilian episode psychoanalytically, using James's diaries, letters and drawings to probe his state of mind. James Irmscher, *The Poetics of Natural History: From John Bartram to William James* (New Brunswick, NH, 1999), chap. 6, also counterpoises Agassiz and James in a book he characterizes as about the 'daydreams of American natural history collectors', with genuine adventure and discovery in natural history 'going out with a whimper' with Agassiz.

19 Quoted in Feinstein, *Becoming William James*, p. 171.

20 Milton Vargas, 'Louis Agassiz and the Story of Geological Surface Formation in Brazil', *Quipu: Revista latinamericano de la história de las ciencias y la tecnologia*, 2/3 (1985), pp. 351–84. Agassiz's arguments about a Quaternary Ice Age in Brazil briefly convinced the geologist Frederic Hartt, who was part of the expedition, but Hartt later changed his mind about the geological evidence. Today, it is accepted that the entire Amazon basin experienced several mini ice ages, though of a quite different character and period than Agassiz suggested.

21 Katherine E. Manthorpe, *Tropical Renaissance: North American Artists Exploring Latin America, 1839–1879* (Washington, DC, 1989).

22 Agassiz took with him to Brazil a letter to Dom Pedro II from the US Secretary of State, who wanted to ensure that Brazil took the Union side in the Civil War, a tricky issue given Brazil's reliance on slavery. The correspondence between Dom Pedro II and Agassiz is in the Houghton Library, Harvard University.

23 The announcement was made at the World Exhibition held in Paris.

24 Gould, *The Mismeasure of Man*, pp. 30–72, argues that the move to the US was the event that galvanized Agassiz to take up the racial issue.

25 Lurie, *Louis Agassiz*, pp. 257–66. The two main publications of the American polygenists are Josiah Nott and George Gliddon, *Types of Mankind* (1854) (which had ten editions between 1854 and 1871), and *Indigenous Races of the Earth* (1857). The first book contains Agassiz's essay on the eight primordial races found in the world, and their geographical provinces; the second publication has a prefatory essay by him.

26 On the general move away from monogenism to polygenism in science see Nancy Stepan, *The Idea of Race in Science: Great Britain, 1800–1960* (London, 1982), chaps 1–2. Though Agassiz's ideas were more extreme than most, in general naturalists and anthropologists at the time emphasized the differences between, and stability of, racial types rather than the variability and unity of the human species. This remained the dominant narrative of the human species from the 1830s until the Second World War and after.

27 Winsor, *Reading the Shape of Nature*, p. 17.

28 The typological approach was closely tied to the sciences of physiognomy and phrenology; it had a wide appeal not just in anthropology but in paintings and portraiture more generally in the Victorian era. See, for example, Mary Cowling, *The Artist as Anthropologist: The Representation of Type and Character in Victorian Art* (Cambridge, 1989).

29 Stepan, *The Idea of Race in Science*, p. 95.

30 Christopher Pinney, 'Colonial Encounters in the "Laboratory of Mankind"', in *The Raj: India and the British, 1600–1947* (London, 1991), pp. 252–63.

31 Stepan, *The Idea of Race in Science*, pp. 8–9.

32 On the early development of a diagrammatic language in geology, see Martin J. S. Rudwick, 'The Emergence of a Visual Language for Geology, 1760–1840', *History of Science*, 14 (1976), pp. 149–95.

33 Stephen Jay Gould, 'Human Equality as a Contingent Fact of History', in *The Flamingo's Smile: Reflections in Natural History* (New York and London, 1985), pp. 185–98.

34 *Ibid.*, p. 189, caption.

35 Josiah C. Nott and George R. Gliddon, *Types of Mankind: or, Ethnological Researches, based upon the Monuments, Paintings, Scuptures, and Crania of Races*, 10th edn (Philadelphia, 1871), p. xiii.

36 Cowling, *The Artist as Anthropologist*, p. 61, on English objections to the pictures.

37 'The Daguerreotype as a Scientific Tool', in M. Susan Barger and William B. White, *The Daguerreotype: Nineteenth Century Technology and Modern Science* (Washington, DC, 1991), pp. 72–97.

38 Quoted in William J. Mitchell, *The Reconfigured Eye: Visual Truth in the Post-Photographic Age* (Cambridge, MA, 1992), p. 5.

39 Daston and Galison, 'The Image of Objectivity', p. 111. Artists, on other hand, tried to break this causal or indexical characteristic of the photograph by means of deliberate alterations of the image to introduce the subjective, human, artistic impression of the world and thereby approximate the photograph to art.

40 Alfred Russel Wallace, 'Museums for the People', *Macmillan's Magazine*, 19 (January 1869), pp. 244–50.

41 Quoted in John Tagg, *The Burden of Representation: Essays on Photographies and Histories* (Manchester, 1988), p. 78.

42 Robert Taft, in *Photography and the American Scene: A Social History, 1839–1889* (New York, 1938), special footnote to p. 61.

43 Allan Sekula, 'The Body and the Archive', in Richard Bolton, ed., *The Contest of Meaning: Critical Histories of Photography* (Cambridge, MA, 1989), pp. 343–89; Tagg, *The Burden of Representation*.

44 The discovery of the Zealy photographs is described in Elinor Reickis, 'Faces of Slavery', *American Heritage*, 28 (1977), pp. 4–5. The photographs are briefly analyzed in Melissa Banta and Curtis M. Hinsley, *From Sight to Site: Anthropology, Photography and the Power of Imagery* (Cambridge, MA, 1986), pp. 58–61, and more extensively in Alan Trachtenberg, *Reading American Photographs: Images as History, Mathew Brady to Walker Evans* (New York, 1989), pp. 52–6. Brian Wallis, 'Black Bodies, White Science: Louis Agassiz's Slave Daguerreotypes', *American Art*, 9/2 (Summer 1995), pp. 39–61, reproduces all fifteen of the images.

45 Thus Jews were made to strip naked before being killed by the Nazis.

46 Trachtenberg, *Reading American Photographs*, on the contrary, suggests that

the nakedness of the slaves in Zealy's pictures, and the fact that their eyes look directly at us, causes us to identify with their suffering humanity and similarity to ourselves. This is of course the opposite of their original intention and indicates the difficulties that exist regarding how to 'read' a photographic image once it is disconnected from verbal accounts or other contextual factors.

47 As they were in fact maintained, by formal laws and informal social practices leading to racial segregation in the Southern states, and the steady removal of the civil and political rights of the emancipated black population.

48 Agassiz and Agassiz, *Journey*, p. 49.

49 *Correspondence of William James*, vol. IV, p. 102.

50 'There is absolutely no distinction of color here; a black lady, always supposing her to be free, is treated with as much consideration and meets with as much attention as a white one,' wrote Elizabeth Agassiz (*Journey*, p. 280). Thirty years later, the city of Rio de Janeiro would appear whiter as the population was swelled by European immigrants, but colour consciousness was also greater following abolition. See my analysis in Chapter 4 of the present volume.

51 Banta and Hinsley, in *From Site to Sight*, pp. 58–61, were the first to publish and analyze briefly some of the Brazilian images. Subsequently, some of them were reproduced in Brazil, and in Gwyniera Isaac, 'Louis Agassiz's Photographs in Brazil: Separate Creations', *History of Photography*, 21/1 (Spring 1997), pp. 3–11 (Isaac usefully comments on how the meaning of Agassiz's racial images was provided by his verbal descriptions), and Irmscher, *The Poetics of Natural History*, pp. 274–81. None of these authors relate the images to the problem of the representation of the hybrid as such, or to pre- and post-photographic conventions in the visual representation of race, as analyzed in this chapter.

52 The 1874 greatly expanded edition of *Notes and Queries on Anthropology, for the Use of Travellers and Residents in Uncivilized Lands* (London, 1874), prepared by the Anthropological Institute in London, included photography as a measuring technique as a means of preserving accurate information on rapidly disappearing 'savages'.

53 See Rosalyn Poignant, 'Surveying the Field of View: The Making of the RAI Photographic Collection', in Elizabeth Edwards, ed., *Anthropology and Photography, 1860–1920* (New Haven and London, 1992), pp. 42–73, on Huxley's project, and Edwards, 'Photographic "Types"', pp. 245–49.

54 Agassiz describes his racial and photographic project in *A Journey in Brazil*, chap. 9, pp. 296–300, and Appendix V, 'Permanence of Characteristics', pp. 529–32. Quote from p. 529.

55 William James, *Brazilian Diary*, 1865, William James Papers, Houghton Library, Harvard University. Pp. 1–4 of the diary are missing. Quote from p. 8.

56 Agassiz and Agassiz, *A Journey in Brazil*, p. 276.

57 James, *Brazilian Diary*, p. 8. Tavares Bastos was a pro-American, pro-abolition politician who wanted to see the Amazon opened up to international trade; he originally favoured race mixture as a way to racial improvement, but drew the line at crossing Brazilians with Chinese.

58 Thomas E. Skidmore, 'Race Relations in Brazil', *Camões Center Quarterly*, 4/3, 4 (Winter 1992), pp. 49–61. A 1976 survey listed 135 ethnic categories then in use in Brazil.

59 Winston Jordan, *White Over Black: American Attitudes Toward the Negro, 1550–1812* (New York, 1977), p. 178. It also produced the phenomenon of

'passing' into white status if the visible signs of black ancestry were sufficiently 'faint'.

60 Chris Amirault, 'Posing the Subject of Early Medical Photography', *Discourse*, 16 (1993–4), pp. 51–76.

61 Sander L. Gilman, 'Darwin Sees the Insane', *Journal of the History of the Behavioral Sciences*, 15 (1979), pp. 253–62, shows that Charles Darwin, in *The Expression of the Emotions* (1872), used photographs of the insane to reveal the stereotypical expressions of fear, anger, shame and happiness that he believed were evidence of the animal origins of human emotions, but argues that Darwin also came to the conclusion that photos were unreliable in depicting the latter.

62 Sekula is especially insightful regarding the ways in which photographs had to be connected to a non-visual archive, or an administrative system of information retrieval, for them to be useable in criminology; he looks especially at the French 'Bertillon' system of criminological identification, which combined anthropometric bodily measurements and photographs as a means of establishing individual identity. See Sekula, 'The Body and the Archive'.

63 Edwards, 'Photographic "Types"', and Poignant, 'Surveilling the Field', both discuss the recognition by scientists at the time of the limits of the photograph as an aid to racial classification, and the need to mix representational techniques such as anthropometric grids, backdrops and so on.

64 One of the most interesting efforts to save the type in racial anthropology, and the photograph as pure denotation, was Francis Galton's compound photograph. See Sekula, 'The Body and the Archive'. Scientists also experimented with compound photographs of skulls, but found diagrams more useful for highlighting differences. See Frank Spencer, 'Some Notes on the Attempt to Apply Photography to Anthropometry during the Second Half of the Nineteenth Century', in Edwards, ed., *Anthropology and Photography*, p. 99–107.

65 Christopher Pinney, 'Underneath the Banyan Tree: William Crooke and Photographic Depictions of Caste', in Edwards, ed., *Anthropology and Photography*, p. 172; *idem*, 'Classification and Fantasy in the Photographic Construction of Caste and Tribe', *Visual Anthropology*, 3/2, 3 (1990), pp. 259–88.

66 See esp. Ann Laura Stoler, 'Sexual Affronts and Racial Frontiers: European Identities and the Cultural Politics of Exclusion in Colonial Southeast Asia', *Comparative Studies in Society and History* 34/2 (July 1992), pp. 514–51.

67 Agassiz, in a letter dated 9 August 1863: 'The production of half-breeds is as much a sin against nature, as incest in a civilized community against the purity of character ...' Quoted in Gould, *Mismeasure of Man*, p. 48.

68 Agassiz and Agassiz, *Journey*, p. 293, footnote.

69 *Ibid.*, p. 292.

70 *Ibid.*, p. 246–7.

71 These remarks are found in *ibid.*, pp. 296–9, in a short scientific essay on race and hybridization by Agassiz, which was inserted into the text.

72 Agassiz and Agassiz, *Journey*, Appendix V, 'Permanence of Characteristics', p. 532.

73 *Ibid.*, p. 292.

74 Gould, *Mismeasure of Man*, p.48.

75 *Ibid.*, p. 49, where he quotes from a letter written by Agassiz on the topic and dated 9 August 1863.

76 The Mundurucu Indians were taken from their home in Mauhes to Manaus to have their portraits taken for Agassiz's collection. In a footnote, Agassiz says that he was unable to get a good likeness and that the engraving did not do justice to either features or expression, but did show the tattoos faithfully (Agassiz and Agassiz, *Journey*, p. 313). Michael Lynch, in an excellent and rare analysis of the relation of photographs to diagrams in scientific representations, 'Science in the Age of Mechanical Reproduction: Moral and Epistemic Relations between Diagrams and Photographs', *Biology and Philosophy*, 6 (1991), pp. 205–26, shows how both the photograph and the diagram in science are constructed representations, and that every diagram is a hybrid of the verbal and the visual.

77 Agassiz and Agassiz, *Journey*, p. 236.

78 Feinstein, *Becoming William James*, pp. 169–81, places this expedition in the larger context of James's search for a profession and the development of his psychological maturity.

79 *Correspondence of William James*, vol. IV, p. 107.

80 Letter to Henry James, dated 15 July [1865]; *Correspondence of William James*, vol. IV, pp. 9–10.

81 William James: 'My coming was a mistake ...' 'I am convinced now, for good, that I am cut out for a speculative rather than an active life ...' Letter to his father, Henry James Sr, 3 June 1865; *Correspondence of William James*, vol. IV, pp. 105–9, quotes on pp. 106, 107.

82 Letter from James to Elizabeth Agassiz, from Dresden, 15 June 1868; *Correspondence of William James*, vol. IV, p. 316.

83 James, *Brazilian Diary*, p. 20.

84 *Ibid.*, p. 13.

4 Racial Transformations

1 A fine selection of images from this archive is reproduced in Eduardo Vilela Thielen *et al.*, eds, *Science Heading for the Backwoods: Images of the Expeditions Conducted by the Oswaldo Cruz Institute Scientists to the Brazilian Hinterland, 1911–1913* (Rio de Janeiro, 1991).

2 Gilberto Ferrez and Weston J. Naef, *Pioneer Photographers of Brazil, 1840–1920* (New York, 1976); Gilberto Ferrez, *Photography in Brazil, 1840–1900*, trans. Stella de Sá Rego (Albuquerque, NM, 1984); Robert M. Levine, *Images of History: Nineteenth and Twentieth Century Latin American Photographs as Documents* (Durham and London, 1989).

3 Susan Sontag, *On Photography* (New York, 1989), p. 3.

4 *Ibid.*, p. 14.

5 Images from Vilela Thielen *et al.*, eds, *Science Heading from the Backwoods*, pp. 134, 135.

6 Nancy Leys Stepan and Sander L. Gilman, 'Appropriating the Idioms of Science: The Rejection of Scientific Racism', in Dominick LaCapra, ed., *The Bounds of Race: Perspectives on Hegemony and Resistance* (Ithaca, NY, 1991), pp. 73–103.

7 Christopher Pinney, 'Underneath the Banyan Tree: William Crooke and Photographic Depictions of Caste', in E. Edwards, ed., *Anthropology and Photography, 1860–1920* (New Haven and London, 1992), pp. 165–6.

8 Quoted in Norma Evenson, *Two Brazilian Capitals: Architecture and Urbanism in Rio de Janeiro and Brasília* (New Haven, 1973), p. 75.

9 On the cultural processes by which a nation is imagined as a unity, see Benedict Anderson, *Imagined Communities: Reflections on the Origin and*

Spread of Nationalism (London, 1986).

10 Data from George Reid Andrews, *Blacks and Whites in São Paulo, Brazil 1888–1998* (Madison, WI, 1991), p. 6.

11 Though the extent of racial mixture in the US has always been underestimated, owing to the dichotomous system of colour classification.

12 Gustave Le Bon, whose *Lois psychologique de l'évolution des peuples* (Paris, 1894) was widely read in Latin America, cited Agassiz on the evil effects of race-crossing in Brazil.

13 On Gobineau's experiences in Brazil, see Georges Raeders, *Le Comte de Gobineau au Brésil* (Paris, 1934).

14 Karl F. P. von Martius, 'Como se deve escrever a história do Brasil?', in *O Estado do direito entre os autóctones do Brasil*, reprint edn (São Paulo, 1982).

15 The only completed work of Gobineau on Brazil was an essay, 'Emigration au Brésil', written in 1873 to please the Emperor. In this essay, Gobineau argued that though mixed races accounted for the majority of the Brazilian population, they would conveniently disappear because of their hybrid infertility, perhaps in as few as two hundred years, while the white stock would fuse with European immigrants to make the country anew. A reprint appears in G. Raeders, *O Inimigo cordial no Brasil: O Conde de Gobineau no Brasil* (São Paulo, 1988), pp. 215–52.

16 Bernard Smith, *European Vision and the South Pacific* (New Haven, 1985).

17 *Revista da Exposição Antropologia Brasileira* (Rio de Janeiro, 1882). See also Luis de Castro Faria, *Antropologia: Espetáculo e excelência* (Rio de Janeiro, 1993), pp. 55–79.

18 Quotation from John Manuel Monteiro, 'As raças indigenas no pensamento brasileiro do império', in Marcos Chor Maio and Ricardo Ventura Santos, eds, *Raça, ciência e sociedade* (Rio de Janeiro, 1996), p. 15.

19 See Paulo Cesar de Azevedo and Mauricio Lissovsky, eds, *Escravos brasileiros do século XIX na fotografia de Christiano Jr.* (São Paulo, 1988), pp. xii–xiii, on this episode, and more generally for an analysis of his career and images. The white slaves are identified by the absence of shoes in most of their portraits, which in Brazil was usually one sign of slave status. On European photographs of slavery in Brazil, see Boris Kossoy and Maria Luiza Tucci Carneiro, *O Olhar europeu: O Negro na iconografia brasileira do século XIX* (São Paulo, 1994).

20 Lilia Moritz Schwarcz, *As Barbas do imperador: D. Pedro II, um monarca nos trópicos* (São Paulo, 1998).

21 José Murilo de Carvalho, *A Formação das almas: O Imaginário da república no Brasil* (São Paulo, 1990).

22 Thomas E. Skidmore, 'Race Relations in Brazil', *Camões Center Quarterly*, 4/3, 4 (Winter 1992), pp. 49–57.

23 The 'whitening' thesis was first described at length by Thomas E. Skidmore, in *Black into White: Race and Nationality in Brazilian Thought* (New York, 1972). See also his 'Racist Ideas and Social Policy in Brazil, 1870–1940', in Richard Graham, ed., *The Idea of Race in Latin America, 1870–1940* (Cambridge, 1990), pp. 7–36.

24 Andrews, *Blacks and Whites in São Paulo*, p. 3.

25 There is now a huge literature on race and race relations in Brazil; see Skidmore, *Black into White*; Andrews, *Blacks and Whites in São Paulo*, esp. chap.1; Jeffrey Lesser, *Negotiating National Identity: Immigrants, Minorities, and the Struggle for Ethnicity in Brazil* (Durham and London, 1999). On the continued realities of informal methods of racial discrimination, see Francis

Winddance Twine, *Racism in a Racial Democracy: The Maintenance of White Supremacy in Brazil* (New Brunswick, NJ, 1997).

26 Sander L. Gilman, *Making the Body Beautiful: A Cultural History of Aesthetic Surgery* (Princeton, 1999).

27 Davyd J. Greenwood, *The Taming of Evolution: The Persistence of Nonevolutionary Views in the Study of Humans* (Ithaca, NY, 1984).

28 Quoted in *New Yorker*, 16 November 1998, pp. 34–6, following the announcement that DNA tests on Jefferson's descendants indicated that he had almost certainly fathered at least one child by his mulatto slave, who was herself half-sister to Jefferson's wife.

29 European scientists argued that only the mixture of very closely allied ethnic stocks could be positive; see Paul Broca, *On the Phenomena of Hybridity in the Genus Homo*, ed. C. Carter Blake (London, 1864). The more liberal anthropologist Armand de Quatrefages took a more positive attitude in his *Histoire générale des races humaines* (Paris, 1887), p. 171.

30 Nancy Leys Stepan, '*The Hour of Eugenics': Race, Gender and Nation in Latin America* (New York, 1991), pp. 138–9.

31 See Jeffrey D Needell, 'History, Race, and the State in the Thought of Oliveira Vianna', *Hispanic American Historical Review*, 75/1 (1995), pp. 1–29.

32 Sílvio Romero, *História da literatura brasileira: Tomo primeiro. Contribuições e estudos gerais para o exato conhecimento de literatura brasileira* (Rio de Janeiro, 1900), esp. chaps 2, 5; idem, *Provocações e debates* (Rio de Janeiro, 1910).

33 Yellow fever is a viral infection, and beriberi a nutrition-deficiency disease.

34 George Spiller, ed., *Papers on Inter-Racial Problems: Communicated to the First Universal Races Congress, held at the University of London, July 26–29, 1911* (London, 1911).

35 João Batista de Lacerda, *Sur le métis au Brésil* (Paris, 1911). See also 'The Métis, or Halfbreed of Brazil', in Spiller, ed., *Papers on Inter-Racial Problems*, pp. 377–82.

36 See also Lacerda's account of the conference, and of the polemics within Brazil generated by his piece, in *O Congresso Universal das Raças reunido em Londres (1911): Apreciação e commentário* (Rio de Janeiro, 1912). Lacerda's work is analyzed in Skidmore, *Black into White*; Luiz de Castro Faria, 'Lacerda e a pesquisa antropológico no Brasil', in *João Batista de Lacerda: Comemoração do centenário de nascimento, 1846–1946*, exh. cat., Museu Nacional, Rio de Janeiro (1951); Giralda Seyferth, 'A Antropologia e a teoria do branqueamento da raça no Brasil: A Tese de João Batista de Lacerda', *Revista do Museu Paulista*, n.s., XXX (1985), pp. 81–98. Seyferth refers to the use of the illustration and caption in Lacerda's original French-version pamphlet; I have been unable to find this version, all exemplars being either missing from the libraries I have searched or showing evidence that the picture had been removed.

37 The reliance on the language and terms of degeneration theory is analyzed in Dain Borges, 'Puffy, Ugly, Slothful and Inert: Degeneration in Brazilian Social Thought, 1880–1940', *Journal of Latin American Studies*, 25 (May 1995), pp. 235–56.

38 Simon Schwartzman, 'Brazil: The Social Agenda', *Daedalus: Brazil: The Burden of the Past; The Promise of the Future* (Spring 2000), p. 43. Only 10 per cent of the population defines itself as 'black'; about 50 per cent calls itself 'white'.

39 These books appeared in English as *The Masters and the Slaves: A Study in the Development of Brazilian Civilization* (New York, 1946); *New World in the*

Tropics (New York, 1959); *The Mansions and the Shanties: The Making of Modern Brazil* (New York, 1963); and *Order and Progress: Brazil from Monarchy to Republic* (New York, 1970).

40 Quoted in Andrews, *Blacks and Whites in São Paulo*, p. 7.

41 Maria do Carnio Tavares de Miranda, ed., *Ciência para os trópicos: Anais do Primeiro Congresso Brasileiro de Tropicologia* (Recife, 1986).

42 Hermano Vianna, *The Mystery of Samba: Popular Music and National Identity in Brazil* (Chapel Hill and London, 1999), traces the history of samba as a national symbol of Brazil.

43 Mário de Andrade, *Macunaíma: O Herói sem nenhum caráter*, critical edn, ed. Telê Porto Ancono Lopez (Nanterre, 1988). I analyze this work at greater length in Chapter 7, in a discussion of artistic modernism and its impact in Brazil, especially on Roberto Burle Marx's landscape designs.

44 Monteiro Lobato, *Mr. Slang e a problema vital*, in *Obras completas* (São Paulo, 1946), vol. 8.

45 Alan Trachtenberg, *Reading American Photographs: Images as History, Mathew Brady to Walker Evans* (New York, 1989), esp. pp. xvi–xvii.

5 The New Tropical Pathology

1 Claude Levi-Strauss, *Tristes tropiques* (London, 1973) (first published in French in 1955), translator's note.

2 For a wide-ranging evaluation of pre-conquest populations in the Americas and the factors causing the decline in the numbers of indigenous peoples, see William M. Denevan, ed., *The Native Population of the Americas in 1492*, 2nd edn (Madison, WI, 1992).

3 There are of course exceptions, especially in regard to historical studies of anatomical illustrations; see Jonathan Sawday, *The Body Emblazoned: Dissection and the Human Body in Renaissance Culture* (London, 1995), and L. J. Jordanova, 'Gender, Generation and Science: William Hunter's Obstetrical Atlas', in W. F. Bynum and Roy Porter, eds, *William Hunter and the Eighteenth-Century Medical World* (Cambridge, 1985), pp. 385–412.

4 For example, Roy Porter, ed., *The Cambridge Illustrated History of Medicine* (Cambridge, 1996), and Irvine Loudon, ed., *Western Medicine: An Illustrated History* (Oxford, 1997). In the latter collection, Martin Kemp contributes a very valuable first chapter which does address some of the issues concerning visual representation in medicine: 'Medicine in View: Art and Visual Representation', pp. 1–22; his themes are not, however, pursued by the other contributors to the volume. The otherwise very useful book edited by F. E. G. Cox, *The Wellcome Trust Illustrated History of Tropical Diseases* (London, 1996), likewise does not comment on the medical images as such. For an invaluable introduction to the issues and literature on medical images, see Sander L. Gilman, *Health and Illness: Images of Difference* (London, 1995), esp. chap. 1.

5 Sander L. Gilman, *Difference and Pathology: Stereotypes of Sexuality, Race and Madness* (Ithaca, NY, 1985); *idem, Disease and Representation* (London, 1988); *idem, Health and Illness*.

6 Monique Sicard, Robert Pujade and Daniel Wallach, *À corps et à raison: Photographies médicales, 1840–1920* (Paris, 1995).

7 Stanley B. Burns, *Early Medical Photography in America (1839–1883)* (New York, 1985); Jacques Carrier with Stanley B. Burns, *Photographie et médicine, 1840–1880* (Lausanne, 1991).

8 John Tagg, *The Burdens of Representation: Essays on Photographies and Histories* (Amherst, 1988), p. 81

9 Christopher Amirault, 'Posing the Subject of Early Medical Photography', *Discourse*, 16 (Winter 1993–4), pp. 51–76.

10 Daniel M. Fox and Christopher Lawrence, *Photographing Medicine: Images and Power in Britain and America since 1840* (New Haven, 1988).

11 Gilman, *Pathology and Difference*; idem, *Disease and Representation*.

12 Betty Ann Holtzman Kevles, *Naked to the Bone: Medical Imaging in the Twentieth Century* (New Brunswick, NJ, 1997), p. 30.

13 Hippocrates, *On Airs, Waters and Places* (Bonn, 1996).

14 David Arnold, *The Problem of Nature: Environment, Culture and European Expansion* (Oxford, 1996), p. 17.

15 E. Le Roy Ladurie, 'Un Concept: L'Unification microbienne du monde (XIVe–XVIIe siècles)', *Revue suisse d'histoire*, 23 (1973), pp. 627–96.

16 A recent evaluation of the demographic loss is found in Noble David Cook, *Born to Die: Disease and New World Conquest, 1492–1650* (Cambridge, 1988).

17 For a review, see K. Kiple, *The Cambridge World History of Human Disease* (Cambridge, 1993), *passim*.

18 Sheldon Watts, *Epidemics and History: Disease, Power and Imperialism* (New Haven, 1997), chap. 5.

19 M. O. Pires Firminio Rúben de Meneses, *Os Autores Ibéricos na História da Medicina Tropical* (Porto, 1971).

20 On medical environmentalism in the eighteenth century, see F. Sargent, *The Hippocratic Heritage: A History of Ideas about Weather and Human Health* (New York, 1982); James C. Riley, *The Eighteenth-Century Campaign to Avoid Disease* (New York, 1987); Ludmilla Jordanova, 'Earth Science and Environmental Medicine: The Synthesis of the Late Eighteenth Century', in *idem* and R. S. Porter, eds, *Images of the Earth* (Chalfont, St Giles, 1979), pp. 119–46; and Michael Owen Jones, 'Climate and Disease: The Traveler Describes America', *Bulletin of the History of Medicine*, 41 (May–June 1967), pp. 254–66.

21 William F. Bynum, 'Cullen and the Study of Fevers in England, 1769–1820', in *idem* and V. Nutton, eds, *Theories of Fever from Antiquity to the Enlightenment* (London, 1981), pp. 135–47.

22 James Lind, *An Essay on Diseases Incidental to Europeans in Hot Climates with the Method of Preventing their Fatal Consequences* (London, 1768).

23 The full title of Moseley's book indicates the colonial and military context of the medicine of warm places: *Treatise on Tropical Diseases; On Military Operations; and on the Climate of the West Indies* (London, 1787). The best-known nineteenth-century examples in English of the medicine of hot climates are James Johnson, *The Influence of Climates, More Especially the Climate of India, on European Constitutions* (London, 1813), which had six editions before Johnson's death, the last appearing in 1841 and co-authored with James Ranald Martin in a greatly expanded version; and James Annesely's medical statistics of India, *Researches into the Causes, Nature, and Treatment of the More Prevalent Diseases of India* (London, 1824). An early French example is Jean Barthomely, *Observations Génerales sur les Maladies des Climats Chauds* (Paris, 1785). An American example is John B. Favidge, *A Treatise on the Autumnal Endemial Endemick of Tropical Climates Vulgarly Called Yellow Fever* (Baltimore, 1798).

24 David Arnold, 'The Place of "The Tropics" in Western Medical Ideas since 1750', *Tropical Medicine and International Health*, 24 (April, 1997), pp. 303–13.

25 David Arnold, *Colonizing the Body: State Medicine and Epidemic Disease in Nineteenth-Century India* (Berkeley, 1993); Mark Harrison, *Public Health in*

British India: Anglo-Indian Preventive Medicine 1859–1914 (Cambridge, 1994).

26 Philip D. Curtin, *The Image of Africa: British Ideas and Action, 1780–1850* (Madison, WI, 1964), vol. 1, chap. 3. The Cape colony, in contrast, promoted itself as a salubrious and temperate place for European recuperation and settlement.

27 Donald Cooper, 'The New "Black Death": Cholera in Brazil, 1855–1856', *Social Science History*, 10/4 (Winter 1986), pp. 467–88.

28 Anne Marie Moulin, 'Tropical Without the Tropics: The Turning-Point of Pastorian Medicine in North Africa', in David Arnold, ed., *Warm Climates and Western Medicine: The Emergence of Tropical Medicine, 1500–1900* (Amsterdam and Atlanta, GA, 1996), pp. 160–80.

29 Caroline Hanaway, 'Discussion', in A. M. Lilienfeld, ed., *Times, Places and Persons: Aspects of the History of Epidemiology* (Baltimore, 1980), p. 41.

30 William Coleman, *Death Is a Social Disease: Public Health and Political Economy in Early Industrial France* (Madison, WI, 1982).

31 A. R. Omran, 'The Epidemiological Transition', *Millbank Memorial Quarterly*, 49 (1971), pp. 509–38.

32 For a recent reassessment of the role of public-health interventions in reducing death rates in Britain, see Simon Szreter, 'The Importance of Social Intervention in Britain's Mortality Decline c. 1850–1914: A Re-Interpretation of the Role of Public Health', *Social History of Medicine*, 1/1 (April 1988), pp. 1–38.

33 Mary J. Dobson, 'Malaria in England: A Geographical and Historical Perspective', *Parassitologia* 36 (1994), pp. 35–60.

34 Patrick Manson, *Tropical Diseases: A Manual of the Diseases in Hot Climates*, 4th edn (London, 1907), p.xiii.

35 Comment by Arnold, in 'The Place of "The Tropics"', p. 304.

36 Jeremy Black, *Maps and Politics* (London, 1997).

37 Lloyd G. Stevenson, 'Putting Disease on the Map: The Early Use of Spot Maps in the Study of Yellow Fever', *Journal of the History of Medicine and Allied Sciences*, 20/1 (January 1965), pp. 226–97.

38 Philip Curtin, *Death by Migration: Europe's Encounter with the Tropical World in the Nineteenth Century* (Cambridge, 1989).

39 Nicolaas Rupke, 'Humboldtian Medicine', *Medical History*, 40 (1996), p. 297.

40 R. W. Felkin, *On the Geographical Distribution of Some Tropical Diseases, and their Relation to Physical Phenomena* (London and Edinburgh, 1889), p. 6.

41 Arnold, 'The Place of "The Tropics"', p. 304.

42 Nancy Stepan, 'Biological Degeneration: Races and Proper Places', in E. Chamberlin and S. L. Gilman, eds, *Degeneration: The Dark Side of Progress* (New York, 1985), pp. 97–120.

43 David N. Livingstone, 'Human Acclimatization: Perspectives on a Contested Field of Inquiry in Science, Medicine and Geography', *History of Science*, 25 (1989), pp. 359–94.

44 David N. Livingstone, 'Climate's Moral Economy: Science, Race and Place in Post-Darwinian British and American Geography', in Anne Godlewska and Neil Smith, eds, *Geography and Empire* (Oxford, 1994), pp. 132–54.

45 The literature is now enormous. For a brief overview, see Brian Bracegirdle, 'The Microscopical Tradition', in W. F. Bynum and R. Porter, eds, *Companion Encyclopedia of the History of Medicine* (London and New York, 1993), vol. I, pp. 102–19.

46 In 1880, a fifth of all doctors trained in the UK were serving in British overseas colonies.

47 'Introduction', in W. F. Bynum and Caroline Overy, eds, *The Beast in the Mosquito: The Correspondence of Ronald Ross and Patrick Manson* (Amsterdam and Atlanta, GA, 1998), pp. v–xxiv.

48 Thomas D. Brock, *Robert Koch: A Life in Medicine and Bacteriology* (Madison, WI, 1988), chap. 20.

49 Nancy Stepan, 'The Interplay between Socio-Economic Factors and Medical Science: Yellow Fever Research, Cuba and the United States', *Social Studies of Science*, 8/4 (November 1978), pp. 397–423.

50 For this expression, see Marcos Cueto, *El Regreso de las epidemias: Salud y sociedad en el Peru del siglo XX* (Lima, 1997), p. 170.

51 Michael Worboys, 'The Emergence of Tropical Medicine: A Study in the Establishment of a Scientific Specialty', in G. Lemaine *et al.*, eds, *Perspectives on the Emergence of Scientific Disciplines* (London, 1976), pp. 75–98.

52 Pasteur Vallery-Radot, 'Les Instituts Pasteur d'outre mer', *La Press medicale*, 21 (March 1939), pp. 410–13; A. Calmette, 'Les Missions scientifiques de l'Institut Pasteur et l'expression coloniale de la France', *Revue scientifique*, 89 (1912), p. 129.

53 Marcos Cueto, 'The Cycles of Eradication: The Rockefeller Foundation and Latin American Public Health, 1918–1940', in P. Weindling, ed., *International Health Organisations and Movements, 1918–1939* (Cambridge, 1995), pp. 222–43.

54 Brock, *Robert Koch*, chap. 7; Edgar M. Crookshank, *Photography of Bacteria* (London, 1887), pp. 1–11 on Koch.

55 Michael Worboys, 'The Comparative History of Sleeping Sickness in East and Central Africa, 1900–1914', *History of Science*, 32 (1994), pp. 89–102.

56 Kirk Arden Hoppe, 'Lords of the Fly: Colonial Visions and Revisions of African Sleeping-Sickness Environments on Ugandan Lake Victoria, 1906–1961', *Africa*, 67/1 (1977), pp. 86–105. John Farley, in *Bilharzia: A History of Imperial Tropical Medicine* (Cambridge, 1991), takes the line that imperialism created the diseases that tropical medicine was invented to control.

57 Megan Vaughan, *Curing Their Ills: Colonial Power and African Illness* (Oxford, 1991), pp. 32–3.

58 A good historical account of the changes in the conceptualization of elephantiasis as a result of parisotology is given in Aldo Castellani and Albert J. Chalmers, *Manual of Tropical Medicine*, 2nd edn (London, 1913), pp. 1124–5.

59 Cox, ed., *Wellcome Trust Illustrated History of Tropical Diseases*, p. 297.

60 See for example, the photographs of elephantiasis in B. Scheube, *Die Krankheiten der Warmer Länder: Ein Handbuch für Ärzte* (Jena, 1900).

61 Sander L. Gilman, 'The Hottentot and the Prostitute: Towards an Iconography of Female Sexuality', in *Difference and Pathology*, pp. 76–108.

6 *Appearances and Disappearances*
 1 Michael Miles, 'New World Trypanosomiasis', in F. E. G. Cox, ed., *The Wellcome Trust Illustrated History of Tropical Diseases* (London, 1996), pp. 192–205; quote from p. 205.

 2 Ralph Colp, *To Be an Invalid: The Illness of Charles Darwin* (Chicago, 1977).

 3 Chagas's discovery was described, for example, in the second edition of the French medical textbook, A. Laveran's *Trypanosomes et trypanosomiasis* (Paris, 1912), pp. 796–812, though Laveran reserved judgement on some of the interpretations given to the disease by the Brazilians.

4 Chagas has yet to receive a modern biography. Useful, if understandably partisan, is the account by his son, Carlos Chagas Jr, *O Meu pai* (Rio de Janeiro, 1993).

5 B. H. Kean, 'Carlos Chagas and Chagas' Disease', *American Journal of Tropical Medicine and Hygiene*, 26/1 (1977), pp. 1084–7; Rachel Lewisohn, 'Carlos Chagas (1879–1934): The Discovery of Trypanosoma cruzi and of American Trypanosomiasis (footnotes to the history of Chagas's disease)', *Journal of the Royal Society of Tropical Medicine and Hygiene*, 73/5 (1979), pp. 513–23; F. Guerra, 'American Trypanosomiais: An Historical and a Human Lesson', *J. Trop. Med. and Hygiene*, 73/1–2 (1970), pp. 82–118. See also Miles, 'New World Trypanosomiasis', for an excellent scientific review. Useful bibliographies of the extensive primary scientific investigations of Chagas's disease are Michael Miles and Jean E. Rouse, *Chagas's Disease (South American Trypanosomiasis); Supplement to the Tropical Diseases Bulletin* (London, 1970) (covering publications in English), and A. Prata and E. P. de Sant'Anna, *Bibliografia brasileira sobre doença de Chagas (1909–1979)* (Brasília, 1983). Chagas's main scientific papers have been collected in his *Coletânea de trabalhos científicos* (Brasília, 1981).

6 The accounts by Olympio da Fonseca, a member of the Oswaldo Cruz Institute, in *A Medicina no Brasil* (Rio de Janeiro, 1940), pp. 112–16, and his 'Doença de Chagas', in *idem*, *A Escola de Manguinhos* (Rio de Janeiro, 1974), pp. 43–66, give an insider's view of some of the controversies. More recent analyses are Matthew Perleth, *Historical Aspects of American Trypanosomiasis (Chagas' Disease)* (New York, 1996), a part-epidemiological, part-historical study that is particularly strong on the connections between Chagas's work and the German protozoological school; and François Delaporte, *La Maladie de Chagas* (Paris, 1999), a vehement inquiry into scientific epistemology and disease conceptualization that views Chagas as almost reprehensible in his mistakes of logic. On the contemporary situation, see J. W. Bastien, *The Kiss of Death: Chagas' Disease in the Americas* (Salt Lake City, 1998).

7 Delaporte, in *La Maladie de Chagas*, pp. 33–65.

8 Julyan Peard, *Race, Place, and Medicine: The Idea of the Tropics in Nineteenth-Century Brazilian Medicine* (Durham, NC, 2000) gives a very interesting analysis of the ways in which Brazilian doctors incorporated and resisted race and climate in explaining disease in the period.

9 Quoted in Nancy Stepan, *Beginnings of Brazilian Science: Oswaldo Cruz, Medical Research, and Politics* (New York, 1986), p. 58.

10 *Ibid.*, chaps 4 and 5, covers these events.

11 The institute was renamed after Oswaldo Cruz in 1907.

12 The generic name for the insect is Triatoma; in Chagas's day the name used was Conorhinus.

13 Carlos Chagas, 'Neue Tripanosomen: Vorläufige mitteilung', *Archiv für schiffs-und tropenhygiene*, 13 (1909), pp. 120–22. A short while later, Chagas renamed it *Schizotrypanum cruzi*, but this was based on error in his understanding of the evolution of the parasite in tissues, and today the original name is used.

14 The first, classic papers on Chagas's disease, published in German, French and Portuguese, are 'Über eine neue Trypanosomiasis des Menschen', *Archiv für schiffs-und tropen Hygiene*, 13 (1909), pp. 351–3; 'Nova tripanozomiase humana: Estudos sobre a morfoliga e o evolutivo do *Schizotrypanum cruzi n. gen., n. sp.*, agente etiológico de nova entidade mórbida do homem', *Memorias do instituto Oswaldo Cruz*, 1/2 (1909), pp. 1–62 (with parallel German translation); 'Nouvelle espèce de trypanosomiase humaine', *Bulletin de la*

société pathologie exotique, 2/6 (1909), pp. 304–7.

15 The first detailed description of the clinical symptoms appeared in print in 1911, in 'Nova entidade morbido do homem', *Memorias do instituto Oswaldo Cruz*, 3/2 (1911), pp. 3–59.

16 In 1913, the French medical scientist Emile Brumpt challenged Chagas's original supposition that trypanosome infection occurred in humans through the insect's salivary glands during a bite (in fact, it occurs through contamination through the parasites found in the insect's faeces). See Emile Brumpt, 'Penetration du Schizotrypanum cruzi à travers la muqueuse oculaire saine', *Bulletin de la societé de pathologie exotique*, 3/9 (1912), pp. 723–4.

17 While in Germany, Oswaldo Cruz made several important contacts with medical researchers; several of them were invited to Brazil to investigate tropical diseases, which is why Prowaseck and Hartmann were at the Oswaldo Cruz Institute and able to help Chagas systematize the parasitology of Chagas's disease. These associations led to Cruz being asked to serve on the Schaudinn Prize jury in 1908, another very helpful connection when it came to awarding Chagas the prize in 1912.

18 'Conferência', in Carlos Chagas, *Discursos e conferências* (Rio de Janeiro, 1935), pp. 81–104, esp. pp. 85–9.

19 Quoted in E. Thielen *et al.*, eds, *Science Heading for the Backwoods: Images of the Expeditions Conducted by the Oswaldo Cruz Institute Scientists to the Brazilian Hinterland, 1911–1913* (Rio de Janeiro, 1991), p. 59.

20 Belisário Penna, *O Saneamento do Brasil* (Rio de Janeiro, 1918).

21 E. Sales Guerra, *Oswaldo Cruz* (Rio, 1940), pp. 543–4.

22 The newspaper *Jornal do Commercio* covered the Brazilian participation in the Dresden exhibition especially closely.

23 Perleth, *Historical Aspects*, pp. 78–9.

24 Chagas first claimed that goitrous symptoms were signs of Chagas's disease in 'Sobre a etiologia do bócio endêmico no estado de Minas Geraes: Nota previa', *Brazil medico*, 24/17 (1910), pp. 3–4, and again in 'Nova entidade morbida do homem'.

25 Milton Carneiro, *Historia da doença de Chagas* (Curitiba, 1963), pp. 8–9.

26 Bernardino Fantini, 'La Revolution pastorienne et les théories sur l'étiologie du goitre et du cretinisme', *Gesnerus*, 49 (1992), pp. 21–38.

27 Chagas referred in his first publication in 1909, for instance, to the work of Bruce, a British medical scientist who discovered the trypansome causing 'nagana', a disease of cattle.

28 Gaspar Vianna, 'Contribuição para o estudo da anatomia patológica da molestia de Chagas', *Memorias do instituto Oswaldo Cruz*, 3 (1911), pp. 276–93. No parasites were found in the goitres themselves, however.

29 Carlos Chagas, in his 1911 paper describing the clinical symptoms in some detail, said that he had examined only a few acute cases but hundreds of chronic ones.

30 Sander L. Gilman, *Disease and Representation* (London, 1988).

31 The expression 'vast hospital' to describe Brazil was coined at a dinner in honour of Chagas in 1916, and was a reaction to the report by Neiva and Penna on the extent of Chagas's disease.

32 Miguel Couto, in *Revista medico-cirurgica do Brasil*, 25 (1917), pp. 9–17.

33 Chagas Filho, *O Meu pai*, p. 202.

34 Chagas knew of no chemical therapy (as Manson reported in the 6th edition of his *Tropical Diseases* [1917], p. 172).

35 Chagas Filho, *O Meu pai*, p. 123; *Boletim da Academia Nacional de Medicina*,

95/7 (28 and 30 June 1923), p. 267.

36 Biographical details from Leonídio Ribeiro, *Afrânio Peixoto* (Rio de Janeiro, 1950).

37 Afrânio Peixoto, *Climat et maladies du Brésil* (Rio de Janeiro, 1907), a 35-page pamphlet prepared for the Brazilian Year Book.

38 The discussions between the doctors at the Rio Medical School and the government were covered in the journal *Brazil medico*, 20 (1906), pp. 379–80, 389–90, 409–11.

39 It is interesting to note here that, in fact, nowhere in the Americas did European-style schools of tropical medicine thrive to the degree they did in Europe.

40 Afrânio Peixoto, *Elementos de higiene* (Rio de Janeiro, 1913), p. 8.

41 Carlos Chagas, 'Aula inaugural de cadeira de medicina tropical', in *Discursos e conferências*, pp. 137–66.

42 R. Kraus, 'Kropf, kretinismus und die krankheit von Chagas', *Wiener klinische wochenschrift*, 35 (1915), pp. 1104–5; Perleth, *Historical Aspects*, pp. 99–102.

43 It on this basis that Delaporte, in *La Maladie de Chagas*, asserts that Chagas was not the discoverer of Chagas's disease at all. This is, however, to take current conceptions as a yardstick with which to measure the past, as well as to overlook the many discoveries and insights about Chagas's disease that are in fact attributable to Chagas.

44 E. Labra, 'O Movimento sanitarista nos anos 20: Da "conexão sanitária internacional" à especialização em saúde pública no Brasil', unpub. Master's Thesis, Rio de Janeiro, 1985.

45 In his lectures to students, later published as a book, *Clima e saúde* (Rio de Janeiro, 1938), Peixoto relegated Chagas's disease to almost the bottom of the list of diseases to be covered in the course.

46 Chagas Filho, *O Meu pai*, p. 195.

47 Carneiro, *Historia da doença de Chagas*, p. 89.

48 Chagas, *Discursos e conferências*, p. 163.

49 Chagas Filho, *O Meu pai*, pp. 187–232.

50 As Perleth observes, Chagas's chronic cases involving the nervous system and paralyses were probably those of late syphilis and other diseases.

51 Named after the Argentinian physician who identified it as a useful clinical indicator. Chagas had noted facial oedemas in many of his patients, but associated them with endocrine infection and not the local port of entry of trypanosome infection. François Delaporte, in 'Romaña's Sign', *Journal of the History of Biology*, 30 (1997), pp. 357–66, and in his book *La Maladie de Chagas*, argues very forcefully that the reconceptualization of Chagas's disease as a non-endocrinal disease, and the recognition in the 1930s that it was indeed widely distributed in the Americas, were results of the acceptance of the sign as diagnostic. Romaña therefore ought to be recognized as the true discoverer of Chagas's disease. But this is ahistorical; it pushes conceptual history too far. And though Romaña's sign is indeed a very significant indicator of Chagasian infection when it is seen, the sign is infrequent; in some endemic areas, out of a hundred people infected, only six might be expected to show it (Bastien, *The Kiss of Death*, p. 49). Knowledge of the wide extent of Chagas's disease in the Americas really only emerged in the 1950s and '60s, largely as the result of serological tests, which measured parasitic infection. See Perleth, *Historical Aspects*, p. 107, *Table 6: Cases of Chagas's Disease Reported after 1930*.

52 These are signs of mega-oesophagus; closely related is megacolon, both

involving great enlargements of the digestive system, which show up very clearly in X-rays.

53 Six states in Brazil were recently certified by an international scientific committee (which includes members from WHO) as being free of *Triatoma infestans*, the species of the barbeiro insect responsible for 70 per cent of all Chagas infections. Several more states are in the process of being similarly certified, suggesting some success in insect and disease eradication (as reported in the newspaper *O Globo* on 22 March 2000). Megacolon can be treated by surgery in extreme cases.

7 *Tropical Modernism*

1 The expression 'tropical modernism' I have taken from William J. K. Curtis, *Modern Architecture Since 1900*, 3rd edn (London, 1996), p. 321, where he uses it to describe Le Corbusier's vision of architecture for Brazil.

2 John Dixon Hunt, *Gardens and the Picturesque: Studies in the History of Landscape Architecture* (Cambridge, MA, 1992), pp. 2–16; quote from p. 3. In nineteenth-century Britain, for example, horticultural journalists and gardeners promoted taste in specific flowers and garden designs as expressions of British national culture.

3 Hunt, *Gardens and the Picturesque*, pp. 290–98.

4 On Burle Marx, see P. M. Bardi, *The Tropical Gardens of Roberto Burle Marx* (New York, 1964); Flávio L. Motta, *Roberto Burle Marx e a nova visão da paisagem* (São Paulo, 1984); Sima Eliovson, *The Gardens of Roberto Burle Marx* (New York, 1991); W. H. Adams, *Roberto Burle Marx: The Unnatural Art of the Garden* (New York, 1991); Jacques Leenhardt, ed., *Dans les jardins de Roberto Burle Marx* (Crestet, 1994). Lawrence Fleming, *Roberto Burle Marx: A Portrait* (London, 1996), is an authorized biography; Lisbeth Rebello Gonçalves, ed., *Arte e paisagem: A Estética de Roberto Burle Marx* (São Paulo, 1997), contains lists of Burle Marx's main exhibitions and projects, as well as a translation of two of his short comments on ecology. For critical analysis, Adams and Leenhardt are the most valuable.

5 Adams, *Roberto Burle Marx*, p. 22.

6 On the nation as a cultural artefact or imagined community, a notion that is closely associated with the rise of modern nationalism, see Benedict Anderson, *Imagined Communities: Reflections on the Origins and Spread of Nationalism* (London, 1986).

7 Few European observers then (and even now, outside professional scientific circles) have conceded the term *civilization* to the complex cultural products and material adaptations of the indigenous Amerindians in their forest environments.

8 Norma Evenson, *Two Brazilian Capitals: Architecture and Urbanism in Rio de Janeiro and Brasília* (New Haven, 1973), p. 2.

9 *Ibid.*, p. 1.

10 Gilberto Freyre, 'Em torno de um novo conceito de tropicalismo', in M. C. T. de Miranda, ed., *Ciência para os trópicos: Primeiro Congresso Brasileiro de Tropicologia* (Recife, 1986), pp. 35–45; Caetano Veloso, *Verdade Tropical* (São Paulo, 1997). Caetano's movement was meant as a form of resistance to the view of the nation imposed by what was then an authoritarian, military and repressive government.

11 Warren Dean, *With Broadax and Firebrand: The Destruction of the Brazilian Atlantic Forest* (Berkeley, 1995), p. 350.

12 Figures from John Kricher, *A Neotropical Companion: An Introduction to the*

Animals, Plants, and Ecosystems of the New World Tropics, 2nd rev. edn (Princeton, 1997), p. 337.

13 Curtis, *Modern Architecture since 1900*, p. 493.

14 Rev. D. P. Kidder and Rev. J. C. Fletcher, *Brazil and the Brazilians: Portrayed in Historical and Descriptive Sketches* (Philadelphia, 1857), pp. 3–5. The book first appeared as D. P. Kidder, *Sketches of Residence and Travel in Brazil*, in 1845. In their preface, Kidder and Fletcher admit that their illustrations delineated the popular notion of Brazil.

15 Brazilians 'displayed them shame-facedly, resigned to the Londoners' and Parisians' pity and disdain', writes Dean, in *With Broadax*, p. 226.

16 See the very interesting analysis of the conceptual vertigo produced by the possibilities of modernity in the wilderness in Brazil in Francisco Foot Hardmann, *Trem fantasma: A Modernidade na selva* (São Paulo, 1991).

17 Sergio Buarque de Holanda, *Visão do paraíso: os motives edênicos no descobrimento e colonização do Brasil* (São Paulo, 1959); Dean, *With Broadax*, p. 145.

18 See Nancy Stepan, *Beginnings of Brazilian Science: Oswaldo Cruz, Medical Research and Policy, 1890–1920* (New York, 1976), chaps 1, 2.

19 An early example is the 1618 Portuguese work attributed to Ambrósio Fernandes Brandão entitled *Dialogues of the Great Things of Brazil*, trans. F. A. H. Hall (Albuquerque, NM, 1987). On the importance of natural resources and nature as the basis of claims to national greatness, see esp. José Murilho de Carvalho, 'O Motivo edênico no imaginário social brasileiro', in Dulce Chaves Pandolfi *et al.*, eds, *Cidadania, justiça e violência* (Rio de Janeiro, 1999), pp. 19–43.

20 Academic painters produced a number of studies in the romantic style, mainly showing heroic but dying Indians in a tropical landscape; in literature, José de Alencar wrote the indianist novel *Irecema* (incoporating an anagram of *America*), and the book *O Guarani* was made into an opera of the same name by the composer Antônio Carlos Gomes and perfomed at La Scala, Milan, in 1870.

21 Dean, *With Broadax*, quotes on pp. 243, 242, 54.

22 Sílvio Romero, *História de la literature brasileira* (Rio de Janeiro, 1902), p. 83.

23 Quoted in Thomas E. Skidmore, *Black into White: Race and Nationality in Brazilian Thought* (New York, 1972), p. 33–4.

24 Euclides da Cunha, *Rebellion in the Backlands*, trans. Samuel Putnam (Chicago and London, 1944).

25 On the making of selected natural topographical features into icons of national identity and sites of tourism, see Stephen J. Payne, *How the Canyon Became Grand* (New York, 1998).

26 Dawn Ades, *Art in Latin America: The Modern Era, 1820–1980* (New Haven, 1989), p. 84.

27 Vânia Carneiro de Carvalho, 'A representação da natureza na pintura e na fotografia brasileira do século XIX', in Annateresa Fabris, ed., *Fotografia: Usos e funções no século XIX* (São Paulo, 1991), p. 205.

28 Ferrez and other Brazilian photographers from the same period are discussed in several studies; see esp. Gilberto Ferrez and Weston J. Naef, *Pioneer Photographers of Brazil, 1840–1920* (New York, 1976).

29 Jeffrey Needell gives a good account of these transformations in *A Tropical Belle Epoque: Elite Culture and Society in Turn-of-the Century Rio de Janeiro* (Cambridge, 1987).

30 Gerald Martin, 'Literature, Music and the Visual Arts, 1870–1930', in L. Bethell, ed., *A Cultural History of Latin America: Literature, Music and the*

Visual Arts in the 19th and 20th Centuries (Cambridge, 1998), pp. 47–130, esp. 91–2.

31 Oswald de Andrade's 'Pau-Brasil Poetry Manifesto' is reprinted in Ades, *Art in Latin America,* pp. 310–11.
32 Quotation from Ades, *Art in Latin America*, p. 133.
33 This drawing was elaborated in a painting, *Anthropophagy*, in 1929.
34 Mário de Andrade, *Macunaíma: O Herói Sem Nenhum Caráter*, critical edn, ed. Telê Porto Ancono Lopez (Nanterre, 1988). Other works of sociology and history took a much more pessimistic view of Brazil's future.
35 The visual and musical arts (one thinks of the great success of Villa Lobos in Paris in the 1920s) could travel in the way that written forms could not (Portuguese was known as the 'tomb of thought' because, until the 'boom' in Latin American literature in the 1960s, it was rarely translated into other European languages).
36 Kenneth Frampton, 'In Search of Modern Landscapes', in Stuart Wrede and William H. Adams, eds, *Denatured Visions* (New York, 1991), pp. 42–61, claims that the first to make tropical modernist gardens in Brazil were Victor Brecheret and Mina Klabin (Warchavchik), who in 1927 designed an abstract cactus garden in São Paulo.
37 Adams, *Roberto Burle Marx*, p. 25.
38 Fleming, *Roberto Burle Marx*, p. 22, on recognition by Burle Marx that he was Brazilian, along with his plants; see p. 35 for Burle Marx's comment about organizing and interpreting nature. See also J. Leenhardt, 'Le Jardin: Jeux d'artifices', in *idem*, ed., *Dans les jardins*, pp. 19–52, p. 22.
39 According to Adams, *Roberto Burle Marx*, pp. 21–2, traces of the public gardens Glaziou designed in Rio de Janeiro between 1873 and 1880 could still be seen in the 1930s, when Burle Marx began to plan his gardens.
40 On British colonial botanical gardens, see Lucille Brockway, *Science and Colonial Expansion: The Role of the British Royal Botanic Gardens* (New York, 1979), pp. 75–6; Richard Drayton, *Nature's Government: Science, Imperial Britain, and the Improvement of the World* (New Haven, 2000).
41 Professor and Mrs Louis Agassiz, *A Journey in Brazil* (Boston, 1868), p. 61.
42 Burle Marx describes this in his own words in 'Questions à Roberto Burle Marx', in Leenhardt, ed., *Dans les jardins*, pp. 55–75, p. 56.
43 Fleming, *Roberto Burle Marx,* p. 35.
44 Burle Marx, in Leenhardt, ed., 'Questions à Roberto Burle Marx', p. 56.
45 He lost the position in 1936 during a confused moment of political conflict when he was accused of being on the left.
46 Bardi, *Tropical Gardens*, p. 14.
47 Ten years later, with Mello Barreto, Burle Marx would design a large-scale Park of Araxá divided into 25 sections, each with different groupings. Unfortunately, only some of these were completed.
48 Curtis, *Modern Architecture*, p. 321.
49 David Underwood, *Oscar Niemeyer and the Architecture of Brazil* (New York, 1994), p. 20.
50 Curtis, *Modern Architecture*, p. 500.
51 Evenson, *Two Brazilian Capitals*, p. 151.
52 Adams, *Roberto Burle Marx*, p. 8, attributes the name of the style to the historian Michael Lancaster.
53 Evenson, *Two Brazilian Capitals*, p. 68.
54 The landscape designer James van Sweden recently praised Burle Marx's designs for their 'utter naturalness' (quoted in *New York Times*, 3 September

1998, p. D7).

55 Adams, *Roberto Burle Marx*, p. 36.

56 I acknowledge a debt to the catalogue essay by Adams, *Roberto Burle Marx*, which gave me the idea of using historical photographs by Gautherot for this chapter. Permission to use these photographs has been given by the Insituto Moreira Salles in São Paulo, as shown in the credits. Rossano Vaccarino, in 'The Correspondence of Time and Instability: Two Gardens', in *Roberto Burle Marx: Landscapes Reflected* (New York, 2000), pp. 42–53, comments on the lack of written documentation available for most of Burle Marx's designs.

57 In addition to this garden, Burle Marx also designed gardens on the ground floor and on a terrace. Much of the rooftop garden is now in a state of disrepair.

58 Overall political management and practical co-ordination of the vast project were in the hands of Lota de Macedo Soares, who is probably best known outside of Brazil for being the American Pulitzer-Prize-winning poet Elizabeth Bishop's lover during the many years Bishop lived in Brazil; Lota de Macedo's role in promoting modernist architecture and in getting Flamengo Park completed deserves greater recognition. 'The energy and technology required for this urban reclamation were monumental,' writes Adams, 'and demonstrate Burle Marx's repeated argument that our advanced means of destroying the environment in the late twentieth century can, with imagination, be used for the common good' (*Roberto Burle Marx*, p. 33).

59 Evenson, *Two Brazilian Capitals*, p. 68.

60 Adams, *Roberto Burle Marx*; quotes on p. 35.

61 Burle Marx, in Leenhardt, ed., 'Questions à Roberto Burle Marx', p. 55.

62 Eliovson, *The Gardens*, p. 45.

63 Le Corbusier, *Towards a New Architecture* (Oxford, 1989), p. 16. Note the negative associations of tropical nature in his remarks!

64 E.g. in the history of Brazilian attitudes to nature, which he sketches in Leenhardt, ed., 'Questions à Roberto Burle Marx'. Very early on, he says, the idea was forged that the virgin forest was too exuberant for the cultivation of civilization. He also comments on what happened when the Amerindian technique of clearing the forests was used by Europeans on a large scale.

65 Burle Marx, in S. Cals, *Roberto Burle Marx: Uma fotobiografia* (Rio de Janeiro, 1995), p. 87.

66 Adams, *Roberto Burle Marx*, p. 28, calls it 'borrowed scenery'.

67 For example, Eliovson, in *Gardens of Roberto Burle Marx*, p. 45, asked Burle Marx why, if he loved plants, he introduced geometrical lines.

68 Alexander von Humboldt developed the idea of 'social plants' in Europe, such as large woodland stands of oaks or plains of useful grasses, in comparison to the typical variety and lack of social plants in the tropical forest, in the essay 'Ideas for a Physiognomy of Plants', in *Views of Nature: or Contemplations on the Sublime Phenomena of Creation*, trans. E. C. Otté and Henry G. Bohn (London, 1850), pp. 210–31.

69 M. Dettelbach, 'Humboldtian Science', in N. Jardine, J. A. Secord and E. C. Spary, eds, *Cultures of Nature* (Cambridge, 1993), pp. 287–304.

70 Leenhardt, 'Le Jardin: Jeu d'artifices', pp. 19–52.

71 Many of these resemble the pineapple family, and many are epiphytes – that is, plants that grow on other plants.

72 Leenhardt, 'Le Jardin: Jeu d'artifices', pp. 30–34.

73 Adams, *Roberto Burle Marx*, p. 14.

74 *The World Almanac and Book of Facts 2000* (Mahwah, NJ, 1999), p. 878.

75 Claude Levi-Strauss, *Tristes tropiques* (New York, 1973), pp. 91–2.

76 Leenhardt, ed., 'Questions à Roberto Burle Marx', p. 57.

77 Interview by Leenhardt of Gilles Clément, 'Burle Marx et la conception contemporaine du Jardin', in *Dans les jardins*, pp. 87–94.

78 Clément, 'Burle Marx et la conception', pp. 85–94.

79 *Ibid.*, p. 89. My translations from the French.

80 For example, Bernard Lassus, *The Landscape Approach* (Philadelphia, 1998).

81 Leenhardt, in question to Clément, in Clément, 'Burle Marx et la conception', p. 93.

82 Hunt, *Gardens and the Picturesque*, p. 299.

Epilogue

1 Tropical medicine (as a sub-speciality under that name) continues to have less institutional presence in places outside the European countries that historically constituted the major colonial powers and their ex-colonies in the tropics.

2 This was the title of the best-selling book by Bill McKibben, *The End of Nature* (London, 1990).

3 Candace Slater, 'Amazonia as Edenic Narrative', in William Cronon, ed., *Uncommon Ground: Toward Reinventing Nature* (New York, 1995), pp. 114–31.

4 Cronon, 'Introduction: In Search of Nature', in *Uncommon Ground*, pp. 38–9.

5 Peter Gow, 'Land, People, and Paper in Western Amazonia', in Eric Hirsch and Michael O'Hanlon, eds, *The Anthropology of Landscape: Perspectives on Place and Space* (Oxford, 1996), pp. 43–62.

6 Today, rain-forests cover 6 per cent of the land's surface, only half of what they did a few years ago. For a detailed atlas of rain-forests in different areas of the world, various estimates of the rates of destruction, as well as an evaluation of the human factor in tropical environments, see Mark Collins, ed., *The Last Rain Forests: A World's Conservation Atlas* (New York, 1990).

7 Peter Coates, *Nature: Western Attitudes since Ancient Times* (Berkeley, 1998), p. 177, has an interesting if brief discussion of some environmentalists' view that the garden, rather than 'wilderness', is the appropriate place in which to repair our relations with nature.

8 Cronon, 'Introduction', in *Uncommon Ground*, p. 43.

9 Jennifer Price, *Flight Maps: Adventures with Nature in Modern America* (New York, 1999); on the packaging of 'wilderness' as a view and idea in film and television, see Gregg Mitman, *Reel Nature: America's Romance with Wildlife on Film* (Cambridge, MA, 1999).

10 Slater, 'Amazonia as Edenic Narrative', p. 127–8.

11 For an account by the well-known cultural geographer Yi-Fu Tuan, who found himself unexpectedly charmed by his experience of Disneyland, see *Escapism* (Baltimore, 1998).

Photographic Acknowledgements

The author and publishers wish to express their thanks to the following sources of illustrative material and/or permission to reproduce it (excluding sources credited in full in the captions):

Acervo Casa de Oswaldo Cruz/Fiocruz, Brazil: 3, 38–41, 45–50, 53–5, 69, 72, 74–77, 79; Acervo Instituto Moreira Salles, São Paulo: 80–82, 84–6; Avery Architectural and Fine Arts Library, Columbia University, New York: 1; Columbia University, New York (Rare Book and Manuscript Library): 4, 6, 13–14, 17–26, 44; Fine Arts Museums of San Francisco: 10; Marcel Gautherot: 80–81, 84–6; Photos courtesy of the President & Fellows of Harvard College: 23–4, 27–31; Photos by permission of the Houghton Library, Harvard University, Cambridge, MA: 36–7; Museu Nacional de Belas Artes, Rio de Janeiro: 51; Museum of Fine Arts, Boston (photo: © 1999 Museum of Fine Arts, Boston, all rights reserved): 15; Museum of Modern Art, New York (© 2000 Museum of Modern Art, New York): 2; The New York Public Library, General Research Division (Astor, Lenox and Tilden Foundations): 11–12, 43; New York Public Library, Science, Industry and Business Library (Astor, Lenox and Tilden Foundations): 7; The Royal Botanic Gardens, Kew, Surrey (photo: © Board of Trustees of the Royal Botanic Gardens): 16, 22; Photo courtesy of the Safra Bank, São Paulo: 87–8; Adam Stepan: 89; Wellcome Institute Medical Photographic Library, London: 56, 58–68.

Index

Note: Page numbers in *italics* indicate illustration numbers.